moments

moments

THE PULITZER PRIZE-WINNING PHOTOGRAPHS

A Visual Chronicle of Our Time—Revised & Updated

HAL BUELL

Appreciation by David Halberstam

Tess Press

For Regan and William Radcliffe. Know the past, see the future.

ISBN: 978-1-60376-144-4

Library of Congress Cataloging-in-Publication Data on file at the
Black Dog & Leventhal offices.

Designed by Dutton & Sherman Design

Published by Tess Press, an imprint of
Black Dog & Leventhal Publishers, Inc.
151 West 19th Street
New York, NY 10011

h g f e d c b a

Manufactured in China

Contents

Appreciation

I know something about the talent, the hard work, the intelligence and the courage it takes to win the Pulitzer Prize in photography. In 1963 I shared a house in Saigon and worked closely with Horst Faas, photographer for the Associated Press. He was not yet the legendary Horst Faas, though he soon would be—he was to win two Pulitzer Prizes in the coming decade. But I already knew how good he was, and how hard he worked, and how he pushed himself to the outer limits of his abilities. I knew, as well, that almost nothing that he did was the product of chance. It was, rather, the result of intense diligence, exceptional preparation, and uncommon sacrifice.

There was a tendency in those days for reporters to look down slightly on photographers, as if we who used words were of a higher order than those who dealt solely in images. But I thought then, and am now more convinced than ever, that Horst was not just a person of rare talent and intelligence, but that he was something of an authentic journalistic genius. We had met a year earlier when we were both young men starting out, looking for our own privileged seats from which to watch the history of our times. We were working in what was then, before Vietnam, the most dangerous venue in the world: the Congo.

From the start he dazzled me—he was *always* perfectly positioned for the action. But it was not just that he had some kind of homing instinct that would allow his readers to view events from the epicenter of any conflict when they saw his pictures in their hometown papers. Rather, I gradually came to understand that it was not happenstance that he always got the shot, but that he saw more than anyone else around and understood more of the political and military byplay than anyone else. His exceptional positioning never resulted from mere good fortune. It was as if he made such good reads on what was going on around him that he always ended up where the action was going to be. We became instant friends in the Congo, and I came to depend on him for a sense of what was happening in the places I had not yet been. He was a great photographer because he was also a great reporter. When a few months later we both were sent to Saigon, it wasn't long before we were sharing a house together.

In those days I marveled at how, while always willing to risk his life doing his job, he nonetheless always managed to tilt the odds in his favor (or at least as far in his favor as he could). If Horst was going out with a South Vietnamese unit, he would check in advance to find out how good the Vietnamese commander was supposed to be; he did not want to be out in the field with a Vietnamese army unit that, when attacked, would turn out to be poorly led. If the Vietnamese officer was said to be good, Horst would still perform his own unofficial inspection, checking before they went out on an operation the conditions of the mens' rifles and kits. If the Vietnamese grunts were careless about their weapons and their gear, he figured that meant they were poorly led, and he wanted no part of them.

He was always extremely well-prepared. If he knew how to get into a combat situation, he had thought just as hard about getting out of it under the worst and most unpredictable circumstances. (Late in the war, after the American units had come and gone and Vietnam became infinitely more dangerous, Horst would go out with a money belt secreted away under his clothes. It contained thousands of dollars, so that if he was seriously wounded and everything around him was breaking down, he might be able to buy his way onto a remaining helicopter, thereby saving himself and any friend.)

He was the first photographer to my knowledge who went out into the field with prophylactics so that he could waterproof his rolls of film after they were shot—Horst was not going to risk his life shooting dangerous combat scenes in the paddies of the Mekong Delta only to have his film ruined by the paddy water. Similarly, as far back as the Congo, where we were constantly dealing with warring political factions, Horst was the first photographer I knew of to carry, in delicate political moments, dummy rolls of film to be handed over at a roadblock with feigned reluctance, while carrying his real film carefully hidden away.

Everything was always well thought-out because it *had* to be well thought-out. Horst was no journalistic cowboy. He had managed to propel himself to the very top amongst people who were in the

perpetual-risk business—that is, people who quite voluntarily risked their lives day in and day out. But there was no bombast, no braggadocio to him. He was aware that he was there by choice, unlike many of the people he was covering.

If you were in the risk business, you took no unnecessary chances. On November 22, 1963, he woke me up early in the morning at our villa to tell me that someone had just shot John F. Kennedy. Horst had been out at Tan Son Nhut, the main Saigon airport, about to get on a helicopter to go into combat when he had heard news of the assassination broadcast on the military radio network in the mess hall. Upon hearing it, he had immediately turned to the officer commanding the armed helicopter squadron, thanked him for the offer to go into combat and for his courtesies, then grabbed a Vietnamese cab and headed back to our house. There he put his cameras away, got into his civvies and essentially took the next few days off. Horst Faas was much too shrewd and careful a photographer to go out and risk his life in the rice paddies of Vietnam for the next three or four days during which no one would care about the war in Vietnam. The only thing anyone wanted to know about was the death of the handsome, young, American president in Dallas.

I mention this now and track Horst's thought processes with so much admiration because I think it helps give a rare insight into what makes so much of the work in this book so special. For, in most cases, the great photo is not the product of exceptional good fortune and a bit of extra luck on a given day, a day when an historic moment just happens to pay you a visit and stay within the range of your Leica or Nikon. Rather, far more often it is the product of constant hard work, of rare preparation, and of uncommon human sacrifice—of a gifted person of exceptional talent who is willing to give up the protections and safety of a 9-to-5 life and work long, bewildering shifts on endless days often in difficult, very dangerous venues. The reason for the choice is inexplicable—not just for lay readers, but often for the men and women themselves. They do not know exactly why the safe and the secure life bores them and why they want—indeed, need—to take these risks. But take them they do. Somehow, in ways that I've never entirely understood, it's their very talent that draws them away from the world of ordinary people and forces them to seek the adventure that entices great photographers. Doing it is an end in itself. It is the ultimate, great hunt.

So when readers of this book look through it, they should realize that behind many of the photos—the ones they see here, and those they see every day in their newspapers that are brilliant but do not win the Pulitzer—are men and women of uncommon talent, and equally uncommon devotion to their work. More often than not the photos in this book are exceptional because the people who shot them are professionals of the highest order, people who have been doing this kind of work for years—taking risks for years—and who have often paid a very high price in terms of their emotions and their bodies. They were always prepared for the exceptional. And when the exceptional happened, they caught it.

Looking at the photos assembled in this edition, I am moved again not just by the photos themselves but by the sacrifices of the people who took them. In difficult and dangerous venues, the kind of venues where Pulitzers are won, photographers are always prime targets. *Always.* In the South, during the Civil Rights days, they were the perfect target for the angry mobs that could not get their hands on the people they were really angry at back in New York and Washington. In combat venues, the perils were more obvious—they had to operate in situations that were singularly dangerous, and their cameras made them stick out, a beacon to soldiers shooting from the other side.

This handsome book reminds me, as well, not just of the unique power of images in our age, but of the immense, powerful connection of these images to our emotions. As I read and reread the pages of this book I am struck again by the degree to which it stands—without any conscious choice on the part of the judges—as a mirror to our time. It is one thing to assemble the leading head-lines from the leading newspapers for the last 60 years. In that case, there is, going through them, a flash of recognition. But it is, at best, a cool and distant recognition. Oh yes, you think, that was the year the Korean War started, and that the year that the Berlin Wall went up, and that the year that James Meredith integrated the University of Mississippi.

But these photos are quite different. They are less cold. They have a far greater power to move us, and to remind us not just of what happened, but of our emotions as we lived through that time. We place not merely the events in some chronological order, but we recall where we were, and what we were doing, and, most important of all, what we *felt* at the time. What those remarkable photographers—people like Horst Faas, who took such exceptional chances for our benefit—were doing all those years, it turns out, was capturing the face of history for us. What a debt we owe them, and how lucky we are that there are still young men and women out there doing it today—in no small part because they feel they can do nothing less than that.

—David Halberstam

Introduction

What is it that makes a Pulitzer Prize picture?

That question has bedeviled photographers and photojournalists for decades. The definitive answer, after more than half a century of Pulitzer pictures, remains elusive.

The ironclad requirements for a picture to be awarded a Pulitzer Prize are simple. The photo, or photos, must have been published in a daily newspaper in the United States, and must have been made in the calendar year prior to the year of the award. Those regulations, however, offer no guidance about picture content, historical significance, technical skill, journalistic experience, or cultural impact.

An examination of the pictures does not help to define the Pulitzer ethic; as the photos reproduced in this book demonstrate, the winning images form an eclectic selection ranging from moments of great history to moments of high drama and human insight.

Is history a consideration? Many of the Pulitzer photos record historical moments: a flag atop Iwo Jima, the shooting of Lee Harvey Oswald, a girl fleeing napalm in Vietnam. At this end of the historical spectrum, those pictures and others stand as durable photographic icons that record memorable events that are widely recognized as signposts of history. But some Pulitzer pictures are simple vignettes that have their own sense of history: a child talking to a police officer, the mystery of birth, the fading life of cowboys. Photos such as these are delightful glimpses that illustrate the human condition.

Is pictorial drama a consideration? Many dramatic photos have won the Pulitzer: a woman and child falling from a fire balcony in Boston, executions in war and revolution, the joyful human encounter of a hero's return from war. Again, the range is wide.

Does journalistic experience enter into the judge's decision? Most winning photographs are made by experienced photographers assigned to stories that make front page news: World War II battlegrounds, Korea, Vietnam, African villages, city streets. But others are literally snapped (how photographers hate that term) by passersby or by amateurs who have their camera with them when their lives intersect with a memorable moment.

In light of this diversity of images, one must say that the Pulitzer-winning photos by and large document universal moments in the passage of time that take us to places we otherwise might not have seen. Frequently they are the chapter headings of history. Too often they are pictures of violence, because history is more likely to be written in blood than beauty. But the Pulitzer catalogue also includes pictures of those delicious moments that each of us encounters individually, those sweet, gentle insights that separate us from the routine of our lives. Shared through photography, these pictures also become universal.

There has always been a fascinating dynamic between technology and picture journalism that, over the years, has altered both the look of photos and the use of the medium in newspapers, and, therefore, the nature of the Pulitzer-winning pictures.

The technical marvel of wirephoto transmission, used initially in 1935 by the Associated Press, brought newspapers a greater selection of pictures, and in real time. This wirephoto technology transmitted today's pictures today, from separate locations around the world to editors' desks throughout the country. By the beginning of World War II, the defining experience of the twentieth century, wirephoto transmission was widely used and photographs became integral to the daily reports of the war's progress. Pictures, once considered a staple of the sassy tabloids, soon found legitimate news space in more conservative publications. This increase in the stature of photography as a serious tool for reporting the daily news led to the establishment of the photo award in 1942. A second Pulitzer category, for feature photography, started in 1968, again reflecting the medium's changing role in journalism.

Photographic technology also changed. About the same time that transmission technology appeared, the cumbersome Graflex camera gave way to the eye-level Speed Graphic. And that soon gave way to the 35mm camera. Black and white film improved substantially, permitting pictures in places once too dark for the news

photographer. Then color entered the scene. Most recently, digital photography and portable satellite telephones have appeared that deliver more pictures in better quality, and with stunning speed, from virtually every corner of the globe.

As a world grew smaller, it also grew more complicated. Readers sought interpretation in their news pages. News itself, never clearly defined, changed. The definition remained fuzzy, but the changes were apparent. Newspapers of the forties and fifties seldom carried stories about life style, personal problems, or about how to decorate the home. Travel articles were rarely printed and entertainment stories were limited primarily to movie reviews. Many papers of that era carried serialized fiction stories. The appearance of television further contributed to the force that made pictures a reportorial contribution to the information flow.

Pulitzer Prize-winning pictures reflected these changing times and the changing ways that daily newspapers reported the news. In the early days of the Pulitzer's photography category, the strong single picture was an essential ingredient of the prize. In later years, however, as the complications multiplied, photographers turned more to the picture story and produced a collection of pictures on a subject. The single, strong, iconic photo that captured the essence of a story in symbolic as well as real terms gave way to multipicture stories. When color was added, it was not only a technical innovation, but added yet another dimension to how newspapers reported the news.

A careful viewing of the Pulitzer Prize-pictures from year to year reveals definable eras of picture reportage that reflect all these influences. Thus, interspersed in the Pulitzer picture chronology in this book, a number of descriptive passages mark the innovations in news coverage and technology that altered picture journalism. The stories that accompany each award-winning picture or portfolio describe the events pictured and the photographer's role as eyewitness. The story of each Pulitzer winner is also accompanied by a time line that offers the reader context in the form of reminders of other events of that year.

In the final analysis, this book has a simple theme. It is about photographers and their pictures. Or perhaps about pictures and their photographers. It may be impossible to construct a sentence that puts that relationship in its proper perspective. Photography is a process that starts in a photographer's brain and ends up on film—or, these days, on a digital chip. What happens in between, any of these photographers would insist, cannot be described. It is a combination of instinct, insight, anticipation, technical proficiency, visual awareness, and the ability to express visually a mood or an understanding of a subject. These considerations are applied differently by different photographers, and in various degrees for each picture. And all are honed by the cutting edge of experience. There is ample evidence that luck is sometimes a factor, but the pattern also tells us that the harder photographers work, the luckier they become.

No matter how the picture taking may actually work, the question remains of why photographers so frequently put themselves in perilous surroundings to get a picture. The answer is simple, but again inexplicable. The pioneering photographer Mathew Brady said it best when the medium was in its infancy: "A spirit in my feet said go, and I went." In his case, it was to the Civil War. In more recent times, photographers have gone to remote battlefields and isolated corners across the globe, to the back alleys of cities, into dope dens, and on the trail with politicians. Sometimes they sought a career-making picture; sometimes they genuinely sought to make the world a better place; sometimes they satisfied their wanderlust.

Photographers are often thought to become insensitive because of the subject matter they frequently encounter, but this is not so. Photographers weep, too, but after the job is done. And the record is filled with stories of photographers helping, not photographing. Many have died in combat. Scores perished in Vietnam. More fell in World War II. Others died in Africa. Still others were killed in helicopter crashes, or caught inadvertently in the crossfire of bricks and bullets between demonstrators and police. Many lived, but carry the emotional and physical scars of the dangers they faced.

As a group, news photographers are not the gentlest of people. The work is hard and physically demanding, and the opportunities for pictures are fleeting. A picture exists in only a cat-wink of time and is lost forever to the photographer who is distracted for just that instant. Or is blocked by a pompous politician, or by an aggressive colleague. Expletives can follow these incidents.

Photographers who document newsworthy events are also a remarkable group of people. They stop history in a microsecond of time and hold it up for us to see and to remember and to learn from. They do this work despite threat to life and limb, and they enjoy doing it. Most would do nothing else. The elders, looking back, say they would do it again despite knowing the trials, tribulations, and frustrations.

It is in this environment, more than anything else, that the Pulitzer Prize for Photography becomes both an aspiration and an inspiration. It stands for accomplishment in picture journalism that is recognized by the photographer's peers. As a group, the Pulitzer pictures become the symbol of photojournalists' continuing search for excellence over the decades. Along that continuum, the individual pictures mark history's milestones. They offer insight into our lives as part of that history. They serve as reminders of where we have been and where we are. And, if history really is prologue, perhaps where we will go.

The Large-Format Camera and the Early Pulitzers

The early Pulitzer Prize-winning photographs—all those between 1942 and 1954 and several after that—were made with the workhorse press camera, the 4x5 Speed Graphic. The prefix 4x5 was used because the camera's film holder carried film that measured 4x5 inches.

The Speed Graphic was considered quite an innovation when it first appeared. It replaced the Graflex, a camera the photographer held at waist level while viewing the subject by looking down into a ground-glass viewfinder. The Speed Graphic was used at eye level, and the photographer viewed the subject through a wire-framing device attached to the top of the camera. This viewing process both made the camera faster to handle and enabled the photographer to see what was happening beyond the lens's view and therefore be better prepared to catch peak action.

The camera was first introduced in 1912 and was quickly adopted by press photographers. The subsequent invention of the flash bulb in 1929 eliminated flash powder and tripods and permitted indoor use of the Speed Graphic as a hand held camera. So pervasive was the Speed Graphic among newspaper photographers of the 1930s and 1940s—and even into the 1950s—that simply carrying one was, in and of itself, a press pass.

Despite the innovations, operating the Speed Graphic required many steps. For each exposure, the photographer had to change the film holder, replace the flashbulb, cock the shutter, sight the picture, focus the camera, set the proper lens aperture, and, at the right moment, push the shutter release button. If events were unfolding, all of this had to be done very quickly; if action took place that made a better picture during the resetting process, it was lost to a photographer who was just a second too early.

Large and cumbersome, and equipped with a large flash pan, the Speed Graphic reflected blinding bursts of light from flashbulbs the size of those in a desk lamp. A battery of working news photographers covering an assignment often created explosions of light that startled, and sometimes frightened, the subject. Photographers also frequently burned their fingers as they rushed to exchange the just-expired bulb with a fresh one before the first had cooled. Sometimes the bulb exploded, adding to the chaos.

Despite the problems, many fine photos came from Speed Graphics and the photographers who operated them. Most Pulitzers of this early period were awarded to single pictures that were compelling and simple, even poster-like in shape and design. They were, by and large, the product of photographers who had to count their shots and calculate carefully the odds against a better picture opportunity appearing seconds later.

This need for a conservative approach to using a Speed Graphic

was never more important than during World War II. Because of supply problems, for example, Joe Rosenthal was so decisive about the pictures he made that he took only sixty-five exposures in the weeks he spent covering the Iwo Jima battle; his picture of Marines raising the American flag on the island became the most famous picture from the war (page 20). Frank Noel made his prize-winning picture of a shipwrecked Indian sailor from a lifeboat, not knowing whether he or his film would survive (page 15). And Earle Bunker had to decide which was the right emotional moment when he photographed a hero's return to his hometown (page 19).

By learning to anticipate action, photographers using a Speed Graphic could save their shots and wait for just the right moment. If that moment were missed, the cry "Just one more!" was often heard. The call became so common that President Harry Truman, who liked photographers, introduced the White House photographer corps to visiting dignitaries as his "Just One More Club."

During the 1930s, smaller, more flexible 35mm cameras had been introduced, and their use became increasingly common in Europe, where photographers welcomed a more candid approach to taking pictures. American news photographers, however, generally stayed with the larger Speed Graphic. They believed that its large film size produced better, sharper prints, which in turn made better newspaper reproductions. They were not incorrect in that initial assessment. The early 35mm film frequently delivered grainy pictures, and it required careful handling in the lab; the larger format was better suited to the hurly burly atmosphere of daily newspapers. The 4x5 format thus remained in use through World War II and beyond.

It was in Korea that American photographers started using smaller formats, first Rolleiflex and Rolleicord cameras that took film in twelve-exposure rolls producing 2 1/4- by 2 1/4-inch negatives. These twin-lens reflex cameras could be operated at either waist level or eye level. The roll-film camera enjoyed a few years of popularity; but by the mid-1960s, most news photographers used 35mm cameras.

Photographers first used smaller formats for making personal shots of themselves and their friends while in the field. As they gained experience, and as the film and lens manufacturers improved technical quality, there was a gradual move toward using the smaller camera for professional work. The last Pulitzer Prize photo made with a Speed Graphic was Yasushi Nagao's picture of the assassination of a politician in Tokyo, which won the award for 1961 (page 53). By then, however, several prizes had already been awarded to pictures made with smaller cameras.

1942

Labor Strife in Detroit

BY MILTON BROOKS, *THE DETROIT NEWS*

In the 1940s and 1950s, before motor drives could feed film through a camera at five frames per second, patience was as much the photographer's tool as was the camera. The cumbersome operation of the Speed Graphic camera meant that photographers could only shoot one frame every six or seven seconds. Yet pictures, as every cameraman working on the street knew, came and went with the blink of an eye.

In the spring of 1941, Milton Brooks's photographic attention was not focused on the war in Europe, or on the growing troubles with Japan. Instead, he was in Detroit, at one of Ford Motor Company's biggest plants, the River Rouge, where labor trouble was brewing. Brooks, who was called "One-shot Milton," was a master of patience. In Detroit photography circles, it was said that he would wait until the right picture was about to happen, make one shot, and then go home.

Never before had a Ford plant in Detroit been closed by a strike; Henry Ford always insisted that he would close a plant before he would deal with the unions. Times were changing, however, and years of violence had characterized much union activity as labor won its franchise in the streets. General Motors had caved in to the union, as had Chrysler. Still, Henry Ford could not bear the idea of negotiation.

On April 3, inside the River Rouge plant, a worker was fired, and the cry "strike" was heard throughout the grounds. Striking workers walked the line, urging nonstrikers to walk out. The 120,000-man plant was closed down. Strikebreakers and unionists clashed.

Milton Brooks was patient, as he always was; and watching for the right moment, he noticed a man arguing with a group of pickets. Brooks later recalled, "He had the wrong side of the argument, and I knew there would be trouble pretty soon." Other photographers moved on to look for scenes with more graphic interest than a verbal exchange, but Brooks waited.

The man arguing with the pickets tried to push his way through the line. The strikers stiffened their positions. The clubs came out, and Brooks moved forward; the man attempted to protect himself, but the clubs swung and the ever-patient Brooks unobtrusively made the picture.

His photograph was awarded the first-ever Pulitzer Prize for photography.

MAY **1941** ■ *Rudolf Hess makes a mysterious trip to Scotland, where his plane crash lands.*

MAY ■ *Orson Welles's film* Citizen Kane *opens.*

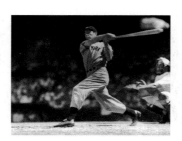

OCTOBER ■ *Joe DiMaggio hits safely in fifty-six consecutive games, establishing a major league record.*

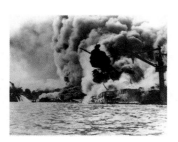

DECEMBER ■ *Japan bombs Pearl Harbor. President Roosevelt declares December 7, 1941 a date "which will live in infamy."*

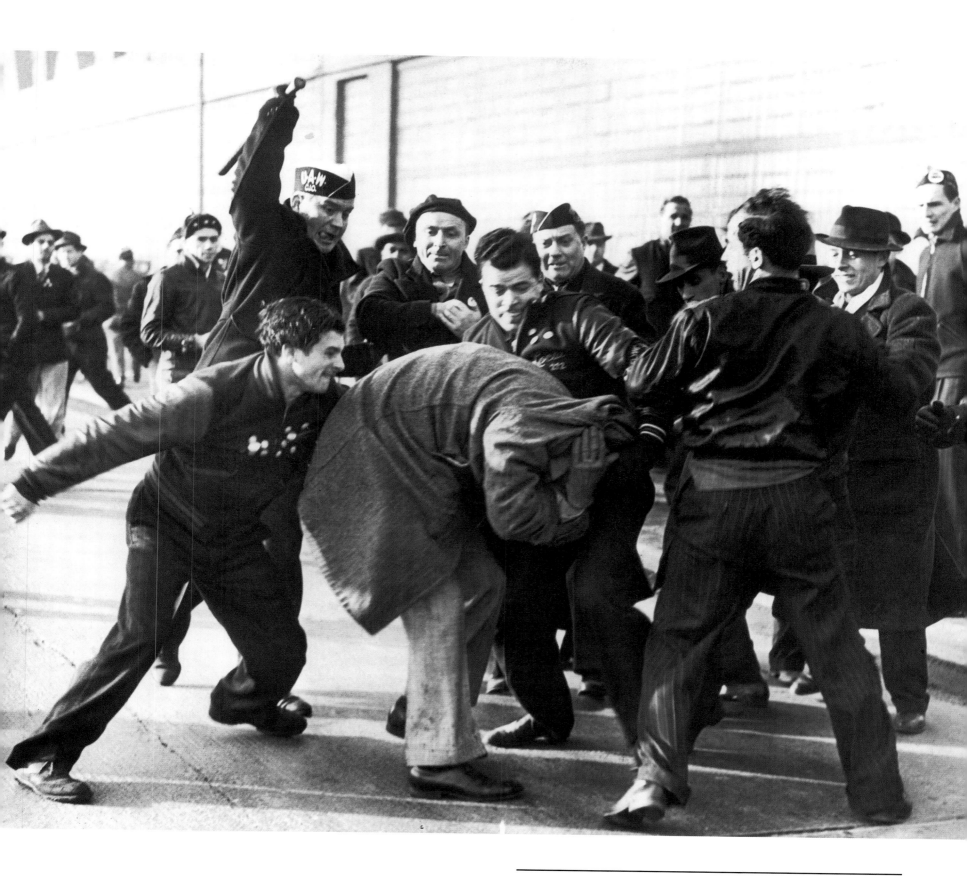

TECHNICAL DETAILS **CAMERA** 4x5 Speed Graphic
FILM Kodak
LENS 127 mm
SHUTTER & APERTURE Unknown

1943

Water

BY FRANK NOEL, ASSOCIATED PRESS

The Pacific war was going badly when Associated Press photographer Frank "Pappy" Noel decided that the time had come to leave Singapore. He had been covering the British troops as they stayed just a few steps ahead of the Japanese army driving south through the Malaysian jungle. Now Japanese bombers were beginning to hit the city. In addition, he had contracted malaria; and, in January 1942, the bitter taste of the December 7 attack on Pearl Harbor still gripped him.

Noel was a journalist of the Hemingway kind—tough, durable, and as good with a camera as any writer was with words. But he could read the signs, and he knew his time covering the British was coming to an end. No one, it seemed, could stop the Japanese onslaught across Southeast Asia. He also knew that to remain meant certain imprisonment, or even death. When the message came from New York to head for home, it was welcome.

Following the home-office orders, Noel booked passage on a freighter that would take him to Burma; the clothes on his back and his Speed Graphic were his only luggage. He hoped he could shake the malaria by the time he arrived in New York. He had a 15,000-mile trip ahead of him, but the trip was short-lived. One night, in the Indian Ocean, less than three hundred miles out of port, a Japanese torpedo ruptured the vessel. Trapped in his cabin,

Noel had to batter the door down to escape. He grabbed his camera and, with twenty-seven survivors of the ship's seventy-seven-man crew, boarded lifeboats. They drifted for five days on an endless sea beneath the searing tropic sun. Home seemed a lot more than fifteen thousand miles away.

After several days, another lifeboat drifted close to the boat carrying Noel. An Indian sailor on the passing boat begged for water—their supply had been lost in the headlong rush to get away from the sinking freighter. Sadly, Noel and his companions had none to offer.

The demoralizing progress of the war, the withering Asian sun, the destructive grip of malaria, and the hopeless situation all failed to lessen Noel's photographic instincts, however. He raised his camera and made an exposure of the wretched sailor whose eyes spoke volumes as his hand reached out to seek help, his expression reflecting the woeful news that there was no water. The encounter lasted only moments before the boats drifted apart; a tropical storm blew in, and the tiny vessels lost visual contact. The Indian sailors were never seen again.

Miraculously, Noel's boat reached coral reefs off Sumatra five days after the submarine attack. He was rescued and made it home safely. When he submitted his expense account, it included "one torpedoing—no charge."

MARCH 1942 ■ *People of Japanese descent living on the West Coast—including American citizens—are interned in camps for the duration of the war.*

APRIL ■ *General James Doolittle and his flyers launch a surprise bomb attack on Tokyo and other Japanese cities.*

SEPTEMBER ■ *In an effort to conserve supplies, sugar and gasoline are rationed in the United States.*

NOVEMBER ■ Casablanca, *starring Ingrid Bergman and Humphrey Bogart, opens.*

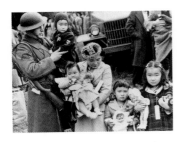

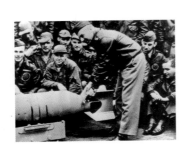

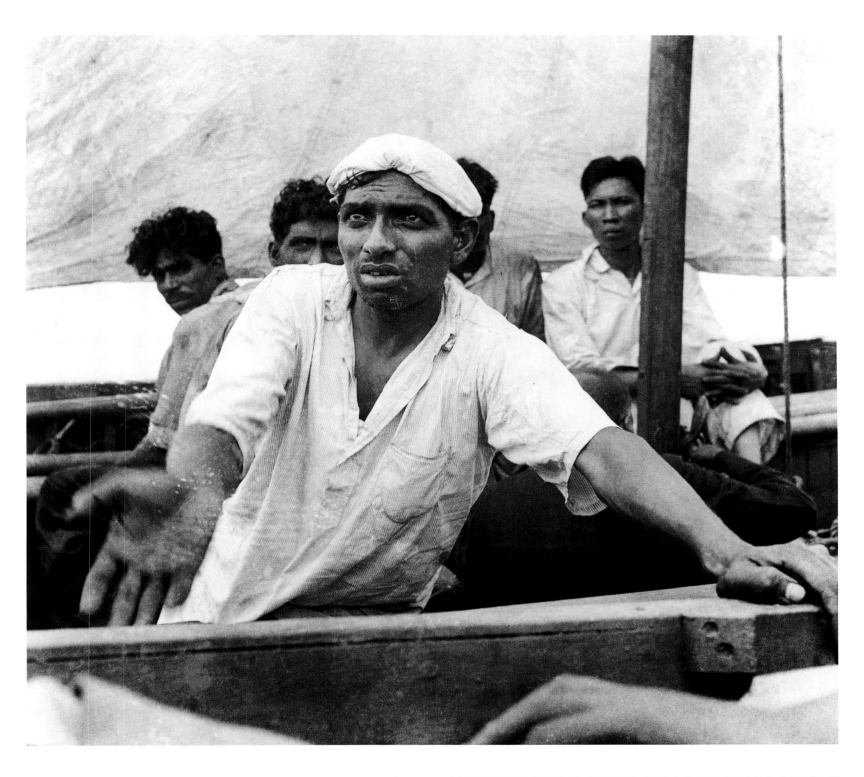

Noel's career didn't end there. He returned to cover the war in Europe, and he photographed the 1948 war in Palestine. He went to Korea to cover the war there, but he was captured by the Chinese early in the conflict and spent thirty-two months in a prison camp. He escaped, was recaptured and punished with beatings and confinement in a small, solitary cell. Noel's Associated Press colleagues in Tokyo managed to smuggle a camera to him in the prison camp, and he sent back unprecedented pictures of GI prisoners awaiting the peace treaty.

TECHNICAL DETAILS **CAMERA** 4x5 Speed Graphic
FILM Kodak
LENS 127 mm
SHUTTER & APERTURE Unknown

Noel was finally released and worked for a while in New York before moving to an AP staff job in Florida. He died in retirement there, far from the Asian sun and Korea's frigid, rocky hills.

1944

Tarawa

BY FRANK FILAN, ASSOCIATED PRESS

Tarawa is an island paradise. A coral atoll about half the size of New York's Central Park, it curves gracefully across the South Pacific to create a lovely tropical harbor. Before World War II, sailors followed the wind to Tarawa's calm beauty; but in November 1943, Associated Press photographer Frank Filan found only blood and death, the island's blue sky hidden by the black smoke of battle.

Those who planned the Tarawa invasion knew it wouldn't be easy, but they also believed taking the island was possible without heavy casualties. The Japanese Rear Admiral Keiji Shibasaki, however, told his countrymen, "A million men cannot take Tarawa in a hundred years." Shibasaki knew the island was well-defended with entrenched concrete pillboxes protected by both steel and densely placed coconut-tree logs that would defy American bombs and shells.

Both the invaders and the defenders would be proved wrong, and the harsh lessons they learned at this early Pacific background became vital to subsequent island invasions.

Filan, wearing a floppy hat, which he preferred to wearing a helmut, watched from a troop ship as American bombers and fighter aircraft hit the island again and again. The naval bombardment sent shell after shell crashing onto the atoll. Like the marines who would be sent ashore, he didn't believe anything could survive the air and naval attack, but the bombing failed to do serious harm to the Japanese defenses.

When the Marines moved ashore loaded with weapons, Filan went with them, loaded with his 4x5 camera, film, and other equipment. The first problem they encountered was a reef just a few feet below the water's surface that functioned as a natural defense for the harbor opening. Amphibious craft crunched over the reef, but Filan and most of the Marines were riding in more numerous landing craft that were stuck on the reef. The invading Marines had to jump into the water and wade neck-deep over the reef to the shore hundreds of yards ahead. Underwater barriers funneled the attackers into lanes, where machine-gun fire, mortars, and rifles caught them in deadly crossfire. Many Marines were killed before reaching shore; others were wounded. Some dropped into underwater holes and drowned.

The landing craft that carried Filan was hit and began to sink. The AP photographer jumped into the water and waded toward the shore. A wounded Marine alongside Filan attempted to make it back to a ship; Filan helped him but as they headed back to the landing craft he realized that they wouldn't make it. He convinced the Marine to head toward the shore instead; both managed to reach the beachhead. While they were in the water Filan lost his cameras and equipment. He recalled later, "There I was with a war going on around me and nothing to take a picture with."

That first day on Tarawa Filan clung to whatever protective cover he could find, as did everyone else who made it to shore.

FEBRUARY 1943 ▪ *The German army is defeated at Stalingrad.*

APRIL ▪ *The Battle of the Warsaw Ghetto begins, ending six weeks later with 5,000 German troops killed and 5,000 Jews killed defending themselves.*

JULY ▪ *U.S. airborne troops and British paratroopers invade Sicily.*

JULY ▪ For Whom the Bell Tolls, *starring Gary Cooper, Ingrid Bergman, and Katina Paxinou opens.*

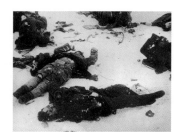

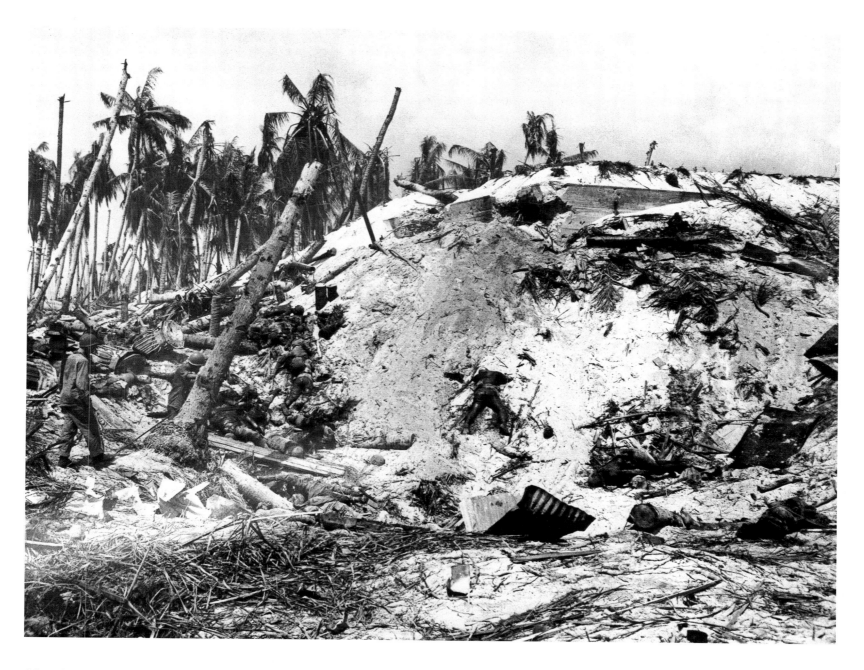

After dark, however, Filan pitched in to help the other soldiers. Combat correspondent Lt. Jim Lucas wrote of Filan's activities, "So all night long we saw him, a funny little man in a panama hat—everyone else on Tarawa wore a helmet—and a loose fitting coat and trousers which might have been a Los Angeles zoot suit, working on the left rear corner of a stretcher. No one but Frankie knows how many wounded marines he brought back from the front."

On the second day of the three-day battle, Filan borrowed equipment from a military photographer to record the carnage. Marines took the Tarawa pillboxes first by sweeping them with flamethrowers and then dropping grenades in the air vents and firing slits. Filan's photographs showed the results—charred bodies, burned logs, and twisted metal blown out by demolition troops.

There were 4,800 seasoned Japanese troops on the island, plus some 2,000 Korean construction workers. Seventeen Japanese and

TECHNICAL DETAILS **CAMERA** 4x5 Speed Graphic
FILM Kodak
LENS Unknown
SHUTTER & APERTURE Unknown

129 laborers survived. More than a thousand Marines died, and some 2,100 were wounded representing an unacceptable 17 percent level of casualties—or forty Marines killed or wounded for every hour of battle.

At Tarawa, the Americans learned that winning the tiny islands of the Pacific would not be easy and that the Japanese troops were determined to die to the last man rather than surrender. And the Japanese discovered that the Americans were just as determined to stay on an island once they were ashore. Both sides came to know that the island war, much of it still ahead, would be costly. Filan's harsh, brutal pictures carried that message to the home front.

A Hero Returns

BY EARLE BUNKER, THE *OMAHA WORLD-HERALD*

In 1943, Villisca, Iowa was a hamlet of eleven hundred people about fifty miles southeast of Omaha, nearly lost on the great prairies that sweep across America west of Chicago. On a road map, Villisca rated just one type size larger than the names of the smallest of villages; it was the essence of small-town America, a town that recognized it heroes.

On July 15, 1943, Lt. Col. Robert Moore returned to Villisca from a distant war. The *Omaha World-Herald* assigned Earle Bunker to cover the story because Moore was a hero, the real thing. Here was a chance for him to make a picture about the war that would be different than the depictions of combat hellfire that filled the news pages in the early 1940s, a chance to reveal the depth of emotion the war stirred in families throughout the country.

Moore *was* a real hero. He and his fellow Iowans had faced off against Germany's Desert Fox, Field Marshal Rommel, and his rugged Panzers in North Africa. Moore and his battalion held off two Panzer divisions on a hill called Lessouda until his outfit was was ordered to withdraw.

That did not end the fighting, however. The U.S. troops were fifteen miles behind German lines, and as Moore led his men through the enemy positions, they faced machine-gun, artillery, and sniper fire. Thirty-five members of the battalion fell before the German guns. The batallion finally reach Kasserine Pass in Tunisia, but German bombing caught up with them and Moore was wounded. He was awarded the Distinguished Service Cross for his heroic leadership and then ordered home.

Villisca is a long way from Tobruk, Tripoli, and Casablanca, names that would become memories, but in 1943 those names were all too real. Earle Bunker waited for some twenty-four hours for the train carrying the hero home to his wife, Dorothy, and their seven-year-old daughter, Nancy, and the patient, jubilant town population.

When the train rolled into the small Villisca station, the soldier, who had been away for sixteen months, stepped out, saw Nancy, and dropped his baggage and equipment. The child rushed from the crowd and was enveloped by her father's arms, while Dorothy Moore covered her face with her hands.

Bunker carefully chose his moment and captured a scene as timeless as life itself—a hero coming home to family, love and a way of life.

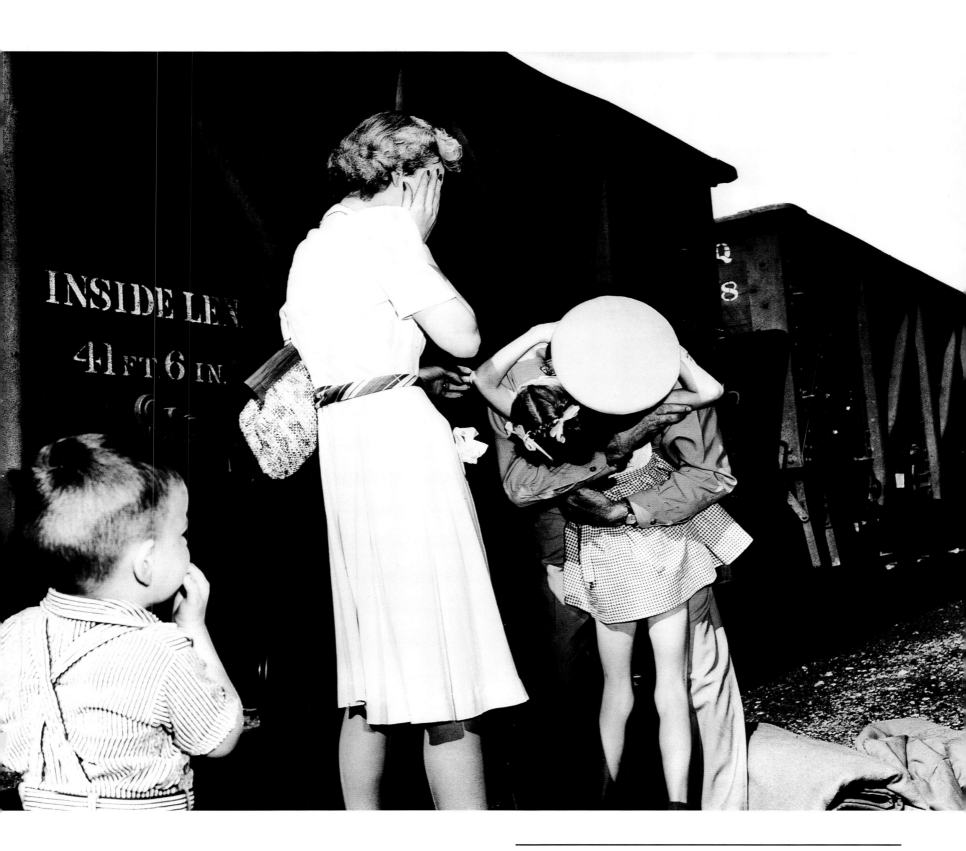

TECHNICAL DETAILS **CAMERA** 4x5 Speed Graphic
FILM Kodak
LENS 127 mm
SHUTTER & APERTURE Unknown

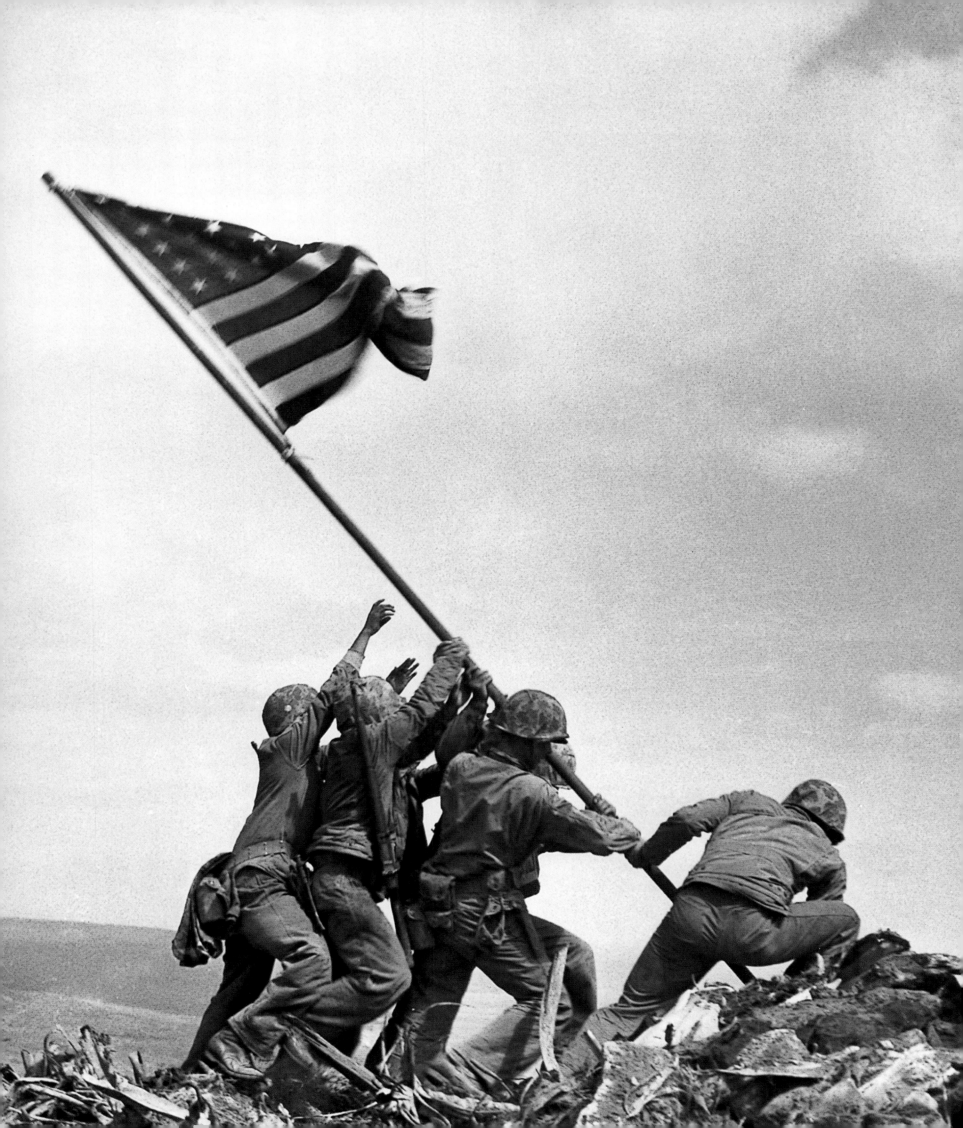

The Iwo Jima Flag

BY JOE ROSENTHAL, ASSOCIATED PRESS

On February 19, 1945, as the landing craft bounced and swayed through the sea toward Iwo Jima, AP staff photographer Joe Rosenthal and his U.S. Marine companions could see their destination—the black sands of the beach and, in the background, Mount Suribachi, a brooding watchtower that commanded a view of the entire island.

The coming days would expose all of them to vicious fighting. Rosenthal knew he would photograph a fierce battle, since all the Pacific Island battles had been fierce; but he didn't know that Iwo Jima would be the site of the bloodiest battle in Marine Corps history. He had no way to foresee that, in several days, he would be atop Suribachi, where he would make the most famous photograph of World War II and arguably the greatest American photo icon in history. And win a Pulitzer Prize.

As the landing craft struck the Iwo beach with a crunch, Rosenthal made his first pictures of Marines dashing toward what little cover there was on the beach. He ran for cover himself as he scrambled to photograph the battle. Marines fell around him, caught in the enemy crossfire. "No one knows how they survived that beach," he says. "It was like walking in rain without getting hit."

Iwo Jima (translated, "sulphur island") was a Japanese home island, actually a part of Tokyo, but some seven hundred miles distant. In the millenia of the nation's history, foreign troops had never invaded Japan's home territory. The American military leaders knew

the impact of a landing on Iwo Jima would be devastating to the morale and intensely nationalistic pride of the Japanese.

Some 70,000 troops—50,000 Americans and 22,000 Japanese—met head to head on Iwo Jima's eight square miles. In the month-long battle, close to forty percent would die, nearly 7,000 Americans and more than 20,000 of the Japanese garrison.

Joe Rosenthal covered the fighting daily, shipping packets of film back to Guam by air. Editors sorted them and transmitted the best images immediately via radiophoto to San Francisco, where they were transmitted to the rest of the world. His dramatic pictures of the Iwo Jima landings won spectacular play in newspapers and magazines.

Five days after landing, Rosenthal heard that a platoon of Marines would ascend Mount Suribachi and raise a flag. He gathered his equipment and prepared to transfer to a landing craft from the command ship just off shore, where he had gone to photograph Navy Secretary James Forrestal. He tossed his cameras to a colleague; but as he turned to step onto the smaller vessel, he slipped and plunged into the rolling sea. The sides of the ships hovered above him, and he thought, as he watched the tillerman fiercely spinning the wheel, I sure hope he gets it right. The seaman did, the vessels moved apart, and Rosenthal was pulled from the water. Once on shore, he replaced the helmet he lost in the incident and pro-

MAY **1944** ■ *Jean-Paul Sartre's play* No Exit *is performed in Paris. His novel* Being and Nothingness *was published in 1943.*

JUNE ■ *D-day landings begin on the beaches of Normandy.*

AUGUST ■ *The Allies liberate Paris.*

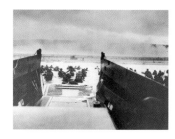

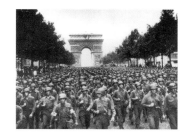

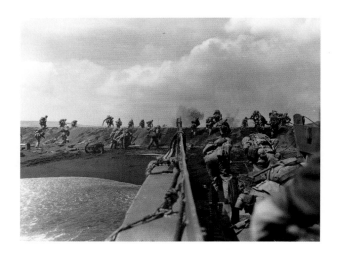

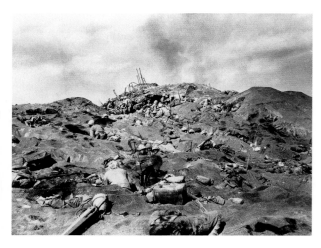

job, to find and capture an image that would give the world a glimpse of what it was like on that mountain on that particular February day.

Atop Suribachi, Rosenthal encountered a group of Marines attaching a flag twice the size of the first one to a twenty-foot pipe that had been blown loose by the bombardment. "What's up?," Joe asked. The men responded that the colonel wanted them to put up a bigger flag, one everyone on the island could see.

Rosenthal found a spot from which to photograph the event, raised his camera, steadied it against his cheek, and watched the rising pole and the flag snapping in the breeze. He made a single shot, frame number nine on a twelve-shot film pack. Genaust exposed 198 frames of color movie film as the flag went up. Off to the side, the first flag came down at precisely the same time.

Three soldiers held the newly raised, makeshift flagpole steady, while others sought rope or cable to tie it in place. Joe asked the Marines to gather under the flag, wave, and raise their weapons. "No," some said. "We aren't Hollywood Marines." Others obliged. Joe took a picture, then another.

It would be a couple of weeks before anyone on Iwo Jima knew the impact of the picture. Three of the flag-raisers never saw the picture—they died in the days afterward as the fighting continued. A fourth flag raiser was seriously wounded. Movie cameraman Genaust fell to the Japanese rifle fire without knowing that his 198 frames would so deeply affect America's perception of the war. Of the forty-man platoon that ascended Suribachi's slope on February 23rd, only five left the island unhurt at the battle's conclusion a month later.

At home, far from Iwo Jima's black sands, sulphurous odors, and deadly encounters, Americans were apprehensive about the war in Asia. European fighting was winding down, but news from the distant, strangely named battlegrounds of the Pacific was not good. Americans could identify easily with Berlin, Rome, Paris, London. But Saipan? Guam? Peleliu? Tarawa? Guadalcanal? To the average American, these were places with mysterious history and no recognizable ancestral heritage. They couldn't be found on a map. Nevertheless, the death toll climbed to staggering proportions in these places. Now, at Iwo Jima, more Americans had been slain on an unknown island, on a limitless ocean, in an endless war.

ceeded slowly up Suribachi with two Marine photographers, still photographer Bob Campbell and motion-picture cameraman Bill Genaust.

Halfway up the Suribachi slope, the team of journalists met Sgt. Lou Lowery, photographer for the Marine magazine *Leatherneck.* Lowery told them a flag was up, "but it's a helluva view up there." Rosenthal and his companions continued. As he neared the rim of the volcano, he could see the flag appear above the mountain's volcanic lip.

"I stopped," he says. "It gave me a jolt. That was our flag, my flag, up there, and I was overcome by the price paid to put it there." He shook off the emotion of the moment and continued forward to do his

APRIL 1945 ■ *President Franklin Delano Roosevelt dies; Vice President Harry S. Truman becomes President.*

APRIL ■ *The Holocaust is revealed.*

APRIL/MAY ■ *Hitler commits suicide; Mussolini is executed; Germany surrenders.*

AUGUST ■ *The atomic bomb is dropped on Hiroshima and Nagasaki by the United States. Japan surrenders; World War II is over.*

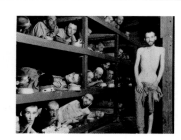

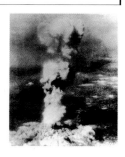

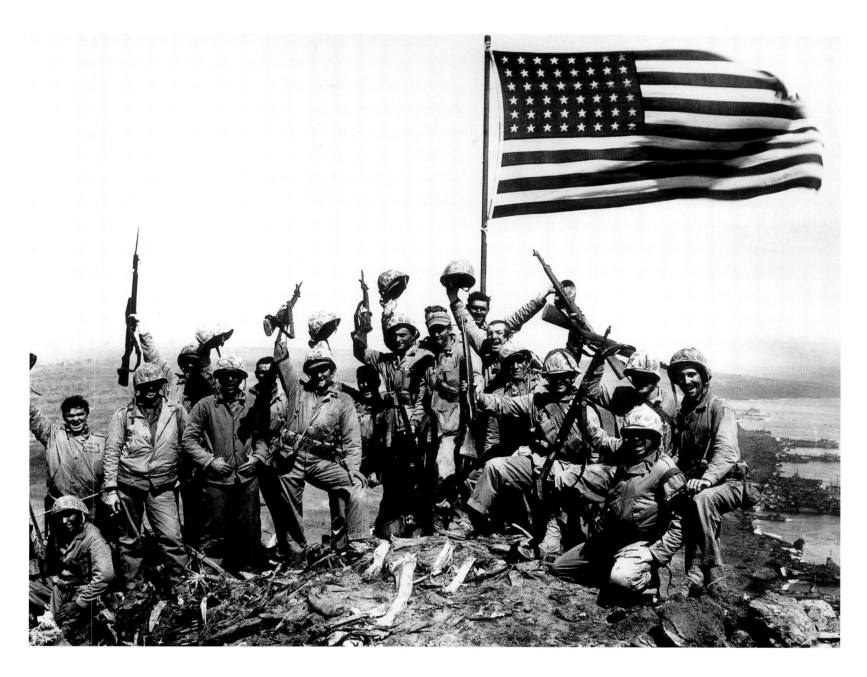

Then came the Rosenthal picture in all its iconic glory—six Americans, all for one, working together in victory and valor; and above them, Old Glory. Finally, for the first time, a clear, simple statement from the Pacific gripped the United States.

The image became the signature of the wartime era's seventh and most successful war-bond drive, and President Roosevelt insisted the flag-raisers be returned home to speak at bond rallies. The post office at first resisted including the image on a stamp, citing its policy that living people cannot be portrayed, but it finally relented and sold 137 million three-cent stamps imprinted with the Iwo Jima scene. The photograph was the subject of movies, books, and television programs and, later, some controversy.

Plans to create a monument, the largest bronze monument ever built, were started within hours of the time the photo appeared. It now stands in Arlington, Virginia, but when it was dedicated in 1954, neither Rosenthal nor the picture that inspired it were mentioned.

TECHNICAL DETAILS **CAMERA** 4x5 Speed Graphic
FILM Agfa
LENS 127 mm
SHUTTER & APERTURE 1/400th @ f16

Joe Rosenthal returned to the U.S., and the Associated Press offered him several top assignments. He received bonuses, salary increases, and awards, including the coveted Pulitzer, which was not only declared by acclamation, but bestowed in the year of its making, rather than the following year. Finally, he moved to San Francisco and accepted an offer from the *San Francisco Chronicle,* where he worked as a staff photographer for thirty-five years. Now close to ninety years old, Rosenthal clearly recalls those days a half century ago on a tiny atoll in the Pacific. He remembers not only that day, but all the days since as his life became intertwined with a photograph of the raising of a flag. He wonders how 1/400th of a second could last so long.

The Winecoff Hotel Fire

BY ARNOLD HARDY, ASSOCIATED PRESS

For Georgia Tech student Arnold Hardy, Friday nights were an opportunity to go dancing and stay out late. Arriving home in the wee hours of the morning on December 7, 1946, Hardy heard the sirens of fire engines. He called the fire department and learned that Atlanta's Winecoff Hotel, on Peachtree Street, was ablaze.

Hardy, an amateur photographer, grabbed his brand new 2 1/4 by 3 1/4 Speed Graphic (slightly smaller than the classic 4x5), a film pack, and his entire cache of five flash bulbs. A cab took him to within two blocks of the hotel, and he ran the rest of the way. He turned a corner and, at 4:15 a.m., stopped short in his tracks. "Rounding the corner, I came upon it all at once. Fire was raging from the upper floors. From almost every window men, women, and children screamed for help," he said later.

Newspapers recounted the horror in detail. A peculiarity in the Atlanta building code allowed the structure, built in 1913, to be constructed without fire escapes. The fire flashed through hallways and stairways, preventing escape from within the building. Only the windows provided a way out.

Fire ladders could only reach the ninth floor of the fifteen-floor structure. Hotel guests tried to escape from upper floors by using bed sheets tied together to descend to the ladders, but the sheets tore or pulled apart and bodies fell to the pavement. Some guests tried to creep along the ledge from window to window and slipped, falling to the street. One woman threw her two children from a window, despite the call of the firemen to wait until nets were ready. She then followed, and all three died. Another woman jumped and crashed into a fireman who was helping a guest escape on a ladder below; the three plunged to the street. A narrow alley behind the hotel became piled deep with the bodies of those who fell trying to leap a ten-foot space between the hotel and a neighboring building.

Hardy made a few pictures as he watched the scene in horror. "Suddenly," he says, "I heard someone shriek. I looked up, raising my camera. A woman was plummeting downward. As she passed the third floor, I fired, using my last flashbulb." The falling woman hit a pipe that held the marquee, then bounced into a railing around the marquee and onto the street. As forceful as each collision was, they broke her fall and she lived.

But 118 others of the 256 guests did not. Many of the survivors on the upper floors were those wise enough to block the cracks around the doors to stop the smoke and await rescue. The owner, W. F. Winecoff, was found dead in his fourteenth floor suite alongside his wife, who also perished.

Hardy developed his pictures and hurried them in a wet towel to the offices of the Associated Press in Atlanta. Three of his pictures were transmitted to the world. His Pulitzer was the first prize awarded to an amateur.

TECHNICAL DETAILS **CAMERA** 2 x 3 Speed Graphic
FILM Kodak film pack
LENS 100 mm
SHUTTER & APERTURE Flash @ f4.5

MARCH 1946 ▪ *Winston Churchill gives his "iron curtain" speech in Fulton, Missouri.*

JULY ▪ *Mother Frances Cabrini, the first American saint, is canonized.*

OCTOBER ▪ *Goering, Hess, Ribbentrop and others are convicted at the Nuremburg war crimes trial. Nine of the convicted criminals are executed.*

DECEMBER ▪ *The film* It's a Wonderful Life, *starring Jimmy Stewart, is released.*

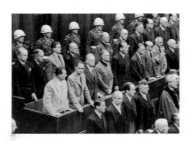

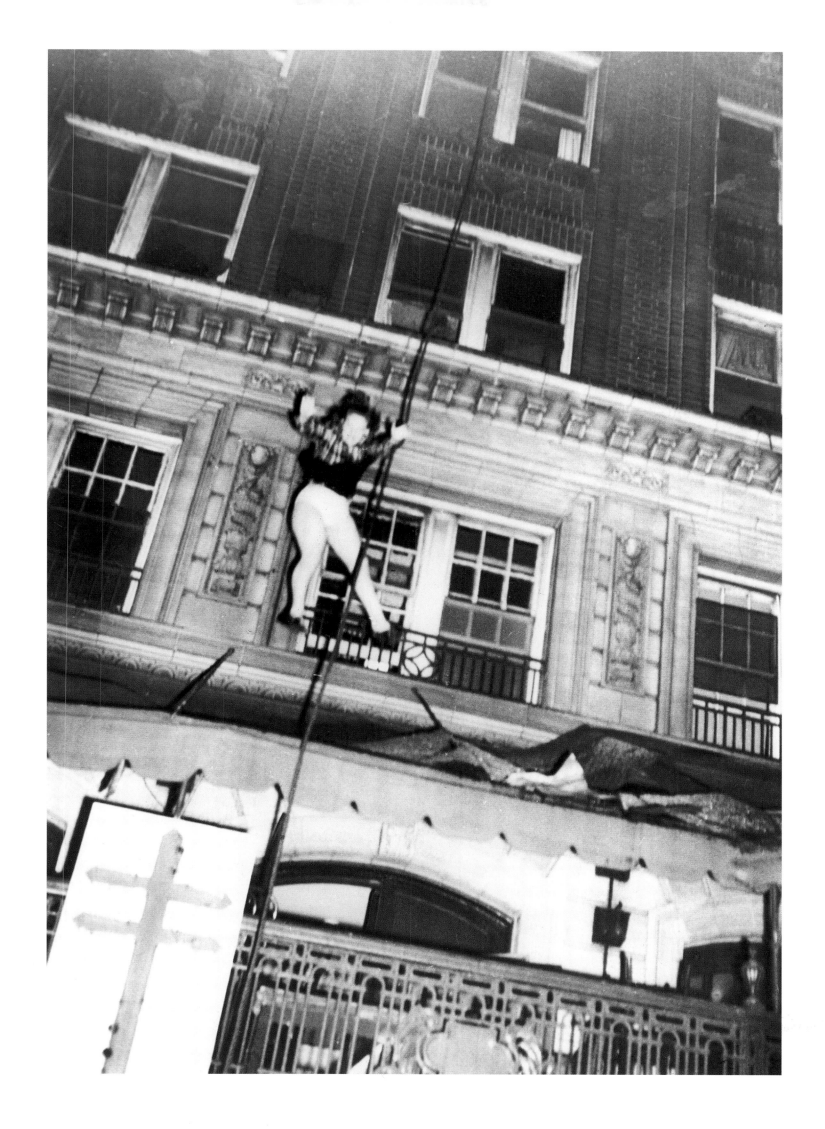

A Boy, a Pistol, and Trouble

BY FRANK CUSHING, THE *BOSTON HERALD*

On a lazy early-summer afternoon in June 1947, *Boston Herald* photographer Frank Cushing was sitting in his radio car outside a Howard Johnson restaurant, waiting to photograph victims of a two-bit holdup. The story was so routine, he knew that the photograph might not even make the paper.

Then Cushing heard the crackled sounds of an alert coming from the radio of a police car parked alongside his vehicle. A shooting had taken place...an officer was injured...a hostage was held...and it was just down the street. Cushing shifted into gear and sped to the scene.

Two police officers had stopped a fifteen-year-old youth and questioned him about a robbery. Suddenly the boy, Ed Bancroft, pulled out a pistol and started shooting. He wounded one policeman in the arm and fled into a nearby alley, where he grabbed a hostage, another fifteen-year-old named Bill Ronan.

The cops quickly blocked the ends of the alley to cut off Bancroft's escape, but he threatened to shoot Ronan if the police came closer. He fired several times at police and repeatedly shoved the gun into Ronan's back.

Cushing managed to make a long shot from the end of the alley, but he knew it would be a bad photo because he was too far away.

Events began to move quickly. The police began to move closer, and Bancroft once again screamed his threat to shoot Ronan. He shot at the police as they moved in.

Meanwhile, Cushing went out to the street and calculated which house was across the alley from where the two youths were positioned. He talked the owner into letting him in, crept along a sun porch, and—very, very carefully—made his picture of the two boys. "I was wondering whether the kid would shoot me," Cushing said later. "But I wanted that picture."

By this time, there were about thirty police in the area. One of them worked his way along the fence to a spot where Bancroft was making his stand and trying to figure a way out. At the right moment, the cop stood up behind Bancroft, reached over the fence, and stunned him with the butt of a weapon. The dazed youth, who had nothing to do with the Howard Johnson robbery, was taken into custody immediately and jailed.

Cushing's photograph was remarkable because at a time when hostage situations were rare, his photograph showed one actually underway. In addition, the limited lens capabilities of the Speed Graphic, the usual camera of the press photographer, meant that cameramen had to be close to their subjects, which is generally not possible in a hostage situation. Cushing's ingenuity and persistence paid off and resulted in an extraordinary picture.

JANUARY 1947 ■ *Chicago gangster Al Capone dies.*

APRIL ■ *Jackie Robinson signs with the Brooklyn Dodgers, becoming the first black baseball player in the major leagues.*

OCTOBER ■ *Hollywood visits Washington, D.C. to protest the House Un-American Activities Committee hearings.*

OCTOBER ■ *The first 300 families move into Levittown, on Long Island, New York, which was constructed to satisfy post-war housing demands.*

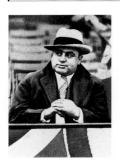

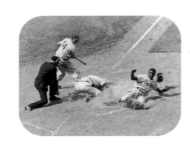

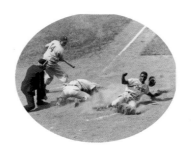

TECHNICAL DETAILS **CAMERA** 4x5 Speed Graphic
FILM Kodak
LENS 127 mm
SHUTTER & APERTURE Unknown

27

The Babe Bows Out

BY NAT FEIN, THE *NEW YORK HERALD TRIBUNE*

Some photographs transcend their subjects. They are images whose meaning grows with time; they mark not just a special place, but a special era. They remind us of much more than the moment in time they depict. These pictures become icons.

Nat Fein, of the *New York Herald Tribune,* made such an icon when he was assigned to Yankee Stadium to photograph the last appearance of George Herman Ruth, the mighty Babe, the Sultan of Swat, the King of Clout. It was June 13, 1948, a dreary, bleak day.

The Babe was very ill and had not played baseball in some fifteen years, but memories of the years when he did play drew a packed house. The fans were there to say farewell, and thanks for everything.

Fein knew that Ruth's uniform, number three, would be retired. As The Babe accepted the cheers of the assembled multitude, Fein positioned himself behind Ruth and photographed the number as well as the man.

No caption was needed for the photograph. The shoulders, stooped slightly by illness, were nevertheless the mighty shoulders of the great home-run hitter. The spindly legs were those that carried Ruth around the bases in his trademark jog. The heavy head of hair was also recognizable from the rear. Ruth leaned on his bat, using it as a kind of cane to steady himself as the crowd's tribute flowed over him. Fein opened his lens wide and shot at a slow shutter speed without a flash. The out-of-focus background that resulted highlighted the Babe and his pinstripe uniform.

The event was Ruth's formal good-bye to baseball, but the farewell picture said good-bye to much more—to a special time in sports, or maybe just to a special time. One writer called it a golden age that was a lazy afternoon in the nation's history, a baseball afternoon. And a Golden Age of sports. Jack Dempsey. Bobby Jones. Red Grange. Paavo Nurmi. Lou Gehrig. Jesse Owens. Joe Louis.

It's true that the Babe caroused. He trained on hot dogs and beer and maybe spent too much time with the ladies; but he hit homers, sometimes on demand. He had a ready pen for the kids, and he brought great excitement to many a summer afternoon. He left a string of records that lasted for years. Even when he struck out he did it with class.

Babe Ruth died two months after Nat Fein made his picture. The man named Babe died, but not the legend named Babe.

JANUARY 1948 ■ *Mohandas K. Gandhi is assassinated.*

APRIL ■ *The Berlin airlift begins, bringing food and supplies to the blockaded city.*

SEPTEMBER ■ *Korea is divided at the 38th parallel, creating two countries, North Korea and South Korea.*

NOVEMBER ■ *Defying predictions, Harry S. Truman is elected president, defeating the Republican favorite, Thomas E. Dewey.*

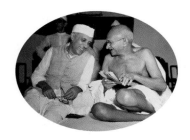

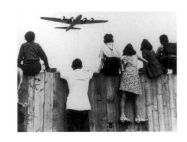

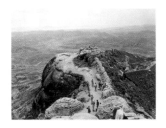

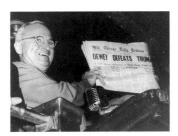

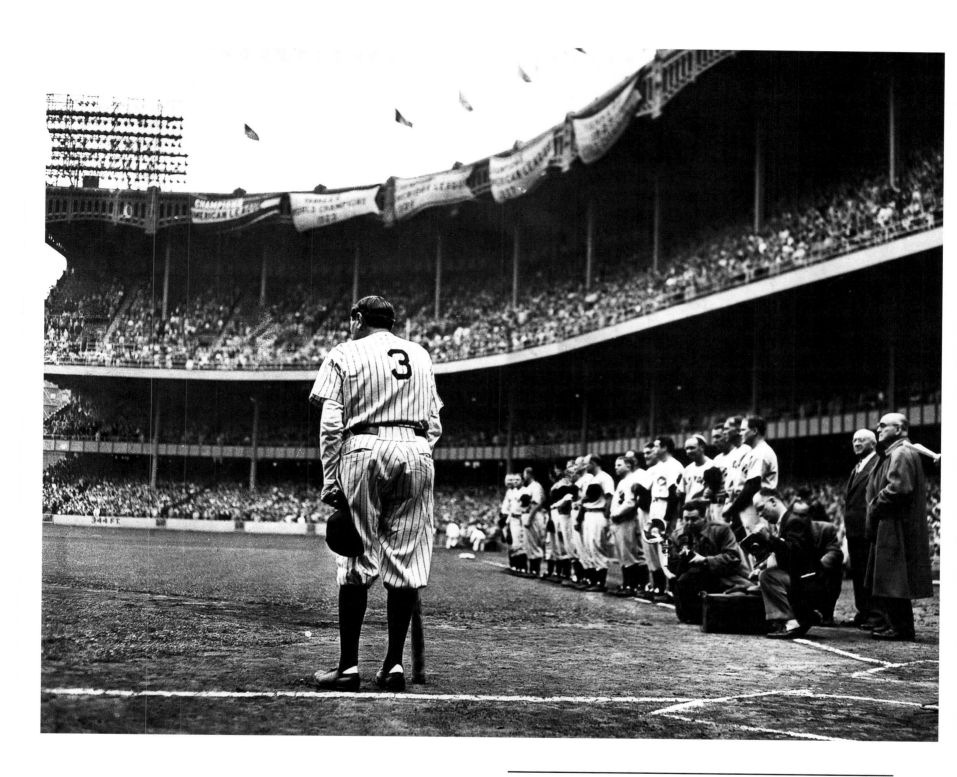

TECHNICAL DETAILS **CAMERA** 4x5 Speed Graphic
FILM Kodak
LENS 5 inch
SHUTTER & APERTURE 1/100th @ f5.6

Close Call

BY BILL CROUCH, THE *OAKLAND TRIBUNE*

Chet Derby made his living as a crop duster. He flew his biplane over Northern California farmland, dodging telephone wires, power lines, and big trees. He made extra income by performing in his plane at air shows, which provided a popular postwar Sunday afternoon entertainment. The spectators got to see the old war planes and watch them fly over, and pilots like Derby performed stunts: loop-the-loop, wing walkers, flying low over the field.

The *Oakland Tribune's* Bill Crouch, himself a pilot, surveyed the sixty thousand air-show fans enjoying a crisp October day at the Oakland Airport as he looked for a good spot from which to photograph the aerial show.

Derby's performance was to culminate in his hottest stunt. Trailing smoke from his agile biplane, he would do an upside-down loop-the-loop, leaving large smoky circles in the sky.

One minute after he finished, three B-29 bombers were sup-posed to come roaring overhead in formation, each a shimmering silver bird with all four engines at full power.

As Derby was flying, twisting, and turning, doing his stuff, Crouch was trying to get an artistic shot that combined Derby's plane with the smoke circles against the blue sky. He bent this way and that, and finally settled on what looked like the correct perspective.

All of a sudden, one minute early, the bombers roared across the airport. Derby, upside down as his stunt proscribed, didn't see them coming. Crouch aimed his camera at the sky. Later he commented, "I was concentrating on shooting pictures of the stunt plane. I saw the bombers flying in and thought it might make a different picture with them in the shot." And then he added, in what is a classic of understatement, "It sure did."

The bomber's wing missed Derby's plane by five feet.

JANUARY **1949** ■ *Mao takes Beijing, proclaims the People's Republic of China.*

MAY ■ *Arthur Miller's play* Death of a Salesman *wins the Pulitzer Prize.*

DECEMBER ■ *Katherine Hepburn and Spencer Tracy appear together in the movie* Adam's Rib.

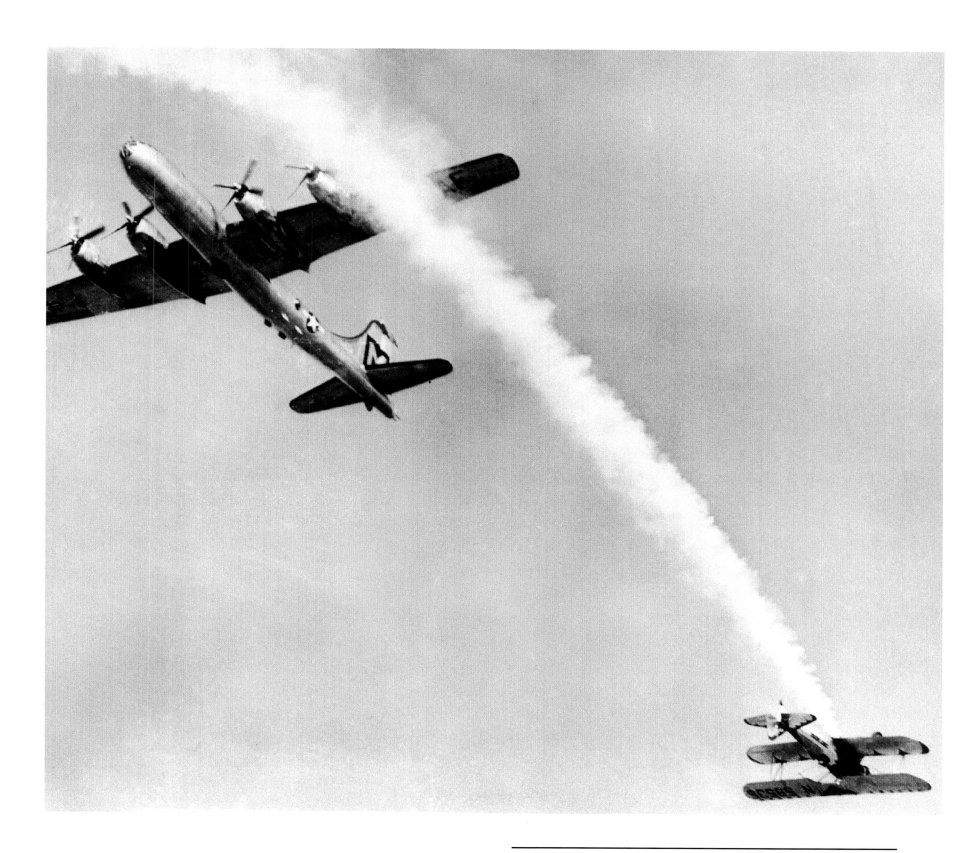

TECHNICAL DETAILS **CAMERA** 4x5 Speed Graphic
FILM Kodak
LENS Unknown
SHUTTER & APERTURE Unknown

1951

The Bridge at Taedong

BY MAX DESFOR, ASSOCIATED PRESS

Max Desfor had photographed a panorama of events during his career—bloody Okinawa in World War II; the war trials in Manila; the crew of the *Enola Gay* returning from the A-bomb drop and, later, devastated Hiroshima itself; the killing fields of postwar India's cruel civil strife.

"But those refugees escaping across the broken bridge over the Taedong," Desfor recalls. "That was something else." His photograph of that Korean War scene of desperate people fleeing before an oncoming enemy brought him the Pulitzer Prize.

The story of the bridge photograph began in the autumn, a few months after Desfor's arrival in Korea. He learned that 1,500 paratroopers were being prepared to be dropped deep in North Korea, where they would intercept a trainload of captured United Nations personnel. He told the military he wanted to join the paratroopers on their mission.

After a quick training session, Desfor took his Speed Graphic, film packs, and a few supplies and jumped with the paratroopers from a "flying boxcar." The paratroopers failed to connect with the train, unfortunately, and Desfor could not shoot the dramatic photographs he had anticipated; but he continued to cover the war as Allied troops pushed closer and closer to North Korea's northern border with China at the Yalu River.

Suddenly the tide of war changed. Masses of Chinese troops swept across the Yalu, and the mostly American U.N. forces, Desfor's unit included, fell back before the onslaught. They retreated to the North Korean capital of Pyongyang, which soon came under attack.

The only way to flee further south was across the Taedong River, but the main bridge had been blown out. Desfor hitched a jeep ride with other correspondents and crossed the river over a military pontoon bridge. He then headed upriver along the southern bank. Suddenly, at a turn in the road, a sight appeared that stopped the veteran photographer in his tracks. The main bridge across the Taedong could not carry normal traffic because of the severe bombing damage, but refugees fleeing the oncoming Chinese were crawling across the broken girders of the superstructure.

"Those poor miserable souls," Max said to himself. Later he noted, "They were fleeing the Chinese just like us. It was an incredible sight, hundreds of them like ants, inching across the bridge."

The refugees, many carrying pitiful packets of belongings on their backs, were exhausted by the arduous crossing. Some found their hands sticking to the frigid steel girders. Others slipped and fell into the river. Despite the dangers, more waited their turn on the opposite bank.

Desfor walked to the edge of the embankment, on the lip of a fifty-foot drop to the water, to a viewpoint that overlooked the bridge. It was so cold that he could only make three or four pictures of the people on the bridge before his fingers became too numb to operate the camera.

Desfor's picture, depicting those caught in the changing fortunes of the war on the Korean peninsula, was transmitted from Japan on December 5, 1950. It put a mark of grim reality on the term *refugee*.

JANUARY 1950 ■ *Armed robbers hold up the Brink's Express Co. in Boston, getting away with $1.2 million in cash and $1.5 million in money orders.*

FEBRUARY ■ *Joe McCarthy claims to have a list of the names of communists working in the United States government.*

JUNE ■ *The Korean War begins.*

OCTOBER ■ *The comic strip* Peanuts, *by cartoonist Charles Schulz, makes its debut in seven daily newspapers.*

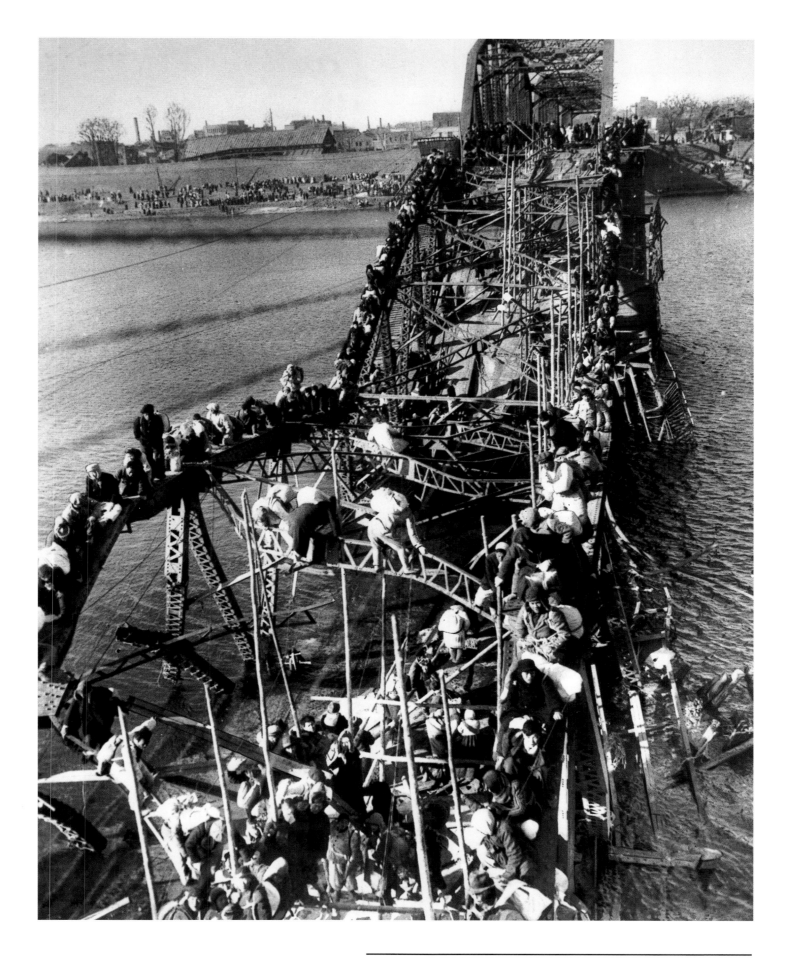

TECHNICAL DETAILS **CAMERA** 4x5 Speed Graphic
FILM Kodak film pack
LENS 7 inch
SHUTTER & APERTURE Unknown

Johnny Bright Sacked

BY DON ULTANG AND JOHN ROBINSON, THE *DES MOINES REGISTER*

On Saturday, October 21, 1951, Des Moines' Drake University was visiting Oklahoma A&M. The Drake team was led by Johnny Bright, probably the best halfback in college football. For three seasons, he rushed for more yardage than any other player; and, in the previous season, 1950, he averaged 266 yards per game.

Bright was different from other college players of the time in one important way, he was black; in the early 1950s, black players were not welcome on the gridiron of big-time college football.

Don Ultang and John Robinson were assigned to the game by the *Des Moines Register,* which covered all the big games involving Iowa teams. They had been experimenting with motion picture equipment, as well as other special cameras, to improve coverage by shooting photo sequences that followed the step-by-step progress of key plays in a game.

Oklahoma A&M kicked off to Drake. Drake had the ball on Oklahoma's thirty-yard line for the first play of the game. Bright got the ball from center and handed it off to the fullback, who headed for a hole in the line. Well back of scrimmage, Bright watched the play evolve. Then, WHACK, he was hit full-force by A&M defensive back Wilbanks Smith, who ignored the fullback but blindsided Bright long after he had handed off the ball.

Smith smacked Bright with his fist and forearm and broke his jaw. Bright was knocked out, but he recovered quickly and got back on his feet. Despite the broken jaw, a wobbly Bright took the ball from center on the next play and threw a long pass for a touchdown. The large contingent of Drake fans went wild.

Oklahoma took the subsequent kickoff, but quickly punted, giving Drake the ball again. On the third Drake play of the game, Bright took the pass from center, and handed the ball off. Once again, ten yards away from the ball carrier, Wilbanks Smith hit Bright, knocking him down. Incredibly, Bright got up; and on the next play, he ran the ball himself. He was hit hard and knocked down; this time he stayed down and had to be carried off the field.

Thanks to their careful planning and high-speed sequence photography, Ultang and Robinson captured the chain of events on film. Using a motion picture camera, Robinson shot a picture series that showed the step-by-step development of the play. Ultang's photo, made with a Speed Graphic and a twenty-inch lens, caught the actual blow (see the upper right corner of both photos). Together, the photos documented how far Bright was out of the play action when Smith hit him. The pictures appeared that Sunday and in subsequent editions of the *Des Moines Register,* and they were picked up by the wire services and transmitted everywhere.

In the controversy that ensued, Oklahoma claimed it was an accident; Drake claimed it was not. Arguments flew back and forth between the schools, and Drake complained about the lack of resolution to the situation and withdrew from the conference for a while.

Bright went on to play successful professional football in Canada. The Ultang/Robinson photos remain testimony to Johnny Bright's courage and to a time when it wasn't that easy for a black football player to take the field on an autumn afternoon.

MARCH 1951 ▪ *Julius and Ethel Rosenberg are convicted of wartime espionage.*

APRIL ▪ *General Douglas MacArthur receives a triumphal welcome at a joint meeting of Congress.*

JUNE ▪ *British spies Guy Burgess and Donald MacLean flee to Moscow; British double-agent Kim Philby has told them that their cover was blown.*

OCTOBER ▪ *I Love Lucy, starring Lucille Ball and Desi Arnez, begins its long run on television.*

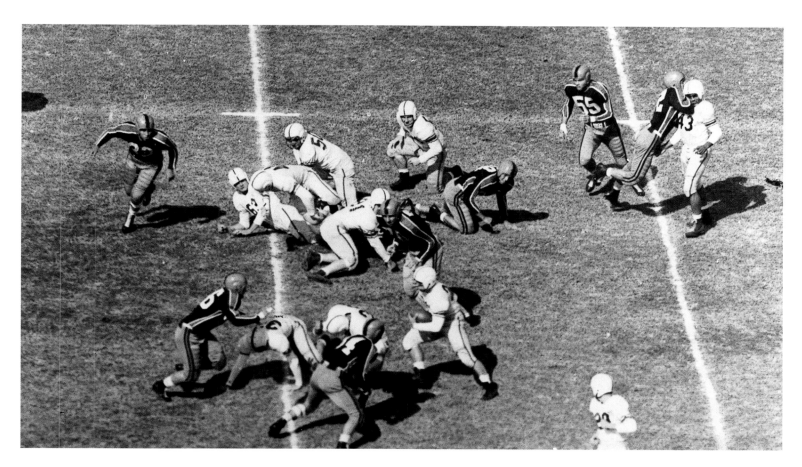

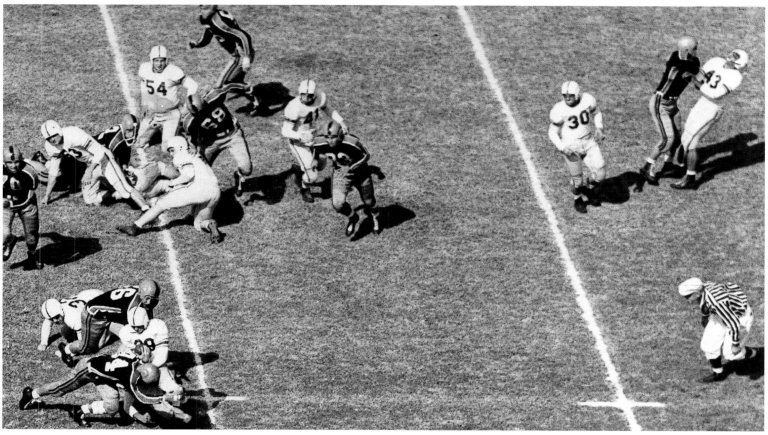

TECHNICAL DETAILS **CAMERA** 35 mm motion picture adapted to sequence still
FILM 4x5 Speed Graphic
LENS 20 inch lens on Speed Graphic
SHUTTER & APERTURE Unknown

Adlai's Shoe

BY BILL GALLAGHER, *THE FLINT JOURNAL*

Good political pictures are difficult to take. Politicians often mug for the cameras, and many photographs of candidates are standard images of them coming and going, waving and smiling, shaking hands and kissing babies. On occasion, however, good opportunities present themselves to photographers who are ready for them. Bill Gallagher, of the Flint, Michigan, newspaper, found his opportunity on Labor Day 1952, in the form of presidential candidate Adlai Stevenson and his overworked shoe.

The presidential political campaign that year pitted Dwight D. Eisenhower, the affable and appealing soldier-hero, against Adlai Stevenson, intellectual and honest public servant, wit, and orator. Stevenson said he didn't want the candidacy, but he was drafted and finally accepted the challenge. He was a good speechmaker, but people had to listen to him to know it. Eisenhower's supporters just blared, "I like Ike."

On a speaking trip, Stevenson, a pro-labor candidate, was scheduled to address the Labor Day crowd at Flint. It was a good choice, since Flint was a hot labor town.

Gallagher grumbled about working on Labor Day; it was a dreary day. "The kind of day you'd like to be somewhere else," he put it later. But the speech was his assignment, and he took to it.

The candidates were up on a stage, and Gallagher worked from floor level. Stevenson sat down to prepare notes for his talk. Casually he crossed his leg, and Gallagher saw the hole in the candidate's shoe. Gallagher wryly said later he thought the situation had prospects for a good shot. The trick, however, was how to keep others from seeing it, how to keep it exclusive. It would have been too obvious to lie down and look through the camera's viewfinder in the regular way.

Gallagher casually placed his camera at arm's length on the floor of the stage, looked the other way, and popped his flash. There was no special reaction, because flashes were going off all over the hall. He hoped he got everything in the picture, but he really wouldn't know until he processed the film. When he did, he knew he had a good shot. The photo was one of those remarkable human interest pictures that doesn't say much specifically about the issues, but endears a candidate to the crowd and brings a smile to the reader of a front page. It is easy for readers to identify with a picture like this one.

Never at a loss for a witticism, Stevenson later autographed a print for Gallagher saying, "To William Gallagher, from a candidate who is really not holier than thou." When Gallagher's picture won the Pulitzer Prize the following spring, Stevenson, long since defeated by the Eisenhower landslide, wired the photographer, "Glad to hear you won with a hole in one."

FEBRUARY 1952 ■ *Princess Elizabeth ascends to the throne at age twenty-five, after her father's death. She becomes Queen Elizabeth II.*

NOVEMBER ■ *Dwight D. Eisenhower is elected president, defeating his opponent Adlai E. Stevenson in a record turnout of voters.*

NOVEMBER ■ *The hydrogen bomb is exploded in the Marshall Islands.*

DECEMBER ■ *Christine Jorgensen, formerly George Jorgensen before undergoing a sex change operation to become a woman, arrives in New York.*

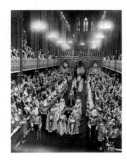

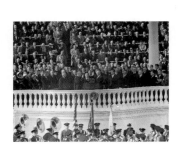

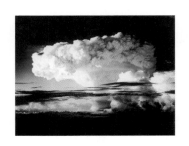

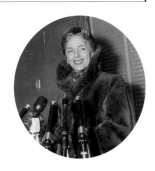

TECHNICAL DETAILS **CAMERA** 4x5 Speed Graphic
FILM Kodak
LENS 127 mm
SHUTTER & APERTURE Flash @ unknown
aperture

Trucker's Rescue

BY VIRGINIA SCHAU, AMATEUR

The countryside along the highway from Los Angeles to Portland is a traveler's delight. Some of the scenery, especially farther north, is lovely if you are an outdoor-lover on a fishing trip, but truckers have their eyes focused on the center line, with occasional reference to highway route numbers and miles traveled. There may be a chance for a quick snooze in the cab while your partner takes a turn at the wheel.

On Sunday, May 3, 1953, Walter and Virginia Schau were out to try their luck on the opening day of the fishing season. Bud Overby and Hank Baum, trucking partners, were pushing for Portland with a load of radishes, carrots, and the season's first watermelon.

The Schaus slowed up behind the lumbering truck. The highway curved at a spot called Bailey Hill, some ten miles north of Redding, and the road's twists and turns prevented the Schaus from passing the slow-moving truck.

A few miles back, Baum had turned the wheel to Overby and was about to climb into the sleeper for a nap. As they rolled onto the Pitt River Bridge, a forty-foot-high structure that carried traffic over Lake Shasta, the truck suddenly lost its steering, swerved, and hit the curb of the bridge. Accompanied by the sound of screeching and tearing metal, the truck tore through the guardrail and bounced over the side of the bridge.

There was a sudden jolt, and the cab stopped in midair. The two truckers were upside down, in a kind of crouch, on the wind-shield of the rig, looking down forty feet to the rocky shoreline of the lake. By some miracle, the wheels of the cab became entangled under the trailer; and the cab and its occupants were suspended in space, swaying ever so slightly.

From their car behind the truck, Walter and Virginia Schau watched horrified as the accident ran its course in front of them. They pulled up behind the truck and asked other drivers, now stopped on the elevated highway, whether they were carrying any rope. One motorist had a length of marine line, and Walter called down to the drivers, "We have some rope. We'll throw it down to you and try to haul you out."

The rope came down and Overby, next to the window, grabbed it. He was the first out. "I'll get it back to you as soon as I can," he told his partner. As Overby was pulled up, Baum began to smell the acrid odor of burning diesel fuel. Smoke began to enter the cabin, and he crawled halfway out the window to escape the fumes. Down came the rope again, and he was hauled up. Atop the bridge, the two men embraced and exclaimed about how fortunate they were to have survived. As if to emphasize the point, the then-burning cab broke loose from the trailer and crashed to the rocks below.

During the course of the rescue, Virginia Schau grabbed her Brownie camera from the back of the car. She recalled that the film had been in the camera for more than a year, but she knew there were frames still unexposed. She ran to a knoll across from the bridge and

MARCH 1953 ▪ *Josef Stalin dies at age seventy-three. He had ruled the Soviet Union since 1928.*

MAY ▪ *New Zealander Edmund Hillary and his Sherpa guide Tenzing Norgay make the first successful ascent of Mount Everest, the world's highest peak.*

JULY ▪ *The three-year-old Korean War ends, leaving both sides in ruins.*

DECEMBER ▪ *The first issue of* Playboy *magazine is published. Marilyn Monroe graces the cover.*

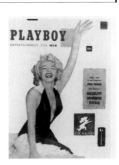

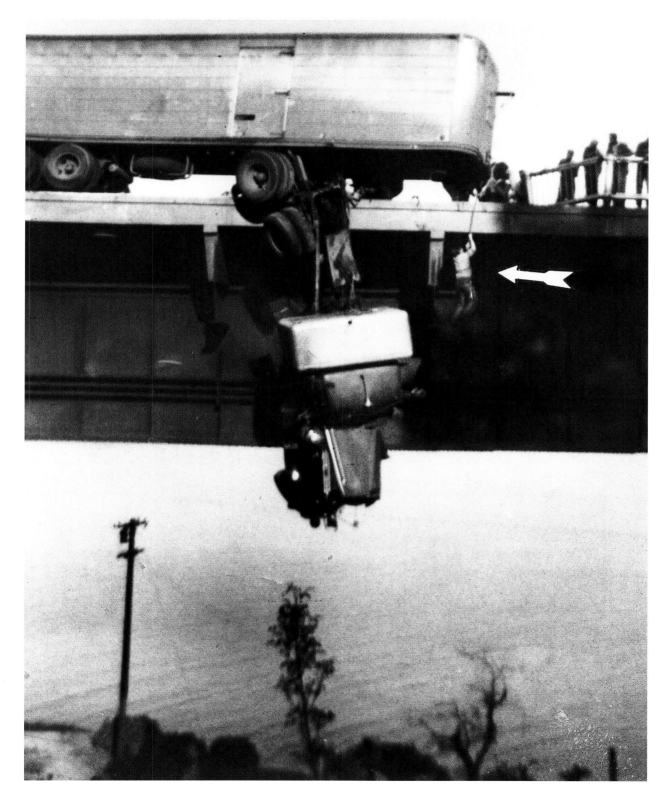

made pictures of the rescue. A professional photographer would say that it was the wrong camera, the wrong lens, and the wrong film, but those same professionals would also admit the importance of being at the right place at the right time—with any camera. The photo was so dramatic that it won the Pulitzer Prize; it was the first Pulitzer photo to be made with a camera other than a Speed Graphic. In addition, it was the first Pulitzer awarded to a woman; it would be another thirty-two years before the award was given to a female professional.

TECHNICAL DETAILS

CAMERA Kodak Box Brownie
FILM Kodak
LENS Bownie lens with standard focal length
SHUTTER & APERTURE Standard Brownie

1955

A Child Taken by the Sea

BY JOHN GAUNT, THE *LOS ANGELES TIMES*

Nature is whimsical. The sky yields water to nurture life, and the earth and ocean produce food and the building materials of shelter; yet nature can turn and, with sudden turbulence, create tragedy that leaves behind only grief.

On April 2, 1954, nature played both roles. First it was a benevolent caretaker; but then, in an instant, it became a thoughtless menace.

John Gaunt, a staffer of the *Los Angeles Times,* was sitting in the delightful morning breeze that came off the Pacific and filled his seaside house in Hermosa Beach, a suburb of Los Angeles. He was assigned to the night shift and would not be heading for the office until later in the afternoon. For the present, there was just the California sun, the ocean wind, and the crashing surf. It was a sweet, delightful morning.

Parents played on the beach with their children. Some lived in the area, and, like John, owned or rented homes along the beachfront. Others were day visitors.

Suddenly a commotion interrupted the peaceful setting. Gaunt heard the shouts of neighbors—there was trouble on the beach. Without knowing what to expect, he took his camera and ran to see what was happening.

On the shore, with high, crashing surf as a backdrop, stood a young couple, Mr. and Mrs. John McDonald. As they moved forward, then back, clinging to one another, their body language told Gaunt a story that tightened his stomach. He realized that someone must be lost and he took a photograph from two hundred feet away. Only then did he learn that just moments before, the couple's nineteenth-month-old son, Michael, had been playing along the shoreline. The surf, suddenly aggressive, reached out and took the child from the shallows. Despite the back-and-forth efforts of the helpless parents, there was nothing to do but wait. Later in the day, the child's body was found on the beach a mile away.

JANUARY 1954 ■ *Nautilus, the first nuclear powered submarine, is launched.*

JANUARY ■ *Joe DiMaggio and Marilyn Monroe marry*

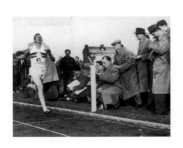

MAY ■ *Roger Bannister, age twenty-five, breaks the four-minute barrier for the mile. He ran the mile in 3 minutes 59.4 seconds.*

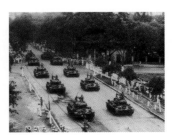

JULY ■ *France signs an armistice agreement with the Viet Minh. The last French forces leave Hanoi.*

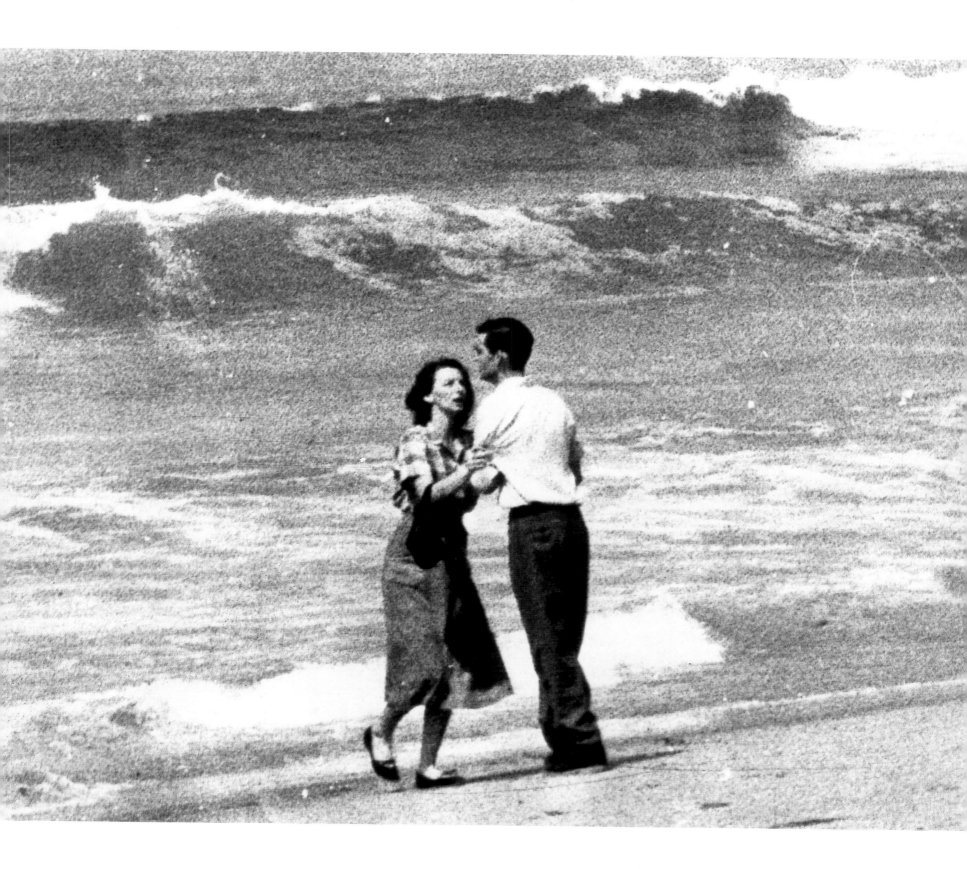

TECHNICAL DETAILS **CAMERA** Rolleiflex
FILM Kodak 120 roll film
LENS 80 mm
SHUTTER & APERTURE 1/250th @ f16

Miracle on Barbara Drive

BY GEORGE MATTSON, *THE NEW YORK DAILY NEWS*

When you look at the typical American suburb from the sky, you can see the careful master plan of the designer. Front lawns and backyards are laid out in an orderly way, the streets are straight and square with other streets. There may be a bit too much similarity, but order has its benefits.

That was how the Long Island community of East Meadows looked from the air on November 2, 1955. *Daily News* photographer George Mattson was flying across the island when suddenly, in the distance, the orderly suburban pattern was broken by a column of smoke rising from the neatly interlaced streets. Thinking it was a fire that might make an interesting aerial picture, he and the pilot agreed to take a look.

What they found was more than a fire. A huge B-26 bomber had crashed into the suburban street, apparently missing all the structures. Mattson leaned out the window with his 4x5 Speed Graphic, and his pilot made several circles around the crash site while Mattson made pictures. He then called in the story, and the *News* dispatched a team of reporters and ground-based photographers. Mattson's shot was used as the centerpiece of the layout, and their collection of photographs won the Pulitzer Prize.

The B-26 had been returning to nearby Mitchell Air Force Base from a routine training flight when the pilot reported by radio that the propellers would not respond and the plane had begun to fall. Meadowbrook Hospital was in front of them, and it appeared they would hit it, but, the plane missed it by five hundred feet.

On the ground, as the plane limped forward completely out of control, some of the residents of Barbara Drive saw it coming; they grabbed their kids and ran, hoping they would run in the right direction.

Once past Meadowbrook Hospital, the plane went into a spin and pancaked onto Barbara Drive in front of the home of Paul Koroluck. As the plane hit the street, metal flew every which way like shrapnel and a fire broke out. One B-26 motor was deposited on Koroluck's lawn, another was in his doorway. A wing rested against his house; the second wing was in Barbara Drive. Koroluck's roof caught fire as did a neighbor's car. Koroluck was at work, however, and his wife was away with their five-year-old daughter.

The B-26 pilot and his sergeant died in the crash, but no one on the ground was hurt. An Air Force representative who arrived on the scene wondered at how the plane could crash land in the street, between the orderly houses, spaced twenty-five feet from the other and twenty-five feet from the street. The plane had even missed the telephone poles that lined the street—only one overhead wire was snapped.

While Mattson's aerial photograph contributed to the collective Pulitzer Prize for the paper, it also demonstrates the immediacy of a spot news photograph. The details gathered by the reporters on the ground reinforced how amazing the scene Mattson photographed was; but at the same time, the visual image serves as indisputable evidence the event occurred.

APRIL 1955 ■ *Albert Einstein dies at age seventy-six.*

JUNE ■ The Seven Year Itch, *starring Marilyn Monroe, opens.*

SEPTEMBER ■ *Less than a month before* Rebel Without a Cause *opens, actor James Dean is killed in a car accident in California at age twenty-four.*

DECEMBER ■ *Rosa Parks, who refused to give up her bus seat to a white man, is arrested. Her refusal to move to the back of the bus sparks the Civil Rights Movement.*

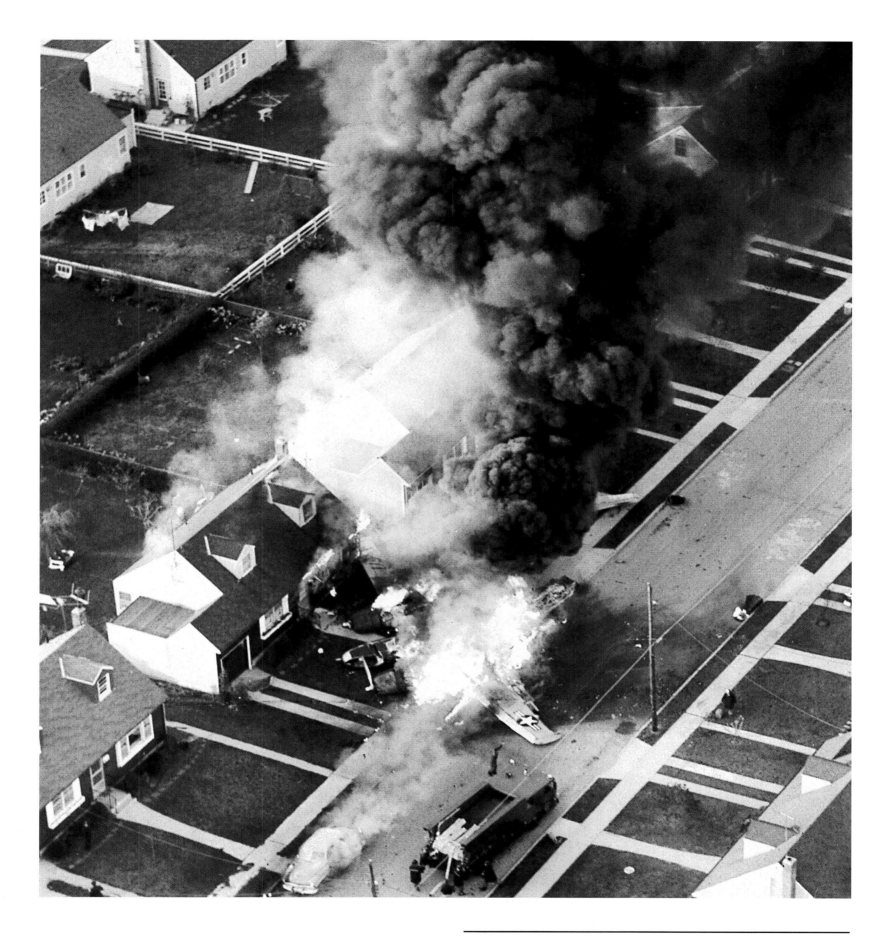

TECHNICAL DETAILS **CAMERA** Various
FILM Kodak
SHUTTER & APERTURE Various

The Death of the *Andrea Doria*

BY HARRY TRASK, THE *BOSTON TRAVELER*

Modern sailors often call the waters around Nantucket Island "the Times Square of the Atlantic," a facetious reference to the heavy sea traffic that flows through the area. Even in the nineteenth century, when whalers sought home and safety on the island, this area was a busy stretch of water. Then, as now, seafarers were aware of the sudden fog that can, and often does, cover the island and ocean, ever so quietly, in a grey blanket of mist. The sailor is struck blind in a silent cloud.

Today's sailors, pleasure sailors as well as those who captain mighty ships, use the electronic eyes of radar to penetrate the fog as they stand the watch. That's what officers on two ocean liners were doing the night of July 25, 1956, between 11:00 p.m. and midnight, a quiet night with a calm sea covered in fog.

The *Andrea Doria,* heading for port, was due in New York City the next morning after nine days at sea. The *Doria* was Italy's finest luxury liner, appointed with art, several swimming pools, and several theaters. The Swedish-American liner *Stockholm,* likewise a fine ship, had departed New York that morning bound for Copenhagen. The *Stockholm* was a smaller, leaner vessel, her prow reinforced to split the ice so often encountered in Scandinavian waters. Both ships were sailing toward Nantucket and the watery Times Square.

Harry Trask, a staff photographer for the *Boston Traveler,* was working nights at the paper. He had been at the paper for a decade, rising from messenger boy. Trask preferred to work nights because he was studying for a college degree by day.

On the *Andrea Doria* and the *Stockholm,* each radar officer watched the other ship approaching off Nantucket through the dense fog. The radar blips told them they would pass safely a mile apart and continue toward their destinations. But something went wrong, and the two ships were suddenly on a collision course. Each crew later said the other ship swerved.

At 11:21 p.m. a card player on the *Andrea Doria* looked out the starboard window and, indeed, it looked like Times Square. There, fuzzy through the fog but clearly visible, were the sparkling lights of another ship bearing down. At 11:22, the *Stockholm* rammed into the *Andrea Doria,* her reinforced prow penetrating some thirty feet into the luxury liner, fully one third of its width. The screech and grind of tearing metal filled the ship's salons; then, as suddenly as it had collided, the *Stockholm* jerked back and withdrew, to more screeching and grinding. In the horrifying moments of the collision and separation, passengers and crew were thrown against walls, tables were torn loose from their secured positions, and sleeping passengers were thrown from their beds.

A forty-foot-wide gash had been torn in the side of the vessel. Within minutes, a quarter-million gallons of water flooded the *Andrea Doria*, and she began to list badly. Water mixed with oil sloshed through corridors, dining rooms, and cabins. She would obviously sink.

APRIL 1956 ■ *Actress Grace Kelly marries Prince Rainier II of Monaco.*

SEPTEMBER ■ *Elvis Presley appears on Ed Sullivan's "Toast of the Town." His hits include* Love Me Tender, Hound Dog, *and* Heartbreak Hotel.

OCTOBER ■ *Don Larsen pitches the first perfect World Series game in history.*

NOVEMBER ■ *Dwight D. Eisenhower is re-elected, defeating Adlai Stevenson again.*

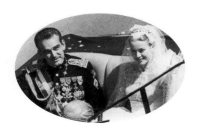

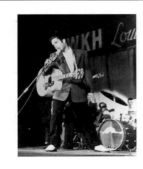

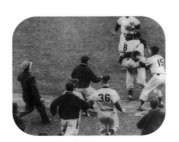

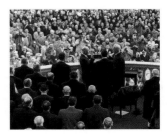

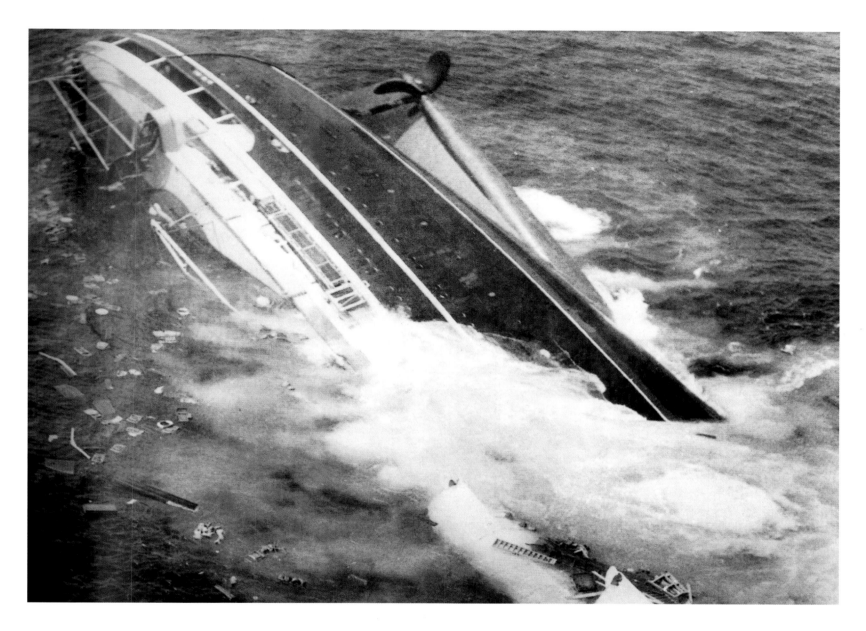

Because of the list, the *Andrea Doria* was able to launch only a few lifeboats. The *Stockholm* immediately set boats on the sea. An SOS went out, and the *Ile de France,* some forty-five miles away, rushed to the scene and launched boats. Other vessels also joined the rescue operation. By dawn, 1,640 survivors had been pulled from the Atlantic, but fifty-two people were lost.

Meanwhile Trask had been alerted to the tragedy and, at first light, headed for the airport, where a plane was to take reporters to the scene. Trask was late, and the plane left without him, so he hired a Beechcraft Bonanza to fly him to the site. It wasn't the best plane for aerial photographs, but it would do.

By the time the Bonanza got Trask and his Speed Graphic over the ship, the others had departed and headed for home. The Bonanza circled the vessel, by then lying on her side, mortally wounded. The plane tipped and dipped. Trask began to get seasick as the horizon line bounced like a see-saw. But he stayed with it.

TECHNICAL DETAILS **CAMERA** 4x5 Speed Graphic
FILM Kodak
LENS 127 mm
SHUTTER & APERTURE shutter unknown
@ f5.6

In the crowded compartment of the plane, Trask wiggled his body into the proper position. He rested his camera on the shoulder of the pilot, and urged him to make tighter and tighter circles. During one of their circles over the vessel, the *Andrea Doria,* like a valiant hunted whale, gave up the struggle. Her propellers reached up in the air as if in salute; the waters swirled and turned to foam, and the giant vessel lunged, then slipped beneath the surface. Trask shot the picture of the *Andrea Doria's* final moment before it sank to a depth of 225 feet. "It was a sad farewell," he recalled later.

Trask won a Pulitzer Prize and went on to get his college degree. He later retired from the paper and became a teacher in the Boston public school system.

1958

Boy & Cop in Chinatown

BY BILL BEALL, THE *WASHINGTON DAILY NEWS*

The Hip Sing Merchant's Association of Washington, D.C., declared that whenever a new building was dedicated in Chinatown, a parade had to be held to celebrate the event. Thus, on a sultry, steamy September 10, 1957, Bill Beall, of the *Washington Daily News,* found himself in the middle of a Chinese parade.

Brightly colored paper lions shook their heads with great ferocity, and strings of firecrackers chattered away, their acrid gunpowder smoke hanging in the late-summer air. A little too much like Okinawa, thought Beall, who covered the Pacific War as a military photographer and, since the war, had photographed just about everything there was to cover in the nation's capital.

Off to one side, police officer Maurice Cullinane watched the proceedings, making certain no one got hurt and that traffic kept moving. There were no problems, everyone was having a ball.

Especially two-year-old Allen Weaver. This was a new adventure for him, and he delighted in the color, the strange, fairy tale creatures, the noise, and the sheer excitement of it all. Amid this unlikely situation a photographer, a cop, and a child were about to create one of the most delightful pictures to ever win a Pulitzer Prize.

Little Allen wanted a closer look, so he stepped off the curb onto the street. Policeman Cullinane sensed danger—the boy was too close to the firecrackers, too close to the exuberance of the dancing celebrants, and too close to moving traffic.

Cullinane moved forward and bent from the waist to explain to Allen, who listened intently, that there was possible danger here for a little fellow and that it would be best if he stayed on the sidewalk and watched the parade from there. Beall caught the exchange in the corner of his eye, raised his camera and shot the picture. Body language in the picture tells us that the conversation was earnest and transcended the decades of experience that would otherwise separate man and child. Beall had only a moment to focus, because in an instant it was over. The child stepped back to safety, the cop moved on to other surveillance, and the photographer wondered whether he had successfully captured the scene. The firecrackers rattled again, and the dancing dragon blocked his view.

Back at the office, Beall processed the film and told the editor, "I think I have a real one." The paper entered the picture in photo contests, and it won prize after prize, including the coveted Pulitzer. There were many other stories that year, and many other photos, but serendipity won out.

Years later the *News* brought Weaver, the boy now grown, and Cullinane, then assistant chief of police, together again. There was handshaking and everyone shared a laugh but the magic was gone. Maybe it was because there were no dragons or firecrackers, but more than likely it was because there was no beat cop, no child, and no serendipity.

JULY 1957 ■ *Althea Gibson, age twenty-nine, becomes the first black woman to win Wimbledon.*

SEPTEMBER ■ *Little Rock High School, in Little Rock, Arkansas, is forcibly integrated.*

OCTOBER ■ *The U.S.S.R. launches Sputnik I, the world's first man-made satellite.*

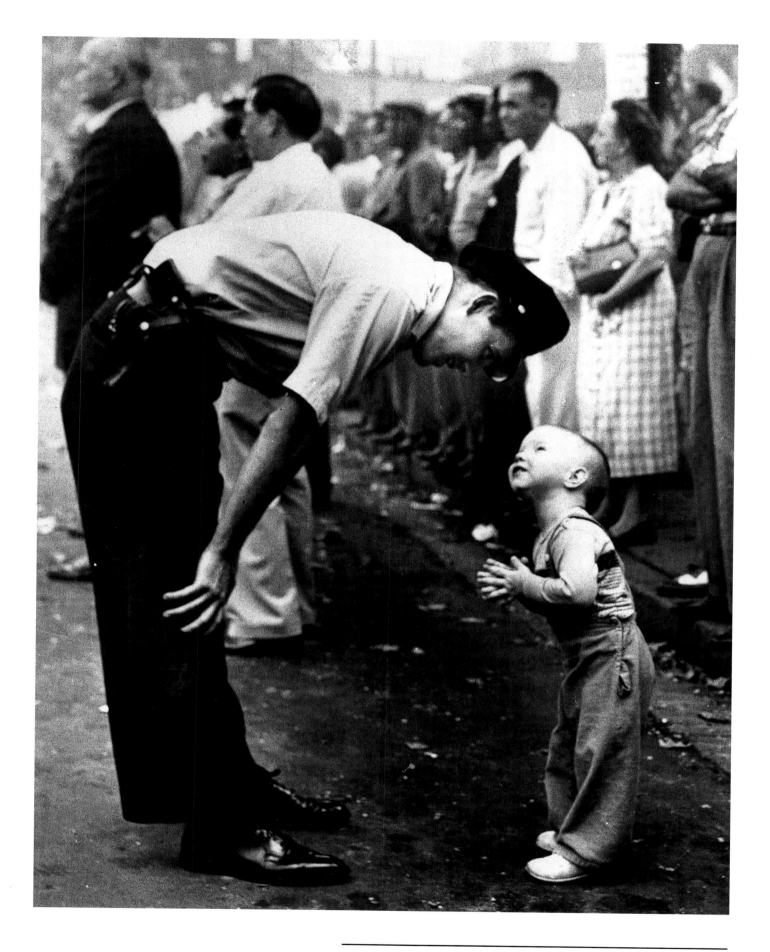

TECHNICAL DETAILS **CAMERA** 4x5 Speed Graphic
FILM Kodak
LENS 127 mm
SHUTTER & APERTURE 1/100th @ f16

1959

The Little Red Wagon and Death

BY WILLIAM SEAMAN, THE *MINNEAPOLIS STAR-TRIBUNE*

In the 1950s, city newspapers assigned photographers to radio cars. Like the police, the photographers patrolled the streets, listening to the tempo of city life on the police radio and responding to news breaks, mostly crimes and fires.

Bill Seaman, of the *Minneapolis Star-Tribune,* drove his radio car through the city about noon on a sunny day in mid-May, alert for stories. Several blocks behind him a garbage truck moved along noisily doing its job.

At the intersection of Riverside Drive and South Twenty-Seventh Street Seaman stopped for a red light. As he waited, a young boy, about the age of Seaman's young son, stepped into the intersection pulling a little red wagon.

Seaman recalled, "I was going to get out of the car and shout a warning to him to not cross, but he stepped back onto the sidewalk."

The light changed, and Seaman drove on. The garbage truck had moved forward to a block or so behind his car. Three blocks later, his police radio crackled out the bulletin that a small boy had been hit by a garbage truck at the intersection where he had just stopped. Seaman turned his radio car around, hoping against hope but fearing the worst. Fourteen people died in traffic fatalities that day, May 16; it was the worst day of 1958 for vehicular deaths.

Seaman, who spent thirty-seven years as a photographer for the *Star-Tribune,* later recalled, "It was the most tragic photo I ever took." He retired in 1982 and continued to photograph for a while; but he later turned to painting, mostly subjects taken from pictures he made during his nearly four decades with the paper.

MARCH 1958 ■ *Nikita Khrushchev becomes chairman of the Soviet Council of Ministries, replacing Nikolai Bulganin.*

MAY ■ *China proclaims its great leap forward.*

JULY ■ *Americans buy 100 million Hula Hoops, manufactured by Wham-O, but the fad is short lived.*

OCTOBER ■ *British Overseas Airways becomes the first airline to begin regular transatlantic service using jet passenger planes.*

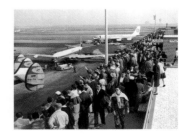

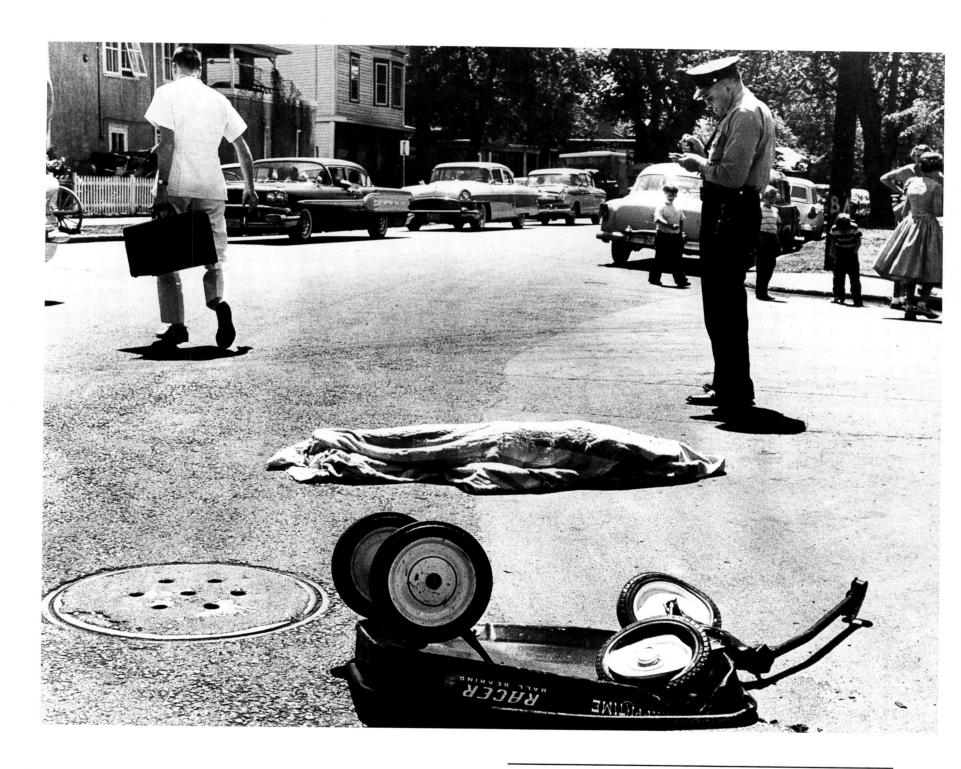

TECHNICAL DETAILS **CAMERA** Rolleiflex
FILM Kodak 120 roll film
LENS 80 mm
SHUTTER & APERTURE Unknown

1960

Execution at the Castle

BY ANDY LOPEZ, UNITED PRESS INTERNATIONAL

Cuba's San Severino Castle at Matanzas was a castle in every sense of the word. A moat surrounded the structure, and to gain entrance, visitors had to cross a bridge over the twenty-foot waterway. It had been a military base for President Fulgencio Batista's army; but after Janaury 1, 1959, it was run by the *barbudos,* the bearded ones.

That was the nickname that Fidel Castro and his rebels were given by a joyful Cuban population that celebrated the fall of Havana and the ouster of Batista, who had fled the island, his party over. It was time for judgment.

Andy Lopez, a veteran New York-based photographer for United Press International, was on the scene at the castle on January 17th to photograph Castro justice in action. Lopez, who preferred Yankee Stadium baseball as an assignment, was among those correspondents who flocked to Havana as Castro and his *barbudos* took over the capital.

"Anything you want," Castro told the journalists, and Lopez asked for and received credentials to cover the trial at the Matanzas castle. A Batista army corporal named Jose Rodriguez, but called Pepe Caliente (Hot Pete), was on trial for his brutal treatment of the populace. So great was the hatred for Pepe that hundreds of people pushed across the castle's bridge, some of them falling into the moat, to volunteer their testimony against him.

As Lopez recalls the trial, "It was noisy and unruly. There were lots of Coca-Cola bottles just thrown on the ground or floor during the proceedings. And on top of that, cigar butts. People walked on tables. The scene was incredible."

The prosecuting attorney was Willy Galvez. He was twenty-five years old and the commander of the Castro troops at San Severino. At one point, Lopez recalls, Galvez turned to Rodriguez and said, "When we get through with you, Pepe Caliente, they are going to call you Pepe Frio (Cold Pete)."

Galvez was true to his word. The trial, broadcast over a loudspeaker system to those assembled, lasted two hours, and Pepe was sentenced to death one minute later.

Lopez soon found himself in the courtyard of the castle with the condemned man and his squad of executioners. Rodriguez was put up against a wall, but a priest came forward. Rodriguez dropped to his knees before the priest, who administered the final sacrament. Pepe kissed a small crucifix and Lopez photographed the poignant moment, with the condemned man kneeling before the priest, the priest bent over, and the executioners in the background.

At that moment Galvez walked up to Lopez and told him, "No pictures." Lopez argued, and the *barbudos* began to get impatient. Galvez said he wanted the film; Lopez handed him a roll of film,

JANUARY 1959 ■ *Rebel leader Fidel Castro takes Havana and becomes premier of Cuba.*

MARCH ■ *Jack Lemmon, Tony Curtis, and Marilyn Monroe appear in Billy Wilder's* Some Like it Hot.

MARCH ■ *Toy company Mattel, Inc. introduces the Barbie doll.*

JULY ■ *U.S. President Nixon and Soviet Premier Khrushchev engage in a their famous Kitchen Cabinet debate in Moscow.*

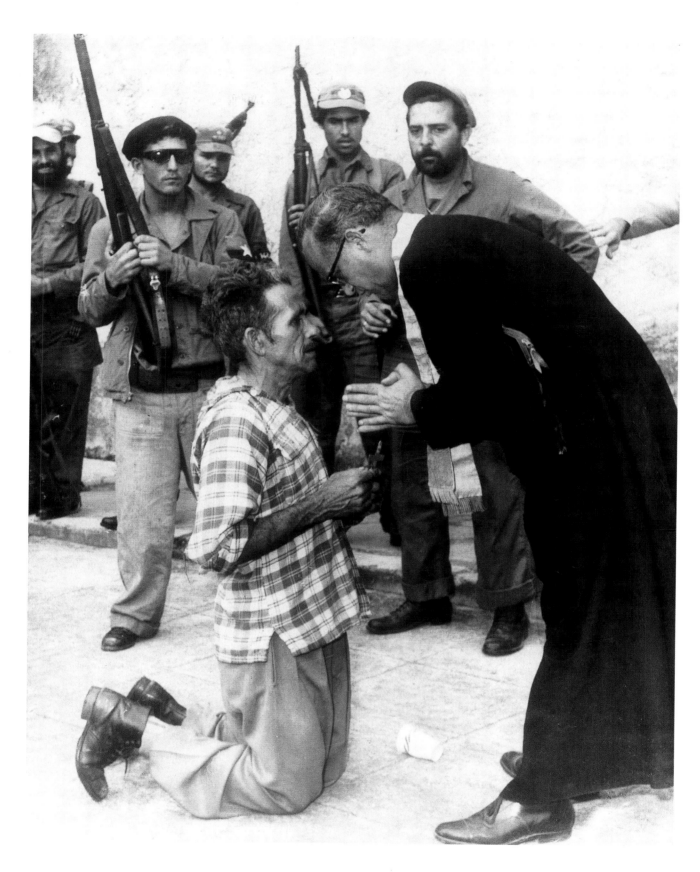

but not THE film. He made a switch and gave Galvez a blank roll, keeping the one with the picture on it, before Galvez sent the journalists away.

Lopez heard later that, at the last minute, Galvez stopped the execution, saying he needed higher authority. He got it, and the next day Rodriguez fell to a burst of gunfire in the courtyard.

TECHNICAL DETAILS **CAMERA** Rolleiflex
FILM Kodak 120 roll film
LENS 80 mm
SHUTTER & APERTURE Unknown

1961

Assassination on Stage

BY YASUSHI NAGAO, THE *TOKYO MAINICHI SHIMBUN*

The year 1960 was a turbulent one in Tokyo as massive student demonstrations by groups on both the right and the left snake-danced through the city causing a constant and unsettling uproar. President Eisenhower cancelled a scheduled visit to Japan even though no one had been killed. Few students suffered injuries, despite the hundreds of thousands who rushed through the streets with arms locked, chanting. "Demo" watchers said the street marches were more theater than real.

On October 12, all that changed. In the Japanese tradition, leaders of the front-running political parties were scheduled to give back-to-back speeches, and then to debate the U.S.–Japan mutual defense treaty. Picking his way through some three-thousand partisans packing the auditorium at Hibiya Hall in central Tokyo was Yasushi Nagao, staff photographer for *Mainichi Shimbun,* one of several national newspapers. Nagao had joined the *Mainichi* staff seven years earlier, after obtaining a university degree in engineering.

The top speakers of the day were the Socialist Party Chairman, Inejiro Asanuma, and the Liberal Democratic Prime Minister, Hayato Ikeda. Nagao loaded his Speed Graphic with a film pack of twelve frames and watched as the heavyset Asanuma leaned on the podium and, in his gravelly voice, lambasted the party in power for its military agreements with the United States. Nagao made eleven pictures of the scene—general views, closeups, photos of the partisans—and he had a single frame left.

Right-wing Zengakuran students sitting in the first row heckled Asanuma and threw wadded paper at him. Then, from the side of the stage, a young man dressed in the brass-buttoned black uniform of a college student rushed toward Asanuma carrying what Nagao at first thought was a stick. It was actually a Japanese samurai sword, razor sharp and deadly. The student ran full-force into Asanuma, plunging the traditional Japanese weapon into his stomach. Several cameramen photographed the first blow, but the podium blocked much of the scene. Their pictures captured Asanuma's shocked expression and the intent visage of the attacker.

Both men staggered back, clear of the podium. By instinct, Nagao changed his focus from ten to fifteen feet as the student pulled the sword from the speaker's body, plunged it into his heart, and withdrew it again. Nagao photographed the scene, his electronic flash freezing the image in horrifying detail.

Asanuma was dead before he could be taken to a hospital two blocks away. The student, Otoya Yamaguchi, a fanatical right-wing zealot, had chosen the time-honored samurai method of killing Asanuma, whom he called a "pro-Communist enemy of the people."

JUNE 1960 ▪ *Leftists stage massive anti-American demonstrations in Japan.*

SEPTEMBER ▪ *Abebe Bikila of Ethiopia wins the marathon running barefoot at the summer Olympics in Rome.*

SEPTEMBER ▪ *Presidential candidates Richard M. Nixon and John F. Kennedy engage in the first televised debate, changing American politics forever.*

DECEMBER ▪ *"The Twist," written by Hank Ballard and recorded by Chubby Checker, launches an international dance craze.*

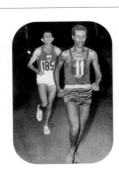

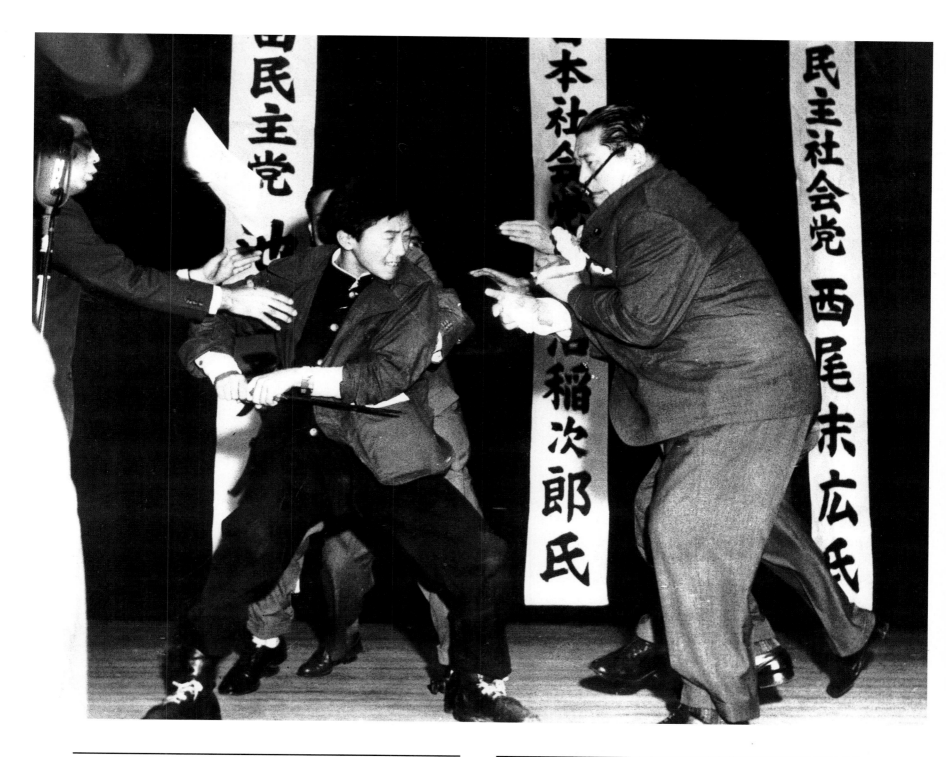

United Press International, which had exclusive rights to *Mainichi* pictures, transmitted the photo worldwide. Nagao was the first non-American to win the Pulitzer Prize for photography, and the first of several Japanese winners. Nagao left *Mainichi* the year after he won the prize and became a freelance photographer producing photo books. Yamaguchi, in samurai fashion, later died by his own hand.

TECHNICAL DETAILS **CAMERA** 4x5 Speed Graphic
FILM Kodak
LENS 127 mm
SHUTTER & APERTURE Flash @ unknown aperture

The Small Camera and the Vietnam and Civil Rights Pulitzers

By the 1960s, most news photographers were using small 35mm cameras. The final Pulitzer photo made with a 4x5 Speed Graphic was Yasushi Nagao's 1961 winner, a striking picture of an assassination by sword in Tokyo. Even before that, the Rollieflex, Rolleicord, and other smaller cameras were being used. The last Pulitzer photo made with a camera other than a 35mm was Rocco Morabito's 1967 Rolleiflex picture of a lifesaving effort high atop a telephone pole (page 75).

The 35mm camera enabled photographers to alter the "look" of their pictures by freeing them from much of the technology's tyranny. Photographers no longer had to worry about missing the peak action because, thanks to motors developed in the 1970s that drove film through cameras at three or more frames per second, fresh film was always in place and the shutter was always cocked for the next image. The cumbersome 4x5 camera process was history.

Film was also more light sensitive than ever before, allowing photographers to shoot in low-light conditions without the intrusive flashbulbs. Most important, finer grain film delivered prints of improved quality that were acceptable to newspaper editors.

These technical freedoms led to journalistic experimentation during news assignments in the field. New lenses—the very wide angle and the very long telephoto—offered a creative photographer the opportunity to "see" the world differently, to depict a scene or a person from a fresh perspective. And that difference was displayed on newspaper pages.

At the same time that these innovations were being implemented by news photographers, two major stories erupted—the war in Vietnam and the Civil Rights struggle in the United States. Both stories were reflected in the photographs given Pulitzer awards. Except for one year between 1965 and 1977, a Pulitzer was awarded to these stories each year—seven for Vietnam and five for Civil Rights.

No war had ever been covered like the conflict in Southeast Asia, and it is unlikely that any future war will be covered like Vietnam was. That war's impact on journalistic practice thus deserves special mention. Photographers and writers traveled and lived with troops. They had near-instant helicopter access to the battlefields, wherever they were; and there was no censorship to protect readers at home in the United States.

Never before had pictures of war captured the pain, the brutality, the excruciating agony of soldiers and civilians caught in the fury of battle. That's because photographers had never been so close to a war, with the frequency that the conflict in Vietnam provided. Their pictures were often dispatched to worldwide readers the same day they were made. Their immediate availability added an urgency that enhanced their impact.

Much has been said about the influence television visuals from Vietnam had on the home front, and no one denies the impact of what was then a relatively new medium. But television's cumbersome equipment and large crew requirements reduced spontaneity, whereas the still picture froze moments of horror or beauty. Even when filmed images supplemented the stills—as they did with Eddie Adams's "Saigon Execution" (page 79) and Nick Ut's "The Napalm Girl of Trangbang" (page 103)—the still picture became the image locked forever in the collective memory. The fleeting television image failed to record, but the stills, which appeared over and over on demonstration placards, in books and magazines, and even as still pictures on TV, remain today as unforgettable, iconic insights into the war, and as recollections of the horror of that time.

The civil rights photos of the era also melded technology with journalistic innovation. New 35mm cameras enabled photographers to record images of the civil strife as never before. Jack Thornell's picture of the wounded James Meredith on a highway (page 71) and Moneta Sleet's photo of a dignified Coretta King at her husband's funeral (page 83) caught different aspects of the struggle. Steve Starr's image of students carrying guns on the campus of Cornell University (page 87) struck yet another tone of this saga. The *Louisville Courier Journal*'s Pulitzer winner about school integration (page 117) filled out the story visually.

In 1968, the Pulitzer committee inaugurated a new prize category, a second award for feature photography, that created a greater opportunity to reward photographers who pursued excellence in picture journalism. This new award promised a regular place for a kind of picture that had won awards earlier, but which more often were pushed out of the award recognition by more compelling, iconic photos of major news events. This new award also recognized photo coverage that documented continuing stories that lacked the drama of a breaking news event, but looked carefully at social issues of the world.

Two Lonely Men

BY PAUL VATHIS, ASSOCIATED PRESS

Paul Vathis learned photography in the cramped confines of the tail-gunner's position aboard a World War II bomber in the Pacific. His job, when not fighting off Japanese attackers, was to photograph the landscape his aircraft had just bombed. He got used to photographing scenes as they moved away from him—or, more accurately, as he moved away from them.

After the war, Vathis joined Associated Press and, for years, was assigned to the state house in Harrisburg, Pennsylvania. Like all statehouse photographers he covered everything, including President Eisenhower at his Gettysburg farm and at Camp David, Maryland, whenever the president decided to spend relaxation time there.

In April 1961, Ike had completed his two terms in office and President Kennedy had been in office only a few months. Kennedy was in trouble as fallout from the disastrous Bay of Pigs fiasco gripped the White House. Castro, in a rage, was playing the propaganda game to the hilt, and Nikita Khrushchev was sending off blistering cables. It was only a few months earlier that he and Castro had hugged each other on the floor of the United Nations.

Since Eisenhower had had his own problems with Fidel Castro's Cuba, the two men—the young, newly inaugurated president and the soldier president who lead the World War II allies through Europe—met at Camp David. They hoped to forge a sense of national unity over an issue they shared in common.

Vathis knew what to expect from this kind of classic, Washington wire-service assignment. There would be a photographer or two from the Washington bureau with Kennedy, and the Associated Press would set up a portable operation in a motel just outside the entrance to Camp David so the pictures could move quickly to the world.

That was essentially the way it happenned. Eisenhower and JFK posed for the cameras—they looked this way and that way and shook hands. The former president made a statement supporting JFK's role in foreign policy. Messengers took the film and hustled off to the motel, even before the "photo op" concluded. This processing had to move quickly because the meeting was the top of the news on that April 22.

Press Secretary Pierre Salinger announced that the lid was on, which was Washington-speak for no more pictures, no more questions.

Vathis heard Eisenhower tell Kennedy, who was on his first visit to Camp David as president, that he knew a place where they could talk. The two men began to walk along a slowly curving pathway toward a small cabin, leaving the press and the Secret Service behind.

Vathis squatted to pack his equipment and as he did so he looked up at the two men walking away. JFK held his back the way he always did to lessen the constant pain he suffered, and Eisenhower strode alongside him, hands clasped behind holding his hat.

APRIL 1961 ■ *The first manned spaceship circles the earth. Soviet astronaut Yuri Gagarin makes the orbit in the spacecraft Vostok I.*

APRIL ■ *Navy Commander Alan Shepard Jr. becomes the first American in space.*

AUGUST ■ *East German authorities close the border between East and West Berlin and begin erecting the Berlin Wall.*

OCTOBER ■ *New York Yankee Roger Maris hits 61 homers, breaking Babe Ruth's record.*

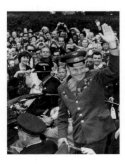

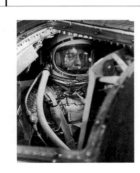

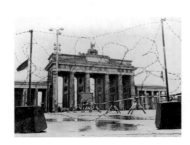

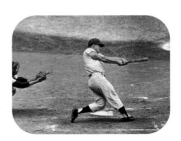

The barren background trees looked more like autumn than early spring. The sky was cloudy and gray and the air was crisp; fallen leaves that had survived the winter were still on the ground.

Vathis's single, most vivid recollection of the scene is that they looked so lonely as the young president spoke with the old soldier. He knew instantly that this would be the story-telling picture, but Moose, a burly Secret Service agent he had known during the years of the Eisenhower administration, was in the way. "Moose, spread your legs! I want to make a picture."

"Paul," Pierre said, "the lid's on." "Moose, spread your goddamn legs. There's a picture there." Moose obliged. Vathis made two exposures through the agent's legs, his camera close to the

ground, angled slightly up. Salinger heard the shutter trip and scolded, "I said the lid's on!" Paul replied that he was just taking the film out of the camera. Moose said, "Get the hell out of here."

At the makeshift AP lab in the nearby motel, several pictures had already moved to the international picture network, but it was clear that Vathis's picture was a winner. It was also a winner in the Pultizer Prize considerations the following year.

TECHNICAL DETAILS

CAMERA Hasselblad
FILM Kodak 120 roll film
LENS 180 mm
SHUTTER & APERTURE Unknown

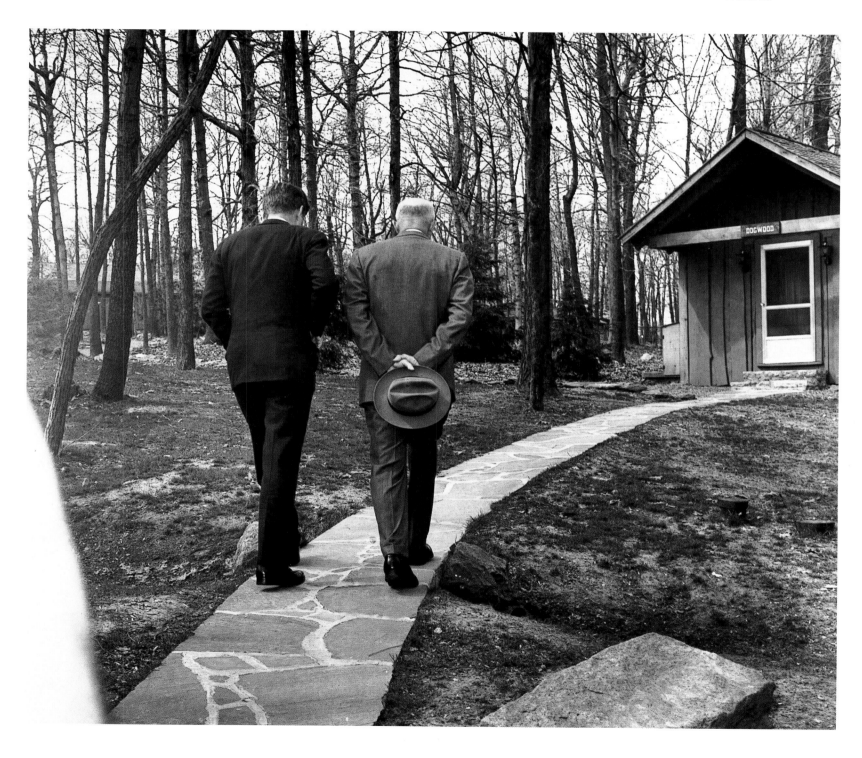

1963

Revolution and Absolution

BY HECTOR RONDON, THE CARACAS, VENEZUELA, *LA REPÚBLICA*

In times past, pirates cruised the waters off the coast of Venezuela seeking loot from ships at sea as well as in seaside towns. At the large, coastal town of Puerto Cabello, just forty miles from Caracas, the Spanish had built rugged defenses effective against pirate marauders attacking from the sea. The city was never meant to withstand twentieth-century revolutions that came from within, however. Its rocky streets and sturdy structures made ideal positions for urban warfare and small groups of opposition fighters could, in the name of revolution, tie up much larger groups of military defenders.

In Latin America of the 1950s and 1960s, revolution was a popular, though deadly sport. In early June 1962, Venezuela's President Rómulo Betancourt, who was popularly elected, was in the fourth year of a five-year presidency. The new constitution was but a year old. To outsiders, Venezuela appeared stable; but in Latin America, where poverty existed cheek by jowl with prosperity, and where the "have nots" saw daily how well the "haves" lived, stability could easily turn to revolution. Only a month before, an insurrection had been put down at Carúpano.

Another uprising began on June 4 at Puerto Cabello, which was safe against attack from sea but susceptible against attack from within. Some five hundred Marines seized the naval base and quickly took control of the town. The year-old constitutional government was under attack.

The central government reacted quickly and sent in troops. Hector Rondon, a photographer for *La República,* joined the troops headed for the city. Once in Puerto Cabello, he crouched behind a tank. The fighting was fierce, as entrenched marines poured withering sniper fire on the government forces. Government tanks shot back, and jet aircraft flew strafing runs over the city.

As the government troops moved from doorway to doorway to flush out the rebels, Rondon found himself pinned against a wall. Peasants from the countryside arrived with weapons, some primitive machetes, to assist the loyalists. The rebel Marines were pushed into a four block area, and an excruciating, deadly game began. Government soldiers fought from one old building to the next to eliminate the remaining revolutionaries

Rondon recalled, "The air was full of lead when I noticed a priest walk into the streets to offer the Church's last rites to the dying." One badly wounded soldier crawled to the priest, later identified as Venezuelan Navy Chaplain Father Luis Padilla, and pulled himself to a kneeling position, grasping the priest's cassock. The sniper fire continued, and bullets chewed up the concrete around the priest as he looked up to face the sniper. Padilla gave the sacrament to the soldier, then moved on to others who had fallen. "I don't know how I made the pictures," Rondon said. "I was prone on the street with my camera, working from street level."

JANUARY 1962 ■ *Peter O'Toole stars in David Lean's epic* Lawrence of Arabia.

AUGUST ■ *Marilyn Monroe is found dead in her Los Angeles home. She was thirty-six years old.*

OCTOBER ■ *U.S. surveillance discovers Soviet missile and bomber bases in Cuba, resulting in a tense nuclear confrontation between Washington and Moscow.*

OCTOBER ■ *Pope John XXIII opens Vatican Council II, less than a century after Vatican I was convened in 1869.*

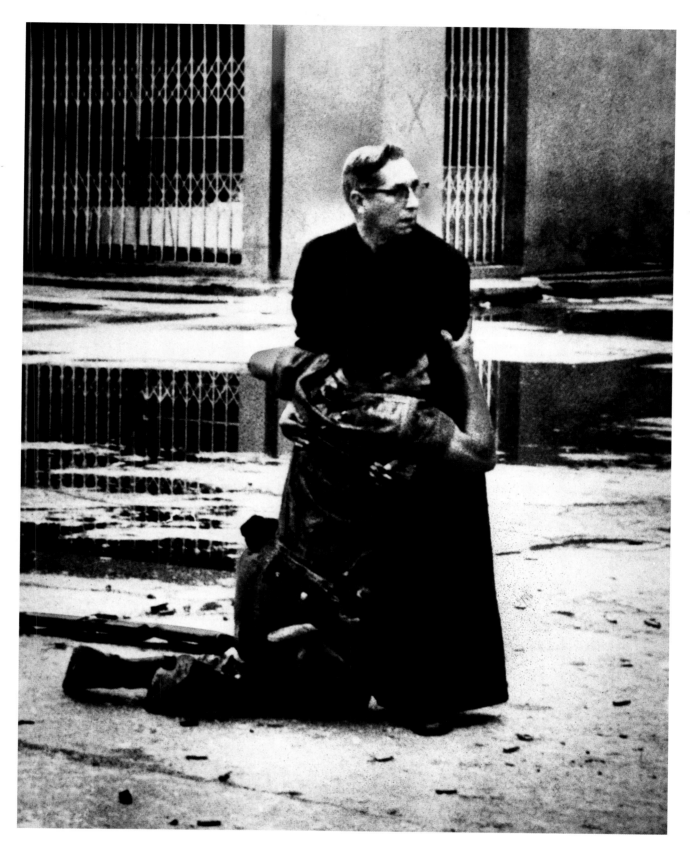

At the end of the two-day uprising, those rebels still alive escaped to mountains outside the city; but two hundred from the two sides died, and another one thousand were wounded.

The pictures Rondon made at Puerto Cabello won the Pulitzer, the most compelling photo showing Father Padilla holding the wounded government rifleman.

TECHNICAL DETAILS **CAMERA** Leica
FILM Kodak
LENS Unknown
SHUTTER & APERTURE Unknown

1964

Oswald Shot, Live to the World

BY ROBERT JACKSON, THE *DALLAS TIMES-HERALD*

The story of how Bob Jackson missed the most of what would have been the important photograph of his career and then came to make one that won a Pulitzer Prize almost challenges credibility. The President of the United States had been assassinated as he rode through the streets of Dallas in an open car. The shooter was captured and identified as Lee Harvey Oswald, although at that point not much was known about him.

At the moment the fatal shots were fired, *Dallas Times-Herald* photographer Bob Jackson was riding in the motorcade following the president through Dealy Plaza. At the sound of the rifle fire, he looked up in the direction of the noise. He saw the weapon's barrel, but it was too late to make a picture before the rifle disappeared from the window.

Two days later, on November 24, 1963, Jackson was in the basement of the City Jail. Exhausted from several days of covering the story, he was still berating himself for not getting the picture of the rifle. That day, however, he was waiting for Oswald to appear. The newspaper and the television people had pressed the Dallas authorities for a picture. The police finally relented; they were going to allow him to be photographed as he was being transferred from the city jail to the county jail at 9:15 a.m. on Sunday.

Jackson waited. The time was approaching ten o'clock and there was no sign of Oswald. A *Times-Herald* reporter called the paper and told them that Jackson could not make his 10:30 a.m. assignment at

Parkland Hospital, where Mrs. John Connolly, wife of the Texas governor wounded in the shooting, was to hold a press conference. He stayed at the jail, and another photographer went to cover Mrs. Connolly.

The clock ticked on, and eleven o'clock came and went. Suddenly there was word that Oswald was on his way. It was 11:21 a.m. The National Broadcasting Company camera was broadcasting live to the network. Jackson took a position to the right and leaned on a police car. The waiting media formed a semicircle around the door that Oswald would walk through. The door opened, and out walked the group. Oswald was cuffed, and a detective on each arm guided him toward a waiting vehicle. As they took a few steps toward Jackson, who held his camera at the ready, the body of a man wearing a fedora moved into his frame from the right. Jackson leaned slightly to the left to keep Oswald in the frame, and he heard a voice shout, "Jack, you son of a bitch!" A shot echoed through the garage. Jackson pressed the shutter button and there was an electronic burst of light. Oswald groaned and began to collapse. The detective on the right was obscured; the detective on the left was astounded. Other men jumped the shooter as Oswald was dragged back through the door. Jackson pressed his shutter button again, but his strobe, with insufficient time to recycle, failed to go off. It was over.

Bob Jackson had to stay at the scene to continue the coverage, and he worried, did I get it right at the right moment? He was anx-

JANUARY 1963 ■ *"I have a dream," says Martin Luther King Jr. at a ceremony to commemorate the 100th anniversary of the Emancipation Proclamation.*

JUNE ■ *A Buddhist monk immolates himself in Saigon to protest President Diem's treatment of the Buddhists.*

JUNE ■ *The Soviet Union's Valentina Tereshkova becomes the first woman astronaut to orbit the earth.*

NOVEMBER ■ *U.S. President John F. Kennedy is assassinated while riding in a motorcade in Dallas.*

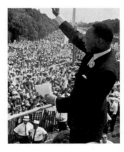
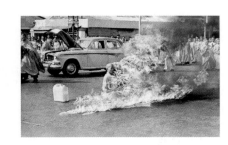
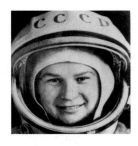
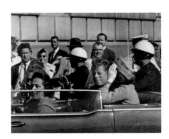

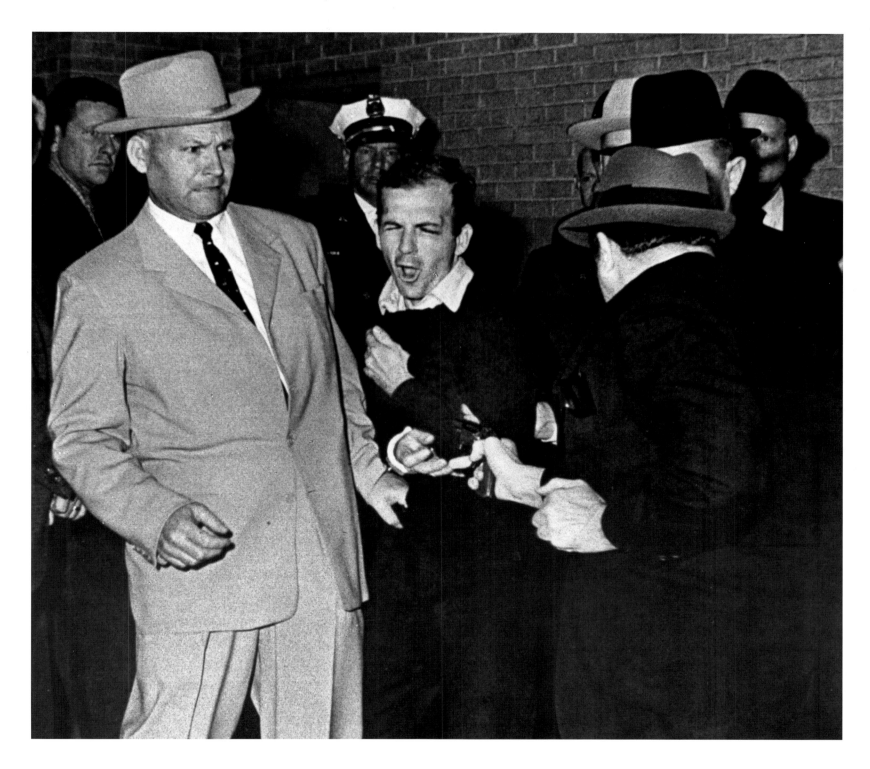

ious to process the film. He made it back to the office, went into the darkroom and minutes later dropped his 11x14-inch print on the editor's desk. The picture, frozen in the burst of high speed light of Jackson's electronic flash, was the same scene that had been broadcast live on television. Jackson's picture clearly and unmistakably showed Oswald going down under the gunshot.

An hour after Oswald was shot, the caisson carrying the president's flag-draped coffin left the White House destined for the Capitol Rotunda, where it would be viewed by hundreds of thousands of Americans. An hour after that Lee Harvey Oswald

TECHNICAL DETAILS **CAMERA** Nikon
FILM Kodak
LENS 35 mm
SHUTTER & APERTURE Flash @ f2.5

died in Parkland Hospital, the same hospital in which the President had died.

Bob Jackson won the Pulitzer Prize for his photo of Jack Ruby lunging forward and firing his pistol into the body of Lee Harvey Oswald, just eleven feet away from Jackson's camera.

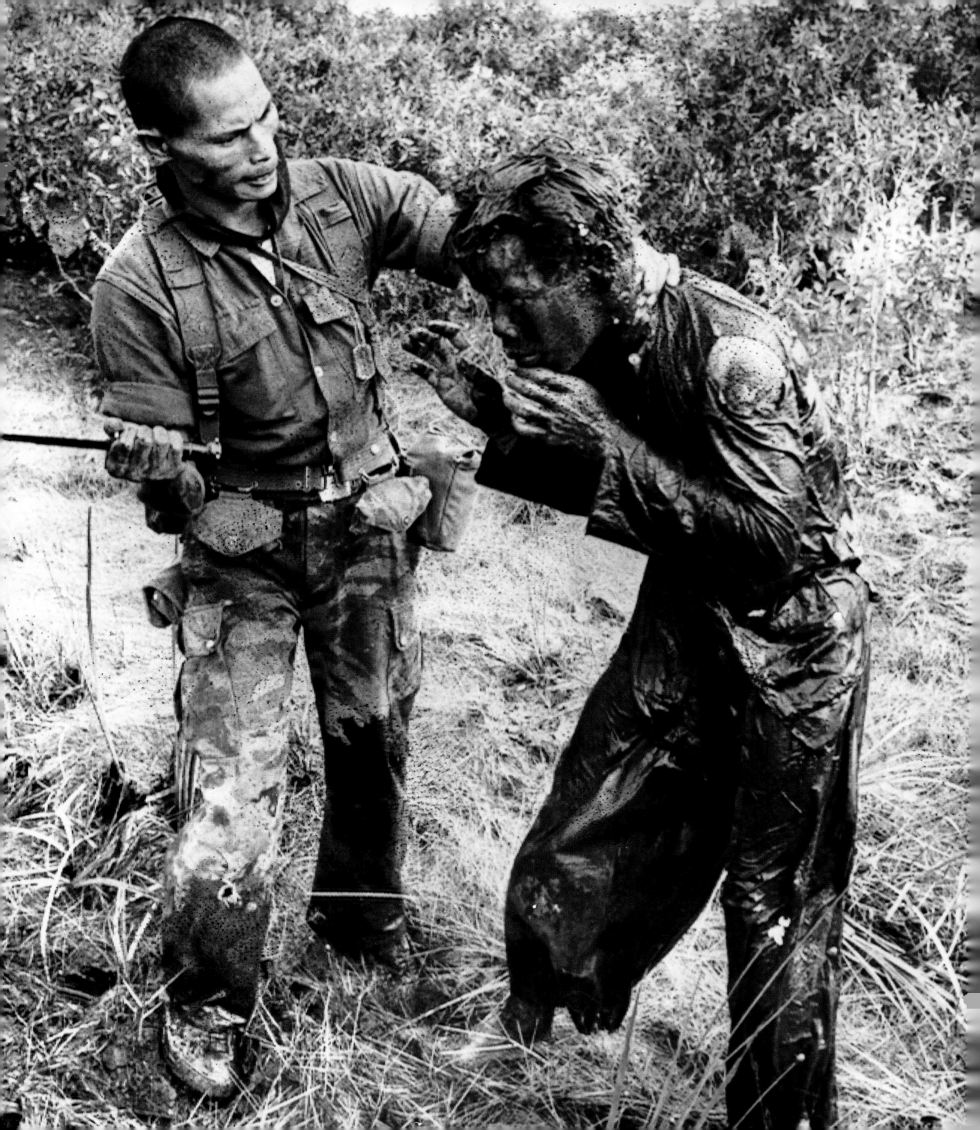

Vietnam Photo Coverage

BY HORST FAAS, ASSOCIATED PRESS

Although Horst Faas was just twenty-nine when the Associated Press assigned him to Southeast Asia in 1962, he had extensive experience. He had covered both the civil war in the Congo, and France's problems in colonial Algeria. Renewed conflict in Indochina, which had been dormant since the French left in 1954, motivated AP to send him to Southeast Asia.

Faas's ambition as a student in postwar Germany was to become a journalist, and he prepared himself with studies in political science, history of journalism, and economics. He soon reached the conclusion that, in many cases, stories could best be told with pictures. He taught himself to be a skilled photographer—careful, precise, in command of the technology, and respectful of the camera's mechanics. His first job was as a photo salesman for Keystone agency in Germany. He believes that seeing the many photographs in the Keystone library files and hearing editors say why they did or did not purchase a picture helped him develop his photographer's eye.

In 1962, Vietnam was becoming an all-out war zone. The Americans, just arriving on the scene, were still counted in the thousands, not the hundreds of thousands. Buddhist demonstrations in the cities were common, and cruel military actions in the countryside were on the upswing. Vietnamese troops were doing the fighting, from the swampy Mekong River delta to the highlands.

Terrorist attacks at the cafes, hotels, and movie houses in the cities were common. Faas's early coverage of the guerrilla war between South Vietnamese troops and the Vietcong quickly taught him some of the rules of survival: carry a three day supply of food, dress like the troops you're traveling with, be first off the helicopter (in the noise and confusion, enemy fire is not as accurate), carry extra money, and carry waterproof bags for your camera equipment. These rules proved sound; when Faas left Vietnam after some ten years, the military agreed he had seen more action than most troops who experienced several tours. The rules did not provide full protection, however. Fass was severely wounded in the leg when shrapnel from a Vietcong rocket exploded nearby, and during his years there he saw many photographer friends and colleagues die while covering the war.

By 1964, Faas's byline under combat pictures was common in newspapers around the world. His photographs showed the muddy delta fighting, the stacked bodies, the napalm victims, the cruel interrogations, the bloody and broken wounded, the helicopter attacks in the mountains, the street riots, and the sudden terrorist attacks in Saigon and other cities. The people in these images were

FEBRUARY 1964 ■ *The Beatles appear on* The Ed Sullivan Show.

APRIL ■ *Arnold Palmer wins his fourth Master's Tournament.*

JULY ■ *U.S. President Lyndon Johnson signs the Civil Rights Act.*

SEPTEMBER ■ *A Soviet coup ousts Nikita Khrushchev from power; Leonid I. Brezhnev becomes party leader.*

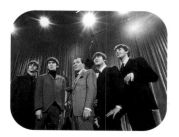

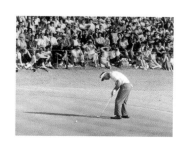

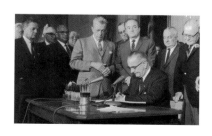

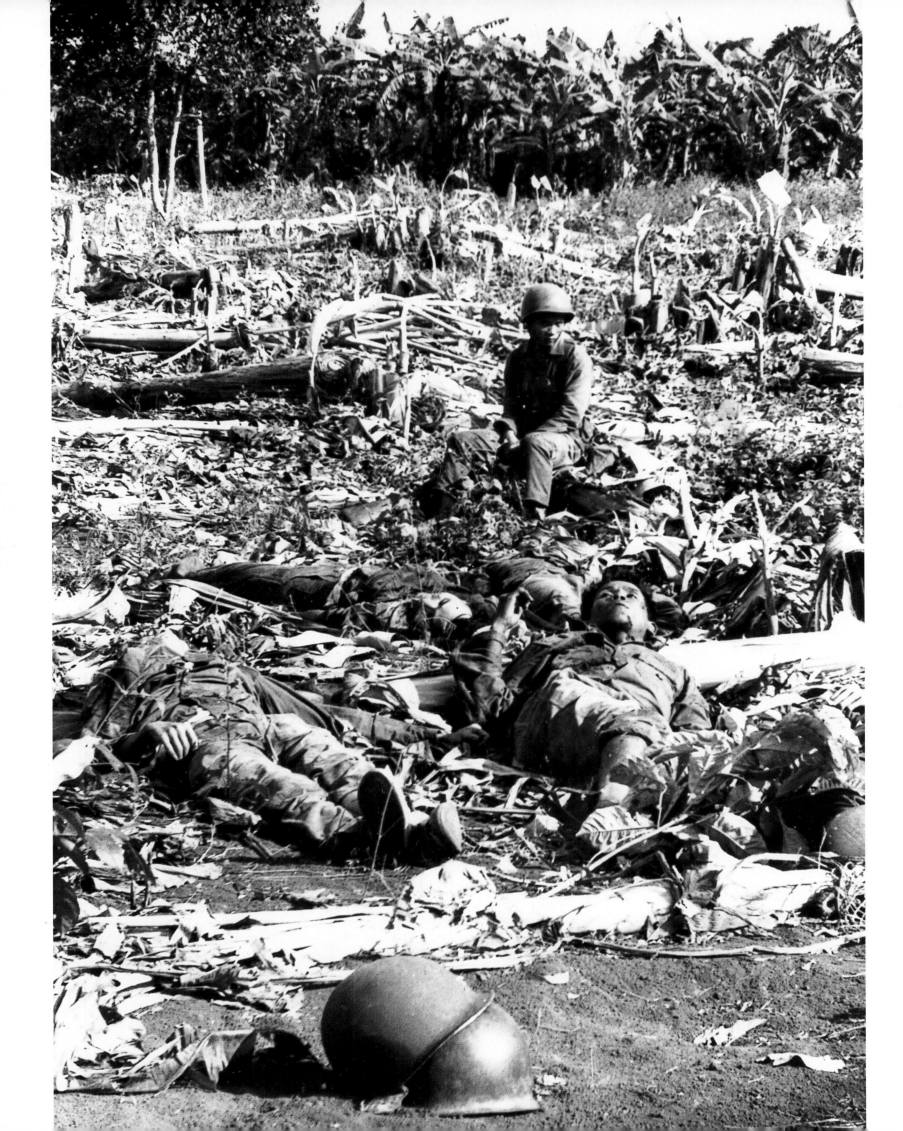

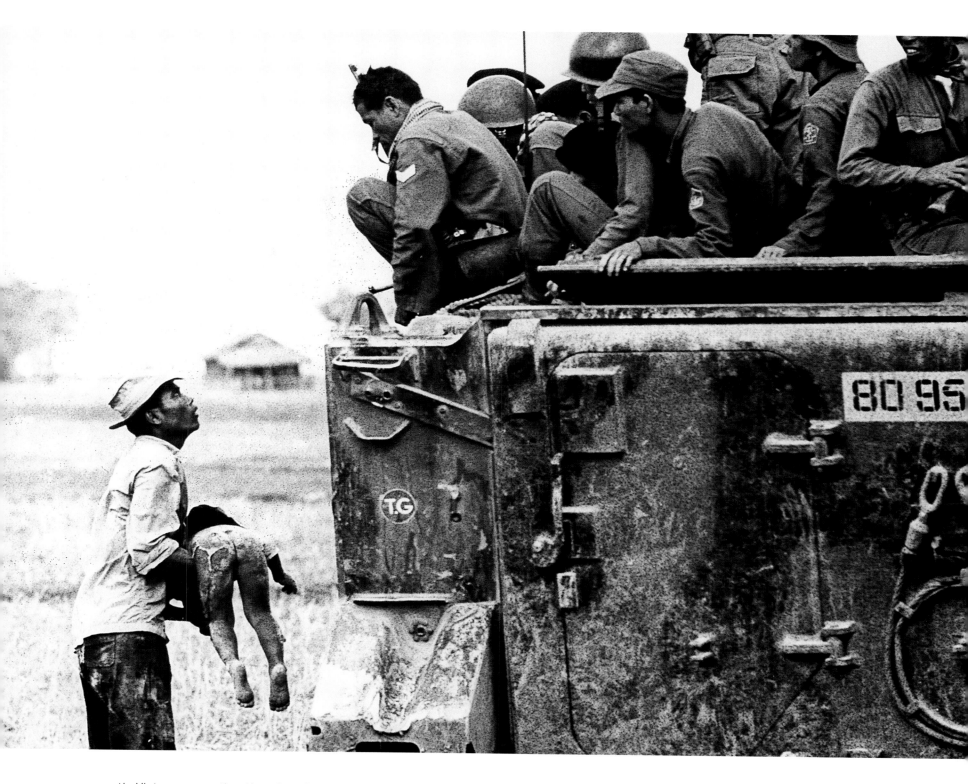

mostly Vietnamese, rather than American, but Faas was concerned then, and throughout his time in Vietnam, about the impact the photos would have on the reading public. Before Vietnam, the war photos the public knew were the relatively sanitized pictures from World War II and Korea. In Vietnam, the United States government and the military decided that coverage would be unfettered and that writers and photographers would have access to the war more or less as they desired. The public, therefore, was not protected from the harsh brutality of an unpredictable guerrilla war. Faas's

concern for the impact of the photographs in the U.S.—and elsewhere—was heightened as the American role in the war grew and the Vietnamese faces in his pictures turned into American faces. The harshness of both war and pictures also grew as the soldiers relied less on mortars and more on artillery, and moved from helicopters to B-52s.

In the United States the war coverage was hotly debated. Hawks and doves took positions supporting or criticizing the writers and photographers working in Vietnam. Faas's response to the crit-

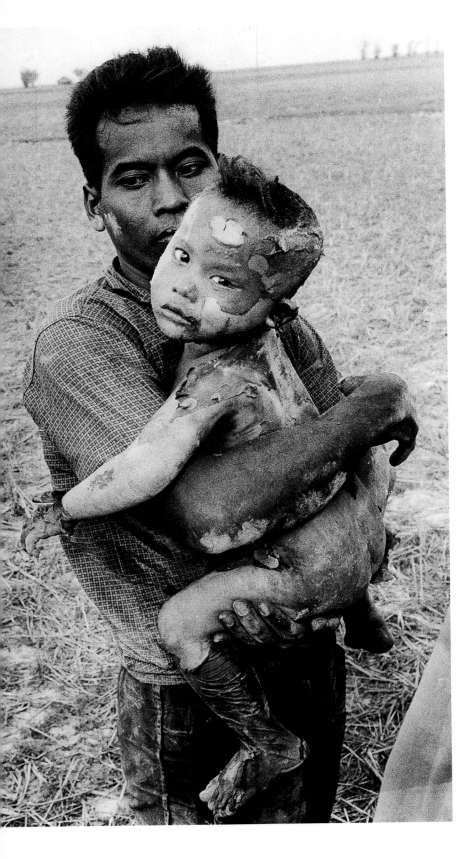

ics was that all he ever attempted to do was to tell and show what happened as truthfully and fairly as possible. This was difficult. At one point, in a piece for an AP publication for staffers, he wrote about photographers who covered the fighting, citing the dangers and the limitations they encountered in Vietnam:

"They [photographers] could crawl to the forward trenches of a besieged outpost, wait beside riflemen in night ambushes, witness brutal interrogations and executions and merciless street fighting. While the enemy—the Vietcong and the North Vietnamese—operated in secrecy, American and allied troops and government civilians performed almost always under the probing eyes and lenses of newsmen."

Even though there was no censorship in Vietnam, Faas said he always tried to use judgment in his coverage. "We worked hard to be truthful. We avoided pictures of the bizarre and the atypical. But when torture became commonplace in the field, we photographed it and distributed the photos."

Faas's Pulitzer Prize for 1965 was the first Pulitzer of many to be awarded over the next decade to photographers and writers who faced the war with only cameras and notebooks as their shield against the battle.

At the end of his tour in Vietnam, he moved to London where he reported various stories in Europe and the Middle East, gradually moving toward an assignment to lead AP's picture operations in Europe, Africa, and the Middle East.

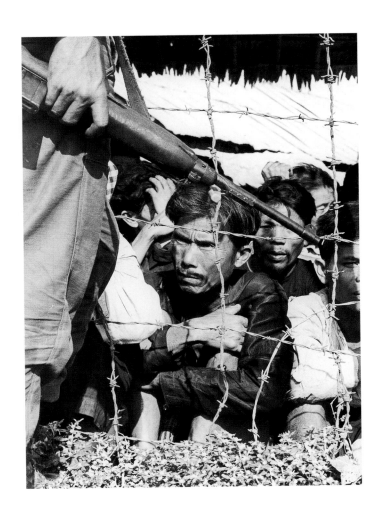

TECHNICAL DETAILS **CAMERA** Leica
FILM Kodak
LENS Range from 35 mm to 200 mm
SHUTTER & APERTURE Various

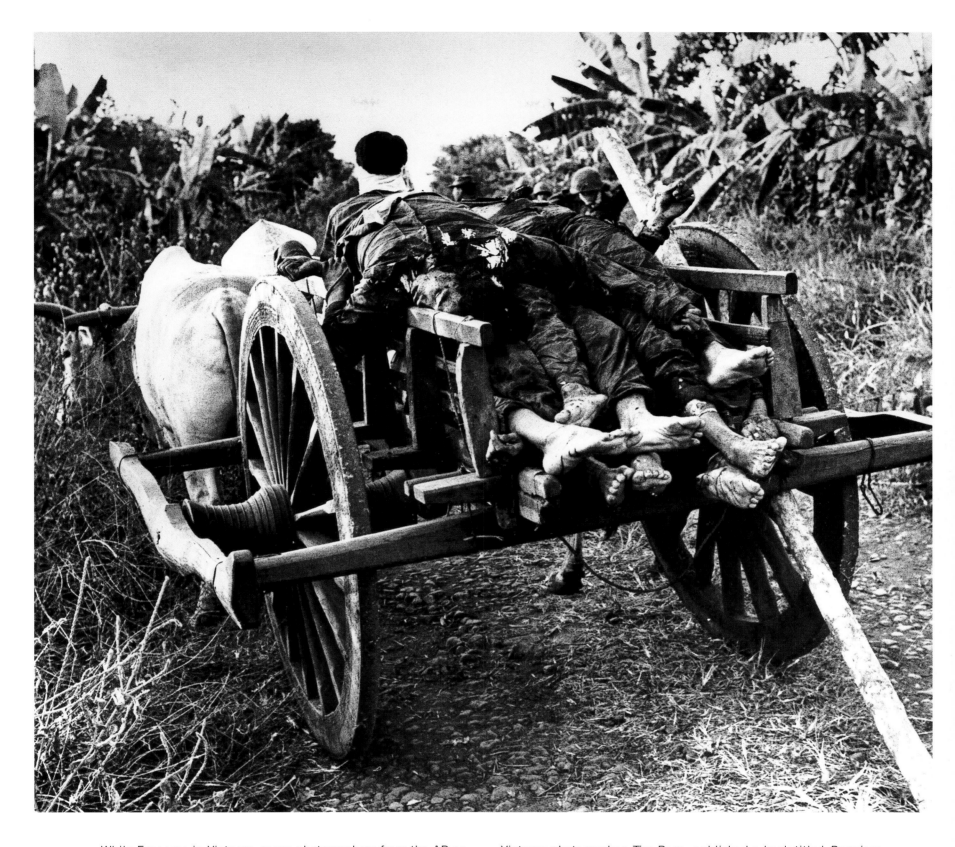

While Faas was in Vietnam, many photographers from the AP as well as from other news companies were killed. Some died directly at the hands of Vietcong; others in aircraft or helicopter crashes. Seventeen newsmen disappeared into Cambodia. Many were Faas's friends, and all were his colleagues. In 1997, Faas and another Vietnam photographer, Tim Page, published a book titled *Requiem: By the Photographers Who Died in Vietnam and Indochina.* It included pictures made by 135 photographers from both sides of the struggle who died during the thirty years of the French Indochina war and the American Vietnam war.

Fleeing the Bombs

BY KYOICHI SAWADA, UNITED PRESS INTERNATIONAL

How do you cover a war that is everywhere and nowhere, a war in which only one side permits newsmen to accompany their troops, and in which reporters and photographers were in harm's way at noon and in a luxury French restaurant at night? The contradictions, danger, and irony found in Vietnam made that a war photographed like no war before or since. Kyoichi Sawada, a photo editor and photographer in the Tokyo bureau of United Press International, wanted to cover that war and sought assignment there in 1965.

He had joined United Press International in 1961 after graduating from high school, and after working as a photo-department clerk in a PX at the U.S. Air Force Base in Misawa, Japan. As the war in Vietnam heated up, Sawada increased the pressure on his bosses for a transfer to Saigon, but his request was denied. Undaunted, he took vacation time and, at his own expense, traveled to Vietnam to photograph.

The pictures he made in the midst of the conflict were so good that UPI assigned him permanently to Vietnam. He covered the nowhere/everywhere war like all the other photographers, taking helicopter rides into camps and patrols, then going back to Saigon with the film. The picture transmitter carried his pictures to the world via UPI's network.

In Vietnam, Sawada earned a reputation as a daredevil cameraman. He once ran into a minefield to photograph advancing American troops. Another time, he moved up to the bank of a river that was under attack and photographed two mothers wading from the opposite shore, guiding their children. They were fleeing their village, which was under U.S. bombardment because the Vietcong used it as a base to attack U.S. Marine positions. The women understood the meaning of the bombs—that the Americans knew about the Vietcong and there would be no letup in the attack. This photograph became the centerpiece of the picture portfolio that earned Sawada a Pulitzer Prize in 1966.

By 1969, Sawada was in Hong Kong, where UPI had installed him as picture editor. But nearly two years of desk work was enough. The war in Vietnam was getting hotter, and visitors to Hong Kong brought him news about friends, other photographers, and the war's expanding coverage into Cambodia and Laos. He wanted to go, and UPI sent him.

In October, 1970, Sawada accompanied his new bureau chief along Cambodia's dangerous Route 2, south of Phnom Penh. Sawada knew the area because he had been detained there six months earlier, interrogated for several hours, then released. This time, however, Sawada and his companion did not return in the evening.

Another UPI correspondent found them the next day, thirty feet from their car, wearing civilian clothes and unarmed, each shot several times in the chest. Sawada's bloodied press card was discovered nearby. They were two of the twenty-four journalists who were killed or missing in action in Cambodia that year.

FEBRUARY 1965 ■ *U.S. bombers pound North Vietnamese targets as American participation in the war escalates.*

FEBRUARY ■ *Malcolm X is killed by an assassin's bullet.*

MARCH ■ The Sound of Music, *starring Julie Andrews and Christopher Plummer, opens.*

NOVEMBER ■ *A massive power failure blacks out New York City.*

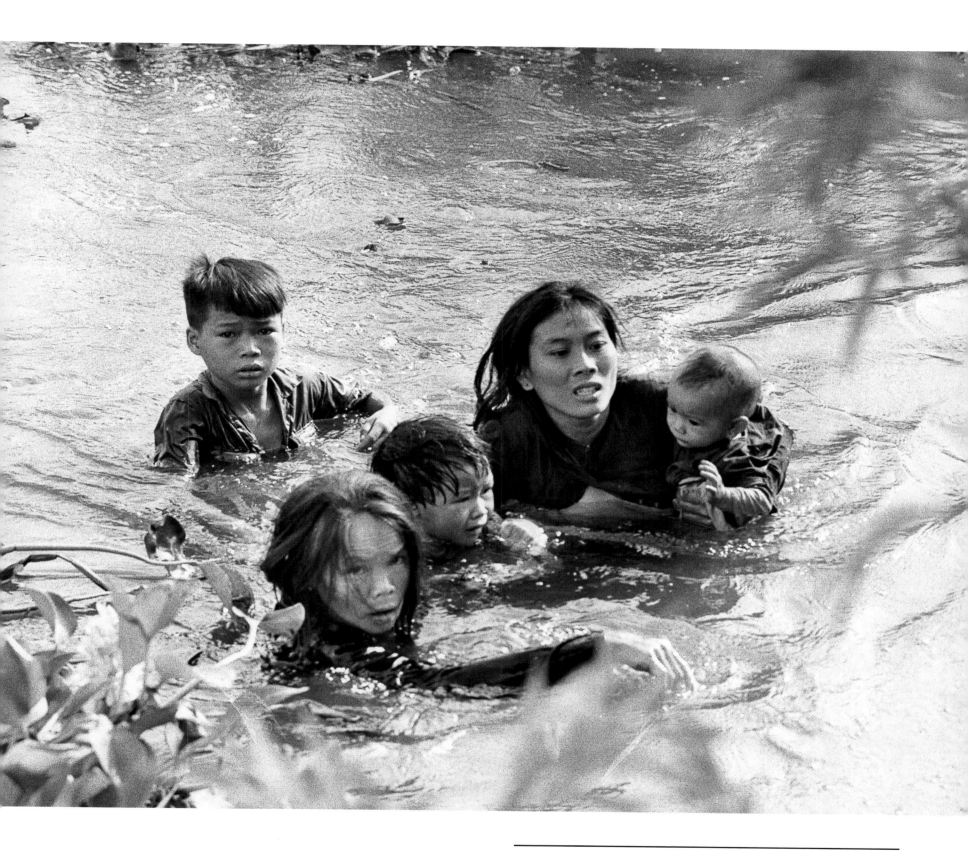

TECHNICAL DETAILS **CAMERA** Nikon
FILM Kodak
LENS Unknown
SHUTTER & APERTURE Unknown

69

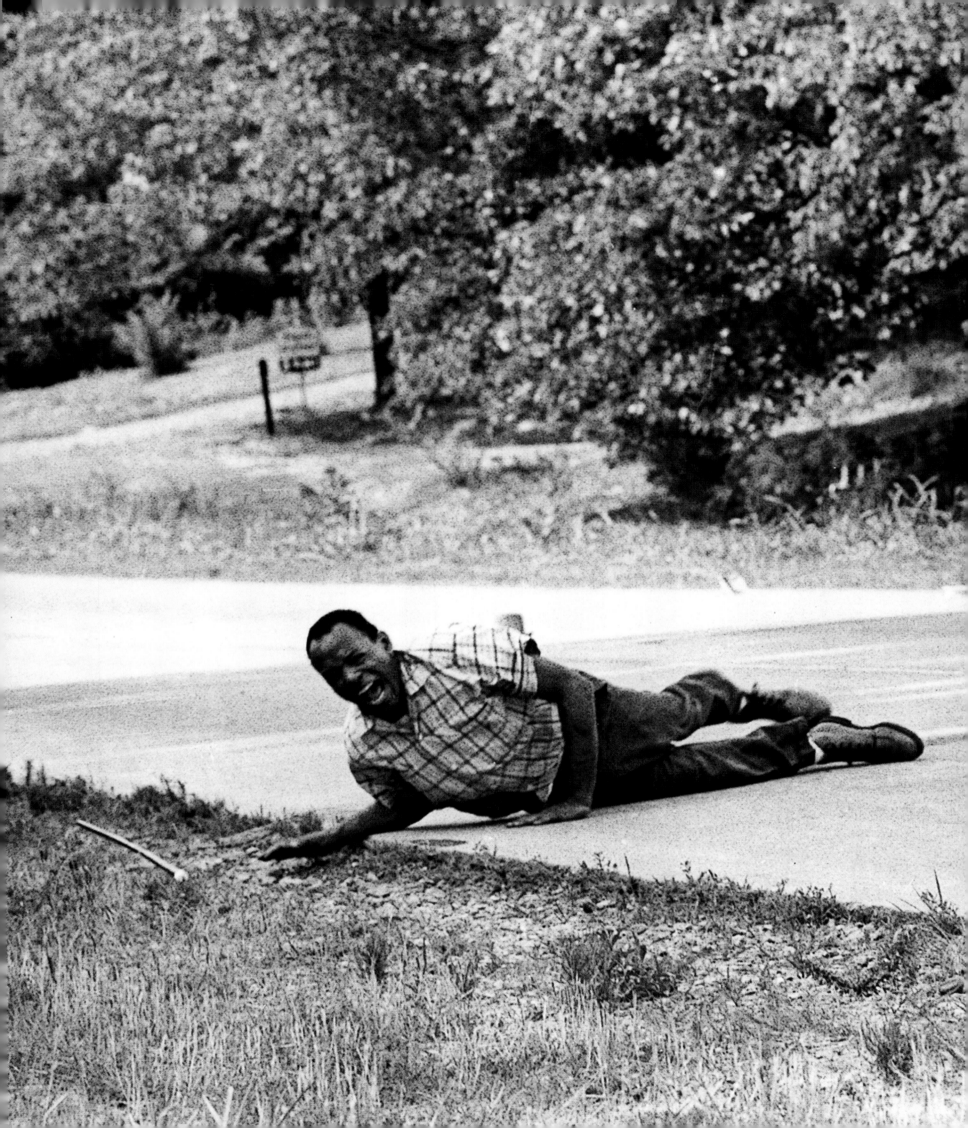

Meredith Shot on Highway 51

BY JACK THORNELL, ASSOCIATED PRESS

James Meredith was a man with a dream. His goal was to convince black citizens to register and vote in local and national elections. He believed that if he walked safely through the deepest part of the deep south he would see his dream become reality. Wearing a yellow pith helmet and carrying an ebony and ivory walking stick, Meredith planned to walk the 220 miles along U.S. Highway 51 from Memphis, Tennessee, to Jackson, Mississippi. In 1966, only twelve thousand of some one million black citizens were registered in Mississippi.

Two years earlier the bodies of three civil rights workers, Andrew Goodman, Michael Schwerner, and James Chaney, who were on a similar voter registration mission, had been found dead near Philadelphia, Mississippi. The perfume of oak and honeysuckle offered regional charm and flavor, but Meredith's walk was no countryside stroll.

Everyone in Mississippi knew James Meredith. In 1962, with the help of the President of the United States, 538 U.S. marshals and 22,000 combat troops, he had integrated the University of Mississippi. After he left Ol' Miss, he spent time in Africa (the walking stick was the gift of a tribal chief) and studied law at Columbia University in New York.

Jack Thornell, from the Associated Press's New Orleans bureau, was assigned to cover the walk. He would stay with Meredith until relieved by another AP photographer several days later.

The story unfolded much as Thornell thought it might. Blacks along the way offered mute support, and many comments from whites were unfriendly. Some drove their cars and trucks too close, swerving as they came down the highway. One yelled, "I hope you die before you get there."

On the second day, Meredith and six companions—three blacks and three whites—walked along the steamy, muggy road in the kind of weather one might expect in June. Just south of the Mississippi line, Highway 51 took a long dip into a hollow. A black friend of Meredith ran up to say he had heard that a man with a gun was waiting for him down the highway.

All he could see coming down the road, though, was a black farmer with cool water. Meredith shrugged. Then a voice, ever so softly but nevertheless easily heard, said, "James. James. I only want James Meredith." Meredith looked in the direction of the call and saw a man in the brush along the roadway. The man leveled a shotgun at Meredith.

Thornell had parked his car a short distance ahead and was waiting for Meredith and his small group. At the first shot, he

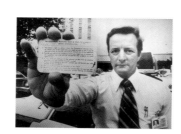

jumped out and started taking pictures from behind his vehicle. Meredith crawled toward the protection of the gully just off the shoulder of the highway, but two more shotgun blasts followed in succession. Thornell later reasoned that the first shot, which skittered along the highway, had been a warning to scare most of the people off the road. The two later shots hit Meredith in the small of his back and in the back of his head.

Thornell heard Meredith scream, "Oh, my God, oh, oh," as he pulled himself across the highway and found protection in the sloping shoulder. Thornell photographed Meredith on the highway

before rescuers came to Meredith's aid and rushed him to a hospital in Memphis. Most of the shotgun pellets were removed, but some he will carry for the remainder of his life.

Thornell also headed for Memphis and the AP bureau there, where he processed his film and transmitted pictures to the world.

Other black leaders took up the march; by the time they reached Jackson, their numbers had grown to eighteen thousand strong, giving birth to the new slogan Black Power. The shooter, Aubrey Norvell, 41, said by the local folk to be a fine neighbor and a quiet Christian man, pleaded guilty to assault and battery with intent to kill and served eighteen months, twenty-four days, in the Mississippi penitentiary.

Thornell's pictures—one of Meredith screaming, the other of him looking at the shooter in the brush with the image of the man actually in the picture—took their place with other civil rights-era images that received the Pulitzer Prize.

TECHNICAL DETAILS	CAMERA Nikon
	FILM Kodak
	LENS 105 mm
	SHUTTER & APERTURE Unknown

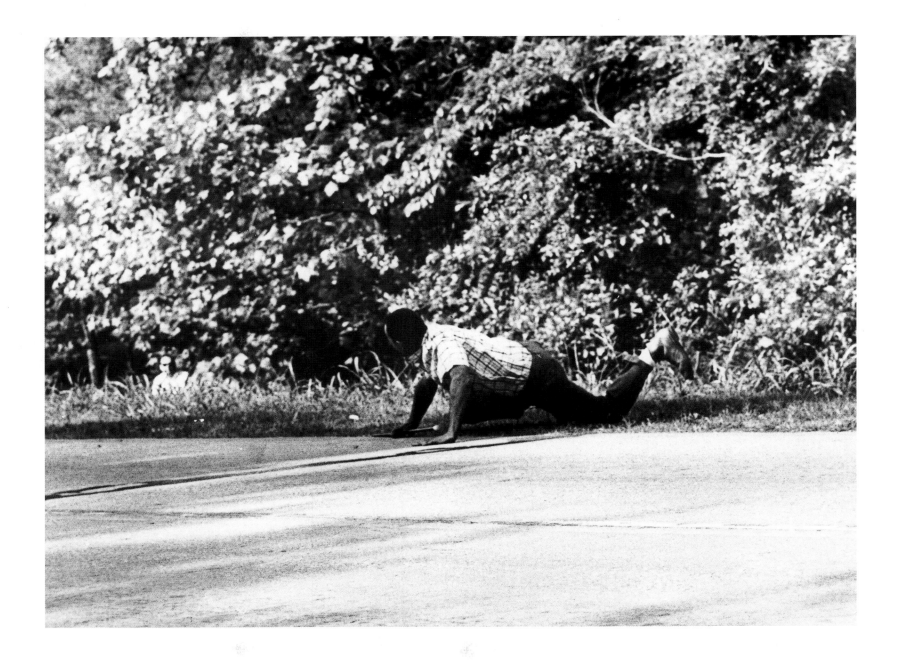

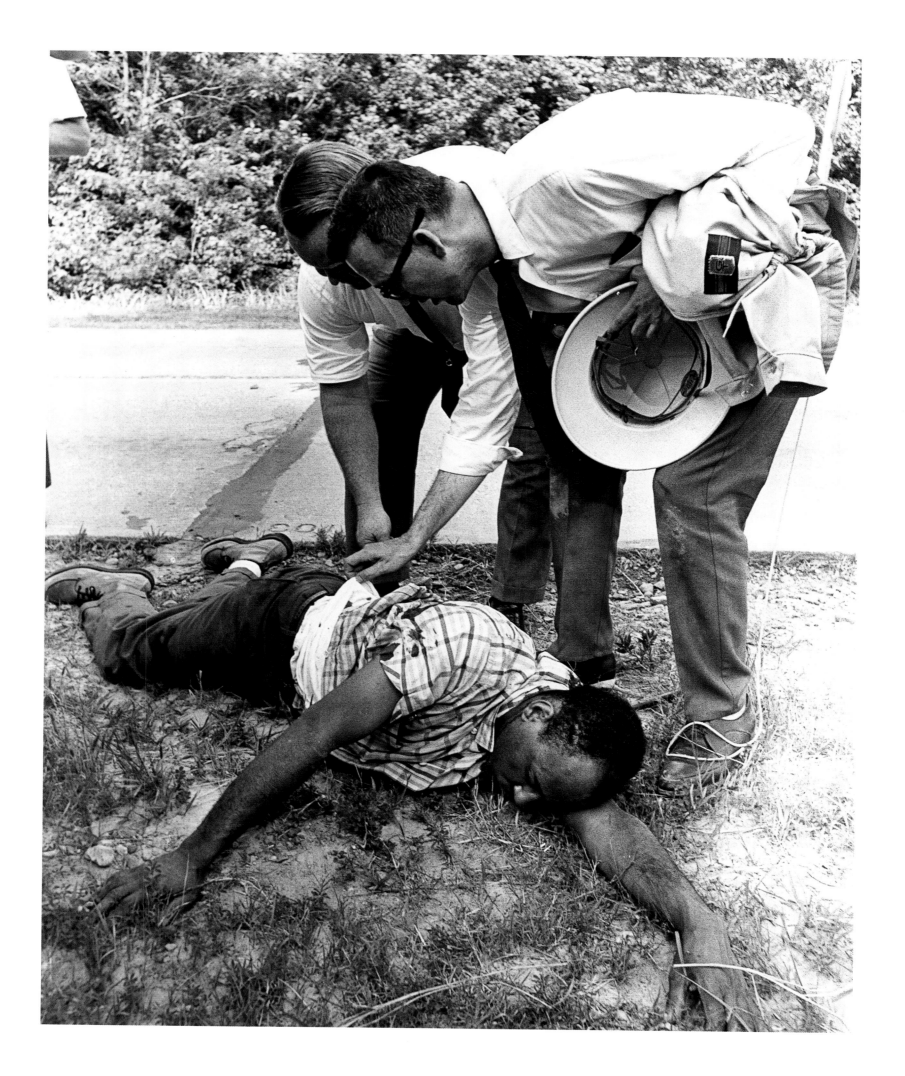

The Kiss of Life

BY ROCCO MORABITO, THE JACKSONVILLE (FLORIDA) *JOURNAL*

July 17, 1967, was a routine summer day in Florida; the heat was muggy and oppressive. It began as a routine day for pole linemen Randall Champion, Jimmy Thompson, and others of a crew that had been called out to restore power in a Jacksonville suburb where residents were complaining about the lack of air conditioning, and for *Journal* photographer Rocco Morabito, who had an assignment in the same suburb where the power was out.

On the way to his suburban assignment, Rocco saw the linemen atop their poles working on the problem. He made a mental note to stop on the way back to see if there might be a feature picture possibility in the work underway. As he completed his assignment, however, the situation with the power outage turned dramatic.

All the power lines were dead, except for one. As he worked high above the street, Champion somehow connected with the live wire and a twenty-one-hundred-volt surge of power coursed through his body, burned out through his feet, and knocked him from the pole. He was held by his safety harness, dangling upside down and unconscious. When Thompson and the others atop other poles saw what had happened, they knew that time was of the essence; the breath of life had to be pumped back into Champion's body.

Thompson was the first to reach Champion's pole. Up he went, grabbing his buddy's shoulders and head and starting CPR. When Morabito drove by enroute to his office, he could tell something was wrong, but didn't know what. He jumped out of his car, took a picture, and assessed the situation. He called his office on his car phone asking them to summon assistance; but unknown to him, a call for help had already been made.

Morabito returned to the scene and took more pictures. The other linemen watched intently for some sign of life as Thompson continued the CPR. He paused for an instant and called down, "He's breathing." By then, an ambulance was on the scene. Champion regained consciousness; he would be out of work for some time and his feet would need skin grafts where the electricity burned through, but he had survived.

Back at the *Journal,* Morabito processed his film. It was a little past the deadline, but the editor said he would hold it for the photo. Printed big on the front page, it was a positive photo that showed one human saving another, in stark contrast to the coverage of the Vietnam war, civil rights issues, and demonstrations in the streets that readers so often faced during the era.

JUNE 1967 ■ *Hostilities between Israel and Syria erupt into the Six Day War.*

OCTOBER ■ *Appointed by President Johnson, Thurgood Marshall becomes the first black United States Supreme Court Justice.*

DECEMBER ■ *Surgeon Christian Barnard performs the first heart transplant in Cape Town, South Africa.*

DECEMBER ■ *The Graduate, directed by Mike Nichols and starring Dustin Hoffman and Anne Bancroft, is released to critical and popular acclaim.*

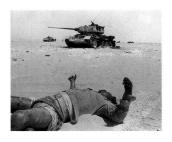

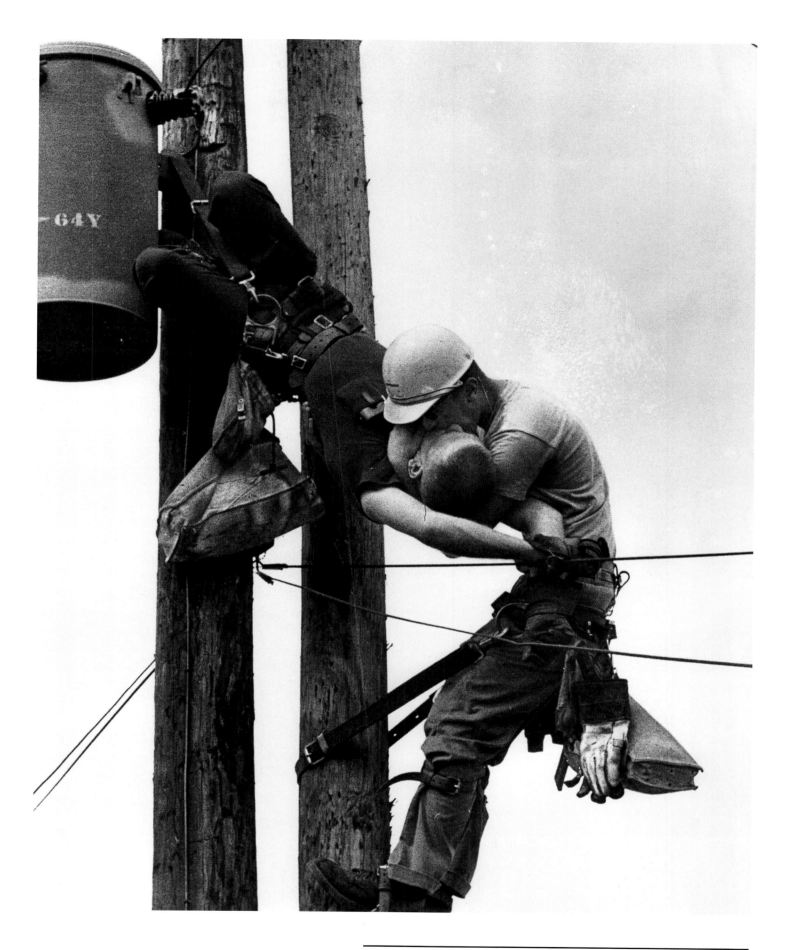

TECHNICAL DETAILS **CAMERA** Rolleiflex
FILM Kodak 120 roll film
LENS 5 mm
SHUTTER & APERTURE 1/500th @ f8

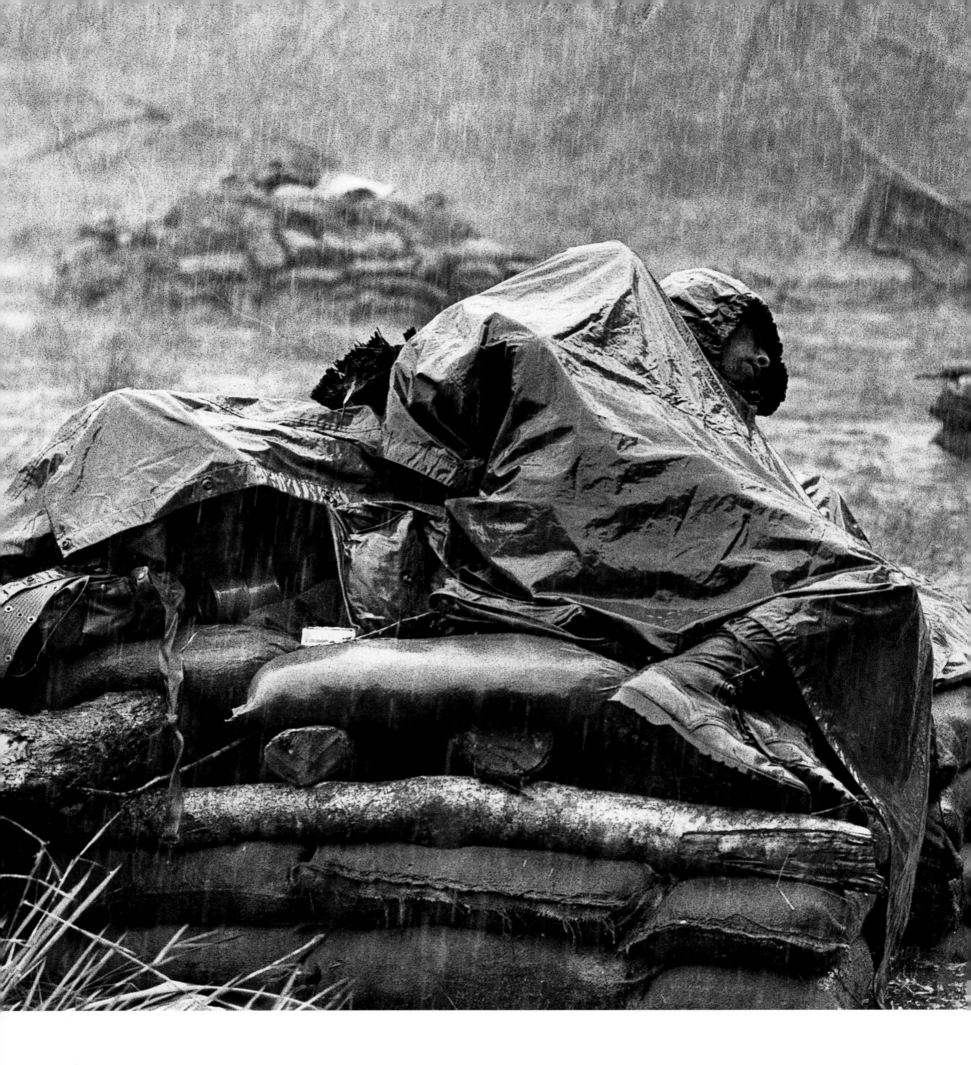

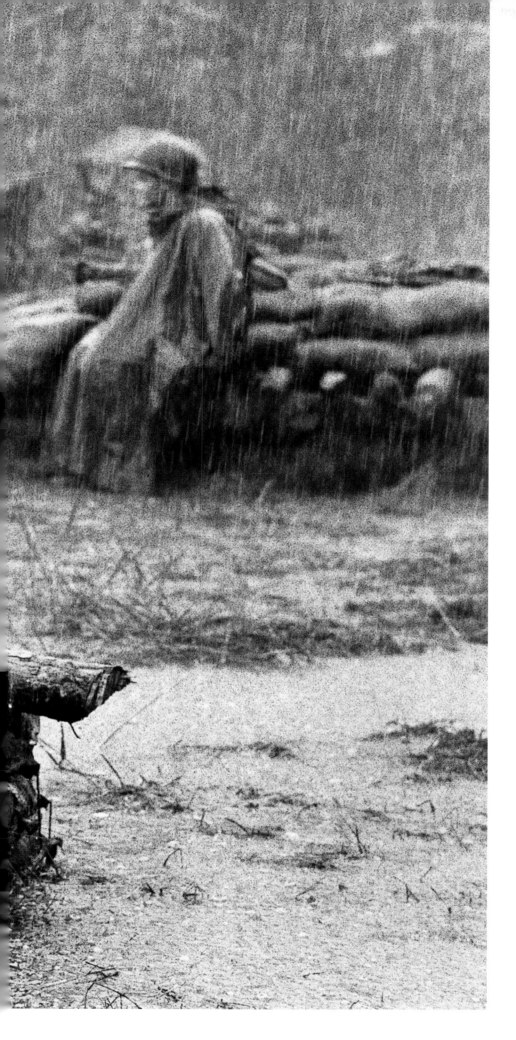

Quiet Rain, Quiet Time

**BY TOSHIO SAKAI,
UNITED PRESS INTERNATIONAL**

When the monsoon rains sweep across Southeast Asia all other movement ceases. The downpour is sudden and heavy. Visibility is obscured. In cities vehicular traffic comes to a halt. Storm drains, dry moments before, become raging rivers. Even the war in Vietnam lets up, momentarily at least

Toshio Sakai asked for a transfer to Vietnam after his Tokyo UPI colleague Kyoichi Sawada won a Pulitzer for photographs he had taken there in 1965. The wire service sent him and he had covered the war ever since—long enough to realize that the heavy rains would provide a quiet time and an opportunity for quiet pictures, which would stand in contrast to the usual fare in Vietnam.

GIs pulled on their ponchos against the downpour. One black GI stretched out atop the soggy sandbags of a bunker for a few moments of shut-eye. His mate, a white soldier, sat quietly in the background, rifle at the ready, on the lookout for the enemy. It was unlikely that an attack would come during the rainstorm. But because that is when attacks come, when they are least expected, the GIs took turns standing watch.

Sakai went about his photography. Their sensitive insight into a quieter side of a violent war won the first Pulitzer Prize for feature photography.

Sakai would cover Vietnam until the end of the fighting. He would then work as a freelancer before joining the French news agency, Agence France-Presse, and return to news photography in the 1980s and 1990s.

TECHNICAL DETAILS **CAMERA** Nikon
FILM Kodak
LENS 105 mm
SHUTTER & APERTURE Unknown

Saigon Execution

BY EDDIE ADAMS, ASSOCIATED PRESS

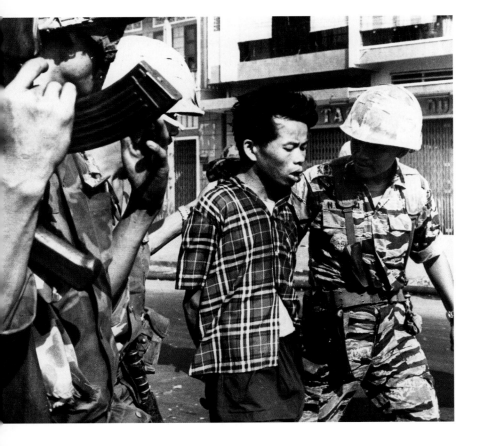

On the eve of Tet, the Vietnamese lunar New Year in 1968, a massive Vietcong offensive struck with surprising strength and sharply increased the level of fighting all across Vietnam. The attackers moved into the cities, even into the courtyard of the U.S. Embassy in Saigon, where Vietcong troops blew a hole in the wall of the embassy building before being killed by marine guards and military policemen.

Americans at home, where the streets were increasingly the scene of antiwar demonstrations, wondered if the bloody, costly conflict would ever end. Eddie Adams, working his third stint in Vietnam for Associated Press, asked himself the same question on the second day of the offensive, February 1. He had covered the Korean War as a U.S. Marine photographer, and he had built a reputation as an excellent newspaper and AP photographer in the early 1960s. But on that day he was with National Broadcasting Company cameraman Vo Su. The two photographers, office neighbors who frequently shared transportation and news tips, had teamed up to investigate reports of fighting in Cholon, Saigon's Chinese section.

They looked around Cholon, but it appeared that fighting had eased up. A pagoda occupied by Vietcong had been recaptured by

JANUARY 1968 ▪ *The North Vietnamese launch the Tet Offensive, a massive attack on enemy forces , breaking the lunar New Year truce.*

APRIL ▪ *Martin Luther King Jr. is shot dead on the balcony of his Memphis, Tennessee hotel room. James Earl Ray is later tried and convicted of the crime.*

MAY ▪ *Student riots in France force universities to close. Violent protests quickly spread to other industries and develop into a national crisis.*

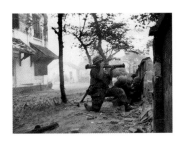

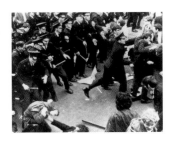

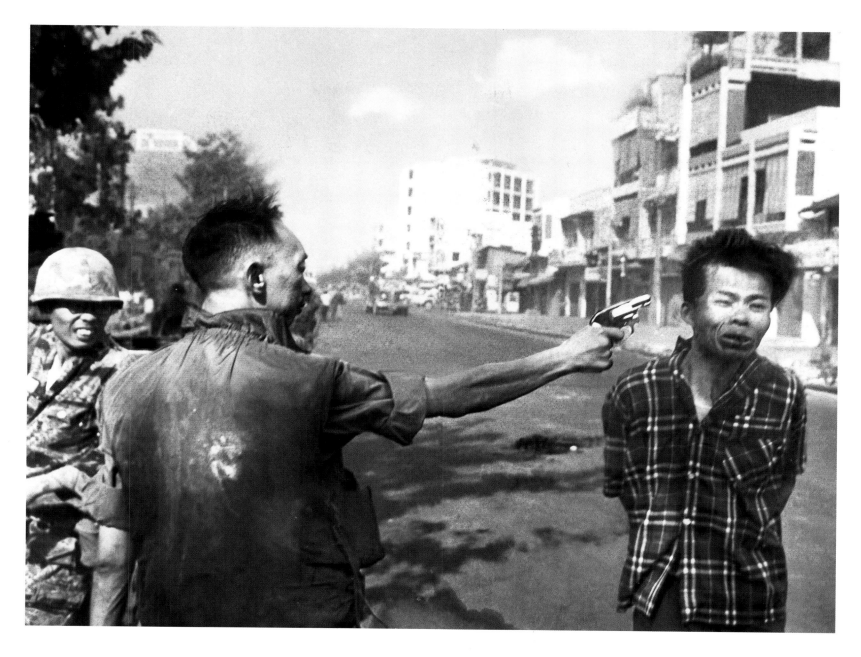

Vietnamese marines and the debris from that battle littered the street, but not much more. They were about to depart when they heard shots a block or so away. Adams recalled that it sounded like infiltrators exchanging fire with Vietnamese army soldiers. The two moved toward the action.

Adams watched as two Vietnamese soldiers pulled a prisoner out of a doorway at the end of a street. The soldiers pushed and pulled what appeared to be a Vietcong infiltrator in a plaid shirt, his arms tied behind his back. They escorted the man toward the spot where Adams and Vo Su were located.

Eddie recalls that it looked like a typical New York City situation of policemen leading crime suspects before the press—called a "perp walk"—and he covered it that way. "I just followed the three of them as they walked toward us, making an occasional picture. When they were close—maybe five feet away—the soldiers stopped and backed away. I saw a man walk into my camera viewfinder from the left. He took a pistol out of his holster and raised it."

Even now, many years later, Adams pauses when he tells the story. He shakes his head in surprise, his eyes open a bit wider, and there is a slight shrug of astonishment. "I had no idea he would shoot. It was common to hold a pistol to the head of prisoners during questioning. So I prepared to make that picture— the threat, the interrogation. But that didn't happen. The man just pulled a pistol out of his holster, raised it to the VC's head and shot him in the temple. I made a picture at the same time."

The prisoner fell to the pavement, blood gushing from his head. Eddie made a shot or two of the man falling but then couldn't take any more and began to leave. The shooter, later identified as Lt. Col. Nguyen Loan, police chief of South Vietnam, walked up to Adams and said, "They killed many of my people, and yours, too."

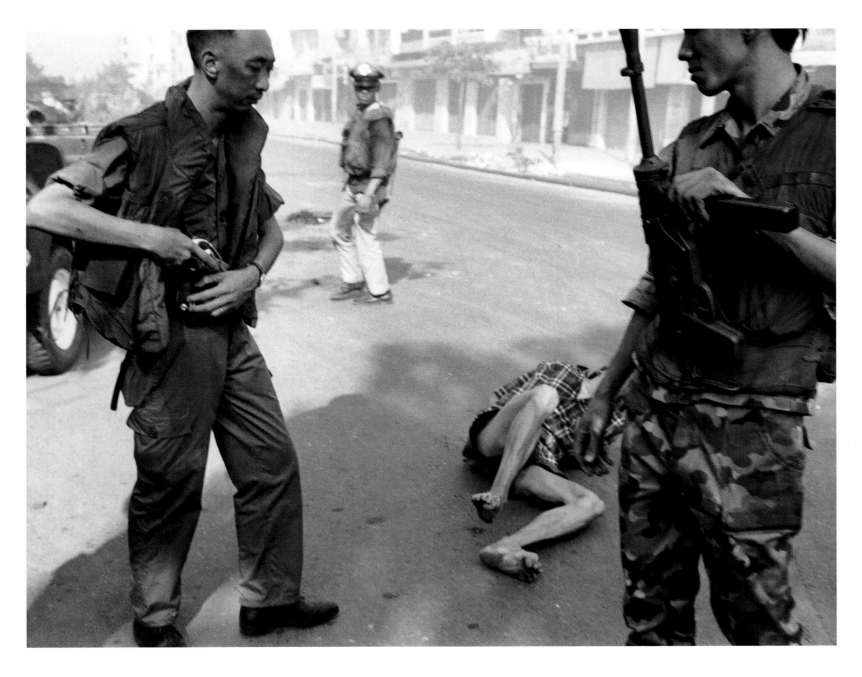

TECHNICAL DETAILS **CAMERA** Nikon
FILM Kodak
LENS 35 mm
SHUTTER & APERTURE 1/500th @ f 11

Adams comments, "And that's all he said. He just
walked away."

Back in the office, Adams turned in his film and went to his
hotel room, exhausted emotionally and upset by the incident. The
pictures, the full sequence of the incident, were sent to the world
by radiophoto.

The photograph was a sensation. It became a political state-
ment and was printed and reprinted, appearing on placards at anti-
war demonstrations. Antiwar advocates used it as an example of the

kind of allies the United States had in Vietnam. One writer
described it as, "The shot not *heard* 'round the world, but *seen*
'round the world."

Loan was later promoted to Brigadier General, but the picture
plagued him the remainder of his life. He and Adams, in fact,
came to know each other later in the war, after Loan was wounded.
Loan told Adams that his wife said he was foolish not to confiscate
the film. But Loan never criticized Adams for the picture, saying
that if he hadn't taken it, someone else would have. At war's end,
Loan left Vietnam and took up residence in Virginia, where he ran a
restaurant that eventually failed. Adams visited Loan at his busi-
ness and, in the bathroom, saw inscribed on the wall, "We know
who you are." Loan died of cancer in 1998.

Adams does not talk much about the picture, but he admits
that it haunts him even now, decades later. "Two men died that

day," he says, "the VC and Loan. Sometimes a picture can be misleading. Sometimes it does not tell the whole story. Many Vietnamese held great affection for Loan. He was not all that bad a guy. I don't say what he did was right, but he was fighting a war and he was up against some pretty bad people. Sometimes we tend to forget what the VC did to a lot of innocent citizens. I think of that sign in his restaurant, and I say to myself that I caused that sign to be there."

In addition to a Pulitzer, the photograph won a host of other awards. Adams appreciates the award, but he wishes he had won a Pulitzer for his other photography, for the more stylized, carefully made journalistic photography for which he was well-known before he covered Vietnam.

In later years, Adams turned to freelance work, and produced photojournalistic stories and countless covers for magazines. He is the founder of The Eddie Adams Workshop, a four-day annual class for young photographers. At his farm in upstate New York, where the workshop is held, the group spends thirty minutes at a ceremony around a huge boulder, on which are inscribed the names of six photographers—close friends of Adams—killed in Vietnam. Wind whispers through a nearby stand of trees that were specially planted as a living monument to all the photographers who died covering the war. Like so many of the photographers and writers who covered Vietnam, Adams shares a special bond with those who survived as well as those who perished.

Adams's picture remains an icon, one of the century's most famous war photos; but it was not the last memorable picture from Vietnam. More would come as the conflict continued.

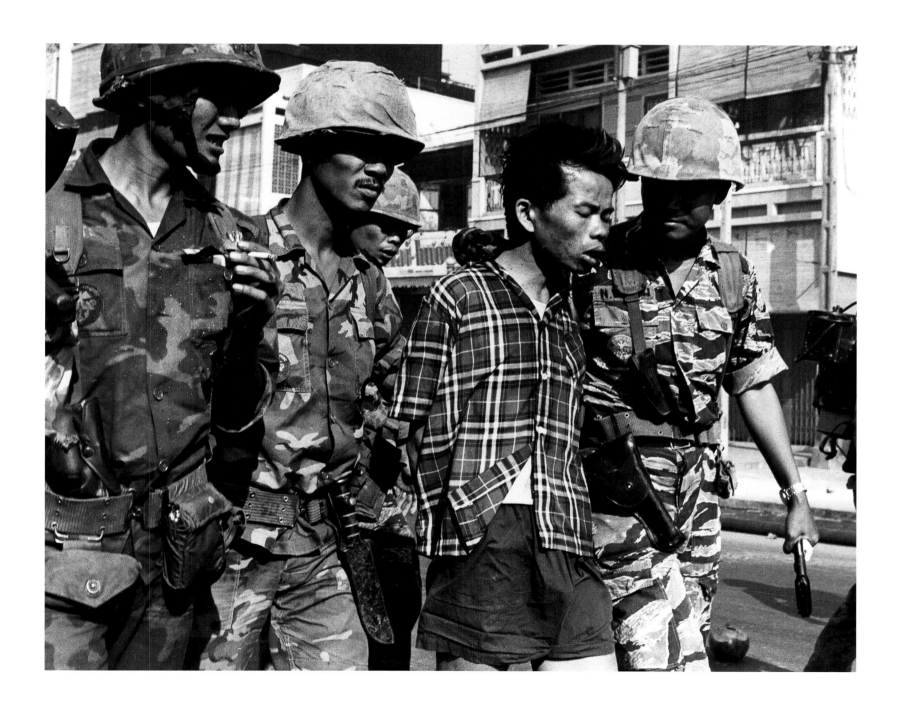

Portrait of Dignity

BY MONETA SLEET, *EBONY* MAGAZINE

1968 was a bad year, and news photographers recorded each tragic incident. The Tet offensive was launched in Vietnam. Bobby Kennedy was assassinated. Students rioted at the political convention in Chicago. The Russians put down revolution in Czechoslovakia. And Reverend Martin Luther King Jr. was assassinated by a sniper as he stood with aides on the balcony of a Memphis motel. The man of nonviolence was gunned down violently as he sought to support poorly paid striking workers in the Tennessee city.

King's funeral service was held at the Ebenezer Baptist Church in Atlanta. It was his church; it held the pulpit from which he preached his message of brotherhood and of quiet, disciplined disobedience of laws that he believed violated human rights.

The funeral was intended to be simple. A wagon carrying his coffin would be pulled by a donkey as it was moved from place to place in the city. The ceremonies would be short. But simplicity is hard to maintain at events like this. The mourners were, of course, his regular congregation; but others attending included Hubert Humphrey, Robert Kennedy, Jacqueline Kennedy. And there were others—Supreme Court Justices, Senators, United Nations officials. In addition, thousands of ordinary people had come to Atlanta to pay their respects to King.

Moneta Sleet, a veteran photographer for *Ebony,* considered the *Life* magazine of the black community, was assigned to the story. He had covered King's encounters on the civil rights journey and was active in the movement himself. He knew the players.

There was tension in the air, Sleet recalled later, "The murderer was still being sought, and the church was guarded against attack by the white state troopers King and his people had confronted over the years."

The streets of Atlanta were jammed with mourners, media, and the curious. No one knew what to expect. A spark could set something off. Press coverage was extensive, but Sleet had been given a pool position inside the church; one of the few photographers so accredited. His pictures would be available to anyone who wanted them, and the wire services would distribute them around the world.

When Sleet took up his position inside the church, he saw Coretta Scott King dressed in black, with a thin black veil covering, but not hiding, her classic features. One of her four children, Bernice, sat close to her, the child's head snuggled in her protective maternal embrace.

Quietly, as unobtrusively as possible, Sleet stepped forward and made the picture, a study of the Madonna-like dignity of King's grieving widow and child. There were many other photos made that day of the street procession, the dignitaries, and the eulogists at the church, but it was Sleet's picture that captured the spirit of strength that would continue into the future, despite the immediate setback of a fallen leader. The civil rights cause would stay alive.

Although Sleet was a magazine photographer, the wide distribution and publication of his photograph in newspapers qualified the image for a Pulitzer Prize. He became the first African-American photographer to win a Pulitzer. Sleet himself continued photograph-

JUNE 1968 ■ *Sirhan Sirhan assassinates Presidential-hopeful Robert Kennedy as he leaves a California hotel.*

AUGUST ■ *The U.S.S.R. invades Czechoslovakia*

OCTOBER ■ *At the Olympics in Mexico, American sprinters Tommie Smith and John Carlos are suspended for using the ceremony as a forum for a Black Power protest.*

NOVEMBER ■ *Republican Richard M. Nixon wins the presidential election over Democrat Hubert Humphrey by a margin of 0.4 percent of the popular vote.*

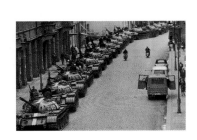

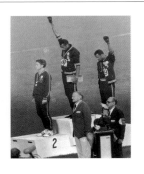

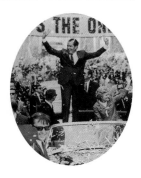

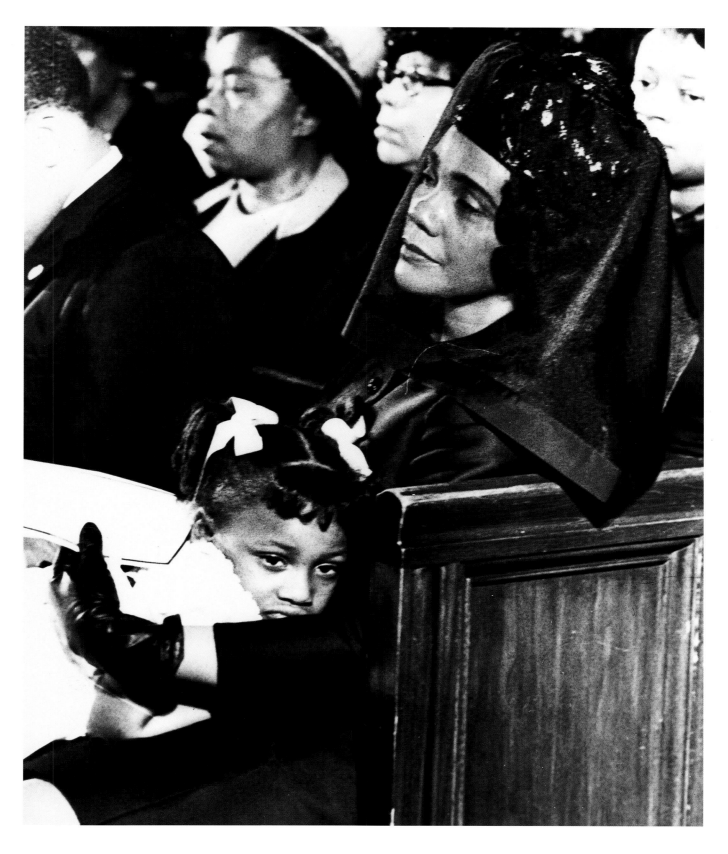

ing, covering the world's black leaders for *Ebony.* He died in 1996, at the age of seventy-three, but his photographs were gathered and published in a book titled *Special Moments in African-American History: 1955-1996.* Ebony's publisher, Johnson Publishing Co. issued the work, which remains a testament of Sleet's dedication to covering a critical period in African-American history.

TECHNICAL DETAILS

CAMERA Nikon
FILM Kodak
LENS Unknown
SHUTTER & APERTURE Unkown

A New Kind of Pulitzer:
The Picture Story

Until 1970, the Pulitzer Prize for photography was awarded to a single photo of a single, specific moment in time. Sometimes there were other pictures available that supported the single outstanding photograph, but it was the lone picture that represented the award. In 1968 a feature category was established, providing the opportunity to present a Pulitzer to a different kind of photograph, or series of photographs, appearing in newspapers. These photos were images of quieter impact, pictures that showed and told readers about stories that, though they did not make headlines on the front page, nevertheless were a significant part of the reader's world. The feature category honored a so-called "softer" photograph, but one no less significant. Yoshio Sakai's picture of GIs in the rain in Vietnam (page 76) was the first winner in the new category; it reflects an insight into a war where the fury of battle was so well documented.

The feature category moved even further afield from hard-core news. It took note of photographers who pursued picture coverage of stories that were more social documentation than breaking news events, but still stories of significance told through arresting photographs. The picture stories, when viewed as a group, reported more to the reader than they would have individually.

In 1970, Dallas Kinney, of the *West Palm Beach (Florida) Post* received the first Pulitzer given for this new kind of photojournalism. In 1971, Jack Dykinga's award-winning pictures in the *Chicago Sun-Times* told his story from a perspective similar to Kinney's, though with different subject matter. Their pictures represented fine photography directed not at a specific news event, but at a subject or story that needed telling.

Kinney took his camera to the back roads of America's farmland, where migrant workers toiled day to day, moving from state to

state to gather the harvest (pages 88-91). Many of his pictures are graphic, artistically strong images. His portfolio is a classic case in which the total is greater than the sum of the parts. Each photo in the story offered a new bit of information about those who follow the ripening crop and work for a pittance just to survive.

Dykinga used photographs to explore an institution for the mentally retarded (page 95). His picture story was a frightening guided tour that portrayed the loneliness and desperation of unfortunate individuals living in what he called "a warehouse for people."

Like many Pulitzer photos before them, these were not easy images to view. They were crusading pictures of the kind that recalled the work of photographer Jacob Riis, who photographed the disenchanted poor in the early twentieth century. The smaller camera used by Kinney and Dykinga and others who followed them had lens capabilities that, combined with the new faster films,

enabled them to portray a dimension of reality that earlier photographers could not attain. And the newly inaugurated Pulitzer Feature award gave recognition to this kind of photography.

The single great iconic picture—the lasting, memorable photo—did not, would not, and should not disappear from the Pulitzer collection. That kind of photo will always be a substantive part of daily picture journalism. But editors and photographers recognized in the extended picture story an added dimension of photography that was useful for informing readers of the world around them. This photojournalism was intended not to deny the great compelling news picture, but to open yet another portal for the newspaper photographer.

Within the next decade newspaper photographers would reach out not just to their communities, but to the more remote corners of the world with their cameras.

Guns on Campus

BY STEVE STARR, ASSOCIATED PRESS

In the late 1960s, activist students at colleges and universities across the nation adopted tactics such as campus demonstrations, sit-ins, riots, and office seizures to get their message across to the establishment. That message was that there was too much war, too much racism, too many poor, too close a tie between schools and government. To many Americans, it seemed like both the list of grievances and the conflict went on and on.

Steve Starr was the Associated Press photographer based in Albany, New York. Ithaca, the home of Cornell University, was his beat; so in April 1969, when he heard about trouble brewing there, Starr headed for the campus.

For some years, Cornell had actively recruited ghetto blacks, and it was close to setting up a black studies program. The university had established one dormitory exclusively for black women students. The black students wanted more, however. They sought amnesty for seven black students who had torn apart the administration building several months earlier, and they wanted the black studies program to be a separate college run by blacks. The Cornell president refused. Then a cross was burned in front of the black dorm.

Saturday, April 19, was the first day of Parent's Weekend. University President James A. Perkins had prepared a speech titled "The Stability of the University," but in the early morning hours, a group of black students took over the Student Union, rousting par-

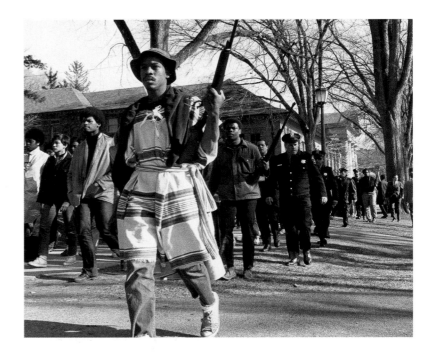

TECHNICAL DETAILS **CAMERA** Nikon
FILM Kodak
LENS 28 mm
SHUTTER & APERTURE Unknown shutter @ f2.8

FEBRUARY 1969 ■ *Palestinian terror groups unite under the umbrella of the Palestinian Liberation Organization, choosing Yasir Arafat as their leader.*

MARCH ■ *U.S. B-52 bombers secretly attack Communist bases in Cambodia.*

MARCH ■ *Golda Meir, formerly a schoolteacher in Wisconsin, is sworn in as Israel's fourth Premier.*

JULY ■ *The world holds its breath and the United States takes the lead in the space race as Neil Armstrong becomes the first man to step foot on the moon.*

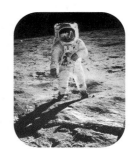

ents staying there and sending them packing. The students intend-ed to hold the building until their demands were met.

When Starr heard about the student takeover he headed for Ithaca. Once on the campus, he sized up the situation and con-cluded it would be an all-night event.

Starr recalled, "The next morning, rumors spread that the black students were armed. There were rumors about guns, but they were about armed whites taking over the Union. I thought I saw a guy in a window with what I thought looked like a gun, but before I could get my camera up he moved away." Starr knew that never before had students with guns taken over any U.S. campus, and if that were the case at Cornell, it would be an historic event.

After thirty-four hours, Perkins, who had long since cancelled his speech, granted amnesty to all the students involved in the incident. The university public relations staff, which up to that

point had not released any useful information, told the media that the students would vacate the union momentarily. Starr moved to a position where he thought he would have a clear view of whatever might happen.

The door of the Student Union opened, and the black students walked out, armed to the teeth. Starr recalls, "There was a silence—a hushed silence. I felt a cold chill. The blacks came out with all these rifles, shotguns, knives, bandoliers."

As Starr shot his pictures, he knew he had historical material, but he was worried that students would start throwing rocks, or that the armed students would begin shooting. That didn't happen; the atmosphere remained tense, but there was no bloodshed.

The black students later said they had heard that other stu-dents on the campus were armed and that they feared for their lives. That was why they had smuggled the guns into the Union.

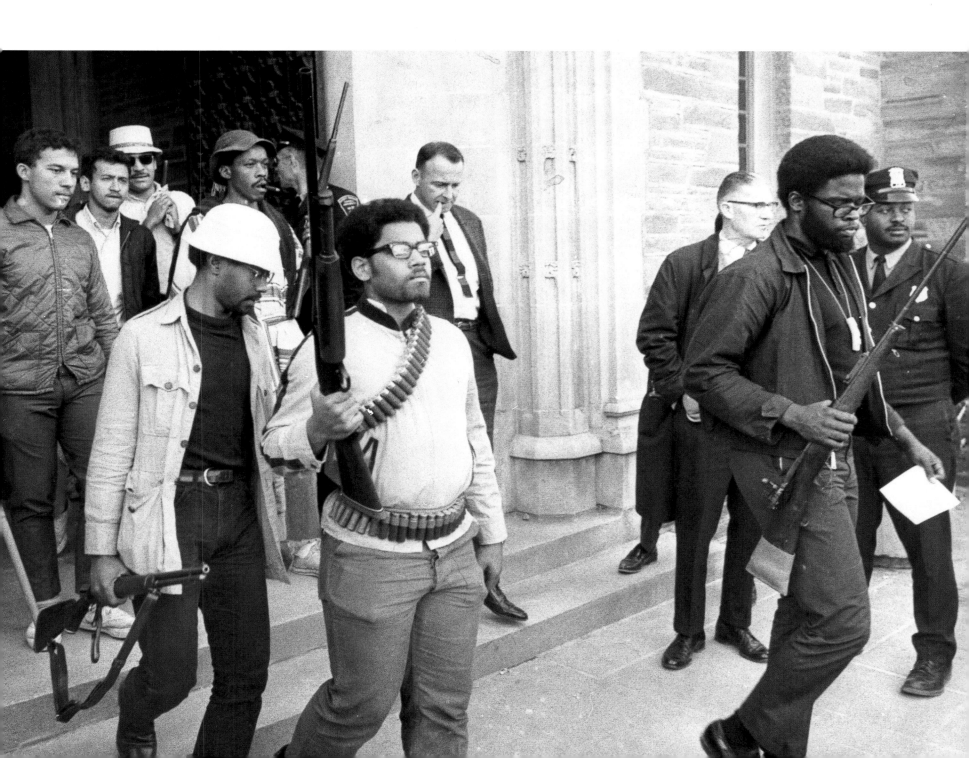

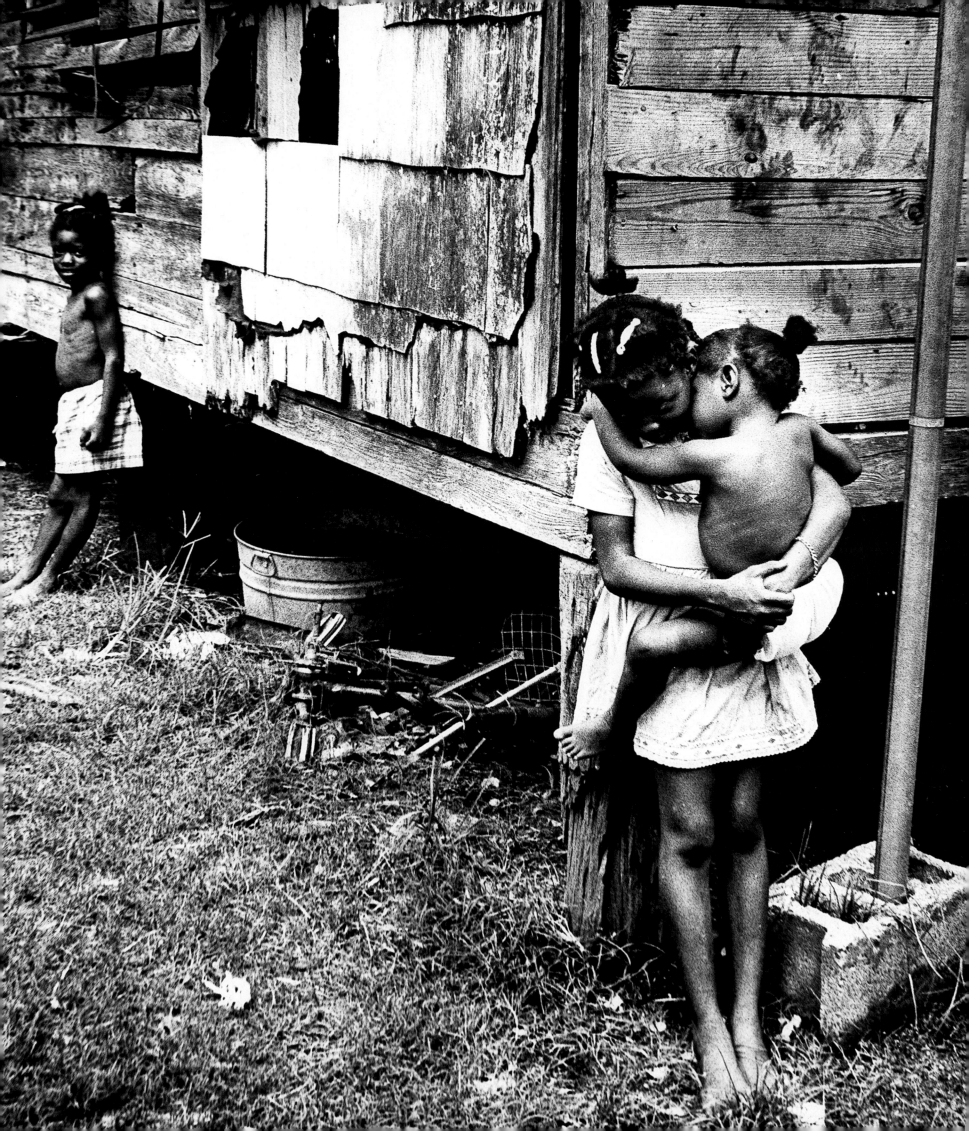

The Migrant's Stream

BY DALLAS KINNEY, THE *PALM BEACH (FLORIDA) POST*

Migrant workers start in the south in January each year and, with the predictability of the seasons, follow the ripening crops north. First they pick and load fruit in Florida, then move on to the truck farms of the mid-Atlantic states. By the time they reach New Jersey, the vegetables there are ready for harvest, and that work is followed by harvesting in New England. This annual trek of backbreaking labor delivers a bountiful harvest to the dinner tables of America.

In the late 1960s, the workers—most of them African-Americans who knew no life but to toil in the fields—fared poorly. They were victims of a complex agrarian society that put them at the bottom of a hierarchy and paid them only a few dollars a day for hours of stoop labor.

Dallas Kinney, a *Palm Beach Post* photographer, thought that his paper should tell the story of the Palm Beach County migrant workers forthrightly, strongly, and in graphic detail, but he knew he would have to convince his editors.

"I was an Iowa farm boy," Kinney recalls, "and I knew what harvest labor was like. The migrants were at it all the time as

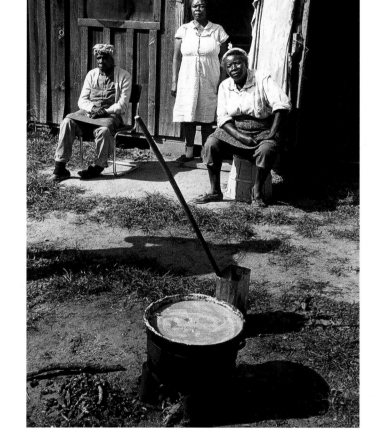

TECHNICAL DETAILS	**CAMERA** Leica and Nikon
	FILM Kodak
	LENS Various, from 20 mm to 200 mm
	SHUTTER & APERTURE Various

JULY 1969 ■ *Mary Jo Kopechne is killed when the car she's a passenger in, driven by Senator Edward Kennedy, crashes off of a bridge into water.*

AUGUST ■ *Woodstock Music & Art Fair brings together 300,000 people, epitomizing the spirit of love and sharing for which the era would become famous.*

AUGUST ■ *Actress Sharon Tate and four others are murdered in her Los Angeles home. Charles Manson is convicted of the crime.*

SEPTEMBER ■ *After fifteen years as president, North Vietnamese leader Ho Chi Minh dies at age seventy-nine.*

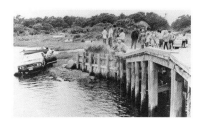
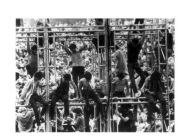

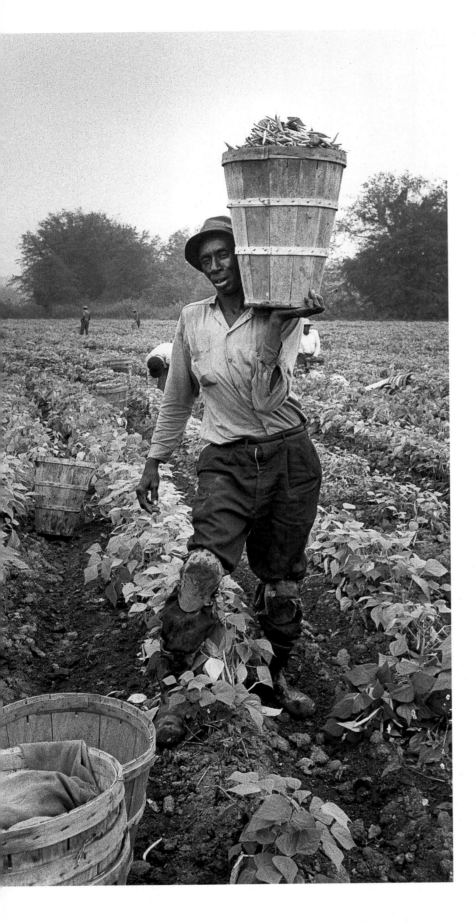

they followed the harvest stream northward. They were poorly paid, ill with serious diseases that were crippling, and with little education for the kids who moved constantly with the family. And they were seldom seen, kind of hidden in the back roads of the countryside."

Kinney and the reporter who would write the story told their editors that they would take them to lunch to explain their proposal. Lunch turned out to be a sandwich at a migrant labor camp, where Kinney showed the editors how the migrants lived in tar-paper shacks and how kids played in the dusty lanes between hovels.

"They got the point," Kinney says, and the paper backed the story to the hilt.

The first pictures were shot in color, and it was expected that the pictures would be printed that way; but Kinney decided to throw away his early days of work. "Color," he said, "made it look too pretty. I switched to black and white and started over."

Kinney printed the first set of pictures and pasted them up in the editor's office one evening. The next morning, when Kinney's editor walked into the room, he was more convinced than ever that the pictures should be displayed dramatically in the paper.

The *Post* published a series of stories, each of which was introduced with a large picture on the front page followed by more pictures and text inside. The *Post's* affluent Palm Beach readership clearly and dramatically saw a side of the community that was seldom, if ever, presented so forcefully.

Kinney's picture series was the first of its kind in Pulitzer history. It represented an approach to photojournalism in which the photographer sought out a continuing story and documented it through an expansive presentation over several days. That a photographer such as Kinney would envision that kind of project was perhaps a natural reaction to the establishment of a Pulitzer feature photography award in 1968. Other stories using this approach would win Pulitzers in future years.

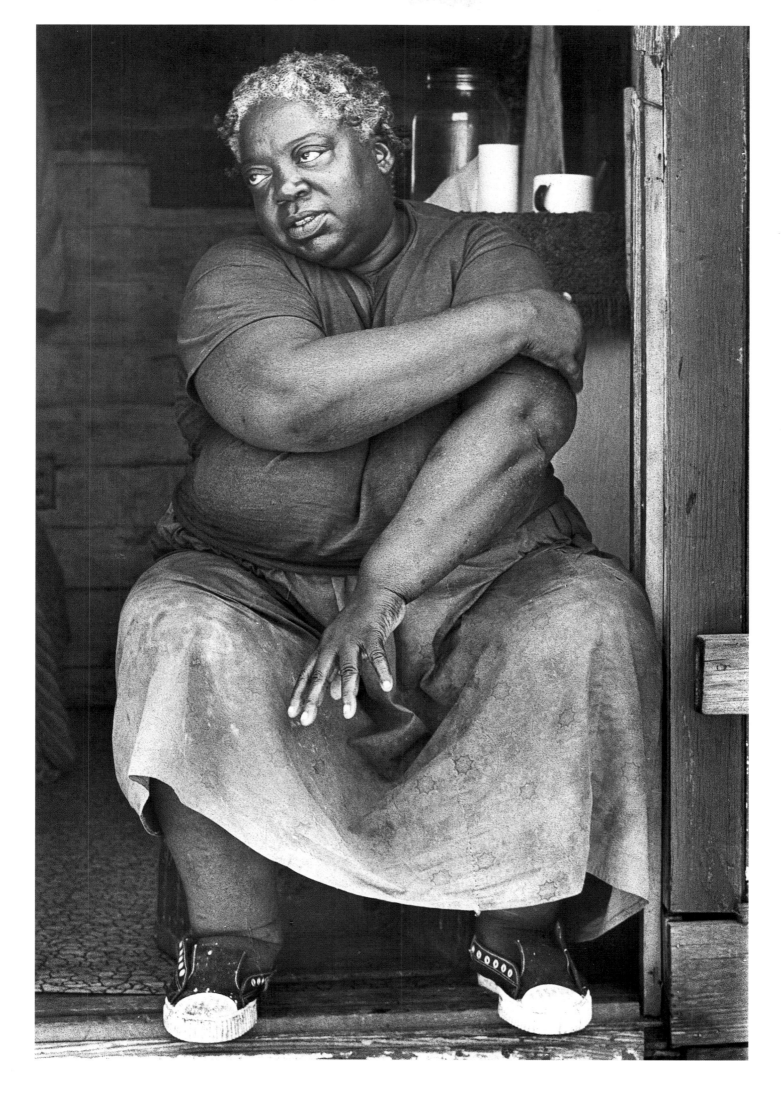

Death on the Campus

BY JOHN FILO, FREELANCE

It is difficult to say what began the inevitable movement toward death on Ohio's Kent State University campus on May 4, 1970; but the events of that day, and a single photograph documenting them, had a lasting impact on the nation. The declaration by President Nixon on April 30 that U.S. forces would enter Cambodia to deny sanctuary to those who attacked American troops led to violent student demonstrations that closed seventy-five universities before the end of the academic year. At Kent State that weekend, police had used tear gas to disperse rowdy students after a beer bust in a downtown bar, and demonstrations at the campus ROTC building had ended with the building ablaze, firemen attacked with rocks, and the National Guard called in. Guardsmen in helmets and black gas masks battled with students on Sunday night, arresting 150.

When the bell in the university tower rang at midday on Monday, May 4, twenty-one-year-old journalist student John Filo, who was working as a photo-lab tech in Taylor Hall, the journalism building, grabbed a camera and film and left the building to photograph a student rally that had been planned for noon.

What Filo found on the lush, green, leafy campus was a gathering of a thousand protesting students, a rally the National Guard attempted to disperse. As Filo came upon the scene, the guardsmen had formed two skirmish lines; the students were throwing rocks, and the guardsmen were returning fire with tear gas. Filo photographed both sides of the confrontation, moving from students to guardsmen. One group of soldiers started to back up a hill, and the students advanced toward them. Their rocks fell short, but the students were moving closer.

At the crest of the hill, Filo recalls, the troops stopped, dropped to one knee, and opened fire. Filo was sure the shots were blanks, fired to intimidate the students; but then, in his viewfinder, he saw a bullet hit a metal sculpture, pass through it, and smack into a tree. Several students fell before the gunfire, dead or wounded; others dove to the ground to avoid danger. Filo realized that the troops had fired live ammunition, and that he was the only one standing as he photographed the scene. He later wondered how he had escaped injury when so many others were wounded.

When the shooting stopped, Filo decided to move out of the area; but as he turned to depart, he saw the body of Jeffrey Miller some few feet away. Miller had been hit in the neck, and in just a few moments, a large pool of blood formed. A young girl ran toward the body.

Filo recalls, "The girl came up and knelt over the body and let out a God-awful scream. That made me hit the shutter button—it was instinct, a reflex action. Just one frame." Only three frames remained on his roll, but he knew he had a picture that documented the terrible events at Kent State.

His memory of the remainder of the day is that of the fear he felt—fear that the film would somehow be taken from him, that he

APRIL 1970 ■ *Paul McCartney leaves the Beatles, thereby splitting up the famed group.*

JUNE ■ *Famed actor Laurence Olivier is named Lord Olivier of Brighton by Queen Elizabeth II.*

SEPTEMBER ■ *Egypt's President Nasser dies at age fifty-two. Anwar el-Sadat is elected as his successor.*

OCTOBER ■ *Janis Joplin dies of a drug overdose.*

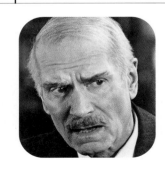

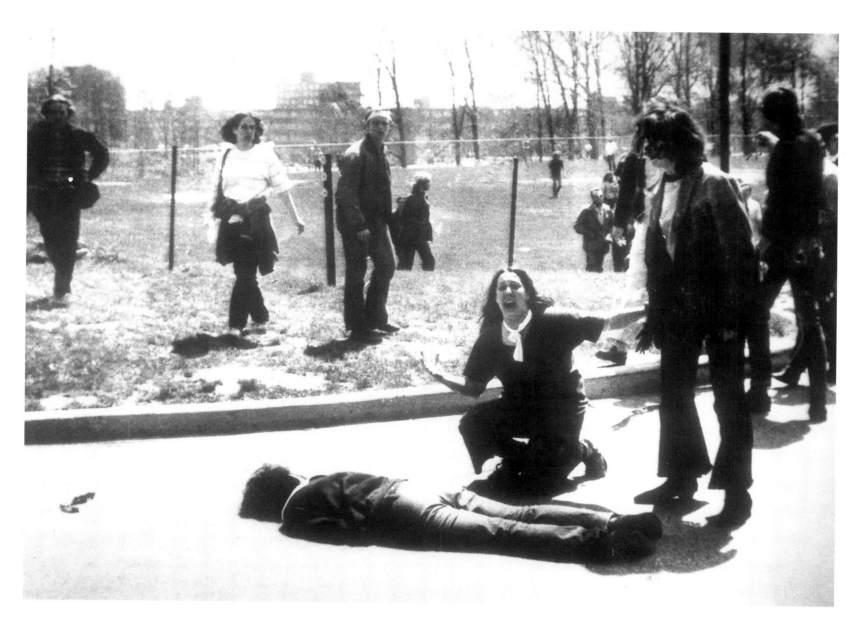

had missed the picture, that a coverup would emerge and his picture would be involved. He made his way to the *Valley Daily News*, a newspaper in Tarentum, Pennsylvania, where he worked as an intern. From there the picture was transmitted to the world via Associated Press.

Initially, some people disbelieved the picture, convinced that it was somehow faked. These critics asked about the girl being in just the right spot, about the way the student's body lay on the sidewalk, about the way the blood flowed in a straight, even path away from the body. The caption originally given to the picture read, "Coed Screams," but it turned out that the girl was a fourteen-year-old Florida runaway who was on the campus because she was curious. The unfortunate use of the word *coed* encouraged critics to attack the picture's credibility.

Nevertheless, the photo quickly became an icon, that special kind of picture that somehow sums up a greater series of events. The criticism of the picture's credibility was soon brushed aside as the death toll—four students dead and five seriously wounded—became known. Filo's picture joined the collection of photographic icons that forever would be part of the history of the Vietnam War,

TECHNICAL DETAILS
CAMERA Nikormat
FILM Kodak
LENSES Zoom lens, 43 mm to 86 mm
SHUTTER & APERTURE Unknown

that are symbolic of the war fought on American streets as well as that in the Asian countryside.

Filo was presented the news photography Pulitzer Prize for 1971, and he later joined Associated Press. He also worked for the *Philadelphia Inquirer, Newsweek,* the *Camden (New Jersey) Courier* and on the photo staff of CBS television.

The girl, Mary Ann Vecchio, was reunited with her parents because of the picture, but she has said that the photo brought her publicity she did not want. It astounded her that critics of the student demonstrations reviled her because she appeared in the photo. She eventually settled in Las Vegas and married. She and Filo did not see each other until twenty-five years later, when they met once again at an educational conference in Boston.

A Warehouse for People

BY JACK DYKINGA, THE *CHICAGO SUN-TIMES*

Jack Dykinga received one of the earliest of the Pulitzer Prizes to be awarded for images that documented a social issue, as opposed to a news event. The photos he made at the Lincoln and Dixon State Schools for the mentally retarded near Chicago were at once artistic and terrifying, and they shocked Chicagoans.

Dykinga's purpose in visiting the schools—which he called warehouses for unfortunates—was to highlight the effect a proposed reduction of state funding would have on what little care these institutions provided.

The impact of the scenes he encountered was so strong that Dykinga was unable to use his camera during the first hours of his visit to the so-called "cottages," which were actually more like hospital wards.

"I just watched. I was overwhelmed by the horror of it," he said later.

His report described overwhelming odors, retarded children and adults smeared with feces, and beds wet from urine. He talked of severely overworked staff members; the four aides, for example, who attended one hundred patients were forced to feed the retarded much too quickly just in order to get around to them all.

Dykinga brought to the assignment a fine eye for composition and detail and a graphic simplicity that enhanced the drama of the photos and the story. The result of the photos' publication in the *Sun-Times* was that funding was extended at its then-current rate. More importantly, Dykinga's pictures sensitized legislators to the desperate, loveless existence the mentally handicapped endured in the schools.

After he won the Pulitzer, Dykinga moved to the Southwest and turned his pictorialist's eye on the environment. He quickly established himself as one of the nation's most prominent landscape photographers, coupling his photographer's eye with the journalist's perspective of environmental reporting. He lectured widely and produced several books; one entitled *Stone Canyon* was influential in the federal government's decision to make the area he photographed a national monument.

NOVEMBER 1970 ■ *Chilean president Salvador Allende Gossens is the first Marxist to be elected head of a government in the Western Hemisphere by a democratic majority.*

NOVEMBER ■ *Charles de Gaulle, the controversial French leader who represented France like no other, dies.*

DECEMBER ■ *The north tower of the World Trade Center is topped out, making it the world's tallest building at 1,350 feet.*

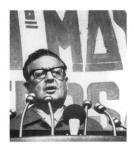

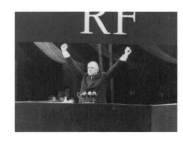

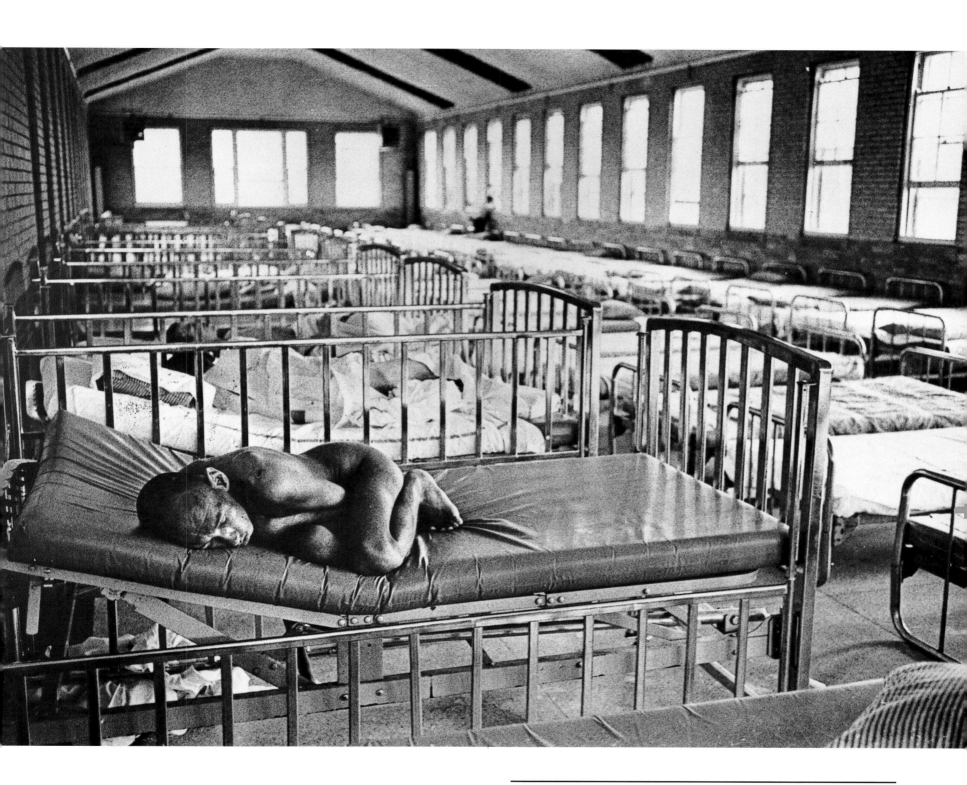

TECHNICAL DETAILS **CAMERA** Leica and Nikon
FILM Kodak
LENS Various
SHUTTER & APERTURE Various

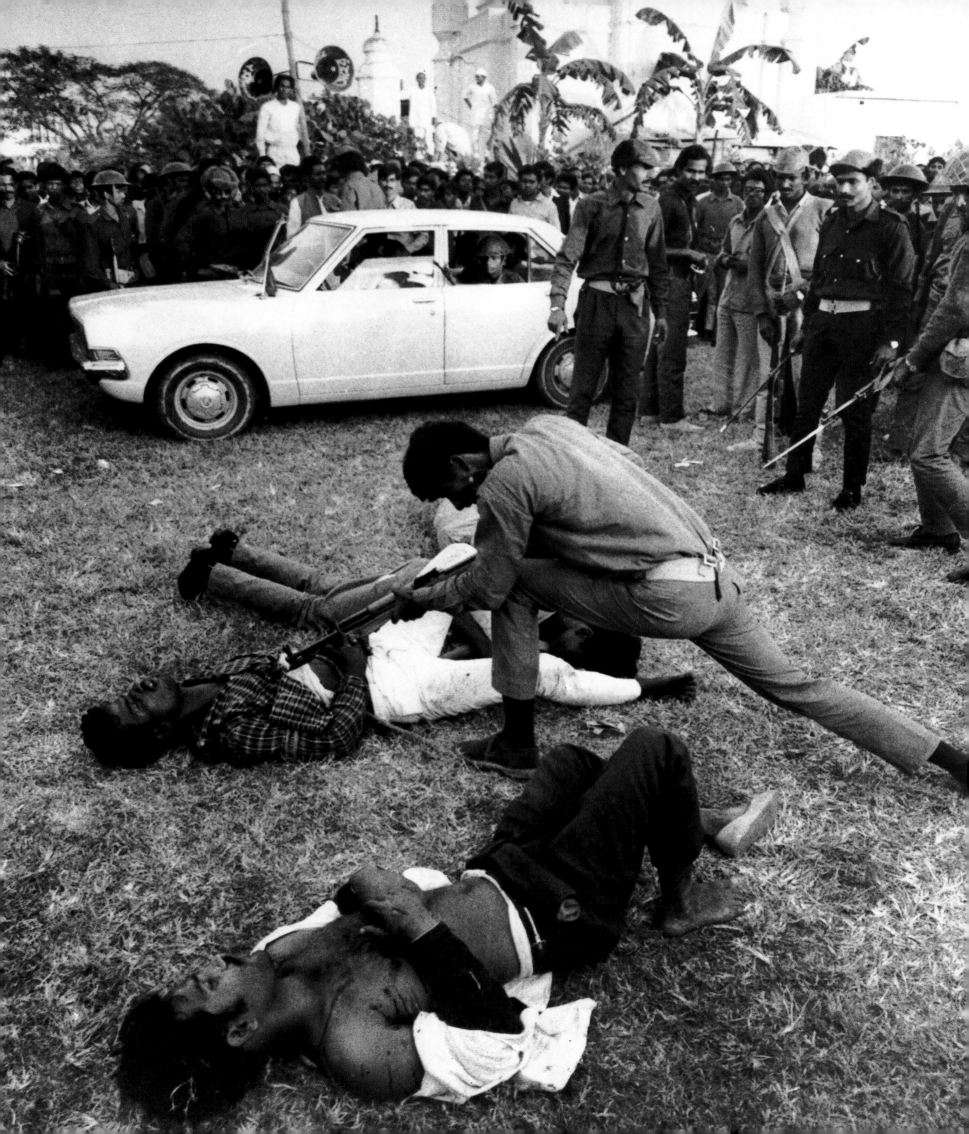

Revenge at the Racetrack

BY HORST FAAS AND MICHEL LAURENT, ASSOCIATED PRESS

December evenings, cooled and refreshed by breezes that temper the day's sun, are pleasant on the Indian subcontinent, but on the night of December 18, 1971, Horst Faas and his Associated Press colleague Michel Laurent were far from comfortable. The two men, veterans of many years covering Vietnam, were not strangers to violence and death, but the night of revenge they photographed at the racetrack in Dacca, Bangladesh, had shaken them as much as anything Vietnam's fury had ever offered.

The history that leads to that night is confusing, blurred by the cultural, historical, and political fabric woven tightly across the region. The end of British colonial rule in India in 1947 left behind a strange geography. India was created as a state, as was Pakistan; but Pakistan was separated into eastern and western sections, with a thousand-mile stretch of India separating them. Over the next several decades, major tensions grew between the two Pakistani regions. By March 1971, a secessionist group in East Pakistan wanted to call itself Bangladesh, declared independence, and was willing to go to war to make it so.

Faas and Laurent, based in Vietnam, were assigned to cover the story. Faas worked out of Calcutta, India; Laurent worked out of Dacca.

To prevent the announced secession, the federal government, based in West Pakistan, unleashed a reign of butchery in the

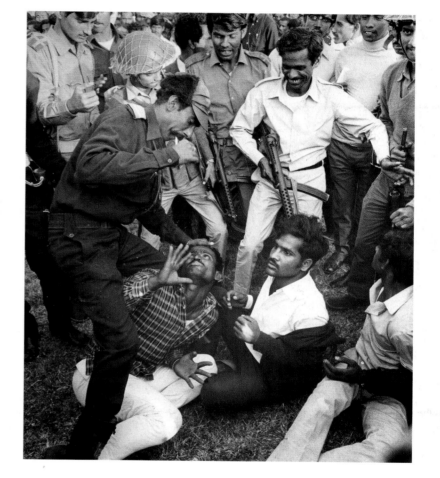

JANUARY 1971 ■ All in the Family *debuts, defying longstanding taboos against ethnic and bathroom humor on television.*

MARCH ■ *U.S. Army Lt. William Calley is convicted of killing twenty civilians at My Lai.*

APRIL ■ *Igor Stravinsky, one of the century's greatest composers, dies at eighty-eight.*

JUNE ■ *U.S. Supreme Court overturns attempts to stop the* New York Times *and* Washington Post *from publishing the* Pentagon Papers.

97

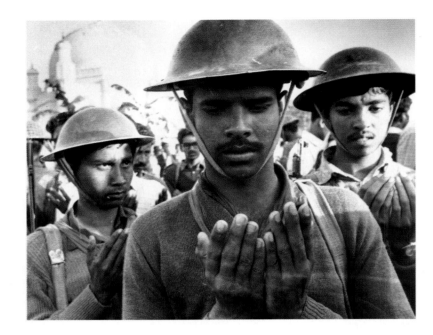

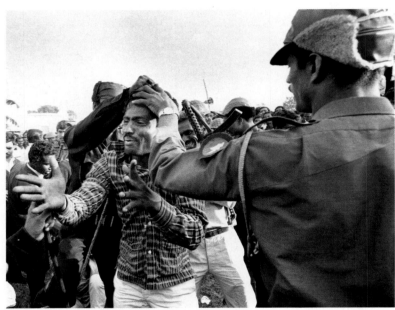

On December 18, an event billed as a rally to mark the beginning of the new nation was to be held at the Dacca Racetrack. When Faas arrived in Dacca that day, he could not locate Laurent, who was out photographing. Faas walked around the city looking for picture possibilities and visited the university. He recalls, "It was a bloody day, with random gangs killing a person here or there. There were many beatings."

In the afternoon, he decided to head for the Dacca Racetrack, where he found Laurent. A dais had been set up, and speakers sang

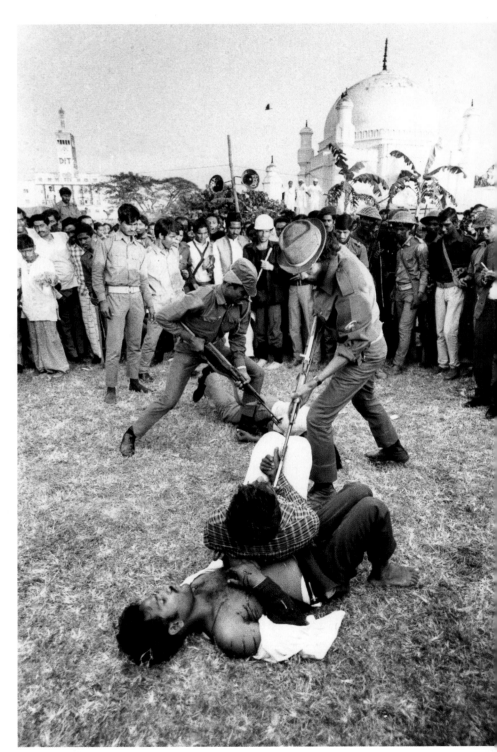

newly named Bangladesh and followed with military encounters that defeated the eastern forces. The violence was so severe that ten million refugees fled into India, leaving behind some one million slain. Victory for West Pakistan was short-lived, however, when India backed the eastern guerrilla movement known as Mukti Bahini. As the Indian troops drove toward Dacca, Horst Faas with them, stories emerged about the executions, torture, and brutality West Pakistanis had directed against the easterners, with the Pakistani military for the most part looking the other way. On December 17, the western side surrendered to the combined forces of the Indian army and the local guerrillas, and the new nation of Bangladesh was thereby ensured. There remained a bitter taste in Bangladesh over the recent merciless slaughter, however.

the praises of the new order. Faas and Laurent made pictures, sometimes of the crowd, sometimes of the new political leaders. They worked together, at times they separated.

Faas saw a large crowd of several thousand spectators standing by as Mukti Bahini guerrillas pushed four bound captives off the back of a truck into a cleared area. These prisoners were known as *razakars,* a kind of local militia that worked under the command of the West Pakistan government. They were accused of rape and murder.

Laurent joined Faas at the scene as the Bahinis tortured the bound prisoners by burning them with cigarettes. Faas twice asked them to stop, then he and Laurent moved away because they thought the event was being staged for the camera and hoped their departure would end the public brutality. No one noticed their leaving, however, and the torture continued. Faas and Laurent moved back, but stayed in the crowd and watched.

One of the political leaders stepped down from the dais and picked up a weapon with mounted bayonet. Faas and Laurent sensed something was about to happen, and they moved to the front of the crowd. The man with the bayonet calmly, carefully, and deliberately pushed the bayonet into one of the bound prisoners with an action that was meant to wound, not to kill. He then passed his weapon to a guerilla fighter, and the Bahinis used their weapons on all the prisoners—stabbing at them and plunging the bayonets into their bodies. Faas and Laurent maneuvered themselves back into the circle of spectators.

Faas recalls, "During the terrible torture, sweat ran down my face and my hands were trembling so much I couldn't change the film. When the bayoneting started, Michel was just as pale as the victims. It went on and on. The crowd cheered and took no notice of us. I hoped the men would die quickly, but it took almost an hour. Then the mob came in to finish the execution with their trampling feet. I hope and pray that no AP man has to see such horror again."

Suddenly members of the mob asked the two photographers what they were doing, so Faas and Laurent moved away. A couple of spectators chased them, but the effort was half-hearted. The two photographers dumped their film into a single bag and worked their way out of the area, fearful that their cameras would attract the attention of the executioners. They might be the next target of the already aroused crowd.

At 4 a.m., Faas used his Indian army accreditation to return to Calcutta, where he processed the film and took prints to the Indian communications center for transmission to London. Indian authorities in control of the communications facilities released some of the images—mostly the torture pictures—but they refused to permit transmission of the bayoneting pictures. The result was that the story was played out in the worldwide media for a much longer

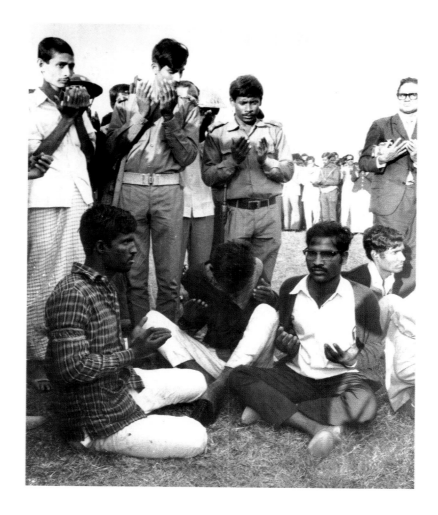

TECHNICAL DETAILS
CAMERA Leica
FILM Kodak
LENS Various, range from 21 mm to 200 mm
SHUTTER & APERTURE Various

period than it might have been. The written story was published first, and the pictures that were transmitted were printed a day later. Faas and Laurent sent their film and the censored photos to London by courier and the bayoneting pictures were ultimately transmitted to the world from there.

Although there was some criticism of the two photographers by people who felt their presence had encouraged the action, others said that the pictures generated international pressures that improved the treatment of the ethnic minority in Bangladesh.

Faas and Laurent returned to their duties in Vietnam. Faas soon left Asia for an AP assignment in London. Laurent was killed in Cambodia some three years later during the final stages of the Vietnamese war.

When the Pulitzer Prize for the Dacca racetrack photo was awarded to the two men, Faas became the first photographer to be honored with a second award. He had won for his Vietnam coverage in 1965.

The Scars of War

BY DAVID HUME KENNERLY, UNITED PRESS INTERNATIONAL

Dave Kennerly's Pulitzer picture from Vietnam was not the last of the awards for Vietnam photos, but it nevertheless captured the image of a war fought for more than ten years that everyone wanted out of; a war that left hideous scars on the landscape, on people, and on the nation; a war everyone knew had to end soon.

United Press International had entered a collection of Kennerly's pictures in the Pulitzer competition, but one had a special attraction for the Pulitzer committee because it spoke with telling imagery to issues being debated in the government and in the nation's streets at the time.

Kennerly made the picture in North Vietnam as he moved up a hill with an American unit. He photographed a single GI carefully approaching a Vietnamese emplacement. The soldier stood quietly amid trees shattered and stripped of their lush subtropic greenery by bombs and gunfire. Battle smoke drifted across the background. The battle-scarred landscape and the soldier's stance captured the essence of the way the Vietnam story was perceived in late 1971. The picture looked more like a classic World War II picture from Europe than a photo made in Vietnam.

The war would continue for several more years and more bloodshed was inevitable, even though fewer Americans would die or be wounded. President Richard Nixon called the process the Vietnamization of the war, and he ordered the American presence reduced. The air war continued, even intensified; but Americans started coming home. Soon POWs would be released.

Kennerly had worked for UPI since 1966, following several years on an Oregon newspaper. After winning the Pulitzer, he took an assignment with *Time* and shot scores of covers for the news magazines. He was appointed as the personal photographer of President Gerald Ford. During that tenure, still a journalist at heart, he released numerous "inside" pictures of the Ford administration at work and made it possible for many other photographers to spend time making pictures inside the government. He wrote a book about news photographers entitled *The Shooters*; he now lives in Hollywood, where he continues to cover stories for magazines and works in cinema.

TECHNICAL DETAILS **CAMERA** Nikon and Nikor
FILM Kodak
LENS Various
SHUTTER & APERTURE Various

JULY 1971 ▪ *Louis Armstrong dies.*

SEPTEMBER ▪ *Former Soviet leader Nikita Khrushchev dies.*

SEPTEMBER ▪ *More than 1,000 prisoners riot at the Attica State Correctional Facility.*

NOVEMBER ▪ *The People's Republic of China is formally admitted into the United Nations.*

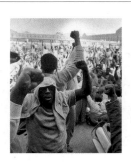

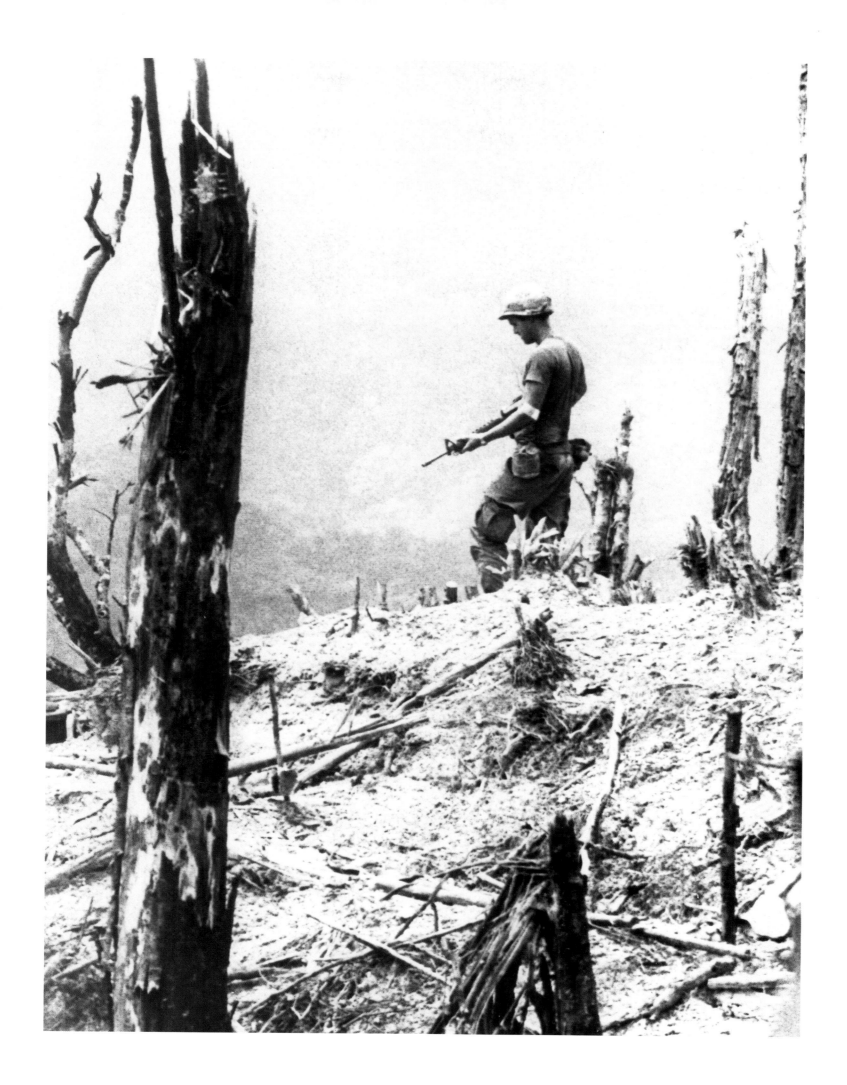

The Napalm Girl of Trangbang

BY NICK UT, ASSOCIATED PRESS

June in Saigon, as spring turns to summer in Southeast Asia, brings on a stifling, sweaty heat. On June 8, 1972, Nick Ut, a staff photographer at the Associated Press bureau there, swung his van out of its parking spot and, thankful for a few moments in the air conditioning, headed for Trangbang, twenty-five miles from the capital. South Vietnamese troops had fought for several days to eliminate a stubborn Vietcong unit from the village, which sat astride Route 1, the road that linked Saigon and the Cambodian capital of Phnom Penh.

In 1965, Ut's brother, also an AP staff photographer, had been wounded while covering the conflict. Awaiting evacuation, he was killed when Vietcong forces overran the South Vietnamese position. Nick, then a sixteen-year-old film messenger, thought it only natural that he should take up camera and cover his country's travail. First he took on simple assignments for AP, but as he grew older and smarter in the ways of battle, he moved deeper into the jungle and closer to the fury.

Ut parked his van some distance from Trangbang and walked toward the town. Other cameramen were also on the scene. A squadron of South Vietnamese planes appeared. They dove toward the Vietcong positions, and Ut photographed them as they dropped deadly napalm. But there had been a miscalculation, and the burning mass fell on friendly troops and civilians. From Ut's position on the highway the fiery explosion seemed close

enough to touch. He later said, "It was hot. I could feel the heat on my body—it was too close."

Almost immediately, people from the village ran screaming down the highway. One woman carried a badly burned child who died in her arms before she reached Ut. Running children appeared, including a naked young girl who had torn off her clothes to escape the fire.

Ut photographed her as she ran toward him. "Hot! Hot!," she cried in Vietnamese. Her back had been seared by the napalm jelly, and so Ut poured water from his canteen on her. Her father came to Ut and asked him to help. Nick and the father took the child to Ut's van, and he drove her to a hospital in Saigon before returning to his office.

At the bureau, a small debate occurred over the photograph. The girl was completely naked, no one would print it, one editor argued. Horst Faas, the two-time Pulitzer winner who had been in charge of AP picture coverage of the war for a decade, ordered the picture transmitted to New York, where it was agreed that the news value of the photograph overrode any reservations about nudity. It was immediately relayed to the world and became a defining photographic icon; it remains a symbol of the horror of war in general, and of the war in Vietnam in particular.

The story did not end there, however. Ut visited the girl the

JANUARY 1972 ■ *British troops shoot dead thirteen Roman Catholics in the "Bloody Sunday" riot at Londonderry.*

FEBRUARY ■ *President Nixon meets with Chairman Mao Tse-tung in China, signaling the end of America's long-standing hostilities with Beijing.*

MARCH ■ *The movie* The Godfather *is released, setting the standard for the generation of gangster movies to follow.*

MAY ■ *President Nixon meets with Soviet Communist Party leader Leonid Brezhnev, becoming the first U.S. president to visit a Soviet leader.*

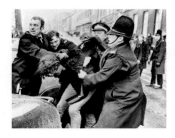

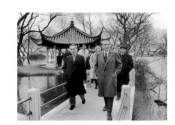

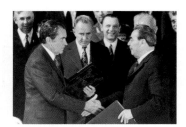

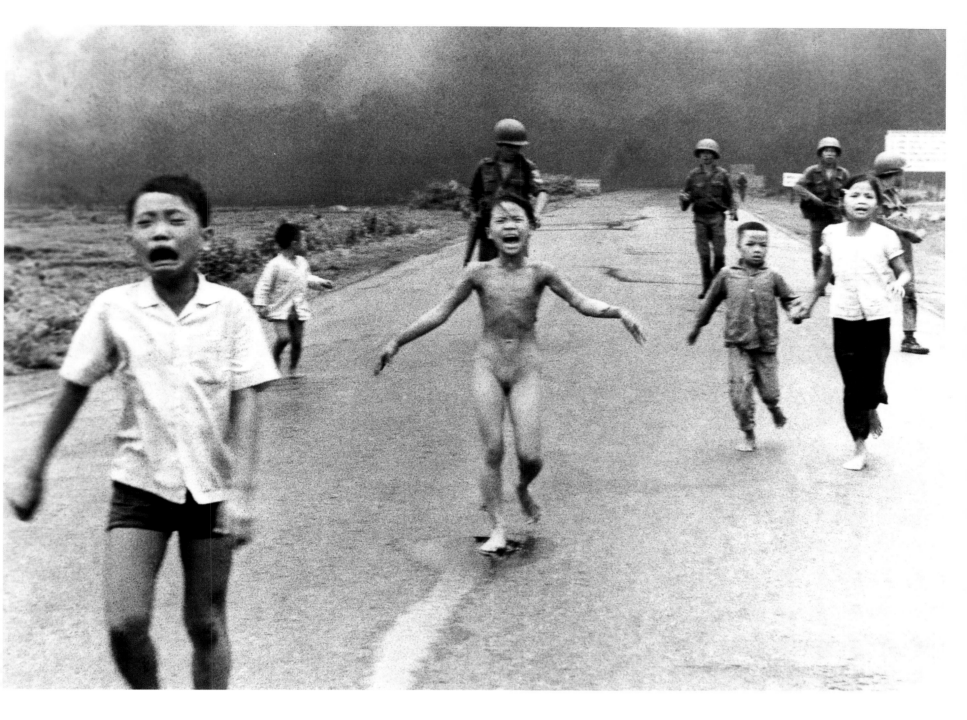

next day and again on subsequent days. Her name was Phan Thi Kim Phuc and she and Ut became friends. Ironically, a few months later, Ut was wounded at a spot very close to where the picture of Kim had been taken. The two lost contact in the final chaotic days of the conflict; and at the war's end, Ut left Vietnam and was assigned to AP's Los Angeles bureau. The North Vietnamese sent Kim to Cuba to study pharmacy and used her and her picture in propaganda releases, but eventually she and her husband defected at the Toronto airport and took up residence in Canada.

Once in Canada Kim contacted Ut, who was living in Los Angeles. Their new lives did not stand in the way of their special friendship and

TECHNICAL DETAILS **CAMERA** Leica
FILM Kodak
LENSES 35 mm and 50 mm
SHUTTER & APERTURE Unknown

they were reunited several times. Kim calls him Uncle Nick. Nick returned to Vietnam in the late 1990s to work briefly in the newly opened AP bureau at Hanoi. He located Kim's family, who still had clippings from newspapers around the world showing Nick's picture. Nick took videos of them and sent them to Kim. Nick and Kim stayed in touch, united forever by a photograph.

1973 [FEATURE]

Birth

BY BRIAN LANKER, THE *TOPEKA CAPITAL-JOURNAL*

Birth is the most universal of all experiences, but before 1972 it had seldom been photographed for the pages of a newspaper.

Brian Lanker was a young, talented photographer on the staff of the *Topeka (Kansas) Capital-Journal*, a paper known for its aggressive use of photography. His friends, Lynda and Jerry Coburn, were involved in Lamaze, a recently introduced process through which a young couple could prepare for and share in the birth of its child. The father and mother, according to the Lamaze theory, should work together as they bring a new life into the world, and the father should be in the hospital delivery room when the child is born. The Coburns agreed to allow Lanker to photograph their baby's birth.

On January 27, 1972, Lynda and Jerry Coburn and Lanker went to the hospital. In smocks, masks, and surgeon's caps, the two men waited for the child. Jerry Coburn was busy comforting his wife, helping her through the labor and birth process as proscribed by the Lamaze method.

Just as the baby, a girl they named Jackie Lynn Coburn, was born, Lanker made the picture. It was the moment of birth—the joyous mother relaxed after her struggle, the father gripping the mother, and the child fresh and new to the world. Lanker would say later that he was so involved in the birth, he did not remember taking the picture.

But there it was, in the paper, its publication a feat—given the intimate content—almost as remarkable as the birth itself.

Although it has become common for husbands to be with their wives during birth, and Lanker's coverage has been duplicated by other photographers over the years, his first foray into the delivery room won the Pulitzer Prize.

SEPTEMBER 1972 ▪ *Swimmer Mark Spitz wins a record seven gold medals at the Olympics.*

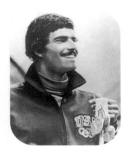

SEPTEMBER ▪ *Eleven Israeli athletes are slain by Arab terrorists at the Olympic Games in Munich.*

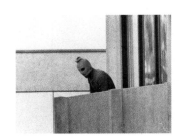

SEPTEMBER ▪ *Bobby Fischer wins the world championship of chess, defeating Russian grand master Boris Spassky.*

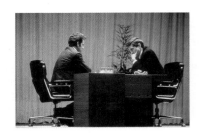

DECEMBER ▪ *Apollo 17 sends back spectacular images of Earth as seen from the moon.*

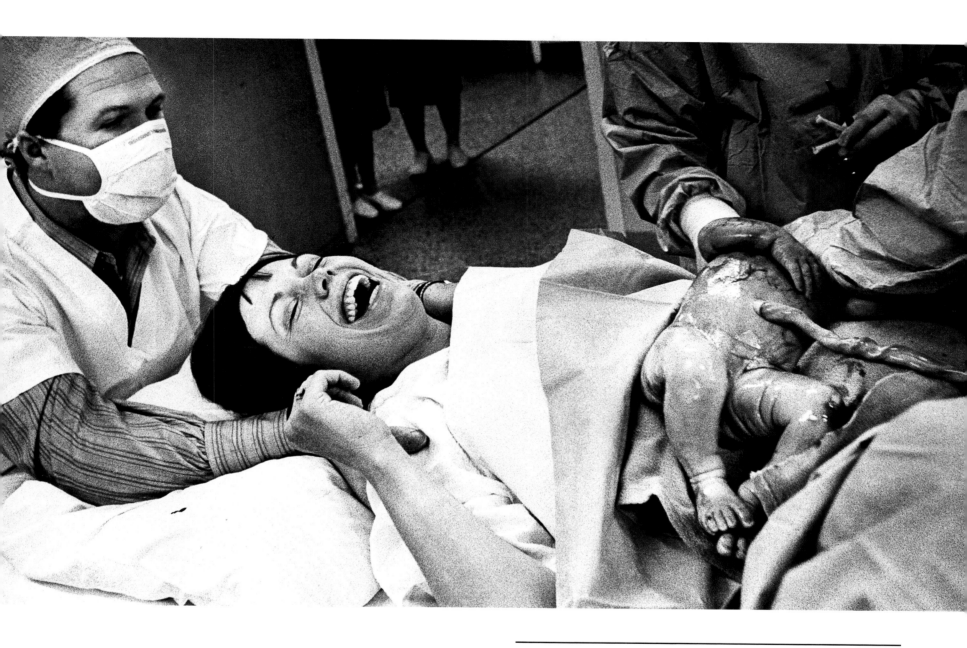

TECHNICAL DETAILS **CAMERA** Nikon
FILM Kodak
LENS Ranges from 35 mm to 105 mm
SHUTTER & APERTURE Various

Hollywood—All Too Real

BY ANTHONY ROBERTS, ASSOCIATED PRESS

The event wasn't scripted. There were no famous names, and neither the villain nor the hero ever got his big moment on the screen. The heroine never even got a close-up, but what happened was Hollywood all the way.

The scene was a parking lot outside a Hollywood discount store. A young woman, twenty-two-year-old Ellen Sheldon, was walking across the lot when suddenly she was grabbed by a complete stranger, Ed Fisher, who threw her to the ground. He sat astride her and clutched her by the throat, but Sheldon struggled to her feet, screaming. Fisher was stronger, and he grabbed her around the waist and held her tightly. He was determined to kidnap the woman.

Security guard George Derby heard her screams and moved to the scene. He told Fisher to free Sheldon immediately, but Fisher pulled a knife and threatened the woman. Derby drew his automatic pistol and, from his position behind a car, aimed at Fisher's head, demanding again that Fisher free the woman. Fisher refused.

Derby knew time was running out, and Fisher was getting edgy.

When Derby again demanded that Fisher free Sheldon, Fisher refused and moved the knife toward her throat. Derby fired and hit Fisher in the head, killing him. He then pulled his pistol back and held it in an upright position, at the ready. The whole drama took fifteen minutes, yet it was conveyed to the public in images taken in a few fractions of a second.

Just before the incident began, freelance photographer Anthony Roberts had pulled into the parking lot. When he heard the screams he grabbed his camera and ran to the source of the commotion. He took a safe position and photographed the entire episode, his pictures following the action step-by-step in a nearly cinematic sequence. The photos were distributed by the Associated Press and printed in newspapers across the country.

TECHNICAL DETAILS **CAMERA** Nikon
FILM Kodak
LENS Unknown
SHUTTER & APERTURE Unknown

APRIL 1973 ■ *Pablo Picasso, one of the century's greatest artists, dies.*

MARCH ■ *Native Americans take over Wounded Knee.*

MAY ■ *Chicago's Sears Tower is topped out, becoming the tallest building in the world at 1,450 feet, and boasting 3.6 million square feet of office space.*

JUNE ■ *Increases in prices and tariffs on oil from OPEC countries result in a summer of high prices and long lines at American gas stations.*

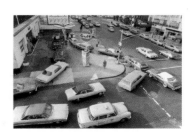

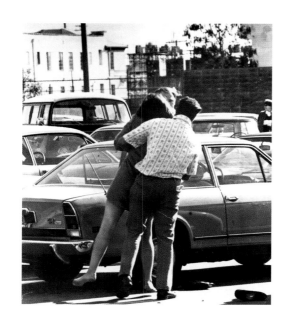
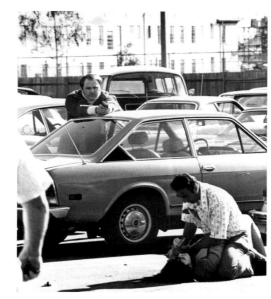
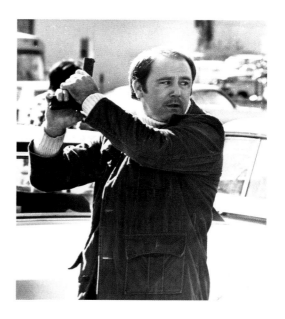
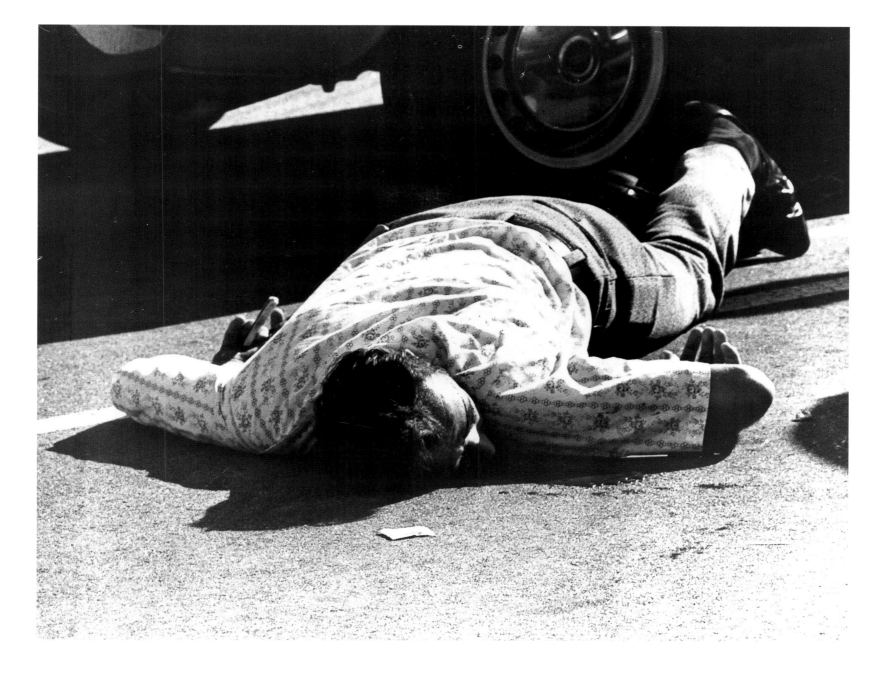

Home is the Hero

BY SAL VEDER, ASSOCIATED PRESS

Photographers Sal Veder and Walt Zebowski were Associated Press colleagues as well as good friends. Veder worked out of San Francisco, and Zebowski was assigned to Sacramento; over the years, they had often covered stories together and had become a well-practiced team.

Veder had been in Vietnam covering the war, but now he was back at home shooting the war from another perspective. The prisoners of war were coming home, and some six hundred of them were due to arrive from North Vietnam in February and March of 1973. Veder and Zebowski were assigned to Travis Air Force Base, west of Sacramento.

The Stirm family was also involved with the Vietnam War. Lieutenant Colonel Robert Stirm was a U.S. Air Force pilot who had been shot down over North Vietnam; now, after some five years in a POW camp, he had been released. His family—his wife and four children—long awaited his freedom and his return.

On March 17, 1973, all of these people were united in a microsecond of time on the tarmac at Travis. Veder and Zebowski started work early. They had to set up a lab on the base where they would develop their film, make prints, and transmit their pictures to newspapers around the world. One of the day's early chores was to decide who would photograph and who would work inside. To the layman, the shooting is the glamour part; but any wire-service pho-

tographer knows that the inside job is vital. Film must be processed, pictures selected, prints made, and images transmitted over phone lines to newspapers and television stations, all on a tight deadline. What good, after all, is a fine picture if no one sees it?

The photographers made their decision by flipping a coin. Veder won and headed for the arrival area to take a position on a stand with other cameramen near where the POWs would leave their aircraft and see their families.

Loretta Stirm and the four children were in position, too, watching as the uniformed airmen disembarked. Stirm was the senior officer of this particular aircraft, and so it was his responsibility to address the assembled parties. His speech was brief and reflected the sentiment that all POWs share—that it was good to be home.

When he finished his speech, he looked about and saw his family dashing toward him, arms outstretched, smiles glowing in a true burst of joy.

Veder watched, and at the precise instant he made his picture. He quickly rewound the film, and gave it to a messenger; off it went to Zebowski, who processed, printed, and transmitted the photograph.

Would that the picture's joy would be there always. The Stirms, long separated and changed personally by time and imprisonment, were divorced within the year. The American pullout was completed in August, but the war continued for another two years.

JUNE 1973 ■ *Secretariat becomes a Triple Crown winner with victories at the Kentucky Derby, the Preakness, and the Belmont Stakes.*

OCTOBER ■ *The Yom Kippur War pits Israel against Syrian, Egyptian, and Jordanian troops; the U.S.S.R. supports the Arab nations. The U.S. supports Israel.*

OCTOBER ■ *Vice President Spiro Agnew resigns after agreeing not to contest tax evasion charges.*

DECEMBER ■ *Bernardo Bertolucci's film* Last Tango in Paris *opens.*

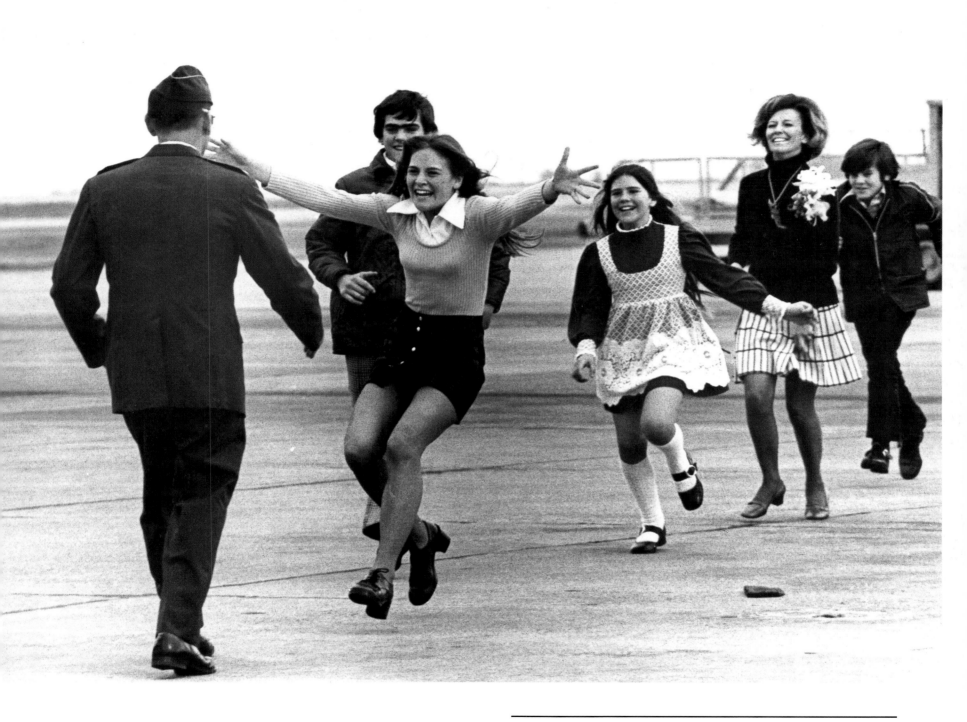

TECHNICAL DETAILS **CAMERA** Nikon
FILM Kodak
LENS Zoom 80 mm to 200 mm shot
at 200 mm
SHUTTER & APERTURE 1/500th @ f 8

Fire's End

BY GERALD GAY, THE *SEATTLE TIMES*

Fire strikes with sudden, fearful, and devastating impact. In minutes, a small, smoky flame can grow into an inferno that consumes everything it touches. Fire is also democratic, with a taste for anything it can devour—modest homes, mansions, warehouses, luxury hotels.

The John Neuffer family called its home a modest house. It was one of those simple but lovely two-story structures that are sprinkled throughout the Pacific Northwest, a home set into the hillside looking out over the water.

The fire started—no one knew how—in the small hours of October 11, 1974. The dog's barking at 3:00 a.m. roused the family to smoky danger; by the time everyone escaped from the house, flames flickered throughout the structure. When firemen reached the scene, the house was an inferno.

Jerry Gay, staff photographer for the *Seattle Times,* arrived for work in the early morning and heard about the blaze in the southern Seattle suburb of Burien. He drove to the scene, but the fire had already won the day. The steep embankment and the slippery hillside, combined with the fire's running start, had frustrated the firefighters' efforts.

Gay found a house in ruins, blackened timbers, and a smoky pall hanging in the air. The early morning light cast a gray, hazy fog-like blanket over the scene.

Despite their failure to save the house, Gay was amazed at the energy the firemen brought to their work fully five hours after the blaze started. They continued to clean out the last vestiges of spark and glowing timbers and brought down a few smoky walls.

When they took a break, they sat in their dark, wet, protective gear, some in helmets, resting against a blackened rise in the terrain. The early-morning light showed the exhaustion etched on their soot-streaked faces. Smoke hung motionless over charred timbers and twisted metal.

What Gay saw in the scene was a study in black of firefighters who failed in their assault on the gate of Hades. He raised his camera and made a picture that looked like a painting.

Fire and firemen have a firm place in the chronicle that six decades of Pulitzer Prize-winning photographs tell. Six of the award-winning pictures are of fires or of firemen coming to grips with the life-and-death reality of their work.

FEBRUARY 1974 ■ *Patty Hearst, the daughter of millionaire publisher William Randolph Hearst, is kidnapped by the leftist Symbionese Liberation Front.*

FEBRUARY ■ *Soviet writer Aleksandr Solzhenitsyn is expelled from the U.S.S.R. as a result of his book about the Soviet prison system.*

MARCH ■ *Popular news anchor Chet Huntley dies.*

MARCH ■ *At the height of the streaking craze, a nude man dashes across the stage at the Academy Awards during a speech by David Niven.*

TECHNICAL DETAILS **CAMERA** Nikon
FILM Kodak
LENS 28 mm
SHUTTER & APERTURE 1/125th @ f8

The Face of Washington

BY MATT LEWIS, THE *WASHINGTON POST*

The *Washington Post*'s Sunday magazine, *Potomac,* was widely recognized for the breadth of its coverage of 1974 Washington. Always on the lookout for a good interview or a good interpretive story based on the comments of a Washington personality, the *Post* assigned Lewis the job of getting the pictures. The pictures that Matt Lewis made in Washington in 1974 offer a complete course in portrait photography in all its variations. One minute he made a sensitive portrait in an office; another he was out in the street with his subject; yet another time he focused on striking architectural design.

If Lewis had a trademark, it was variety. He did not make pictures at photo ops, or of fires, or follow the daily beat of the news-paper's city pages; it was the milieu of Washington that Lewis photographed. Journalists, spies, politicians, and everyday folks sat patiently for his camera while he made photos that would adorn the magazine pages and hook the reader.

With reporters—and on his own—he roamed the streets, buildings, and corridors of the capital to find and photograph the city's face—the capital's face.

TECHNICAL DETAILS **CAMERA** Nikon
FILM Kodak Ektachrome and black & white
LENS Various
SHUTTER & APERTURE Various

APRIL 1974 ■ *Baseball great Hank Aaron hits his 715th home run in Atlanta, breaking Babe Ruth's record.*

AUGUST ■ *President Richard M. Nixon, facing impeachment, resigns the Presidency, the first President in American history to do so.*

AUGUST ■ *Vice President Gerald R. Ford becomes president. In September, he gives Nixon a complete pardon.*

SEPTEMBER ■ *Emperor Haile Selassie, who ruled Ethiopia for fifty-eight years, is ousted from power.*

"They don't say... I'm not smart."

Mean John Wilson and his law partner at the cutting edge

By George Lardner Jr.

John J. Wilson.

Nixon: *"Was he lying down? Wilson? An old-timer?"*
Haldeman: *"Nothing like . . ."* — White House Tapes

At 73 he moves slowly about the courtroom—an aging lion thoroughly at home in his den. He glares. He filibusters. He cites cases no one else can quite remember.

He is also, in no particular order, crusty, charming, contentious, impulsive, and one of the best trial lawyers in town. He has a reputation for being an SOB. He revels in it. If the Watergate coverup trial begins (an uncertain point at press time, given President Ford's pardon fever), John J. Wilson, the attorney for former White House chief of staff H. R. (Bob) Haldeman, can be counted on to be the most outspoken advocate in the room.

It is an old-fashioned style that some say could hurt the Watergate defendants, given the damaging evidence already confronting them on the White House tapes. But Wilson has made a career of roaring in the courtroom and surprising even his colleagues with the results.

George Lardner Jr is a staff writer with the national news desk of The Washington Post.

"Isn't it funny?" he says zestfully. "I'm the meanie. I'm the whipping boy." But at least he has never been accused of not knowing his business. "I mean I get a good paragraph," Wilson declared. "I said to somebody the other day, in the egotistical way that I possess, that the one thing they don't say about me is that I'm not smart."

"He's like my old Irish grandfather," says one of his fellow Watergate defense lawyers. "Most of the disparaging things that are said about him, I consider as compliments."

John Johnston Wilson does not always inspire such fondness overnight, except perhaps in his clients. With them, as one Washington lawyer has put it, he quickly displays "a narrow-minded affinity."

"He's very open, out front, and very honest," says Washington attorney Harry Huge who tilted with Wilson, successfully, several years ago over the mismanagement of the United Mine Workers' pension fund. "I thought him very nasty and petty at first. But he just fights like hell for his client. And once you get over that rough, gruff exterior, it's a pleasure to deal with him. He tells you what he's going to do and he does it."

Continued on page 27

David Brinkley's Journey

The man behind the electronic mask

By Philip J. Hilts

David Brinkley retells the story about himself with a little chagrin, a little laughter. The incident was not an uncommon event, but at the time it irritated and embarrassed him.

"It was in a shopping center somewhere or other. There was a politician—it was Nelson Rockefeller in one of those campaigns of his—and he had an audience of about 50. I kept trying to hide in a store because I had an audience of about a thousand. They were asking for autographs."

Brinkley doesn't like these bouts with gawkers and idol-hounds. They have demolished his privacy and strained his family life. It is absurd, he says, and inappropriate for a newsman to have such fame.

But he has it and despite his protests he has not run from its source. He has spent 30 years in broadcasting; he has been courted by Presidents and knaves; he has polished or dented the national reputations of a cavalcade of Washington's best and brightest. A high-school dropout, he now earns a salary near $500,000 a year. Being a Washington oracle, at the center of the center of events, he enjoys. Rubbing tailored elbows with the powerful pleases him. The money, even though he says he is overpaid, he relishes. But this enormous, freakish brand of fame . . . it seems something to apologize for.

"You could put a baboon on television every night for 15 years and he'd become a celebrity," he says. "In fact, we did that once. With an ape. The 'Today' show once had an ape named J. Fred Muggs. He became quite famous . . ."

It is 11 a.m., and David McClure Brinkley, 53, has just arrived at his office, still rubbing his eyes. The office at NBC, on Nebraska Avenue, is not large but has room for a desk, a couch, and a chair. Two walls are bookshelves, and two are windows. For someone who has seen him only through the TV dimly, Brinkley's freckles and reddish hair are a surprise.

Philip J. Hilts is a free lance writer.

Illustrations by John Heinly

His manner is friendly, and his face seems to have two main poses: a look of slight annoyance and a look of bemusement. He is clearly a man who enjoys laughing, and will do so at every opportunity, most of which are his own jokes.

He is wearing a red tie and yellow shirt, his hair is long, neatly trimmed, and runs down his neck to just above the collar. A pile of newspapers stands at one side of his desk, and a sheaf of mail runs across the front. His manual typewriter, a pale-blue Royal, is at his right as he leans back in the cushioned swivel chair.

His manner of speaking is just what it is on the air, with all the words compacted, and some said with quick, heavy emphasis. But the pauses between words and between lines, which are brief on television, are now not at all brief. The gaps between words and lines at times seem endless—10 seconds, 20 seconds, and longer.

Brinkley answers all questions in a friendly way, but the answers are short and surrounded by large pauses. The four words often used to describe Brinkley are witty, cynical, aloof, and "a loner." Asked what he thinks of those, he pauses for a moment. "I guess they are all fairly accurate." Pause. More pause. Total silence.

When not talking about himself, he speaks a little more fully and he slips in a number of comic quips. The whole effect

of listening to him is a pleasant hypnosis. Each word grows in significance. Little wry comments become very funny. When he puts on his look of bemusement, ironies crowd around every sparse phrase. Chet Huntley, who had a plain, sober way of talking once commented, "I've killed more good jokes than any man alive. David could read the dictionary, and it would be light and frothy!"

David Brinkley . . . "witty, cynical, aloof, and 'a loner'"

Photographed by Matthew Lewis

Brinkley, in fact, created the I'm-just-a-fellow-telling-you-the-news approach to television journalism. Before Brinkley, TV news was mostly either sober, puffed-up commentary borrowed from radio, or banal, Macy's parade narrative borrowed from the newsreels. Brinkley refused to give up his natural speaking style, he wrote simple English, and was not afraid to laugh on the air if something struck him funny, or frown at some obvious fraud. During the Huntley-Brinkley show, a little intimacy was even carried in the tag-line: "Good night, David. Good night, Chet. And good night for NBC news." Then: a smile.

Beyond that Brinkley has been an important intellectual influence in the short history of TV journalism. Brinkley has helped change some of the ground rules—newsmen now give news instead of just film cues, and politicians have lost their early dominance of the airwaves. Inevitably, Brinkley's concise, punchy style has attracted a legion of imitators. Even Walter Cronkite has admitted being leery of watching Brinkley. "In three days I'd be imitating him," Cronkite has said.

These points may be lost on most of the millions who watch, but his face and his wit are not. He is better known to Americans than Cary Grant, Jimmy Stewart, and even John Wayne, one survey outfit discovered. For more than a decade he has been seen each night by more people than pack all the movies in all the theaters for a month. He has an odd, ethereal intimacy with some 20 million people.

"The radio, and the television even more than the radio," says Jacques Ellul, the French philosopher of technology, "shut up the individual in an echoing mechanical universe in which he is alone . . . It envelopes him in solitude and at the same time

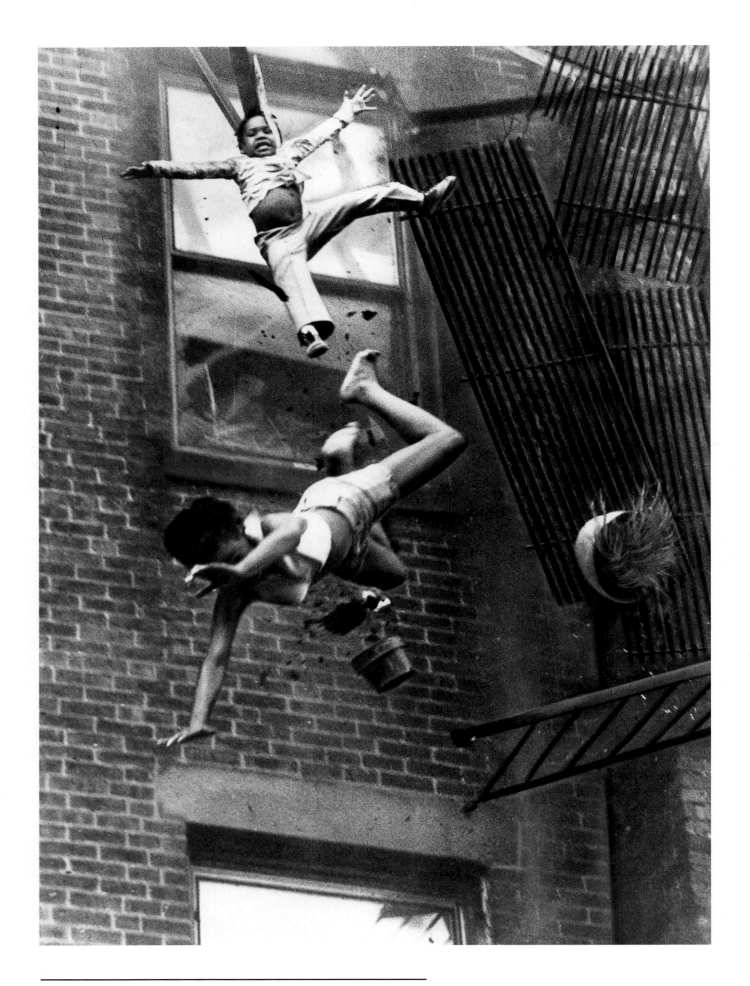

TECHNICAL DETAILS **CAMERA** Nikon
 FILM Kodak
 LENS 35 mm and 135 mm
 SHUTTER & APERTURE Unknown

The Boston Fire Balcony Collapse

BY STANLEY FORMAN, THE *BOSTON HERALD AMERICAN*

There are times when photographs are so dramatic, so telling, so clearly capture high drama that the pictures themselves become the story. Stanley Forman's shocking pictures of two people falling from a collapsing Boston fire balcony are pictures of that kind.

Forman was a staff photographer for the *Boston Herald American*. On July 22, 1975, the crackle of the city desk police scanner told of a fire in Boston's South End. A scrambled reference to people trapped in the building prompted Forman to run to his car.

When he had driven as close to the blaze as he could, Forman jumped out of his car and ran the rest of the way, looking for the ladder rescue company. It's easy to locate a truck like that in the back streets of Boston; and, once he found it, Forman climbed onto the bed of the truck to gain another ten feet in height.

What he saw before him was a classic rescue mission. A fireman lowered himself from the roof down to the fire balcony to join a trapped woman and child. Firemen below strung out hoses. The ladder unit backed into position to erect the rescue ladder, and the firefighter, the woman, and the child edged to the front corner of the balcony. The firefighter reached up to grasp the ladder and guide it into position.

Forman watched through the camera, its motor drive speeding film through the system. He recalled later, "There was a terrible shriek. I don't know now whether it was someone screaming, or the tearing metal of the balcony as it ripped free of the building and started to fall. I watched everything give way through my lens as people and metal tumbled through the air. I remember thinking I didn't want to see them hit."

Forman turned away then he looked back up at the balcony. He thought all three had fallen, but the fireman had grabbed the ladder at the last moment and dangled there until he could pull himself up.

The woman, nineteen-year-old Diane Bryant, died in the fall. The child, her niece, landed on Diane; her fall thus cushioned, she was not seriously injured and she recovered.

Forman's pictures were printed large in the *Herald American,* and the Associated Press distributed them around the world.

Reader reaction to the pictures turned hostile; they charged newspapers with being ghoulish, with catering to sensationalism, with invading Diane Bryant's privacy. Editors responded that newspapers must publish the news, be it harsh or gentle; and they reminded readers that the pictures resulted in vigorous inspection of fire balconies in many cities, and thereby saved lives.

The Pulitzer Prize for these photos was based primarily on their sheer dramatic content. Forman won a second Pulitzer the following year, becoming the first photographer awarded back-to-back Pulitzers. Forman continued to photograph Boston's city life, but traded his still cameras for a video camera and began working for television.

APRIL 1975 ▪ *Nationalist China's Chiang Kai-shek dies of a heart attack in Taiwan at age eighty-seven.*

APRIL ▪ *Saigon falls to the North Vietnamese.*

APRIL ▪ *Jack Nicklaus wins his fifth straight Masters Tournament.*

JUNE ▪ *Steven Spielberg's terrifying film* Jaws *opens.*

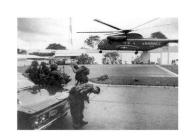

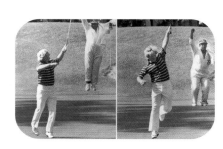

Cameras On Busing

BY THE STAFF OF THE *LOUISVILLE (KENTUCKY) COURIER-JOURNAL*

The question for the staff of the *Louisville (Kentucky) Courier-Journal* was not whether there would be busing—the federal courts had mandated that—but how would it be covered by the paper's photographers and reporters.

Tom Hardin, then director of photography for a staff of twenty-seven, recalled that the simple goal the staff sought was to keep everything in balance—to keep the pictures' subject matter in balance, to avoid pictures of subjects who were performing for the media, to tell both sides of the story without fear or favor. These guidelines meant that if there were two people protesting, a photo should show the protest as a two-person gathering; if there are a thousand gathered, the picture should show that. As it turned out, both scenarios materialized.

Obtaining balance and perspective would not be as easy as it sounded. Feelings ran high on the issue, not only in Louisville but around the country; and many believed there was no option for achieving equal education for children except to bus them. An equally large and vocal group believed that busing was plain wrong.

Busing was to begin on the first day of school, September 4, 1975. In one sense, Louisville lucked out during the early days because a school boycott reduced the number of children that actually moved about the city from 130,000 to 90,000. Nearly six hundred yellow school buses ferried these children to their classrooms. In some cases, whole student bodies were switched in an effort to meet the federal government's mandate.

The *Courier-Journal*'s coverage continued for months, as photographers chronicled the preparations, the actual busing, and the many weeks of controversy and activity that swirled around the issue.

"The signature picture," Hardin says, "was a wonderful shot of a black child and a white child shaking hands in an otherwise empty classroom." Other key pictures included one of a police officer seated squarely in the middle of a bus as it lumbered on its way to school and others that depicted large crowds in support of, or opposed to, the busing.

The picture portfolio presented to the Pulitzer committee consisted of seventy photos that portrayed much of what happened in Louisville related to the busing issue that year. Still others were shots of fighting and peaceful protests, of kids together, and of police watching over the activities of both the Ku Klux Klan and those who supported busing.

All in all, the *Courier-Journal* presented a balanced picture report of a troubled time in its history, a report that did not incite, and was not sensational; it presented in the proper perspective a story that affected nearly every Louisville family.

JULY 1975 ■ *Arthur Ashe beats Jimmy Connors at Wimbledon.*

JULY ■ *Chinese archeologists discover 6,000 funerary figures dating from 221-206 B.C.*

OCTOBER ■ *New York City faces a grave financial crisis; President Ford refuses to help.*

NOVEMBER ■ *Generalissimo Francisco Franco, who ruled Spain for thirty-six years, dies.*

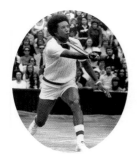

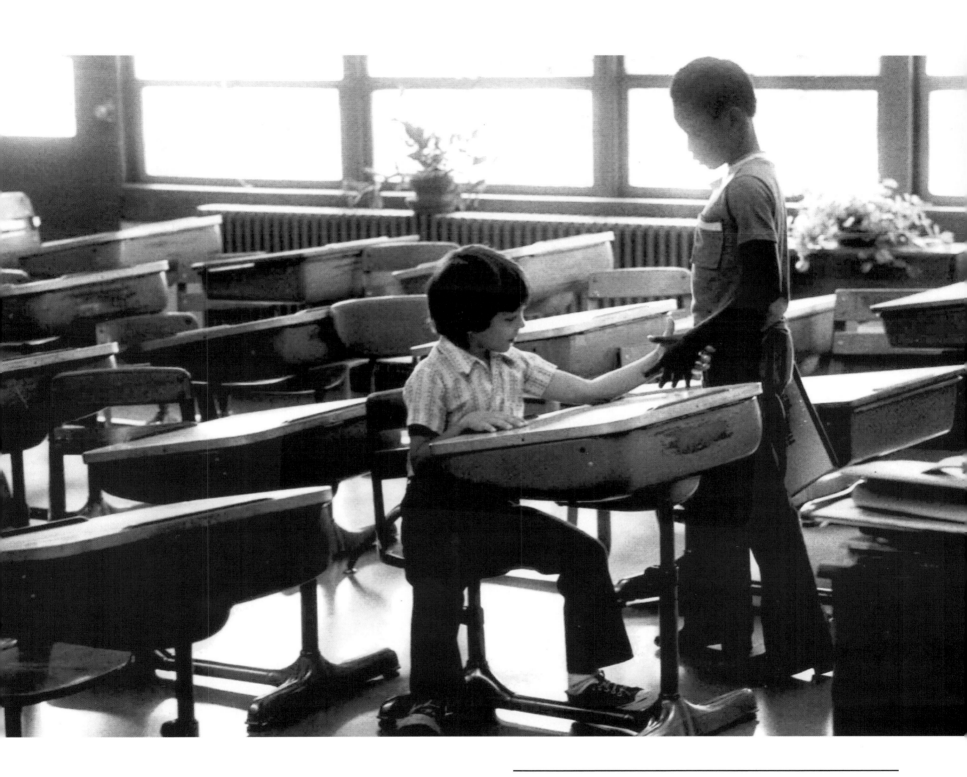

TECHNICAL DETAILS **CAMERA** Nikon and Leica
FILM Kodak
LENS Various
SHUTTER & APERTURE Various

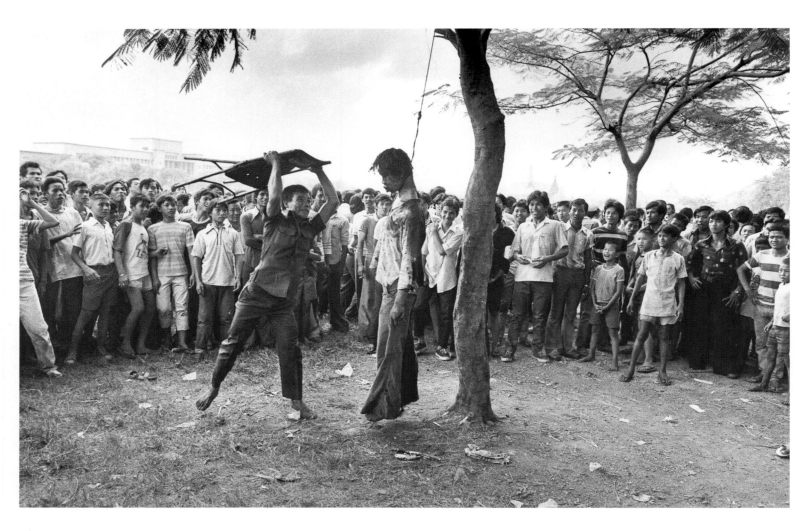

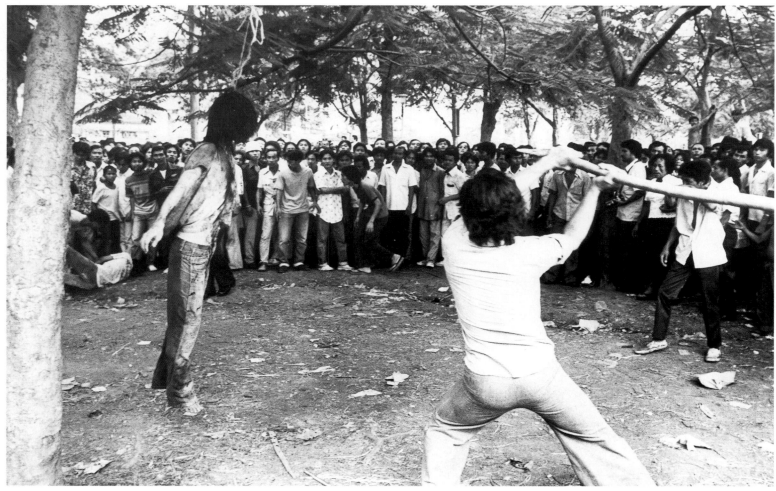

Bangkok's Nasty Politics

BY NEAL ULEVICH, ASSOCIATED PRESS

On October 6, 1976, Neal Ulevich was covering the conflict between rightist students and leftist students. Ever since the end of the Vietnam conflict, the Thai government had drifted left, and conservative elements were worried to the point of planning a coup.

When an ex-dictator named Thanom Kittikachorn returned to Thailand for a visit, enraged leftists demanded his expulsion. Backed by armed supporters, rightist students attacked the leftists, and a bloodbath followed on the Thammasat University campus. Before it was over, there were scores dead and hundreds injured.

Ulevich covered the story from within the skirmish for several hours, and then headed for the AP office to process film and transmit the photographs.

Just outside the campus, as Ulevich looked for a taxi, he saw a student crowd near several trees. He walked over to take a look and came upon a horrible scene. The bodies of two leftist students, lynched earlier in the attack, hung lifeless, each from a different tree. Rightist students continued to beat them with a folding chair and a pole. The bodies jumped and swung under the clubbing, and onlookers responded with gleeful laughs and smiles.

Ulevich had photographed violent crowds before, and he knew they could turn in an instant and vent their anger, especially on strange foreigners. He made just a few exposures, then left the area and took a taxi to the AP bureau where he filed his pictures. The gruesome images received dramatic front-page treatment throughout the United States. His photograph was one of two that were awarded Pulitzers in the news category in 1977.

Ironically, after the October 6 event, the Thai government visited newspaper offices and confiscated the film of Thai photographers who had made pictures of the student upheaval, but it never contacted the Associated Press. Some six months later, when the story of Ulevich's Pulitzer honor was reported in the Bangkok press, the story had a sense of pride that pictures from Thailand had won the prestigious award. The actual photographs, however, never appeared in print in that country.

Ulevich continued photographing in Southeast Asia for some time, then was director of AP's Tokyo operation for a while. He worked in China when the Chinese government permitted a new AP bureau there. He later returned to the United States, where he worked on AP photo technology.

TECHNICAL DETAILS **CAMERA** Nikkormat
FILM Kodak
LENS Various
SHUTTER & APERTURE Various

MAY ▪ *The movie* All the President's Men, *about two reporters on the trail of the Watergate investigation, opens.*

JUNE ▪ *10,000 Soweto students protest the required use of Afrikaans in public schools. Rioting continues for days; the requirement is lifted in July.*

JULY ▪ *Fourteen year-old Rumanian gymnast Nadia Comaneci scores the first perfect 10.0 score in Olympic history; she'll earn a total of seven perfect scores.*

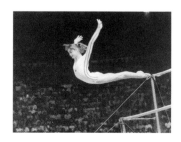

119

The Flag in the Plaza

BY STANLEY FORMAN, THE *BOSTON HERALD-AMERICAN*

Boston Herald-American staff photographer Stanley Forman always listened to the police scanner in his car when he cruised the city's streets. The previous year, a scanner message had alerted him to a fire, and the pictures he made from it won a Pulitzer Prize. Although that was not likely to happen again, it did not reduce the value of the police radio as the source of tips for many of the paper's daily stories. The sooner a photographer was on the scene of a possible story, the greater the chance for telling photos. On May 4, 1976, Forman heard the police dispatcher report trouble in City Hall Plaza, and he turned in that direction.

Like many cities in the United States in that bicentennial year, South Boston was in the throes of a school busing issue. Busing too often brought out the worst in people, and Boston was no exception. Plans were underway to transport schoolchildren from one section of the city to another with the goal of improving educational levels of the city's underprivileged.

The police dispatcher's call was prompted by students who marched in City Hall Plaza and chanted antibusing slogans. They were there, they said, to make demands on the council; but when they arrived, the city chambers were closed. They milled about, riled and angry.

Unaware of what was happening, black attorney Theodore Landsmark walked into the scene, headed for offices in City Hall. A group of some two dozen students spotted him; and in a sudden burst of racial hatred, they attacked him.

Forman arrived moments ahead of the police, just as the melee started, and he began taking pictures.

"They were all over him," he recalls. "They were punching him, hitting him, and they knocked him to the ground. In my viewfinder, I saw one student carrying a long flagpole with a good-sized flag mounted on it. Some students held the helpless man steady as a target, and the student with the pole struck him repeatedly in the head with the end of the pole."

The police arrived, broke up the attack and rushed Landsmark to a hospital, where he was treated for a broken nose and facial cuts. Much of his body was covered in bruises.

The *Herald-American* published Forman's graphic picture in a large size. It was widely distributed, and it became one of the year's most ironic photos—a flagpole carrying America's patriotic symbol, the Stars and Stripes, had been used as a weapon for an unjust cause inspired by racial hatred. In terms of the Pulitzer Prize, of course, the irony does not end there. The picture was only the second award-winning photo in which an American flag played such a significant role; the first was the raising of Old Glory on Iwo Jima.

Forman was the first photographer to win a Pulitzer Prize in two consecutive years.

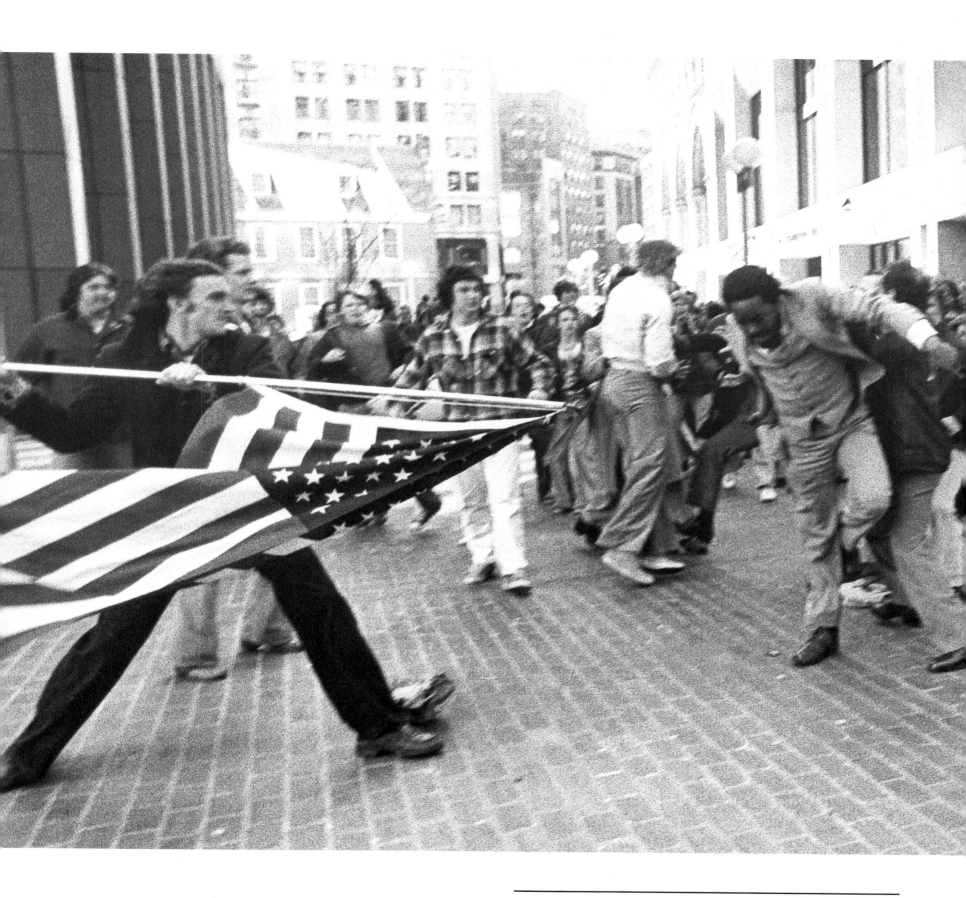

TECHNICAL DETAILS　　**CAMERA** Nikon
FILM Kodak
LENS 20 mm
SHUTTER & APERTURE Unknown

A Face in the Crowd

BY ROBIN HOOD, THE CHATTANOOGA (TENNESSEE) *NEWS FREE PRESS*

The Vietnam War was past but its memory lingered on, refreshed constantly in the minds of those who fought there by the common incidents of everyday life. In Chattanooga, for example, as in many American towns and cities, Armed Forces Day inspired a parade that honored veterans, including Vietnam veterans.

Photographer Robin Hood of the *News Free Press*, himself a Vietnam veteran, walked the parade route, camera in hand, in search of a good picture. It was in Vietnam, in fact, that Hood learned his trade. He started out as a public information officer guiding the press through the military maze to get their stories. Then he picked up a camera and, with coaching by military photographers, learned to make pictures. The *News Free Press* hired him when he returned home.

Now it was 1976, only a year after the war shutdown, and the memory of many still carried the images of harried helicopters taking off from the roof of the U.S. embassy. Here on the parade route Hood caught sight of a Vietnamese refugee family waving the flags of their newfound homeland as they watched a parade that must have been hard for them to understand. He made pictures of the family.

Hood continued on along the parade route trying to keep his camera dry in the chilly rain of a bleak day. He photographed young veterans and old timers out to catch a little nostalgia.

Then he saw the man, legs lost on an Asian battlefield, wearing a military poncho and an army shirt against the rain, his child nestled in his lap between the wheels of the chair that carried him. The man watched the Vietnamese wave their flags.

The circle was complete: Vietnamese family in a new land and a warrior who fought for them but would carry his wound forever. Hood made a picture of the man. It showed him proud and strong, somehow symbolic of all that had gone before but with the determination to move forward.

The man's name was Eddie Robinson. To Hood, Robinson was the star of the parade that rainy day, a veteran who had given much so that others could live free.

Hood continued as a photographer at the paper but eventually opened his own publishing business.

TECHNICAL DETAILS **CAMERA** Nikon
FILM Kodak
LENS 105 mm
SHUTTER & APERTURE Unknown

AUGUST 1976 ■ *West Point accepts women cadets for the first time.*

SEPTEMBER ■ *China's Mao Tse-tung dies of Parkinson's disease at age eighty-two.*

NOVEMBER ■ *Democrat Jimmy Carter wins the U.S. presidential election.*

DECEMBER ■ *Sylvester Stallone stars in* Rocky.

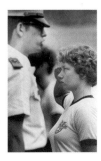

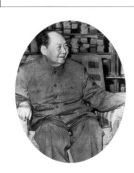

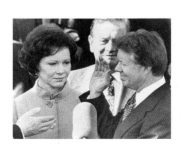

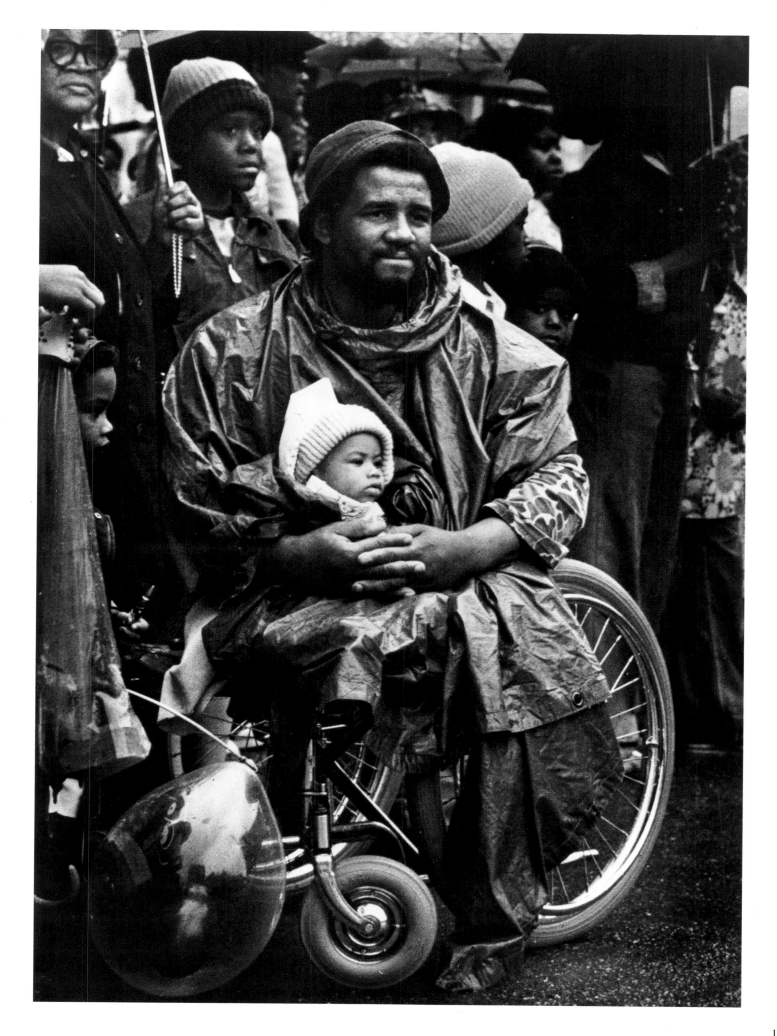

A Time in the Spotlight

BY JOHN BLAIR, FREELANCE FOR UNITED PRESS INTERNATIONAL

Anthony Kiritsis planned it carefully. First, the shotgun: .12 gauge, sawed-off. Second, the wire: reliable but flexible. The arrangement: he figured out exactly how to wire the weapon. The timing: he would wait for the man to arrive at work.

It was Tuesday, February 8, 1977, when the plan went into action. Richard Hall, president of the Meridian Mortgage Company, entered his Indianapolis office at his usual early-morning hour. Kiritsis had been waiting for him; he yanked out his shotgun as Hall entered and quickly wired the shotgun to Hall's neck and head. He then wired the weapon to himself and to the trigger of the shotgun.

The plan had worked fine so far; Kiritsis had Hall where he wanted him. The two men were attached as one, with the shotgun in the middle. If Hall tried to escape, the shotgun would fire into his head. If police snipers shot Kiritsis, he would fall and his weight would pull the trigger. Either way, Hall was a goner.

Kiritsis was in control at last, unlike his position of previous months. Hall's company had loaned Kiritsis money which, combined with his life's savings, he had invested in the construction of a mall. Kiritsis felt Hall had refused to back him in the business, even encouraging others to avoid investment in the mall so that Meridian could foreclose.

Kiritsis, Hall, and the shotgun took to the street, where a passing police car stopped to investigate. Kiritsis forced the officer to drive him and Hall to Kiritsis's apartment, and a classic standoff was underway.

On Wednesday afternoon, freelance photographer John Blair joined the United Press International staff to help with the coverage of the story. By that time, hundreds of police, including a SWAT team, were on the scene, as were news media, in great numbers. It looked as though the standoff would last a long time, so UPI rented an apartment nearby and set up a portable picture operation.

Events of this kind can capture the attention of the world, and that is just what John Kiritsis had done. He was perceived, rightly or wrongly, as the poor little guy who had been done in by powerful business interests that rolled over him, his modest fortune, his very life.

By the third day of the story, the authorities and Kiritsis had negotiated a solution to the encounter. Kiritsis would get immunity from the local prosecutor's office and be given an opportunity to describe his grievances to the world via press conference.

Blair was in the lobby of the apartment house as Kiritsis, Hall, and the ever-present shotgun, still wired in place, stepped into the media setup. It was the first time most people had seen the two men. Blair found himself standing so close to the scene that, as he looked at Hall, Kiritsis, and the muzzle of the shot-

JANUARY **1977** ▪ *The television miniseries* Roots *is aired for an unprecedented eight nights in a row, breaking all previous viewership records.*

MAY ▪ *George Lucas's film* Star Wars *is released.*

JULY ▪ *The 799-mile Trans-Alaskan oil pipeline begins full operations.*

gun, he could have reached out and touched the weapon, had he wanted to. Fearful there would be shooting, Blair stepped off to the side.

He recalled, "Kiritsis shouted right at me, 'get those god-damned television cameras rolling.'"

And then Kiritsis followed with a rambling presentation of his grievances. He wept openly at the injustice done to him. Hall was bleary-eyed; and when Kiritsis demanded that Hall forgive the $130,000 loan and apologize, Hall was unable to respond articulately, no doubt exhausted by the days of captivity and the ever-present gun at the back of his head.

Kiritsis rambled on, wild-eyed; he waved his arm, pointed dramatically at the disoriented Hall, and told the world that he was a national hero. But the perception of the little guy versus the big guy dissipated. Kiritsis was obviously out of control.

Near the end of Kiritsis's ranting, Blair made his dramatic Pulitzer-winning picture of the confrontation.

The press conference over, the cops cleared the lobby. Kiritsis gathered himself and walked Hall into a nearby apartment. Blair remembers the deathly silence that gripped the crowd outside the building, a silence shattered by the unmistakable roar of a shotgun. Everyone wondered who was dead, who was alive.

Kiritsis walked out unarmed and surrendered to the police. Hall was alive in the apartment. Kiritsis had released him and fired the shotgun into the air from the apartment patio. It was his final gesture of defiance and protest.

Hall was taken to a hospital for rest and observation. Kiritsis later was tried and found innocent by reason of insanity, then confined to a mental institution.

TECHNICAL DETAILS **CAMERA** Pentax
FILM Kodak
LENS 20 mm
SHUTTER & APERTURE Unknown

Up-Country in Rhodesia

BY J. ROSS BAUGHMAN, ASSOCIATED PRESS

Most mercenaries in the Rhodesian army of 1977 were tough, battle-hardened Americans. They learned guerrilla warfare in the rice paddies and high country of Vietnam and took a liking to the soldier-of-fortune lifestyle. Toughest of the lot were Grey's Scouts, said to be the last active fighting cavalry unit in the world.

An opposition force was growing quickly in the remote villages of up-country Rhodesia, one that was resentful of a white population that represented only 4 percent of the nation's total that controlled the 95 percent that was black. Grey's Scouts' basic assignment was to ferry their horses into these rugged sections by truck or helicopter and, once on the scene, to sniff out the guerrilla teams and use search-and-destroy tactics to eliminate them.

J. Ross Baughman, an Associated Press photographer in Salisbury, was a member of the corps of newspeople who covered the increasingly important Rhodesian story. They knew that guerrilla activity was on the upswing, but the carefully guided tours provided by government agencies offered little meaningful information about what was really happening. When Baughman heard about the Scouts, he decided to make a connection and get access to the areas they patrolled. He visited the Scouts at their "Crippled Eagle" barbecues on Saturday afternoons and spent time talking to them. He learned that their strategy was to come down hard on the smaller of the many tribal factions that made up the overall opposition force. Baughman eventually persuaded them to let him join one of their missions.

In December 1977, he traveled with Grey's Scouts in the border area of Botswana as they searched for guerrilla activity; and he saw and photographed many scenes of brutal interrogations. Some of his pictures showed suspects forced to hold themselves in an exercise position until their bodies shook with exhaustion and pain. In another incident, Scouts would select one man, take him behind a building, knock him out and fire a gun. They would repeat the process with one after another until someone finally talked. In other cases, they simply beat people with a bat in order to get information; but if they got information at all, it was frequently inaccurate.

The military high command in Salisbury heard that Baughman was in the field with the Scouts; when he returned to the capital, the military demanded to see his film under threat of being jailed. Baughman processed most of the film, but hid three rolls in his camera bag. He turned the contact sheets of the other rolls and the negatives over to the military, which confiscated all but forty frames of nondescript scenes. The contact prints were inked over and effectively destroyed.

AUGUST 1977 ■ *Elvis Presley dies at Graceland, his mansion in Memphis. He was forty-two years old.*

AUGUST ■ *David Berkowitz, the Son of Sam killer who terrorized New York City for a year, is captured.*

SEPTEMBER ■ *Happy Days, a light-hearted look at life in the 1950s, begins its run on television.*

NOVEMBER ■ *Egypt's President Anwar el-Sadat makes a historic visit to Israel, and addresses Israel's Knesset.*

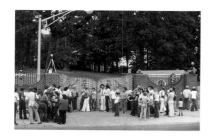

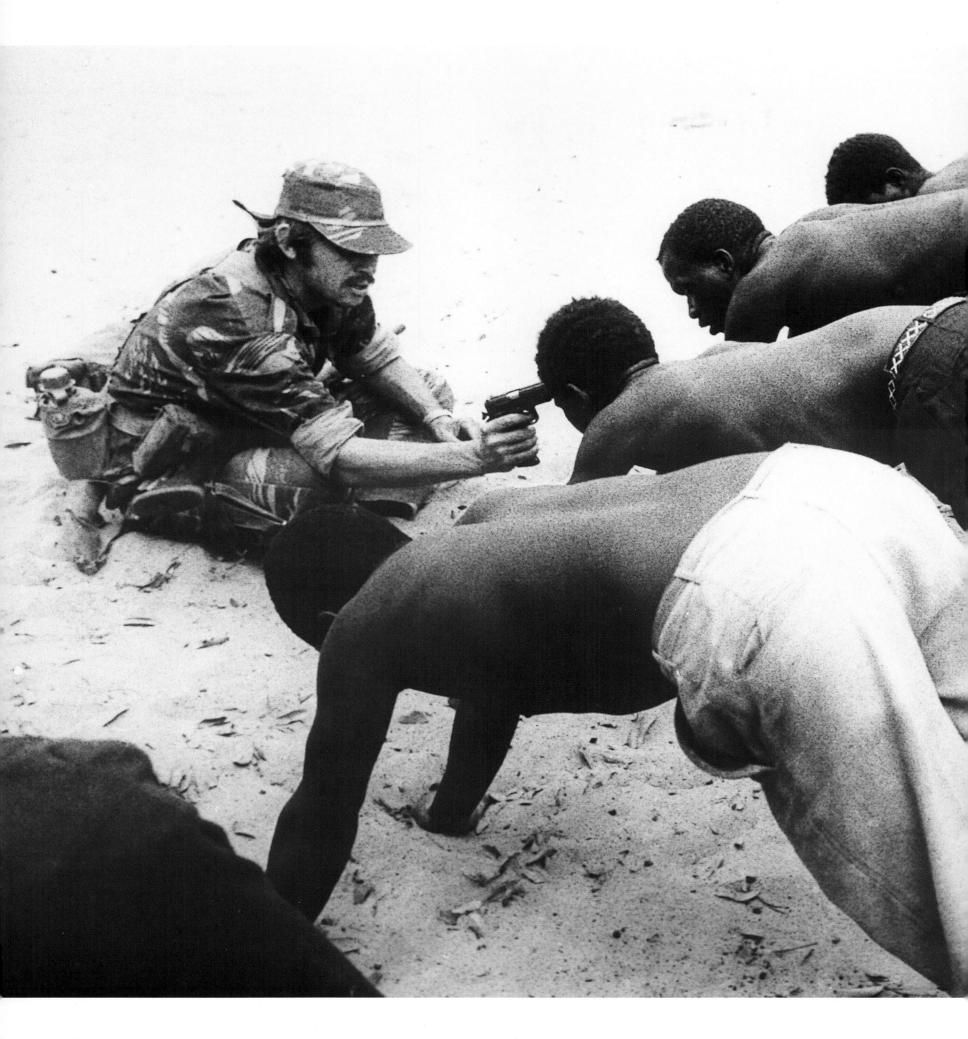

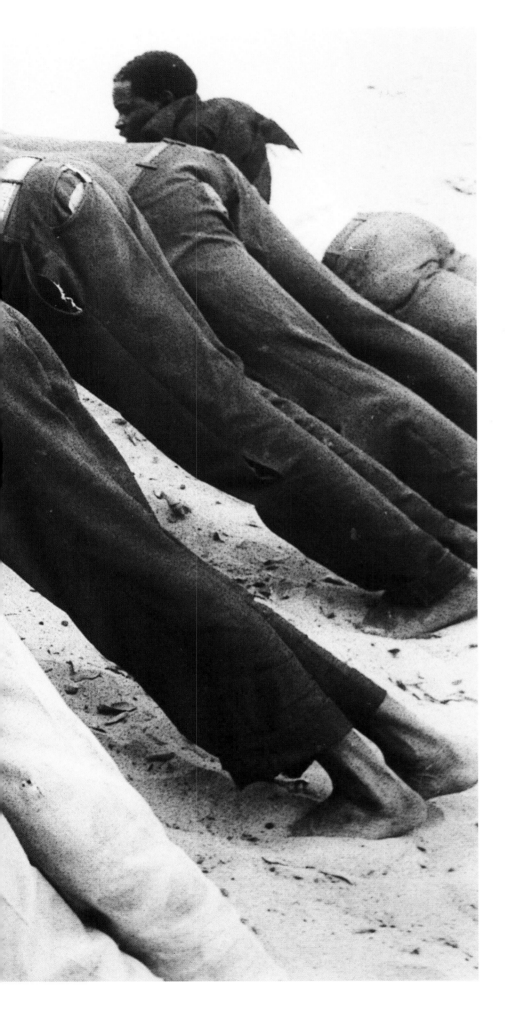

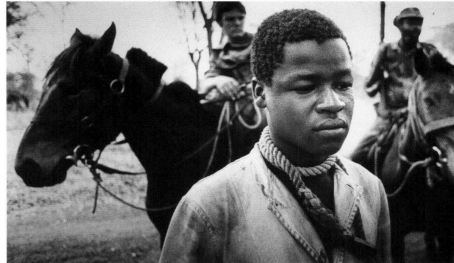

TECHNICAL DETAILS
CAMERA Leica
FILM Ilford HP
LENSES 24 mm and 35 mm
SHUTTER & APERTURE Various

Once he processed the three hidden rolls, Baughman flew to Johannesburg and laid out the story and pictures to Associated Press editors there. Serious questions arose. Would Baughman be safe after the pictures were released? Would AP be expelled from Rhodesia? Baughman believed that, if the story were held up, he could go back and get better material; but already word was leaking out that sensational pictures of Grey's Scouts' activities were available. After careful consideration, the pictures and story were released to world media. Baughman received harassing phone calls about the pictures, and he was forced to leave Africa for other assignments.

Baughman, just twenty-three years old, was the youngest photographer to win a Pulitzer Prize. Winning the award encouraged him to open Visions, a picture agency in New York. On assignment for Visions in Central America in 1981, Baughman stepped on a landmine, suffered a shattered leg, and underwent a long period of rehabilitation. It was the worst of several injuries he sustained in a career shooting dangerous assignments around the world.

Horror in a Small Town

BY TOM KELLY, THE POTTSTOWN (PENNSYLVANIA) *MERCURY*

Like so many before it, the story of Tom Kelly's Pulitzer pictures began with a broken staccato alert from a police scanner.

"Someone is stabbing people…body on the front lawn…may be armed…use caution." The dispatcher called for ambulances and local officers to assist state police.

Pottstown, Pennsylvania, is a normal quiet town, and the community along Sanatoga Road in 1978 was not the kind that would generate a story dramatic enough to win a Pulitzer Prize in photography. On May 10, however, when Kelly pulled up in front of a white house inhabited by Richard Griest and his family, the scene was neither normal nor quiet. Kelly was just minutes ahead of the main rush of police, which quickly filled the road with patrol cars and emergency service vehicles.

Neighbors said Richard Griest had come home for lunch from his job as an aide in a nearby psychiatric hospital. He walked up the pathway with his pregnant wife, Janice. The next thing anyone saw was the grandmother of the family lying bloody on the front lawn. What Kelly saw first when he arrived was a medical team working on the grandmother and then rushing her away in an ambulance.

Before Kelly's arrival, Griest's brother, Joe, had rushed into the house and rescued his two children and one of Richard's children. But Richard's wife and second daughter, Beth Ann, were still inside.

Kelly made his way through the skewed gathering of police cars in an effort to get a good angle and a clear view of the house's front door. He scrambled through high grass to get a little bit closer, and soon was just yards away from the entrance. For an hour, the police—and the media—waited for something to happen. There was no gunshot, no noise. Joe Griest used a bullhorn to plead with Richard to release his family and come out. No response.

They waited and then, slowly, the door opened.

Kelly recalls, "It was the most horrible sight I'd ever seen. The child was stabbed in the face and in the eyes. We learned later that Griest had used a screwdriver. Her face was bloodied. I tried to raise my camera, but I couldn't. My arms just wouldn't move. She walked toward us, even though she obviously couldn't see well. Blood ran down her face. She said, 'Please don't hurt my daddy.' Tears came to my eyes. I just couldn't shoot the picture. I couldn't raise my hands."

A police officer carrying a shotgun charged forward and swept the child into his arms. The action jolted Kelly, and he photographed the policeman carrying the child to an ambulance.

The police then stormed the house, and inside they found Richard Griest standing near the body of his wife who had been stabbed repeatedly. Nearby was the corpse of the family cat, cut

MAY 1978 ▪ *The first legal casino in the U.S. outside of Nevada opens.*

JULY ▪ *Louise Brown, the world's first "test tube baby," is born in London.*

SEPTEMBER ▪ *Egypt's Anwar el-Sadat and Israel's Menachem Begin reach an accord at Camp David, ending two decades of Israeli-Egyptian hostility.*

OCTOBER ▪ *Cardinal Karol Wojtyla becomes the first Polish prelate to be elected Pope and the first non-Italian to be elected to the papacy in 450 years.*

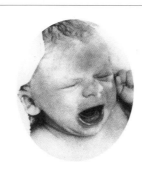
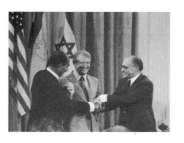
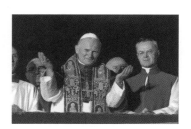

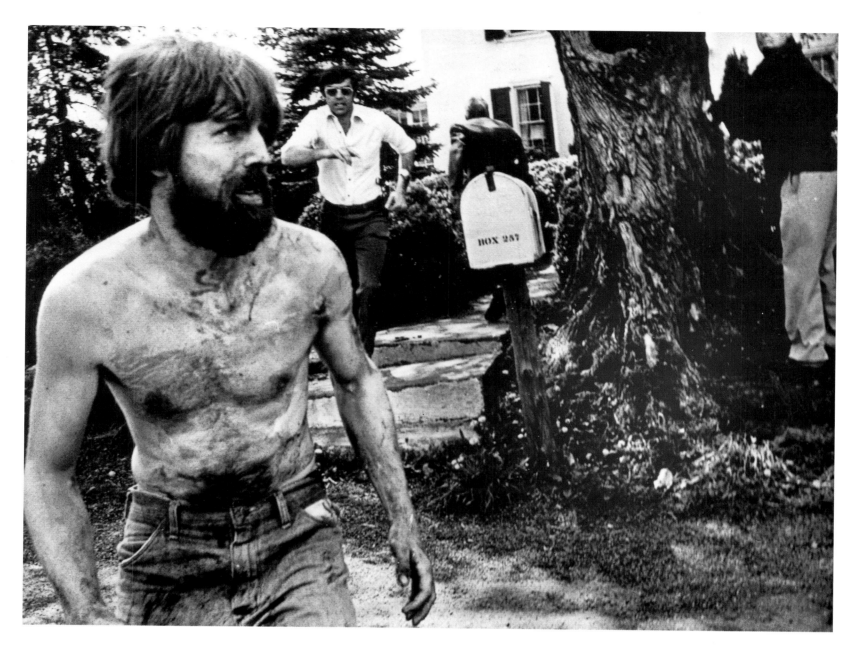

to shreds.

A detective led Griest outside; but in a sudden lunge forward he broke away from the officer and headed for Kelly, screaming that his brother Joe had committed the atrocities. Kelly held his ground and made a picture when Griest, his bloody body bearing down at full force, was just a few feet away. The cops subdued the man, handcuffed him, and took him to jail. He was later tried, found innocent by reason of insanity, and confined to a state pyschiatric institution.

Today, Kelly looks back at the story with continued horror. He remembers how he could not talk about the event for months, how he rarely looked at the negatives he had exposed. Finally, more than a year later he was asked to discuss the coverage at a meeting for photographers. That session helped him to come to grips with

TECHNICAL DETAILS **CAMERA** Fujica
FILM Kodak Tri-X
LENSES 28 mm and 135 mm
SHUTTER & APERTURE 1/500th @
f8 and f5.6

the horrible day on Sanatoga Road when he made his Pulitzer Prize-winning pictures and became the first photographer from a small-town newspaper to be so honored.

Kelly is proud to be numbered in the Pulitzer group, but like some other photographers who won the award for scenes such as his, he wishes the prize had been given to him for his other work. Kelly left the *Mercury* years later, but he still works out of Pottstown as a freelance video photographer.

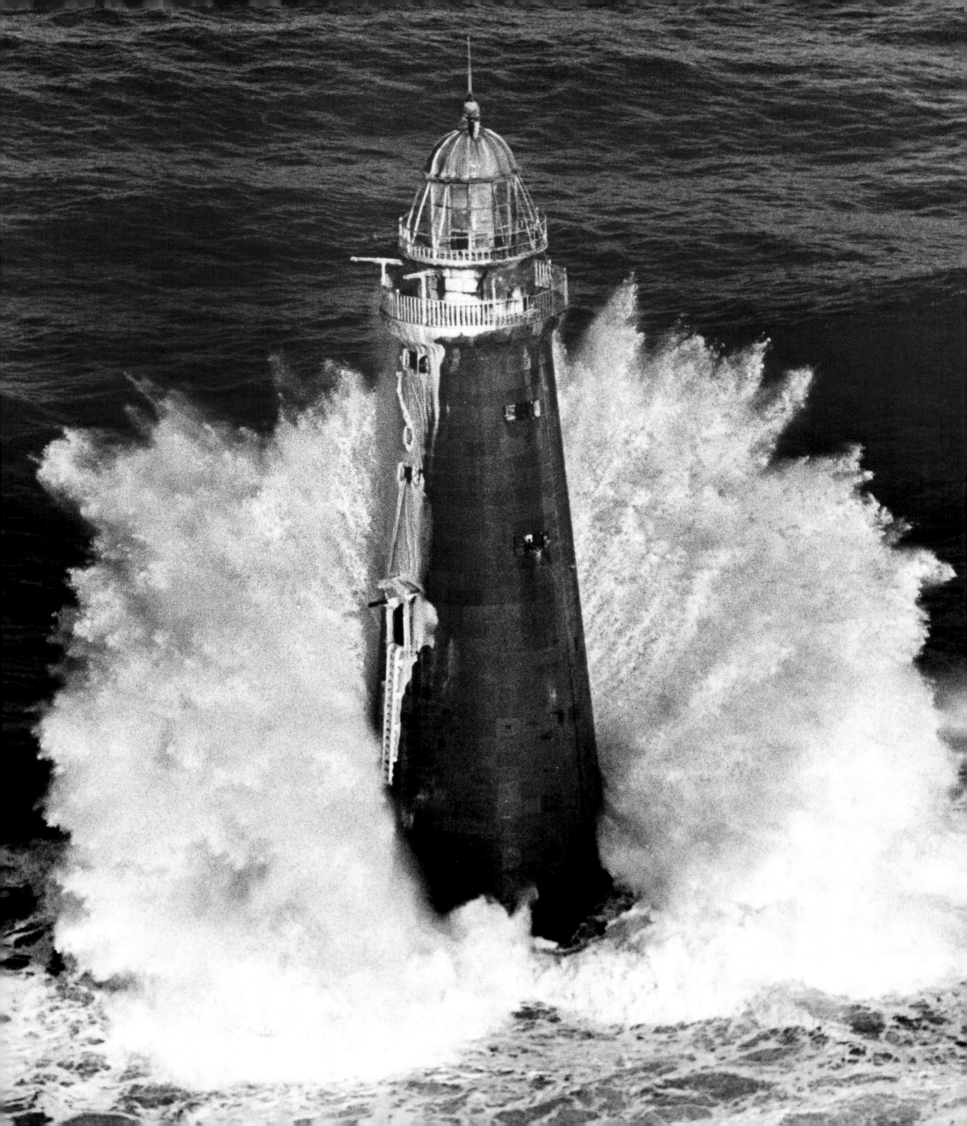

Boston Snowbound

BY THE STAFF OF THE *BOSTON HERALD*

Kevin Cole, chief photographer of *The Boston Herald*, stood waist deep in water as he photographed, on his day off, a raging ocean surf near his home in Plymouth, Massachusetts, that chopped away the shoreline and carried chunks of earth into the sea. A wind had suddenly whipped up, and that's what enticed Cole, who had lived next to the water most of his life, to the seashore to photograph. The water was not particularly cold, despite being early February, but it suddenly chilled sharply and Cole knew that Boston was in for trouble. As it turned out, the storm of February 8, 1978, caused the worst winter trouble in some two hundred years.

The storm started quietly, with just a light snowfall. Forecasters had predicted a few inches, not considered much to hardy New Englanders who dealt regularly with northeasters and other furies of an unpredictable Mother Nature.

As the snow continued to fall, forecasts were altered.

In Boston, the steady snowfall emptied offices early, and children were dismissed from school early in an effort to get them home before snow clogged the highways.

Snowplows swung into action, likewise hoping to get ahead of what by then had been forecast as a powerful storm. The snow fell and fell, into the evening, all night, into the morning.

Cole recalls that, when he woke up on Tuesday, he could not see out the windows of his house, which was buried in snow.

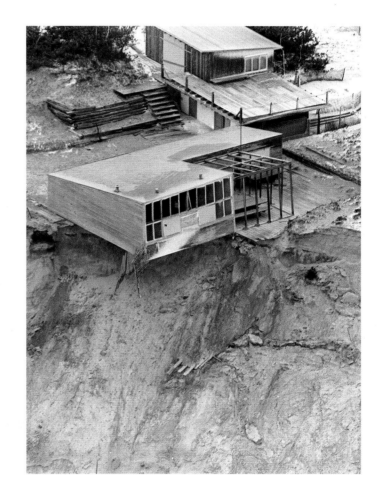

NOVEMBER **1978** ▪ *Led by cult leader Reverend Jim Jones, over 900 people commit mass suicide at the Jonestown, Guyana, compound of the People's Temple.*

DECEMBER ▪ *Karl Wallenda, patriarch of the famous aerialist troup, falls to his death in Puerto Rico.*

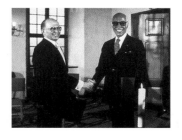

DECEMBER ▪ *Menachem Begin and Anwar el-Sadat win the Nobel Peace Prize.*

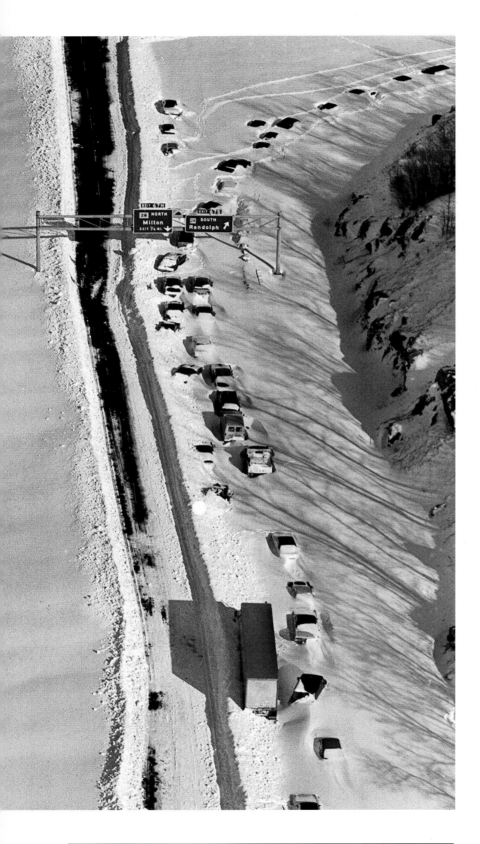

Boston highways were closed down. Route 128, the major highway that encircled the city, was clogged by a mass of some three thousand cars that had been caught and stranded by the snowfall. The wind remained despite a clearing, even brightly sunny day.

Cole knew Boston was out of business so he headed southeast from Plymouth, toward Hyannis, on Cape Cod. It was possible, he thought, to charter a plane in Hyannis and fly back to Boston with the film he made the previous day and any pictures he might take during his return to the city. He drove along a highway with a single lane of traffic opened; the two sides of the road were high walls of snow. "It was like riding a toboggan," Cole says. "All you could see was what was in front of you."

Once at the Hyannis airport, Cole went to the Discover Flying School, where a pilot said he'd take him to Boston if he could get into the air despite the winds. He took Cole to his plane, which turned out to be a small, two-seater aircraft used primarily for local flights. Cole recalls, "I wondered where the rubber bands were to wind it up."

The plane took off, however, and Cole saw for the first time the extensive shoreline destruction caused by the storm. Houses were tumbled about like toy blocks; some were actually in the sea, pulled out by the tides and winds. Seawalls of concrete and steel were twisted and washed away. People were atop their homes, des-

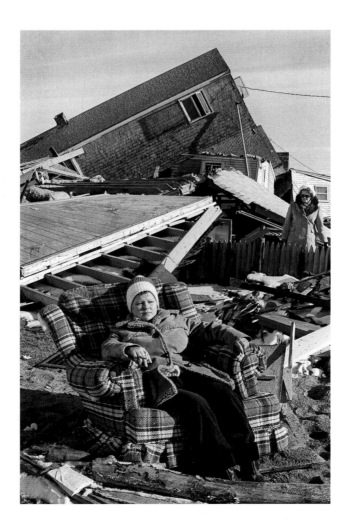

TECHNICAL DETAILS **CAMERA** Nikon
FILM Kodak
LENS Various
SHUTTER & APERTURE Various

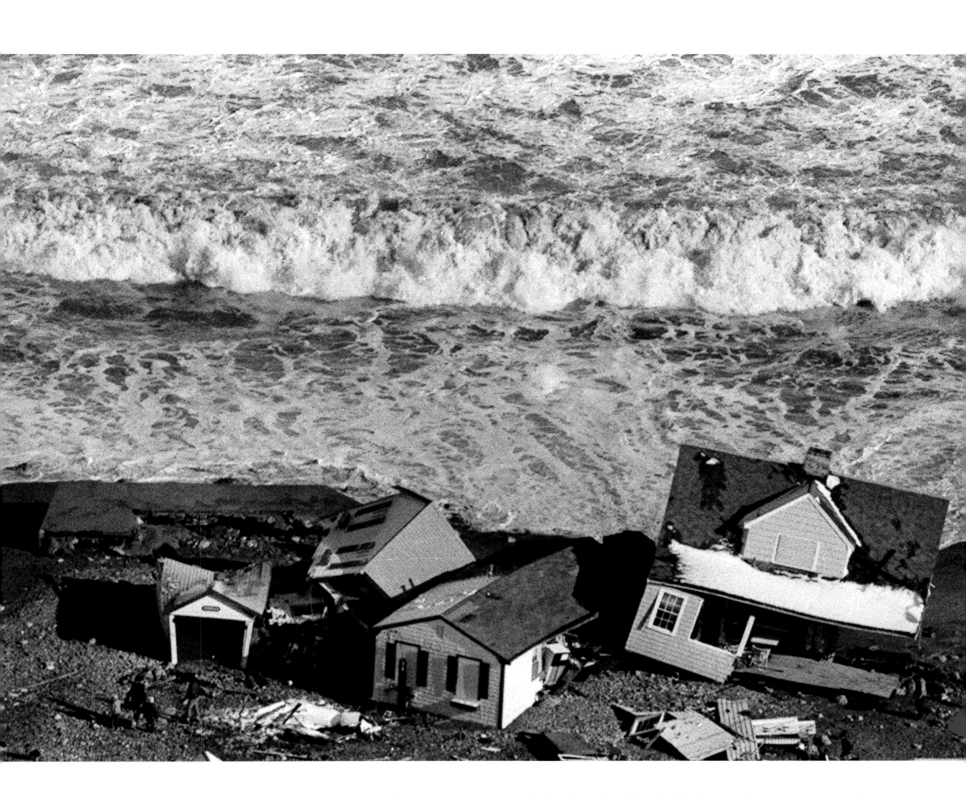

perately awaiting rescue. Waves driven by gale force winds continued to pound the shoreline and flood the coastal towns. Being in the small plane gave Cole a unique perspective from which to photograph the storm's damage.

Cole saw Minot Light, a lighthouse and popular historical landmark, in the distance. Giant waves crashed against it, and he wanted to get a picture. They flew out to the lighthouse, and as the plane circled several times to get in position for a picture Cole became airsick. As they turned away to head back, Cole made one final shot of the lighthouse engulfed in the white, churning water of a huge wave that crashed over the structure.

Other *Herald* staffers had their own adventures documenting the storm. Paul Benoit, for example, walked ten miles through the snow-covered landscape to Revere to photograph the rescue of some one thousand people from that isolated coastal town.

Power was lost throughout the area, and back at the paper staffers camped out on cots and desks, trying their best to get ready to go to press. Cole made it back, as did Benoit, and their pictures, along with those of the few others from the staff who were able to make it to the *Herald* office, were featured in a special tabloid picture section added to the regular broadsheet edition. The portfolio won the Pulitzer Prize for the *Herald*'s photo staff as a group.

A Message from Khomeini

ANONYMOUS, UNITED PRESS INTERNATIONAL

EDITOR'S NOTE

In December, 2006, the Wall St. Journal published a lengthy article by writer Joshua Praeger that revealed the identity of the photographer of the picture on these pages—the 1980 Pulitzer Prize image showing a mass execution in Iran. The photographer was Jahangir Razmi, a Teheran cameraman of long experience and a staff member of the newspaper Ettela'at. *Razmi covered government activity in Iran on a regular basis, attended the instant trial and execution and sent his film off to his newspaper where it was published. It was quickly circulated throughout the world but Razmi was never identified for fear of government retaliation. Razmi continued his photographic career over the years that followed. The Pulitzer committee accepted the identification and Razmi was invited to the 2007 Pulitzer award luncheon in New York and given the Pulitzer $10,000 prize.*

The story that appeared originally in MOMENTS *is published here unchanged.*

There was no room for discussion in the Iran of Ayatollah Khomeini in 1979. Nor were the Kurds, a cultural minority in the country, in the mood to discuss issues of economics, cultural heritage, and religion.

To the Kurds, Khomeini was just another dictator who saw himself as the personal representative of God to the Shiite Muslims. His divinely inspired purpose was to rid his people of the satanic influences of the West, and nothing would stand in his way.

The Kurds, while no great lovers of western culture, did not see Khomeini as their salvation. They sought a place for their Suuni Muslim faith, which stood opposed to the Shiites. Even more, they sought independence for Kurdistan. For hundreds of years, they had fought would-be conquerors from all sides—Turks, Iraqis, Syrians, Iranians, and even some Soviet troops—and they had developed a hardy, rich, warrior heritage.

The Kurds in Iran were a remarkable people. Hardened physically by the rugged terrain of their Kurdistan, many dressed in traditional garb and looked more like characters in a Rudyard Kipling novel than citizens of the late twentieth century. Belts of ammunition wrapped around their bodies made them modern warriors, but they might also have curved daggers in elaborate scabbards stuck in their waistbands. The latest in Uzis and other weapons were also common.

Khomeini's philosophy did not accommodate the Kurdish way of life. His simple approach was that one was either with him, or against him. His Islamic Revolutionary Government sent squads into Kurdistan to bring the Kurds in line. The killing—what has come to be called "ethnic cleansing"—was inevitable.

The cleansing was done in isolated killing fields, beyond the prying eyes of reporters and photographers. Beheadings, firing squads, and other forms of execution were conducted throughout Kurdistan as Khomeini's henchmen sought to remove those considered troublemakers.

On March 27, 1979, a UPI photographer witnessed and photographed one such execution in Sanandaj, Iran. A government firing squad executed nine Kurdish rebels and two former police officers of the deposed Shah of Iran. The killing came immediately after so-called trials handed down "guilty" verdicts. On March 28, another twenty-one faced the executioners' rifles.

To protect the photographer from a similar fate, one that might even follow him beyond Iran's borders, United Press chose not to identify the man who was awarded the Pulitzer Prize. He is the only photographer in Pulitzer history who is not identified.

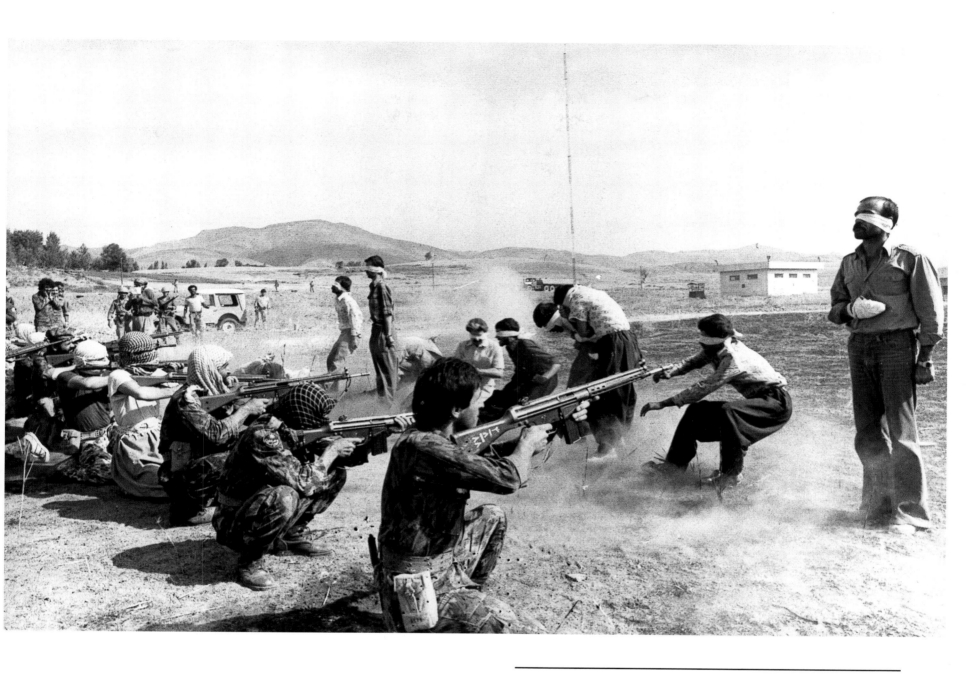

TECHNICAL DETAILS CAMERA Unknown
 FILM Unknown
 LENS Unknown
 SHUTTER & APERTURE Unknown

FEBRUARY 1979 ■ *The Shah of Iran is overthrown; Khomeini returns to Iran from Paris. Iranian students seize the U.S. embassy in Tehran, taking forty-nine hostages.*

MARCH ■ *An accident at the Three Mile Island nuclear station raises fears that the year-old reactor may explode and release radioactive cesium.*

MAY ■ *Margaret Thatcher is elected Prime Minister in England, becoming Britain's first woman Prime Minister.*

JUNE ■ *John Wayne, the hero of countless Westerns, dies at age seventy-two.*

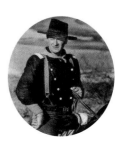

Home on the Range

BY ERWIN "SKEETER" HAGLER, THE DALLAS *TIMES-HERALD*

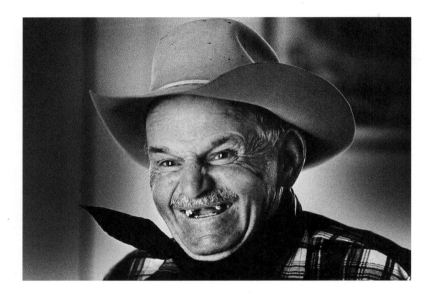

Every Pulitzer Prize of the twentieth-century except for one either told the story of a specific news or historic event or documented a current social issue or trend. The exception came from the cameras of Erwin "Skeeter" Hagler, who used modern methods of photography to take readers on a nostalgic ride backward in time with a dying breed—the classic American cowboy.

"Cowboys are a hard bunch to get to know," Hagler said, "but I got to know them out of sheer persistence." At the time, Hagler worked for the *Times-Herald* Sunday magazine and had the luxury of suggesting his own assignments.

Hagler and a reporter drove to the Texas panhandle, where the large cattle ranches are located, and developed a routine they followed for several weeks, repeating their visits over a period of months. They began their day with the start of the cowboy's day, in the cookhouse for breakfast, and then moved out to the range, where the cowboys dealt with hundreds of head of cattle.

Hagler, who describes himself as a city man, never attempted to become a cowboy. He didn't ride well and preferred to follow the trail on foot, or to move ahead of the herd in a pickup truck to photograph the cowboys and cattle as they passed by. Nevertheless, he reported, he was closer to his subjects on this project than he had been on any other. He still visits occasionally to renew friendships made on the trail.

Hagler captured the modern cowboy's attraction to his historic role as a saddle-worn range wanderer in wide-brimmed hat and kerchief, but he also showed the cowboy's healthy regard for appropriate modern tools. He pictured cowboys pulling and tug-

AUGUST 1979 ■ *Earl Mountbatten of Burma is killed by a bomb planted by the I.R.A.*

DECEMBER ■ *Soviet troops invade Afghanistan to quell anti-Marxist rumblings.*

DECEMBER ■ *Mother Teresa wins the Nobel Peace Prize for her work with the sick and destitute in Calcutta.*

DECEMBER ■ *Francis Ford Coppola's* Apocalypse Now *opens.*

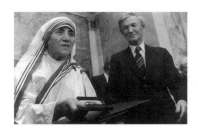

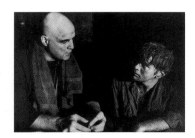

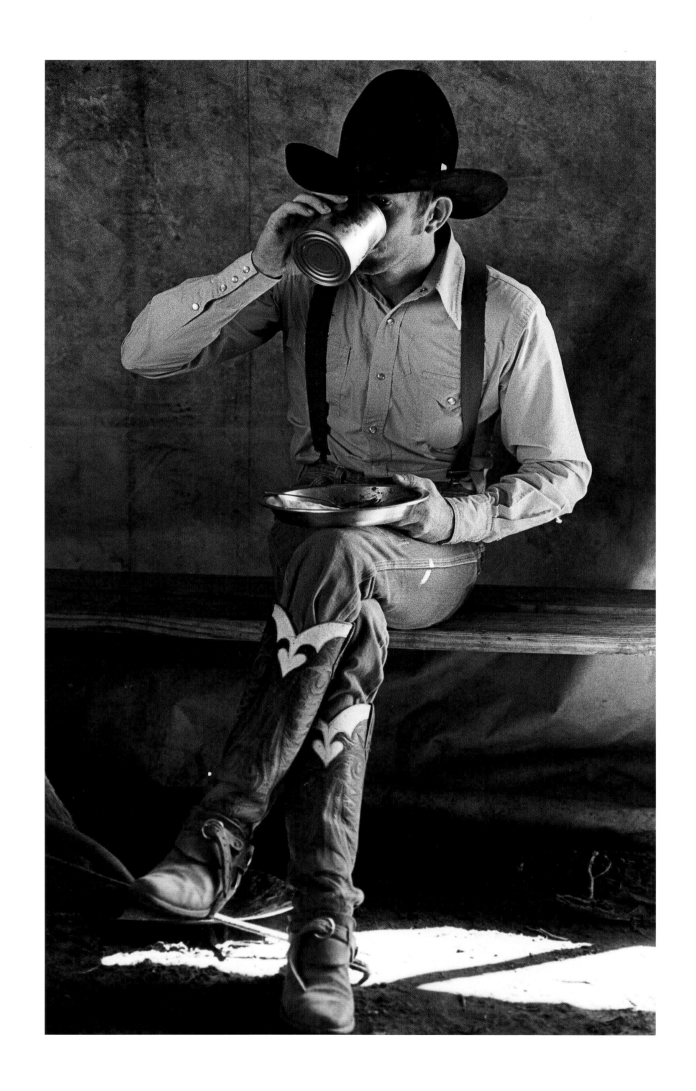

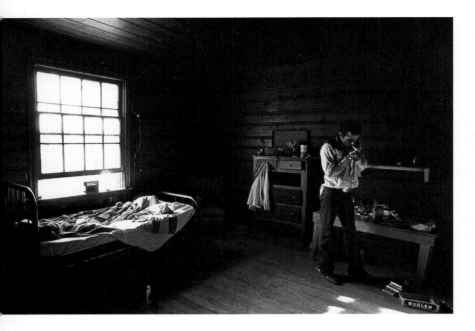

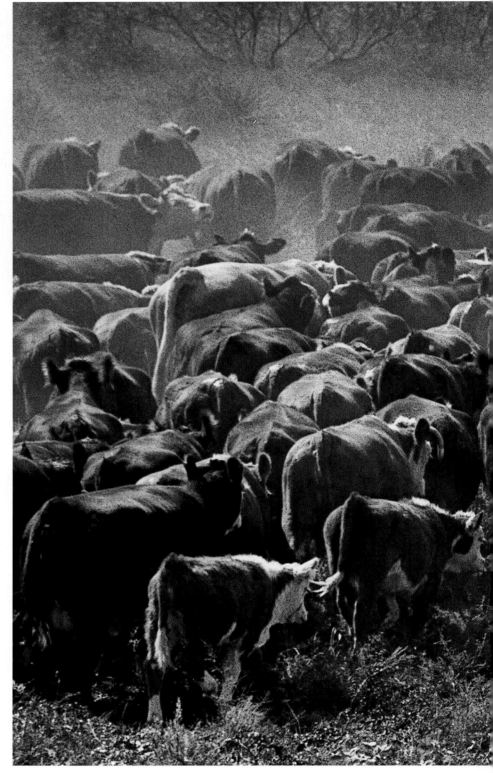

ging at the reins of their horses as well as handling the controls of a small helicopter. In each case there was but one goal in mind, to drive cattle.

While the helicopters and pickup trucks were part of the cowboy scene, Hagler's pictures from many weeks on the range told a story of men who lived and worked the way they had for more than a century—close to the earth and hardened by the sun, the wind, and the dust of the trail.

"The toughest part of the coverage was the boredom, the waiting for something to happen. But you know, you get to know the people; and pretty soon you are invisible, and that's when pictures happen."

Hagler insisted on doing the story in black and white. "It's gritty," he said, "like the dust on the prairie. Black and white is somehow dirtier and fit this story better than color. I didn't want these guys to look like the Marlboro Man, because that was not what they were."

The product of Hagler's determination and his hours on the prairie was a series of classic photos that could have been made by photographers who roamed the west more than a century ago to record America's western expansion with huge cameras, glass plates, and wet-film processes. Hagler's pictures, made at a time when astronauts walked on the moon and nuclear submarines glided beneath the polar extremities of the earth, showed modern cowboys to be the same rugged individuals of yesteryear whose lifestyle had changed little from that of their predecessors.

The paper's Sunday magazine published forty pictures of cowboys one weekend, and then a second story the following Sunday on just one individual said to be the oldest cowboy working.

"You know," Hagler muses twenty years later during a quick break from his freelancing work in Dallas, "people still recall those pictures. When I introduce myself as Skeeter Hagler they frequently say, 'Didn't you make some pictures about cowboys?' That makes me feel good."

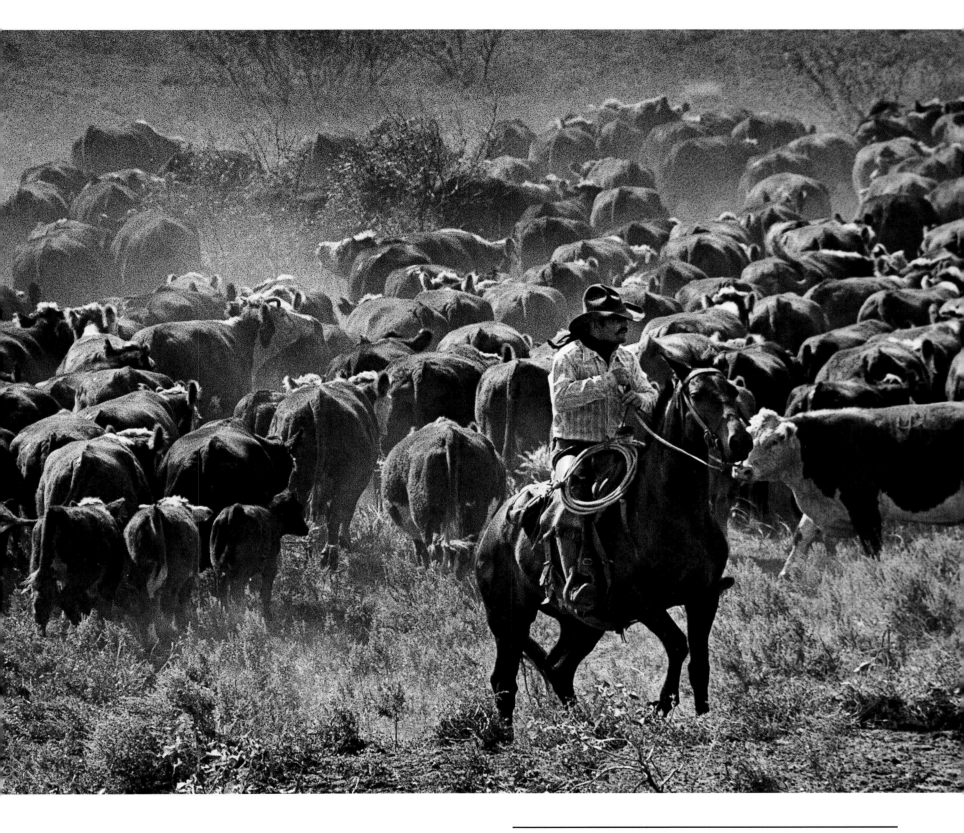

TECHNICAL DETAILS **CAMERA** Nikon
FILM Kodak black & white and
Kodachrome
LENS Various, ranging from 35 mm to
600 mm
SHUTTER & APERTURE Various

Color and Digital Photography, Women Photographers, and the Africa Pulitzers

The Pulitzer Prize winners in the final two decades of the twentieth century reflected the dynamic nature of the era. Color pictures dominated the awards, but pictures from Africa also appeared for the first time, photographs by women were submitted in greater numbers, and the influence of new technology was apparent.

The most notable change in Pulitzer Prize photography was the ascendancy of, and ultimately the predominance of, color pictures. This was made possible by advances in newspaper technology—particularly in the area of digital picture scanning and transmission—that opened the door to faster, easier, and more economical reproduction of color.

In the late 1970s and the early 1980s, the only newspapers that used color widely were the handful that had taken a leadership role in its development. In the latter part of the eighties and the early 1990s, the Associated Press abandoned the antique technologies of picture transmission that had existed unchanged for generations and switched to high-speed digital transmission. This technology not only delivered high-quality pictures from all corners of the globe, it also made handling color photographs easier and more efficient. The equipment used for wire pictures also accommodated local pictures, so news photographers soon could venture into an all-color world.

The emergence of color in newspapers was mirrored in the Pulitzer Prizes. In the century's final decade, only three of the twenty awards were for black-and-white photography.

In past years, editors had debated the "reality" of color, asking whether color pictures were as truthful as black and white. It wasn't truth—or the lack of it—that actually hampered the use of color, however; it was the poor quality of newspaper color reproduction that readers found confusing. With reproduction technology under control, newspapers were able to print color photography that rivaled that of magazines. And readers loved it.

Prior to the 1970s, relatively few women chose photojournalism as a career. Their numbers increased in the post-Vietnam war years, and that change was reflected in the increasing number of women photographers who won Pulitzer Prizes. Except for the amateur Virginia Schau, who captured the 1954 Pulitzer with her Box Brownie picture of a truck dangling from a bridge (page 39), there were no women Pulitzer-winning photographers until 1986, when Carol Guzy and Michel duCille won for their photographs of the devastating impact of a volcanic eruption in Colombia (pages 174-177). Guzy would win another Pulitzer in 1995 for her work in Haiti (page 227). In the 1990s, three women captured Pulitzers, and there were women on Associated Press photographic teams that won awards covering the Olympics, politics, and international affairs.

These women did not necessarily bring a different perspective to news photography. Based on the pictures they made and the subject matter they covered, they clearly were professional journalists producing pictures of the same high quality as their male counterparts. Women won Pulitzers for hometown spot news (Annie Wells in 1997 for a gripping picture of a river rescue), for difficult foreign assignments (Guzy in Haiti in 1995 and Martha Rial in Africa in 1998); and for challenging subject matter (Stephanie Welsh in 1996 for her picture story on female genital mutilation in Africa).

As news photographers pursued stories in critical hotspots around the globe, it was only natural that new datelines from different countries enter the Pulitzer chronology. In 1978, J. Ross Baughman's pic-

tures from Rhodesia won the first Pulitzer from an African location. In the next two decades eleven more Pulitzers, out of some forty that were presented, were for pictures made in Africa. The pictures honored were in classic Pulitzer tradition; some were picture series and others were single pictures, but all were unrelenting images from a continent that was struggling with the horror of genocide, hunger, and revolution.

The period's final hallmark—digital cameras and portable satellite telephones—came in the late 1990s. To understand the impact of this new technology, one has to go back to Max Desfor, who was the Pulitzer winner in 1951 for his pictures from the Korean War. Desfor used a cumbersome 4x5 Speed Graphic and made his pictures on 4x5 film carried in a film pack. He shipped his film via courier to an air base in Japan, where it was picked up by AP Tokyo staff and processed; a few selected pictures were transmitted to San Francisco or New York on unreliable radiophoto circuits. Sometimes pictures had to be transmitted repeatedly before they actually were received at their destination. Frequently, otherwise worthwhile pictures were not published because the quality of radio transmission was so poor. Color was out of the question. The field situation was not all that different in the Vietnam years.

By the late 1990s, photographers, especially wire-service photographers, could use digital cameras in which electronic chips replaced film. Technicians saw images on computer screens, not as prints in the chemical baths of a dimly lighted darkroom. In remote locations, photographers carried small satellite transmission dishes that connected them to their home base in a matter of minutes. In other environments, they used cell phones to transmit their pictures. Most of the pictures from the Associated Press's 1999 Pulitzer Prize series on the Bill Clinton/Monica Lewinsky scandal were transmitted from office hallways and automobiles minutes after they were made by using digital cameras and cell phones. A picture from Desfor in Korea could take twenty-four or forty-eight hours to reach New York. In the late 1990s it might take fifteen to twenty minutes. And the picture would be in color of excellent quality.

Newspaper photographers eagerly adopted these advances and soon utilized the technology either on their own or by using the facilities made available by wire services that covered the same stories. More newspapers sent their own photographers to the scene of major international stories.

Higher quality pictures delivered to newsrooms more efficiently and quickly meant that more pictures were available for use in time for deadlines. This immediacy thrust photography toward a greater role in daily print journalism.

It is a credit to the Pulitzer process that exotic datelines did not push solid hometown coverage from the Pulitzer collection. Tom Gralish received his 1986 award for a story on the local homeless in Philadelphia and Dave Peterson won in 1987 for a picture report on the troubles faced by farmers in the Midwest. And Clarence Williams won an award in 1998 for his story of drug addiction in Long Beach.

In 1987, Scott Shaw made the marvelous picture of Baby Jessica saved from a well and, with Annie Well's single picture in 1996 of a river rescue in Santa Rosa, maintained the presence among the Pulitzer winners of the single, graphic picture.

Despite technology, despite speed, despite the far-flung travels that photographers undertook to cover the world, the thread of the Pulitzer's classic standards prevailed.

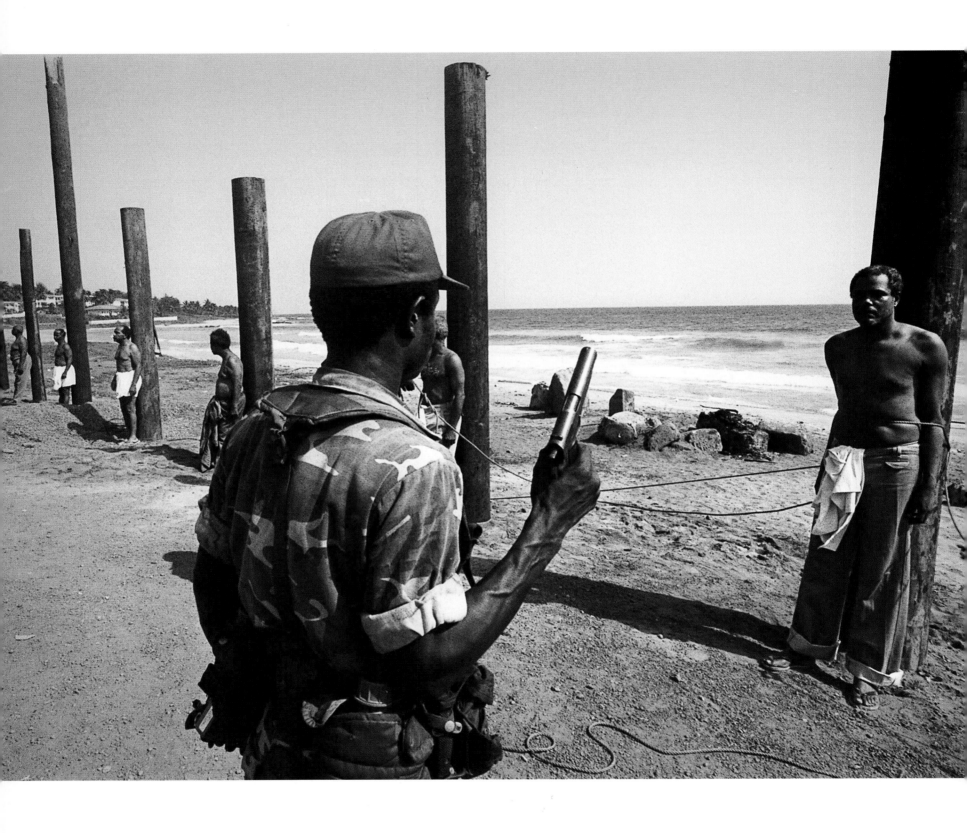

Execution on the Beach

BY LARRY PRICE, THE FORT WORTH (TEXAS) *STAR-TELEGRAM*

Larry Price went to Liberia to photograph missionaries but ended up covering the final phases of a coup d'etat—the mass execution of the government's leadership.

Liberia is a country that, by African standards, has had a long, stable history. It's roots, deep in American soil, go back to slaves freed before the American Civil War who sailed to Liberia to take up a new life. These black colonials developed a ruling aristocracy that presided over the more traditional tribal populations. Inequity was deeply established in the country.

In the small hours of April 12, 1980, Master Sergeant Samuel Doe headed up a handful of enlisted men who quietly entered the presidential grounds. They killed a staff of very surprised guards, stormed the corridors of the building's posh living quarters, and shot and killed President William Tolbert. The rest of the military, who like Doe came from the oppressed class, rose up in support of the insurgents. Political prisoners who had sought to install reforms and otherwise improve the lot of 90 percent of the population were set free.

Larry Price was assigned to cover the revolution's impact on missionaries in Liberia, many of whom had studied at a Baptist

divinity school in Fort Worth. He spent several days photographing schools, missionaries at work, and their lifestyle. Nearly finished with his missionary coverage, Price decided to attend a press conference, the first Doe had called some ten days after the explosive overthrow of the government. The conference was brief, but at the conclusion it was announced that executions were underway on the beach.

Nine stakes the size of telephone poles had been plunged into the sand; and, as Price arrived, thirteen members of the Tolbert cabinet had completed a forced march through the streets and nine of them were being lashed to poles. Armed soldiers stood nearby. Price originally took up a position with other members of the press corps; as the soldiers took their positions, however, he moved forward and stood behind the lineup of executioners. Thousands of onlookers watched in a near carnival mood, shouting, singing, laughing. The soldiers lifted their weapons; the crowd became silent.

Tolbert's men, Price recalled, looked exhausted. None of them spoke or struggled, but silently waited the inevitable, which came in a volley of rifle fire. As if on signal, the crowd burst out in joyous

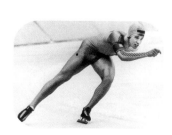

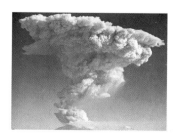

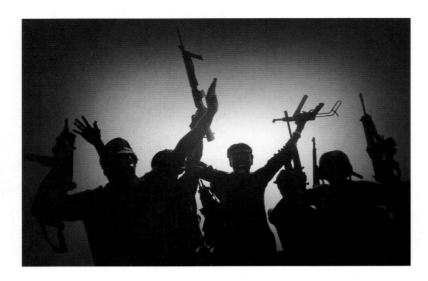

TECHNICAL DETAILS **CAMERA** Nikon and Leica
FILM Kodak
LENS Various, ranging from 20 mm
to 300 mm
SHUTTER & APERTURE Various

exclamation. The remaining ministers were taken to the stakes and lashed in place amid the bodies of their former comrades. Another volley echoed along the beach, and another cry erupted from the crowd. Soldiers moved forward and, in a frenzied blood lust, emptied their automatic weapons into the corpses. A flying shell case hit Price in the face. The jubilant crowd danced in the sand around the jumbled bodies.

The only American cameraman on the scene, Price boldly photographed it all, then left Liberia carrying his film past airport inspectors who carefully examined all the other journalist's baggage.

Some ten years later Sergeant Doe fell to an executioner's bullet.

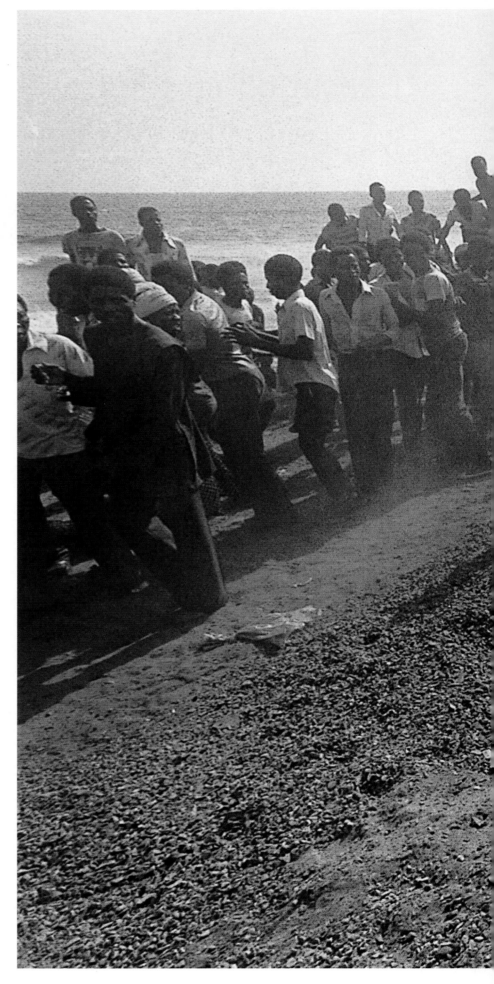

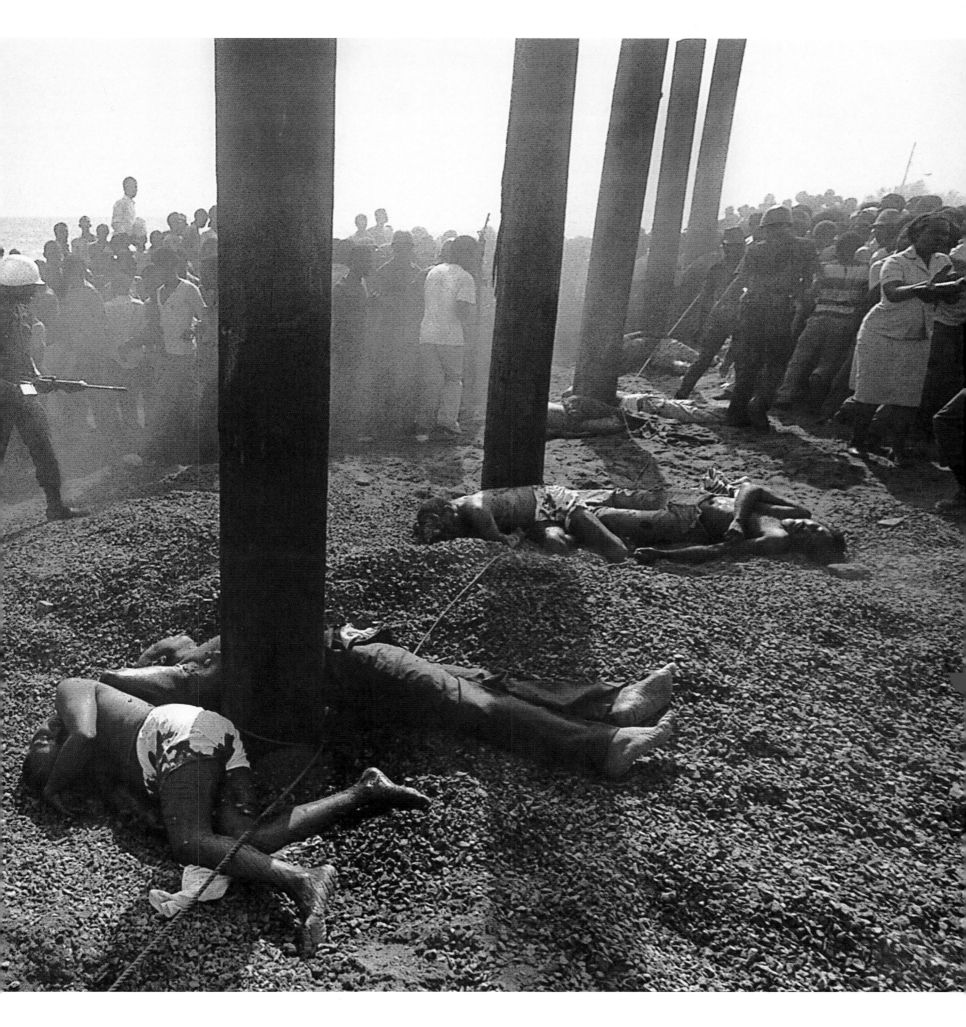

Life in Jackson Prison

BY TARO YAMASAKI, THE *DETROIT FREE PRESS*

When Taro Yamasaki proposed to his editors that he do a story on life in the State Prison of Southern Michigan at Jackson he said that the outside world really didn't know what was going on behind the silent walls. Reporters received their information filtered through prison authorities and photographers seldom, if ever, took cameras into the hidden world of bars, locks, and guards. He told his editors that someone, with a camera, had to go in there and talk to the prisoners, photograph their way of life and try to understand why violence was so much a part of the prison world.

The time was ripe for such a story, he said, because the fall election contained a proposition that held the promise of more funding for the prison system.

For support Yamasaki mustered an eclectic corps of backers.

- The warden wanted him to come inside to see and photograph the overcrowding in the hope his story would favorably influence the vote.

- The prisoners wanted him to see and photograph the violence, the prevalence of arms from knives to guns, and the pervasive presence of drugs.

- The guards, paid at the rate of $9 per hour, wanted the world to see what they had to contend with for their wages.

With that support Yamasaki began a twelve day odyssey into a world beyond the high gray walls and watchtowers that is all most people see of Jackson State Prison. His coverage started each day at 7:00 a.m. when the doors of the individual cells slid open and concluded at 9:00 p.m. when lockdown ended the day's activities.

Photography in a prison environment is difficult. Taking pictures requires concentration and attention to the subject. Prison

JULY 1980 ■ *Bjorn Borg defeats John McEnroe to win a record fifth consecutive Wimbledon title.*

AUGUST ■ *Led by electrician Lech Walesa, Polish shipyard workers strike; Solidarity becomes the first independent labor union in a Soviet-bloc country.*

NOVEMBER ■ *The U.S. spacecraft Voyager I sends back breathtaking images of Saturn's rings.*

DECEMBER ■ *John Lennon is fatally shot by a crazed fan outside of his apartment building in New York City.*

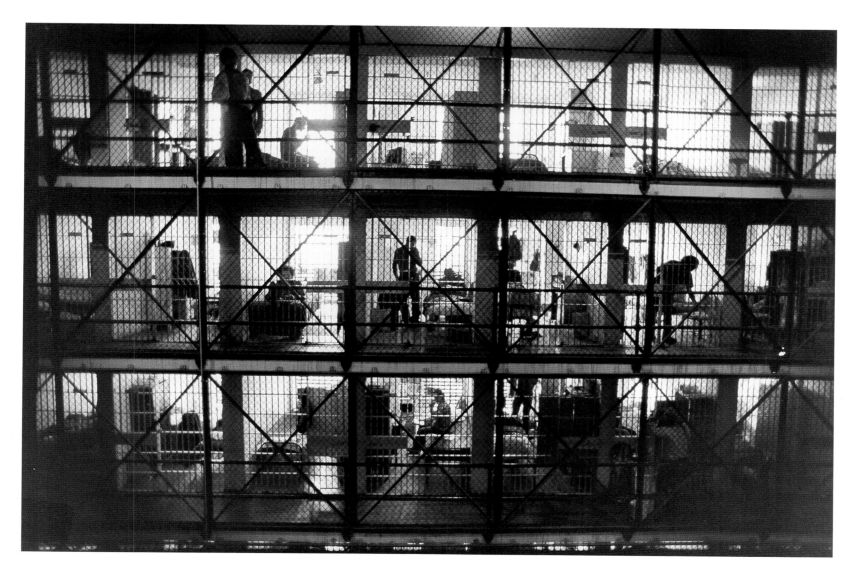

life, on the other hand, demands constantly being alert to danger, even if you are a visitor.

Yamasaki's first job was to win the confidence of both the prisoners and the guards.

"One of the conditions for my access to Jackson was that I would always be accompanied by one of the guards. After several days it became apparent that prisoners would not tell me about or show me examples of their real lives. So I convinced the guards to let me roam through the cell blocks alone."

Yamasaki recalls that it was scary working unescorted in the tense atmosphere of the prison but the story unfolded quickly. Prisoners showed him and allowed him to photograph their weapons—knives made from kitchen utensils and others made from broomsticks. They even gave him a price list.

Yamasaki reported, "Knives only cost $5 because they were made inside the prison. The price for knives went as high as $20 depending on the length of the blade." Yamasaki photographed prisoners with their weapons and reported in his story that scores of knives were made daily in different workshops in the prison.

"In here, man," Yamasaki quoted a prisoner, "not having a knife is a death sentence."

One prisoner, as he talked in his cell more than 100 yards from the guard office at the opposite end of his cell block, showed Yamasaki how a key, made from a bent soda can, could open more than 200 of the cells on the 300-cell block.

Yamasaki was never bothered by the prisoners. He discovered why in a conversation with an artist whose cell walls were decorated with his pictures of prison life.

"He told me that the prisoners believed that I was a martial arts expert. They came to that conclusion because I carried myself in a confident manner. I was Asian and, at the time I wore a ponytail. And they believed that I could kill with my hands, and so they let me alone. I'm not a martial arts type, of course, but what they believed was all right with me."

At the close of his final day of shooting Yamasaki said he felt a great relief at knowing he would not have to return to the prison.

TECHNICAL DETAILS

CAMERA Nikon
FILM Kodacolor and Kodak black & white
LENS Various, ranging from 24 mm
to 180 mm
SHUTTER & APERTURE Various

"The doors clanged shut and I really felt free." However, his relief was short lived. The *Free Press,* like many newspapers in the early 1980s, was just beginning to print color. Yamasaki, therefore, shot almost all black and white and only a few rolls of color film. But his editors, impressed by the color pictures, decided they would use more color with the story. They asked him to return to the prison to reshoot some material in color.

He did so, and his Pulitzer was one of the first that featured color pictures.

His story was carried as a seven part series in the *Free Press.*

In one of the stories Yamasaki wrote to go with his pictures, he quoted a guard talking about the pervasive violence and the overcrowding. The guard said that the only thing that would change the situation would be a riot. Several months later rioting broke out in the Michigan prison system.

Several years later Yamasaki left the *Free Press* and worked as a freelance photographer shooting primarily for *People* magazine covering stories as far flung as Bosnia and Nicaragua. He also taught at Michigan University's School of Art and Design, occupying the prestigious Distinguished Visiting Artist's Chair at the school.

Assassination Attempt on President Reagan

RON EDMONDS, ASSOCIATED PRESS

Ron Edmonds had worked for the Associated Press in Washington for years, and countless photo ops had passed before his camera. Photographing them had taught Edmonds one thing for certain—pictures come and go in the flicker of an off-guard smile, a glance in the right direction, or a fleeting expression. The hallmark of the successful Washington photographer is an ability to maintain a steady, persistent concentration level in order to capture images that get beyond routine.

An AP photographer always accompanies the President of the United States whenever he leaves the White House, whether it is a several-day journey to another part of the world or a cross-town visit to a convention, dinner, or a meeting. Edmonds had covered all kinds of trips, and on March 30, 1981, it was his turn to go with President Reagan on a quick speaking appearance at an AFL-CIO convention at the Washington Hilton.

As Edmonds waited outside the Hilton for the president to emerge, he consciously increased his concentration level, even though the event seemed thoroughly mundane. John Hinckley was also outside the Hilton. His concentration was fixed, as well, but his mission was different. His purpose was to shoot President Reagan with a .22 caliber, six-shot pistol commonly called a Saturday Night Special. Hinckley was a loner who had developed a fantasy relationship with actress Jodie Foster. Before he departed his hotel for the Hilton, he had written a love letter to Foster in which he said that he

hoped his attempt to "get Reagan" would open her heart to him. Foster had not the slightest idea who Hinckley was.

Because he was the pool photographer, Edmonds was on the opposite side of the limousine from the door Reagan would enter. The president would walk directly toward Edmonds, perhaps wave to the assembled crowd, or perhaps favor Edmonds, whom he knew, with a gesture directed at the camera. The general public, typical of crowds gathered where the president appeared, was cordoned off across a driveway, but Hinckley somehow worked his way into the press section to Edmonds's right.

It is nearly impossible to grasp how quickly the assassination attempt played out. The doors to the hotel opened, and Reagan stepped out, protected against a soft spring drizzle by a canopy. Edmonds raised his camera at about the same time Hinckley aimed his gun and he fired six shots in rapid succession. As the president walked to the car, waving to the crowd, it took Hinckley just 1.9 seconds to empty the pistol. At the sign of the first presidential gesture, Edmonds touched his camera's motor-drive button and

TECHNICAL DETAILS **CAMERA** Nikon
FILM Kodak
LENSES 35 mm and 85 mm
SHUTTER & APERTURE Various

JANUARY 1981 ▪ *Ronald Reagan is sworn in as the fortieth president of the United States.*

JANUARY ▪ *After 444 days in captivity, the U.S. hostages are freed in Iran.*

APRIL ▪ *The space shuttle Columbia, the world's first reusable spacecraft, lands safely after its maiden voyage.*

MAY ▪ *Pope John Paul II is wounded in Rome in an assassination attempt.*

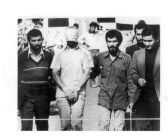

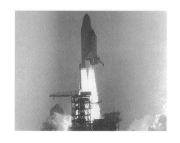

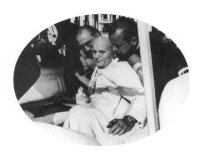

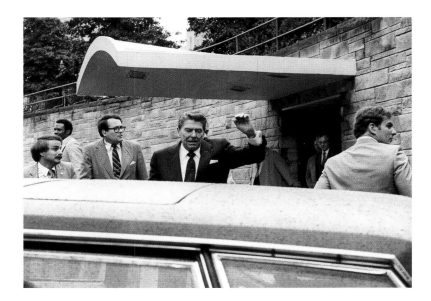

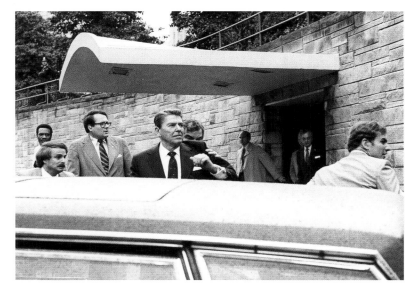

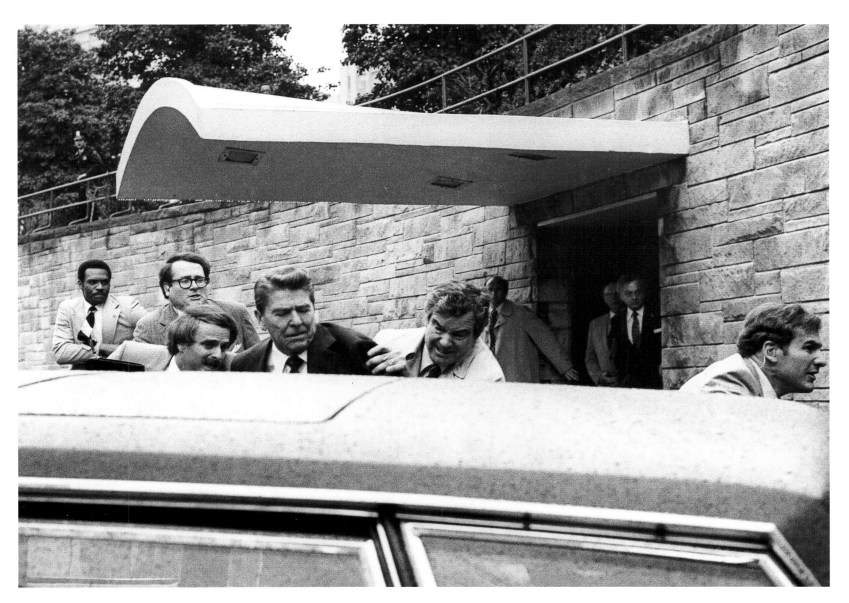

President Reagan waving at the the crowd (top, left). President Reagan becoming aware that an attack is underway (top, right). Secret Service Agents pushing the President into the limousine. Reagan was hit by the bullet an instant after this picture was made (bottom).

At the right in these three pictures is Agent Timothy McCarthy, who at the first shot reacts and moves to place his body in the line of fire. He was hit in the chest by one of Hinckley's bullets.

film whirled through the system at the rate of five frames per second. He heard the popping sound, and first thought it was firecrackers. He heard one bullet whiz past his head and then fly through a window of a building behind him. His picture series would show President Reagan beginning a wave to the crowd, then with a startled look, then being pushed by Secret Service agents into the limo.

The car sped off, but Edmonds's job was not complete. With the limo gone, he noticed the wounded left behind by Hinckley's attack. Presidential Press Secretary James Brady, hit in the head by Hinckley's first shot, had fallen to the sidewalk. Agent Timothy McCarthy, who at the first shot had placed his body in front of the president, was also on the sidewalk, with a bullet in his chest. Washington police officer Thomas Delehanty was also down, with a bullet in the neck. Behind the wounded, a Secret Service agent had his Uzi ready to protect against any further attack, and a pyramid of people had jumped Hinckley and disarmed him. Edmonds

continued photographing the scene. His pictures provide a full story of the attack.

President Reagan, who was hit by Hinckley's final shot, later told the nation that he felt like someone hit him in the side. He believed the pain came from being pushed into the limo by an agent when the firing began, but he soon coughed up blood and the limo rushed him to a hospital.

Reagan recovered; Hinckley was declared not guilty by reason of insanity and confined to a psychiatric hospital. Ron Edmonds was awarded the Pulitzer Prize for his picture coverage of the attack. He continued covering events of the capital in the Associated Press Washington bureau.

After the limousine pulls away Edmonds photographed the results of Hinckley's attack. The photo below shows Press Secretary James Brady, struck in the head by a bullet, lying on the sidewalk across a grate. The photo on the right shows Agent McCarthy in the foreground, after being hit in the chest. In the center of the photo is Washington police officer Thomas Delehanty, hit in the neck by Hinckley's first shot. James Brady's legs are alongside the fallen policeman.

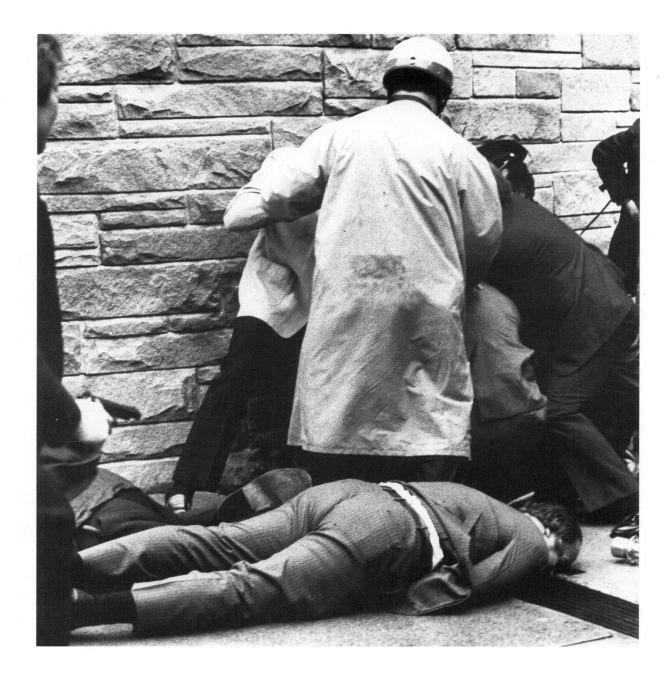

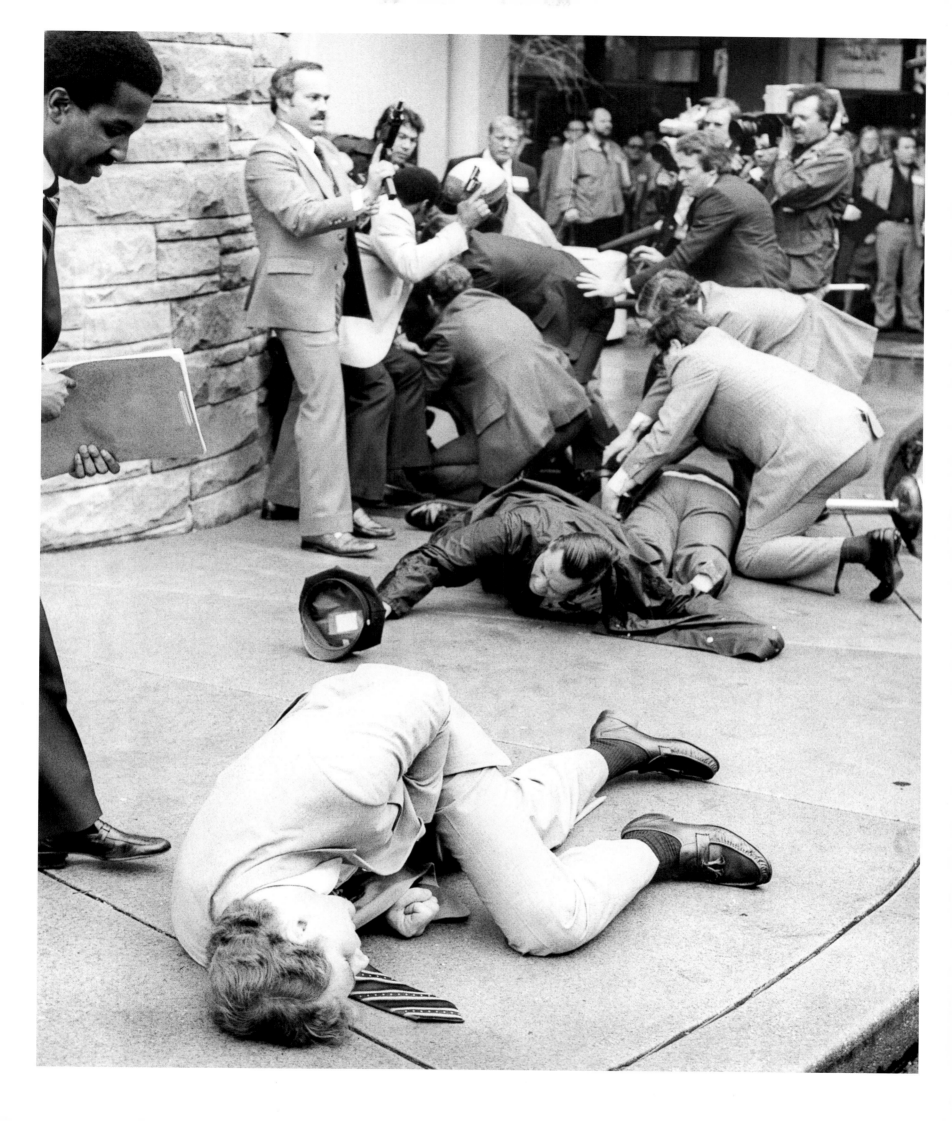

One Man's Chicago

BY JOHN WHITE, THE *CHICAGO SUN-TIMES*

Carl Sandburg called Chicago the "city of the big shoulders," and Nelson Algren named it the "Neon Wilderness" in his short stories. James T. Farrell captured the feel of the city's back-of-the-yards neighborhoods in his Studs Lonigan trilogy. Each writer saw a city different from the others, yet each portrayed a classic Chicago.

Photographer John White, a North Carolinian and an ex-Marine, went to the city to be a newspaper photographer. Like others who came from distant places, White likewise developed a vision of Chicago, but he expressed that vision in pictures rather than words.

His photos were not all about one story, nor did they follow a theme. They were observations from a photojournalist's notebook, vignettes White captured on film as he traveled through the Chicago where he lived and worked. Each picture was insightful and, taken together, the group made for a unique Pulitzer collection in which the total was greater than the sum of the parts.

"I see myself as a visual servant," White says, "showing people what I see in Chicago and what comes to me as I travel about the city on assignment. These special pictures are sometime full stories and sometimes just a single picture but they breathe a bit of Chicago across the newspaper page and they show something that people relate to."

The work White produced in 1981 led to thirty picture pages in the *Sun-Times* as well as twelve special photo projects for the paper, only a small number of which could be entered in the Pulitzer competition due to a limit of twenty photos per entry.

TECHNICAL DETAILS

CAMERA Nikon
FILM Kodak
LENS Various
SHUTTER & APERTURE Various

JULY 1981 ■ *Sandra Day O'Connor is appointed to Supreme Court. She is the first woman to serve on the high court.*

JULY ■ *Britain's Prince Charles marries Lady Diana Spencer at St. Paul's Cathedral in London.*

OCTOBER ■ *Anwar el-Sadat, the Egyptian leader who made peace with Israel, is assassinated.*

Massacre at Sabra Camp

BY BILL FOLEY, ASSOCIATED PRESS

The history of the Middle East, especially since World War II, has been a continuum of violence, bloodshed, and death. One incident has led to another, then another, and another, and on through the decades. International power politics, religious and cultural differences, and the need for vengeance have all played a role in aggravating the moods, polarizing the factions, and creating a pervasive volatile atmosphere that, time and time again, has exploded in the streets of the area's cities.

In the early 1980s, Associated Press photographer Bill Foley covered the Middle East from his home base in Cairo. He was present in 1981 when Egyptian president Anwar Sadat was assassinated by

Muslim fundamentalists as he watched a military parade in Cairo. It was said that Sadat was shot because he had betrayed Palestinians when he signed the 1979 Camp David accords with Menachim Begin of Israel. As Foley photographed the aftermath of Sadat's assassination, he made pictures while enraged soldiers who had been assigned to protect Sadat lashed out at everyone who looked different or unusual. Foley did all he could do to get away from the parade ground with his pictures.

The Sadat assassination recharged guerrilla activity in the form of attacks on Israel from Palestinian camps in Lebanon. In 1982, Begin launched an invasion of Lebanon with the stated goal to establish a twenty-four-mile security zone between Israel and the Palestinian camps. The incursion was so successful that Israeli troops soon occupied the southern third of Lebanon, up to the outskirts of Beirut. Three new Israeli goals quickly emerged: to oust the 6,000 or so guerrillas at PLO headquarters in Beirut, to push out some 60,000 Syrian troops that occupied northern Lebanon, and to establish a Christian government in Beirut friendly to Israel.

On September 14, however, the Christian president elect, Bashir Gemayel, was killed by a bomb. Foley was in Cairo when the assassination took place, and he rushed to Lebanon to cover the aftermath and the troubles certain to arise. On a Thursday, Foley visited a Palestinian refugee camp at Sabra. He knew people who lived there, and he was certain of the possibility of good pictures.

APRIL 1982 ■ *Argentine troops invade Britain's Falkland Islands and seize control of South Georgia Island.*

JUNE ■ *The movie* E.T., The Extra Terrestrial, *opens.*

SEPTEMBER ■ USA Today *begins publication, keeping stories brief and making wide use of color.*

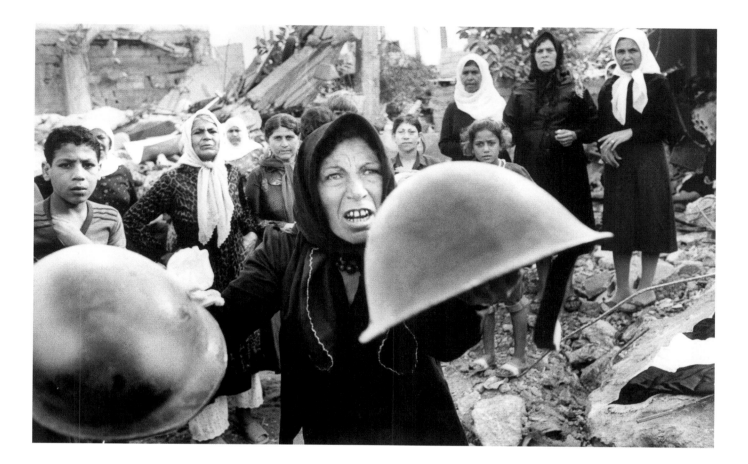

Armed militiamen at the gates of the camp ran him off, but not before he heard the noise of armored vehicles in the camp and the more distant sound of random gunfire.

Foley returned twice on Friday, and each time he met the same resistance. Starting out by taxi early on Saturday, Foley arrived to find the gates unguarded. He entered the camp. "You could hear your heartbeat, it was so quiet," he said. "Usually the camps were noisy with kids running around, and donkeys in the street, and people everywhere. But that morning nothing moved.

"I noted what looked like a pile of rubbish at one spot in the street; but as I got closer, I saw that it was a pile of dead bodies. Then I looked in a house window and saw a family that had been shot as they ate dinner. Down the street was the corpse of a dead horse, its throat slit."

While he was making pictures, Foley learned from survivors that the militia hired by the Israelis to manage the Palestinian camps had turned its wrath over the Bashir Gemayel assassination on the camp members and had slaughtered some eight hundred of them, mostly women and children.

The sound of oncoming vehicles alerted Foley to the fact that Israeli forces were coming to the camp, so he and his taxi driver departed. Using a circuitous route through Beirut, they made their way to an Israeli press camp at Baabda, in the Israeli-controlled sector of Lebanon just outside Beirut. Foley placed a call to AP in New York and dictated details of the story. He was about to transmit his photos on the same phone circuit when the power was cut.

Foley had heard that NBC television had arranged a charter air-

TECHNICAL DETAILS **CAMERA** Nikon
FILM Kodak
LENS Various, ranging from 20 mm to 18mm
SHUTTER & APERTURE Various

craft to carry television footage to Tel Aviv; and as he and the taxi driver headed for the airport, he hid his prints and film in the back of his shirt, just in case they were stopped. They made the plane, put the film and prints in the pouch, and AP staff in Tel Aviv transmitted the pictures to the world.

International reaction to Foley's pictures and their mute testimony to the massacre at Sabra Camp was vigorous. In 1983, an Israeli investigation found that Israel's Defense Minister, Ariel Sharon, bore indirect responsibility for the incident. Throughout 1983 Foley found himself in the middle of an urban guerrilla conflict as various factions fought to protect their turf. Snipers fired at passersby. Car bombs exploded. The U.S. embassy was bombed. The barracks housing a U.S. military group assigned to Beirut to repair the embassy was bombed, killing two hundred and forty one servicemen. Foley's pictures, flashed to the world on the AP wire, told the story day to day and showed the city as a bona fide war zone. Beirut, once called the Pearl of the Middle East, was reduced to rubble.

Later Foley joined *Time* magazine in the Middle East, and then returned to New York, where he began to work freelance.

El Salvador Killing Ground

JAMES B. DICKMAN, THE *DALLAS TIMES-HERALD*

TECHNICAL DETAILS	
	CAMERA Nikon
	FILM Kodak black & white, plus Ektachrome and Kodachrome
	LENS Various, ranging from 20 mm to 180 mm
	SHUTTER & APERTURE Various

Terror gripped El Salvador in 1982 as the military escalated its harsh tactics to beat back a guerilla movement that was growing quickly. The turning point came earlier, in 1980, when Bishop Oscar Romero, a severe critic of government policies, fell to an assassin's bullet. Days later, a bomb was thrown into a group of mourners at his funeral.

In a country largely Roman Catholic, the violence at the Bishop's funeral generated a new bond among the various guerrilla groups and led to new and vigorous antigovernment activity. This, in turn, led to tougher crackdowns by the military.

John Dickman, of the *Dallas Times-Herald,* had visited El Salvador on several occasions during the early 1980s, and in 1982, when the strife was at its greatest, he accompanied military excursions into the countryside.

Death squads were common. Their purpose was to patrol the villages and cities and execute those thought to be in positions of antigovernment leadership.

Dickman's graphic pictures showed soldiers dragging the executed away from the killing ground. Another photo showed a woman standing in near collapse before the rifles of the executioners after being spared in a last-minute reprieve. Yet another showed the bleached skulls and bones of those slain, dumped and left for animal scavengers.

After winning his Pulitzer, Dickman joined the *Denver Post*, the sister paper of the *Times-Herald,* then later turned to freelancing.

NOVEMBER 1982 ■ *The Vietnam War memorial is dedicated in Washington, D.C. The names of all 57,692 killed or missing are inscribed on the memorial.*

NOVEMBER ■ *Leonid I. Brezhnev dies at age seventy-five, after seventeen years as Soviet party secretary.*

DECEMBER ■ *Barney C. Clark becomes the first recipient of an artificial heart.*

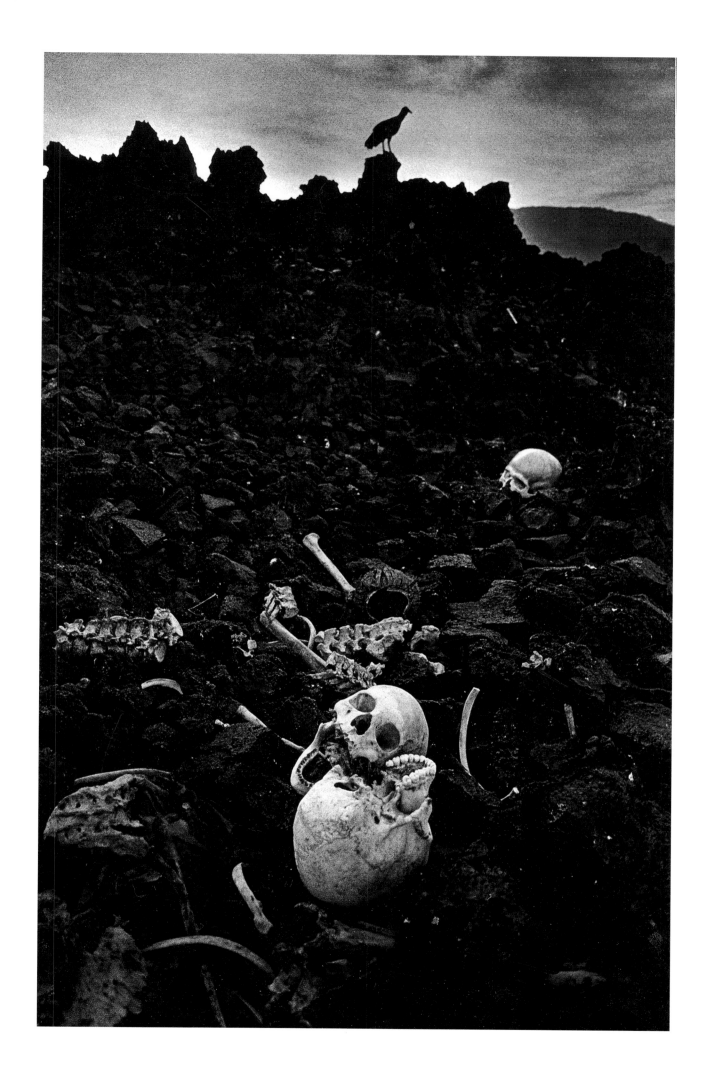

War and Children

BY STAN GROSSFELD, THE *BOSTON GLOBE*

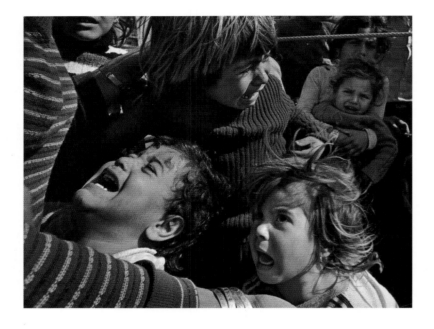

TECHNICAL DETAILS	
CAMERA Nikon	
FILM Kodak	
LENS Various, ranging from 18 mm to 300 mm	
SHUTTER & APERTURE Various	

There was plenty of violence to cover in Lebanon in 1983. The country was split by political, religious, and economic factors. Palestinian refugee camps that were home to guerrilla units were under constant attack by Israel. An Israeli invasion the previous year moved to the outskirts of Beirut before withdrawing under world pressure. A barracks where United States Marines on peace-keeping duty lived was blown up, killing two hundred and forty one. Car bombs exploded regularly, and Beirut's beachfront hotel district was in ruins. The city was a mess, beset by snipers, looters, and others passionately dedicated to their cause.

Stan Grossfeld, of the *Boston Globe,* covered his share of the war, making pictures during firefights in Tripoli as well as in Beirut. He frequently turned his camera away from the fighting itself, however, and focused on the children of Lebanon who knew no life but that of the besieged. His purpose was to show how the war had infiltrated the childhood world of Lebanon's coming generation.

To find good picture subjects, he carefully picked his way through the city's rubble, alert for snipers, who took potshots at anything that moved in sectors of the city considered "the other side."

JANUARY 1983 ■ *Chiang Ching, widow of Mao, has her death sentence commuted to life in prison.*

APRIL ■ *The U.S. Embassy is bombed in Beirut, killing sixty-three people.*

JUNE ■ *Sally Ride, one of a five-member crew aboard the space shuttle* Challenger, *becomes the first American woman to go into space.*

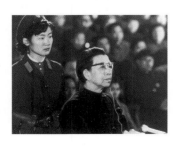

His searches were rewarded. Here and there he found children playing the games of children, just as their parents played the war games of grown-ups. There were children with hula hoops, but there were also children in panic as shells fell near their protected schools. Children rode Ferris wheels, but in the background were warships moving into place in the harbor. In one instance, Grossfeld discovered a group of children, armed with guns almost as big as they were, who had been assigned to protect younger children.

The Pulitzer Prize has frequently been awarded for photographs showing the heat of battle, or its impact on soldiers involved, but in this case it was given to a photographer who, although assigned to cover the war, had the instinct to step back and document the greater implications of the situation in Beirut.

1984 [FEATURE]

Remembrance

BY ANTHONY SUAU, THE *DENVER POST*

Some pictures are so simple and so direct, and have a message so clear, that they need no caption or explanation. And sometimes such pictures win a Pulitzer Prize, as this photo did for Anthony Suau. He saw the woman in the cemetery on Memorial Day in 1983, made a telephoto shot, and then asked her permission to use the picture in the paper. It appeared on the front page.

TECHNICAL DETAILS **CAMERA** Nikon
FILM Ektachrome
LENS Telephoto
SHUTTER & APERTURE Unknown

SEPTEMBER 1983 ▪ *Australia wins the Americas Cup, ending the U.S.'s 132-year reign, the longest winning streak in sports history.*

SEPTEMBER ▪ *The U.S.S.R. shoots down a Korean Airlines 747 carrying 269 people, claiming the plane was spying for the U.S.*

OCTOBER ▪ *The U.S. invades Grenada to restore democratic institutions and to repel a group of what President Reagan calls "Cuban thugs."*

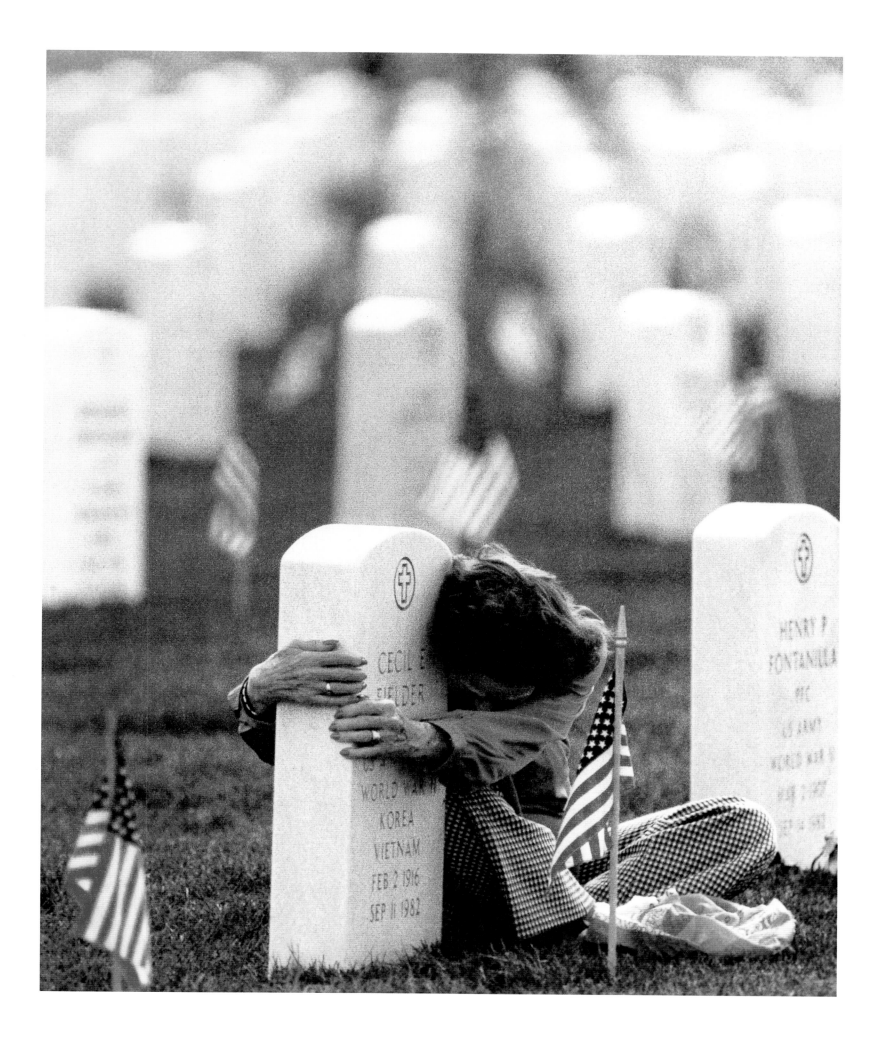

The Los Angeles Olympics

BY THE STAFF OF THE *ORANGE COUNTY (CALIFORNIA) REGISTER*

The Olympic Games are a spectacle. Exotic languages from every corner of the world are spoken in a single city. Pageantry abounds. Athletes are motivated to run faster, jump higher, and throw greater distances than they do at other competitions.

The Games are a photographer's delight. With muscles rippling and faces taught with strain, the athletes push their talents to the ultimate limit. Joyous winners celebrate their victories enthusiastically; losers sometimes show their disappointment openly. Because the events are structured, photographers have the opportunity to seek camera positions that will produce pictures at once artistic and newsworthy. The smaller cameras and, more importantly, longer lenses available for recent Games offer challenging picture possibilities to the creative photographer.

The Los Angeles Olympics of 1984 was different from other games in one respect. The Soviet Union, in retaliation for an American boycott of the 1980 Moscow games, refused to participate, and most of the Eastern European nations followed suit. Still some eight thousand athletes from 140 countries gathered in a steamy Los Angeles August for two weeks of competition.

The *Orange County Register*, which is published in Santa Ana, California, assigned three staff photographers. Their goal was to cover the games and tell the story of the winners and losers, but to give special attention to pictures that also caught the beauty of the Olympic pageant.

Rick Rickman, Hal Stoelzle, and Brian Smith did just that. Their combined picture portfolio told both stories—athletic achievement and the beauty of the Games.

MAY 1984 ▪ *Public confidence in banks declines after the Continental Illinois Bank narrowly escapes failure.*

JULY ▪ *Geraldine Ferraro is picked by Walter Mondale to be his running mate for the presidential campaign.*

JULY ▪ *Miss America Vanessa Williams is forced to give up her crown due to the furor over the publication of nude photographs of her.*

OCTOBER ▪ *India's Indira Gandhi is assassinated at age sixty-six.*

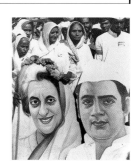

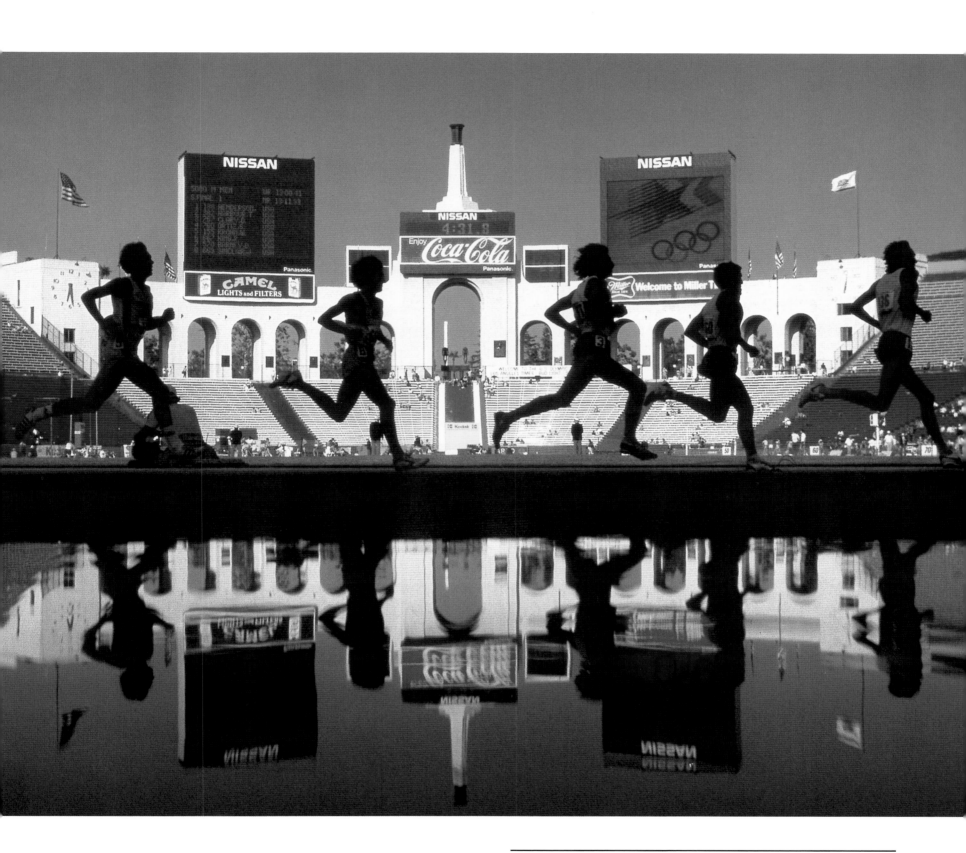

TECHNICAL DETAILS **CAMERA** Nikon
FILM Kodacolor
LENS Various
SHUTTER & APERTURE Various

Famine

BY STAN GROSSFELD, *BOSTON GLOBE*

Ethiopia was dry in 1984. Subnormal rainfall had reduced grain production for three years until it was dropping at precipitous rates, as much as 30 percent a year. The problem was not unique to Ethiopia; all of Africa was suffering as the fields once lush with crops slowly turned to dust.

The lack of food put people on the move, forcing them from their farms and villages to refugee camps that had been set up on an emergency basis. The situation was made worse by rebel activity in Ethiopia, another problem common to the African nations. Food became first the trophy of the rebel and guerrilla groups, and then became the national currency. Shipments of international aid were diverted from one side of the political spectrum to another, depending frequently upon which side controlled the highway or the warehouse involved in food shipments.

Stan Grossfeld, a Pulitzer winner of the previous year for pictures made in strife-torn Lebanon, went to Africa and provided some of the first pictures to come from rebel-held areas. This was the year that international aid officials estimated that half a million people perished from starvation.

Classic among all-time Pulitzers is his striking picture of an African madonna, holding her starving child only hours before the child perished in a refugee camp. Another photo shows a line of refugees fleeing hostilities and beginning their trek across a dusty plain bound for a refugee camp in Sudan.

These early pictures by Grossfeld were the first of several Pulitzer Prizes that showed the persistent famine problems and the brutal civil war that inevitably became woven into a fabric of politics and starvation in Africa.

TECHNICAL DETAILS **CAMERA** Leica and Nikon
FILM Kodak
LENS Various, ranging from 24 mm to 200 mm
SHUTTER & APERTURE Various

DECEMBER ▪ *Bernard Goetz, New York City "subway vigilante," shoots four black youths on the subway after they allegedly robbed him.*

DECEMBER ▪ *A Union Carbide plant in Bhopol, India, leaks lethal gas, killing more than 2,000 people.*

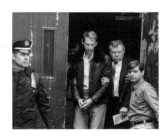

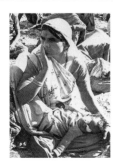

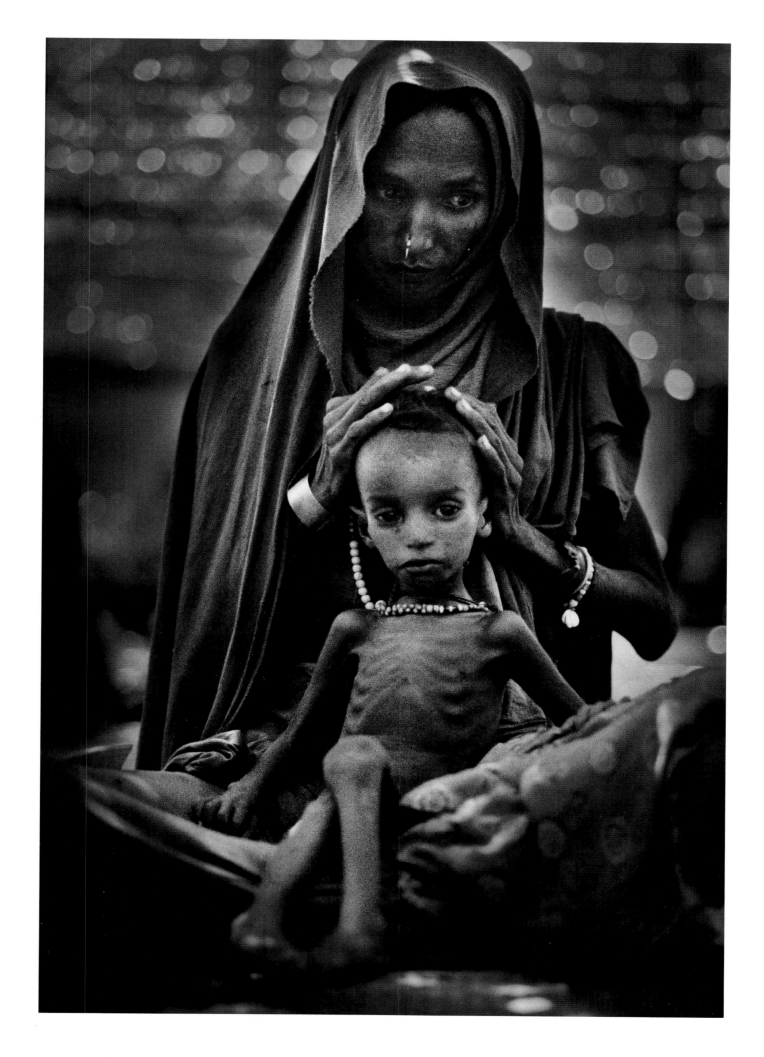

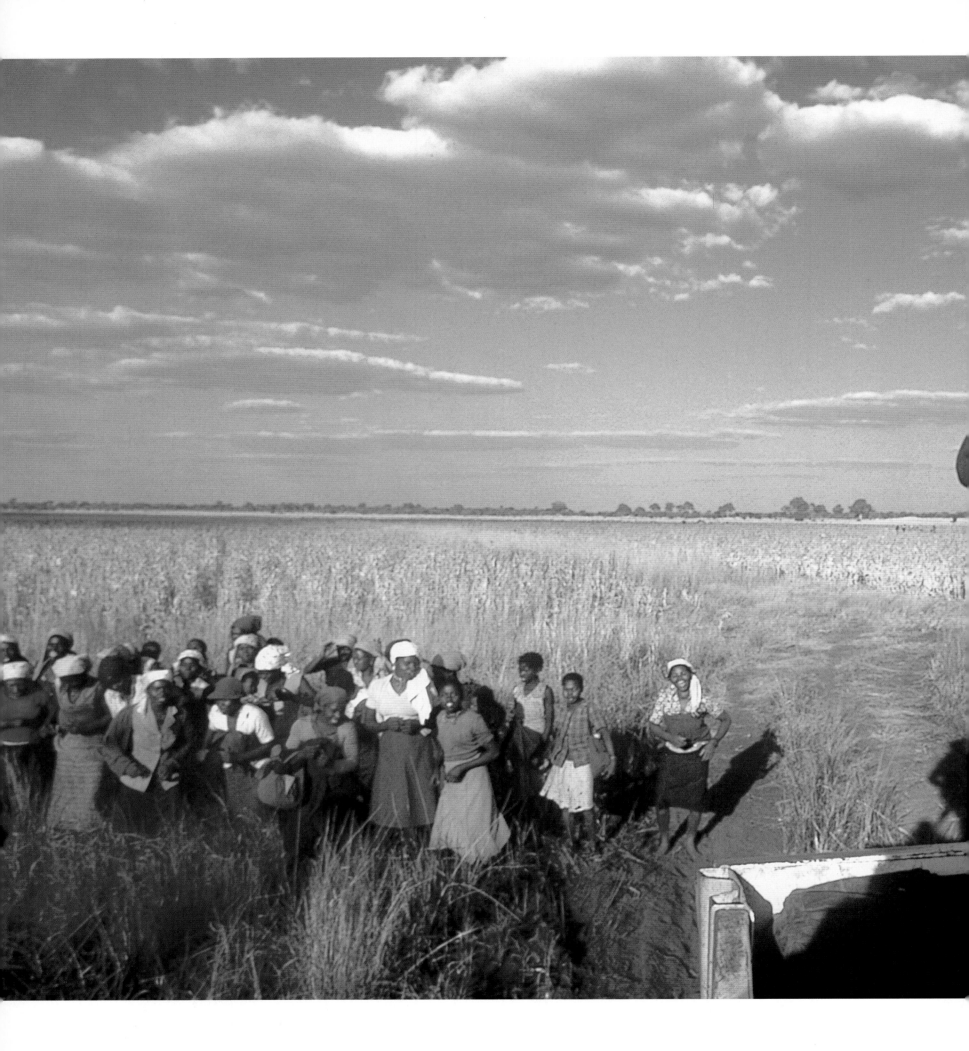

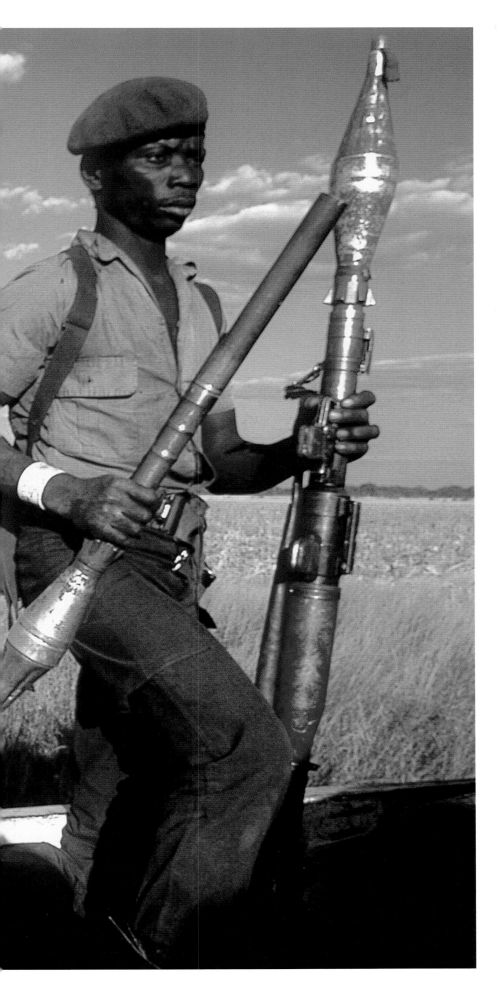

Covering The Rebels

BY LARRY PRICE, THE *PHILADELPHIA INQUIRER*

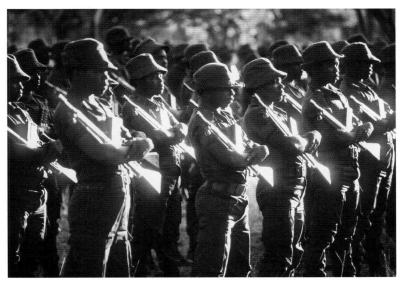

Shooting pictures of rebel movements in third world countries is a dangerous game. Larry Price of the *Philadelphia Inquirer* covered two separate rebel struggles in 1984.

Angola

High on the list of "to do" stories at the *Inquirer* was a feature on a rebel movement in Angola. Backed by the United States against the Cuban/Soviet supported central government, the well-armed rebels held about half of the country, but coverage of their activities had been light. There were problems contacting them and there would be problems getting into the country.

Price found a way, however, when he met a nurse who knew medical aid personnel working in Angola. They put him in touch with anti-government Angolan representatives in Washington; after months of conversations, the setup was arranged. Price and an *Inquirer* writer traveled to Zaire, where authorities were sympathetic to the rebels. They did not enter the country officially but embarked on an eight-hour flight in a prop plane that took them to rebel head-quarters in Angola. There they joined a rebel unit in the field.

"We spent weeks," Price reported, "riding in the back of a

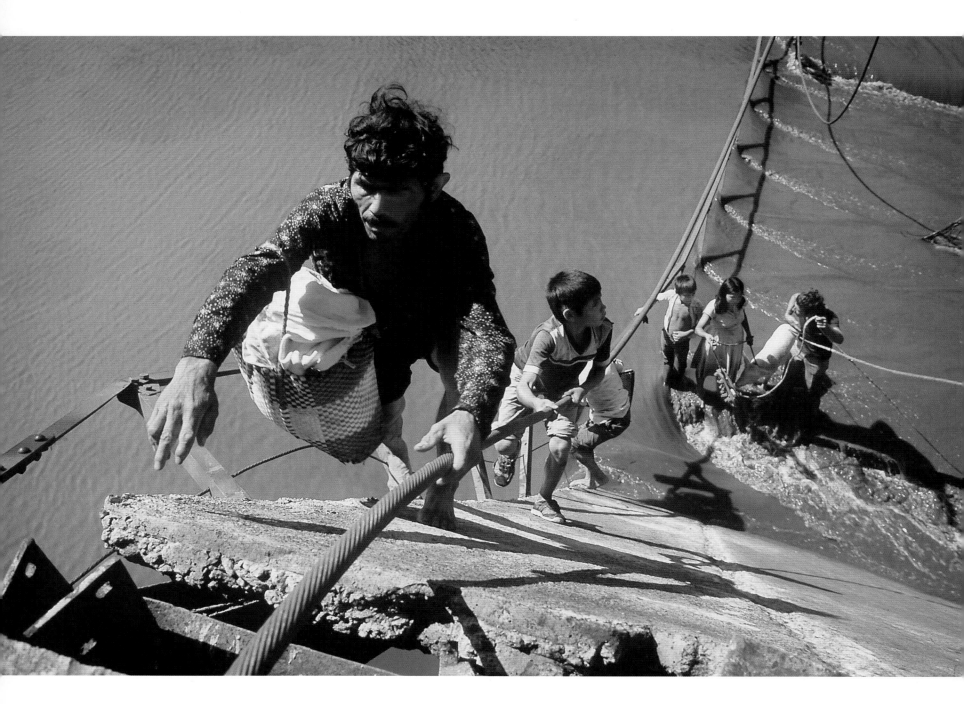

TECHNICAL DETAILS **CAMERA** Nikon
FILM Kodachrome
LENS OPENING Between f8 and f11
SHUTTER SPEED 1/400th second

truck with the soldiers. The trip was supposed to last three weeks, but it went on for six. Once in, we couldn't get out when we wanted to. Our families and the people at the *Inquirer* wondered what happened to us."

At one point the rebel unit was pinned down in a town by Angolan air surveillance and went without water for two days, but eventually they slipped out, crossed into Zaire and returned home.

El Salvador

Coverage of rebel troops in El Salvador proved more dangerous, simply because there was much less territory for the rebel soldiers to hide in. Government troops were in better control, and at one point, an army helicopter caught Price's unit in an exposed position and attempted to wipe out the rebels with gunfire.

"We scrambled for cover under a culvert and were safe, but the greater fear was that government ground troops would be sent out to capture the rebel units," Price said, "but that didn't happen."

Both the Angola and the El Salvador stories appeared as major layouts in the *Inquirer*'s Sunday magazine.

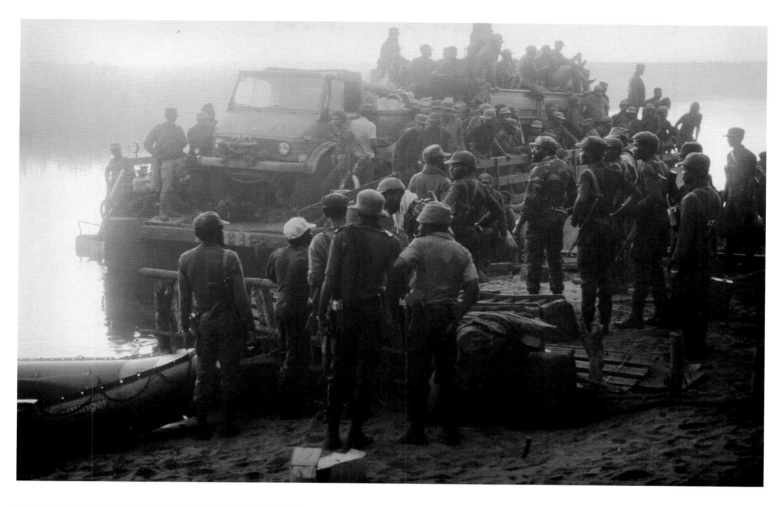

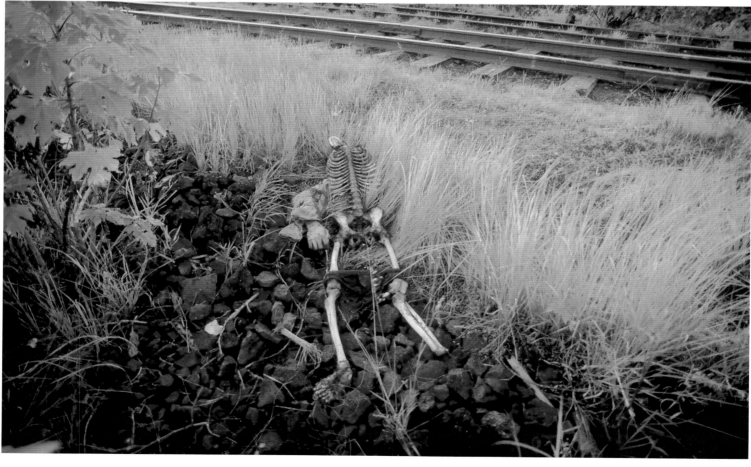

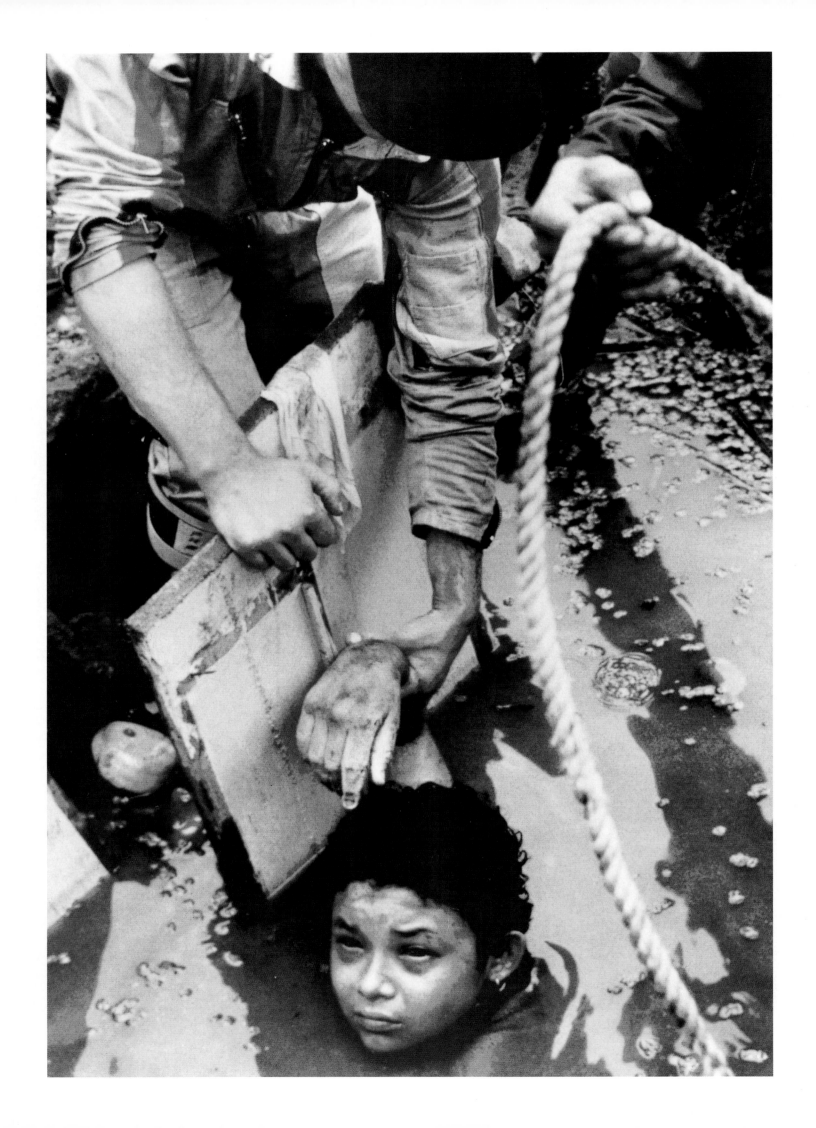

Volcano Disaster in Colombia

BY CAROL GUZY AND MICHEL DUCILLE, THE *MIAMI HERALD*

A Colombian monk wrote in his report that the volcanic eruption sounded like three canon blasts. Local rivers, he reported, flooded with melted snow mixed with ash and dirt and the odor of sulfur was unbearable. He signed his report: Father Pedro Simon, March 12, 1595.

Some four hundred years later, on November 13, 1985, Manuel Cevero guided his jet cargo plane through the night sky toward Bogota. The volcano Nevado del Ruiz, the same one Father Simon described, exploded, sending red illumination 26,000 feet upward as the jet passed over the 17,700-foot peak. Cevero said a shower of ash covered the aircraft, scorched its nose cone, and left him with no visibility. The cockpit filled with smoke and heat and the smell of sulfur. Using instruments, Cevero headed for nearby Cali; he had to push open his side cockpit window to identify the airfield's landing lights. He was one of the lucky ones.

A second detonation, ninety minutes after the first, exploded with a force sufficiently strong to be felt in Cali, 150 miles away; some Cali residents mistakenly thought it to be a terrorist bomb. It was one of history's most violent volcanic eruptions, ranking with those that destroyed ancient Pompeii. The residents of Amero, Colombia, would soon know that Ruiz's destructive power was just as devastating as that ancient volcano.

MARCH 1985 ■ *Mikhail Gorbachev becomes general secretary of the Soviet Communist Party.*

JULY ■ *Seventeen-year-old Boris Becker wins the men's singles title, becoming the youngest Wimbledon champion in history.*

SEPTEMBER ■ *An earthquake measuring 7.8 on the Richter scale hits Mexico City, killing more than 5,000.*

SEPTEMBER ■ *Researchers locate the wreckage of the Titanic in water 12,000 feet deep south of Newfoundland.*

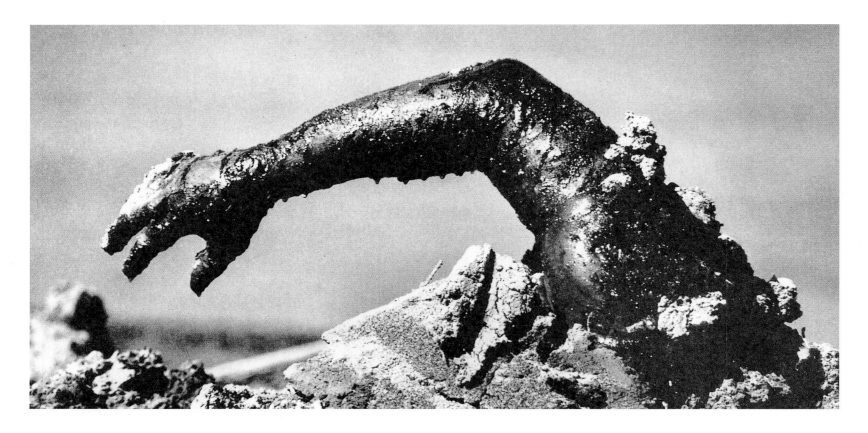

TECHNICAL DETAILS **CAMERA** Nikon
FILM Fuji color negative
LENS Various
SHUTTER & APERTURE Various

Amero was located in a canyon, a neat, prosperous community of 22,000. The residents of Amero worked crops in the fabulously rich soil created by a previous Ruiz eruption in 1845.

Ruiz's rebirth sent steam and ash into the Andean air and created an avalanche of snow, mud, boulders, and slime that plunged toward Amero about thirty miles away. The avalanche grew and gained speed as it roared downward, eventually creating a crest fifteen to thirty feet high. In a single sweep the avalanche wiped out the town, leaving more than 21,000 dead.

Miami, Florida's, 175,000 Colombians focused their attention on the story, and the *Herald* sent Carol Guzy and Michel duCille to cover it. They were enroute by 9:00 a.m. the next morning, just six hours after the eruptions, in a chartered Lear jet shared with other news organizations.

Once on the ground in Colombia, Guzy and duCille drove part way but were forced to walk the final three or four hours to

Amero. "We were under terrific pressure to shoot pictures and get back to a city where we could transmit photos home for the next morning's edition," duCille recalled. "We spent only about an hour at the scene that first day, but we shot just about everything we could. The local people were helpful even as they worked at the rescue operation."

What they saw and photographed testified to the sudden wall of death that had swept across the town. One man's arm was poised in a swimming-like motion, although his body was crushed by the heavy slime. A young girl, held in a death grip by her aunt, was submerged in water up to her chin. The rescuers worked for several days, but they were unable to extricate her and she died.

After shooting as much as they could, the two photographers started their long trek to Bogota. Once back in the city, they prepared their pictures and transmitted them home to Miami.

Each returned to Amero and stayed for several days to do additional coverage, but the portfolio that won the Pulitzer came almost exclusively from their first day's shooting.

Guzy and duCille would each win another Pulitzer in later years for separate stories. Both later joined the *Washington Post,* duCille as photo editor and Guzy as a staff photographer.

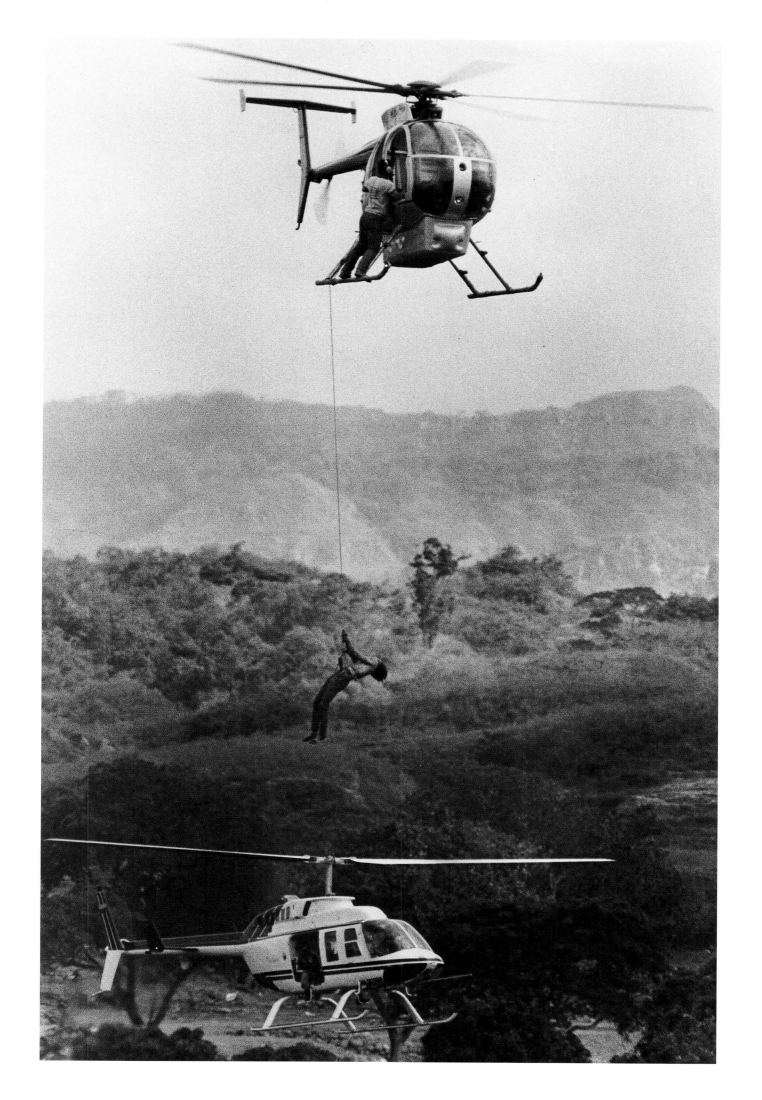

1986 [FEATURE]

Homeless in the Winter

BY TOM GRALISH, THE *PHILADELPHIA INQUIRER*

Winter in the city is cruel to the homeless. The cold combines with sleet and wind, and, without protection against falling temperatures after dark, the homeless often die where they sleep, in their cardboard homes.

Tom Gralish, of the *Philadelphia Inquirer,* had made pictures of the city's homeless over several years. He had photographed them during the holiday season, and they became an obvious subject for a cold-weather picture feature. When *Inquirer* editors decided to do a major photo feature on the homeless for the paper's Sunday magazine, it only seemed natural that he draw the assignment.

"My style is fly-on-the-wall photojournalism," Gralish says, "just straightforward picture coverage. What I really want to do is share my experiences and the life I see around me with others, with our readers."

The paper gave him a month to produce the picture story. His first step was to walk the streets where the homeless congregated and to figure out the best way to approach his subject. "For the first month, I only carried one camera and kept it pretty much out of sight. I wanted the people I covered to get used to seeing me around. I talked with them. I don't smoke, but I always had a pack of cigarettes in my pocket to share with those I met. In all cases, I told them I worked for the *Philadelphia Inquirer* and wanted to do a story. It didn't seem to bother them."

SEPTEMBER 1985 ■ *Baseball player Pete Rose makes his 4,192 career hit, breaking Ty Cobb's record.*

OCTOBER ■ *Palestinian hijackers commandeer the Italian cruise ship Achille Lauro.*

OCTOBER ■ *Film star Rock Hudson dies of AIDS.*

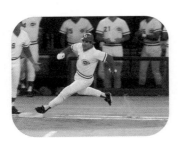

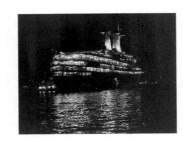

Gradually the story defined itself. He discovered that the various street corners in the area the homeless inhabited were each a separate community. He decided to concentrate on three.

Gralish's pictures showed the desperate methods the homeless adopted to survive Philadelphia's winter. He made pictures of Walter, the vent man, so-named because he camped out over a heating grate on the sidewalk. Others took to living in tiny huts made from old cartons that cut the wind but did little against the frigid air. Still others used mats made of newspaper layers as insulation against the frozen sidewalk.

Gralish made an effort to make pictures of other citizens reacting to the homeless. He photographed diners enjoying their evening meal while the homeless, separated from those indoors by a sheet of glass, watched from outside. And he caught pictures of the occasional concerned passerby who stopped to investigate the condition of a man or woman sleeping on the sidewalk in the glare of streetlights.

The magazine printed a multipage layout of some twenty pictures. "Winning the Pulitzer was gratifying," Gralish says, "because it gave validation for my style of photography. The other reward is that people stopped me in the office, and others, too, and said they liked the pictures."

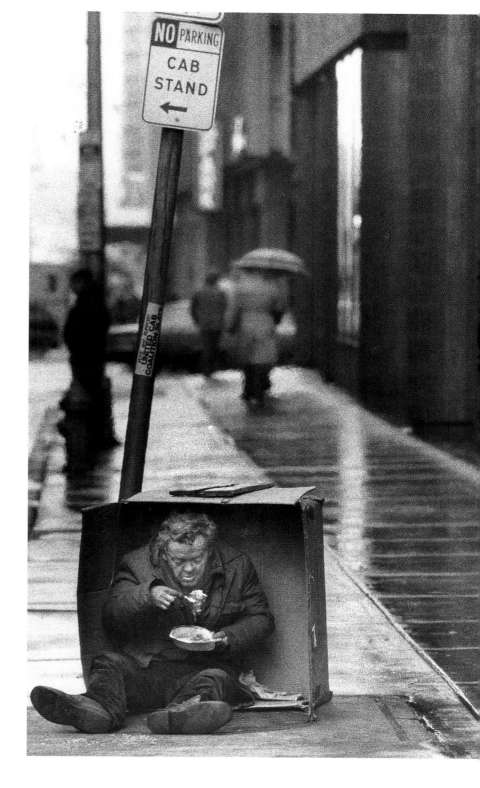

TECHNICAL DETAILS **CAMERA** Nikon
FILM Kodak
LENS Various, ranging from 24 mm to 180 mm
SHUTTER & APERTURE Various

179

Philippine Dictator Falls

BY KIM KOMENICH, THE *SAN FRANCISCO EXAMINER*

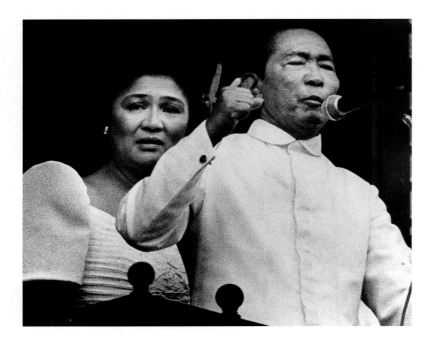

TECHNICAL DETAILS	
CAMERA Leica and Nikon	
FILM Kodak	
LENS Various, ranging from 24 mm to 500 mm	
SHUTTER & APERTURE Various	

Ferdinand Marcos ruled the Philippines with an iron hand for more than twenty years, but early in 1986 the end was clearly in sight.

The Marcos saga had been reported in detail by the *San Francisco Examiner* as part of its responsibility to Northern California's large Filipino population and because much of the Marcos resistance from the United States was based in the region.

Kim Komenich traveled to the Philippines on several occasions over two years not only to photograph feature stories, but also to cover the New People's Army, which opposed Marcos, and to do stories on the Muslim resistance in Mindanao, one of the nation's larger islands.

In February of 1986, history caught up with Marcos. He was newly re-elected, but his victory at the polls was known to be fraudulent. The Catholic Church, in a country 85 percent nominally Catholic, openly supported Marcos's critics. Army support was slipping, even among Marcos's elite personal guard.

On February 25, the army, which by then openly supported Corazón Aquino, wife of the assassinated Benigno Aquino, took over the television station in Manila. During the encounter, a man standing next to Komenich was shot in the head, and Komenich carried him out to a waiting ambulance. The situation was getting tense.

JANUARY 1986 ■ *The space shuttle* Challenger *explodes 73 seconds after liftoff, killing all astronauts on board, including schoolteacher Christa McAuliffe.*

MARCH ■ *Ferdinand Marcos is given sanctuary in Hawaii after Corazon C. Aquino is elected president of the Philippines.*

APRIL ■ *The Soviet Union's Chernobyl power plant explodes, sending clouds of radioactive fallout across much of Europe.*

JULY ■ *Newly refurbished, the Statue of Liberty celebrates her 100th birthday.*

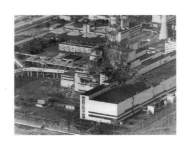

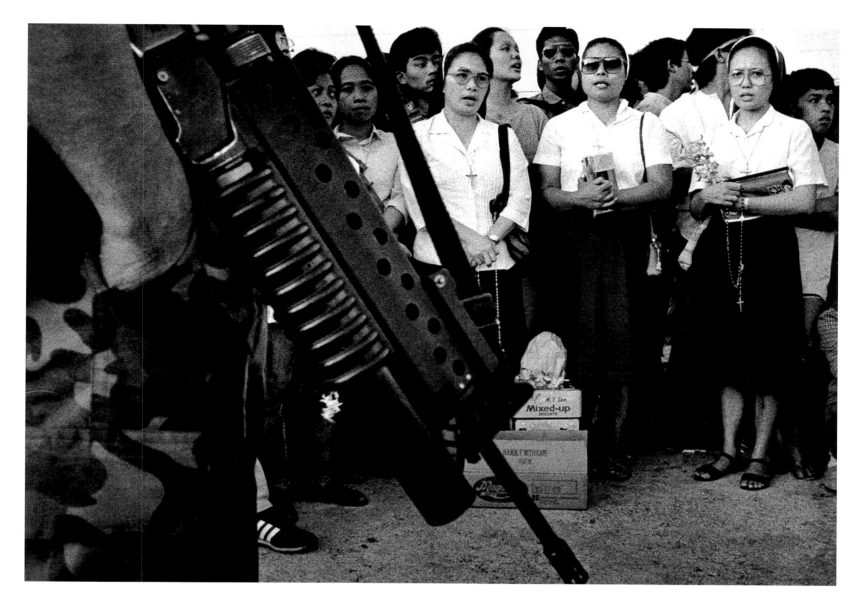

The Army installed Corazón Aquino as president, and she was prepared to make an inaugural speech. The Americans advised Marcos to leave the country to avoid a bloodbath, but Marcos was determined to make his own inaugural address. Within two hours, Komenich made pictures of Aquino being sworn in as president and photographed her making her inaugural address, then rushed to the presidential palace to document Marcos making his address, which, it turned out, was also his last public appearance in the Philippines.

To get from one site to another, Komenich drove through Manila streets ripe for violent revolution. Tires burned in the avenues and forces opposed to Marcos were coming together. Mass violence was avoided when, hours later, Marcos boarded an American aircraft for Guam and eventually Hawaii.

The announcement that Marcos was out prompted street celebrations in Manila not seen since the Japanese surrender in 1945 and the granting of independence from the United States in 1946. Komenich's picture coverage of the last days of the Marcos regime won the Pulitzer Prize.

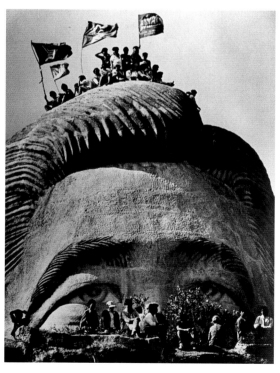

1987 [FEATURE]

Farmers in Crisis

BY DAVID PETERSON, THE *DES MOINES REGISTER*

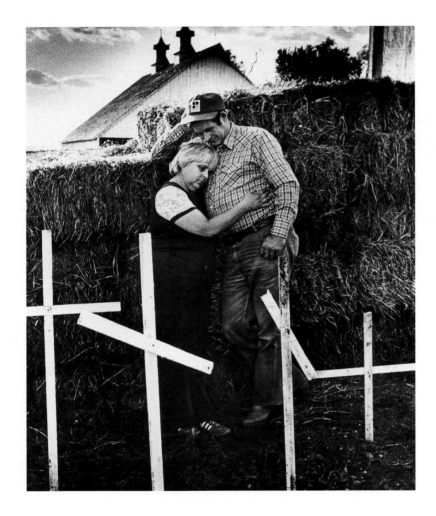

TECHNICAL DETAILS **CAMERA** Canon
FILM Kodak
LENS Various, ranging from 17 mm
to 300 mm
SHUTTER & APERTURE Various

The prairie spreads west and south and north from Chicago, an end-less, flat stretch of soil rich enough to feed uncounted millions. A motorist who cruised at sixty-five miles per hour past field after field of full-grown grain might wonder why farmers would have difficulty surviving in land gifted with such a promising natural resource.

The difficulty was there, however, laid out in ample statistics that told a devastating tale—families could coax the soil to yield its fruit, but fell victim to the financial vagaries of farming in the late 1980s. The experts had urged farmers to expand when crop prices were high. Then after land values went up, they suddenly col-lapsed; and farmers who were burdened with the debt of expansion were out of business. The towns followed in the wake of the farm failures, and soon empty stores lined empty streets.

The *Des Moines Register* tracked developments in Iowa over several years, piling detail upon detail; teams of reporters and pho-tographers came from other states to tell the story, too.

David Peterson, a photographer at the *Register,* believed that the story should be told in pictures that transformed the faceless numbers into the human tragedies they represented. He wanted to tell it through the eyes of a few families who actually struggled and lost. His approach would take a lot of time, and the first reaction from his editors was

lukewarm. But Peterson was determined, and he used a sabbatical plus another month the paper made available to pursue the pictures.

Before he began, Peterson first spent considerable time planning; he prepared a series of goals, one of which called for him to make just three truly fine photos each week. "I just took it bit by bit, picture by picture, building the story gradually," he said. "It can be difficult making pictures under those conditions. You can't just walk around putting your camera out there and shooting away. You have to build trust with the people, they have to get to know you. After a while, the people get used to you and the pictures look natural."

He worked with several families, but spent much of the time with Pat and Elmer Steffes, a farm family he had covered on several occasions over the years.

Journalistic balance was tough to maintain, because Peterson was personally sympathetic to the farmers' predicament. "They [the farm families] loved the land. The issue was more than money, much more," Peterson maintains. "They just liked working the land and making crops grow. When they lost their farms, they lost more than money. They lost a way of life."

Peterson made pictures of the Iowa farmers and their plight for four months, including images of their lost farms and their slow, sometimes agonizing transition to other forms of work.

Elmer Steffes lost his farm and became a long-distance truck driver, but he still lives in a small town not far from Des Moines where the plains ripen each summer and the air smells of rich soil.

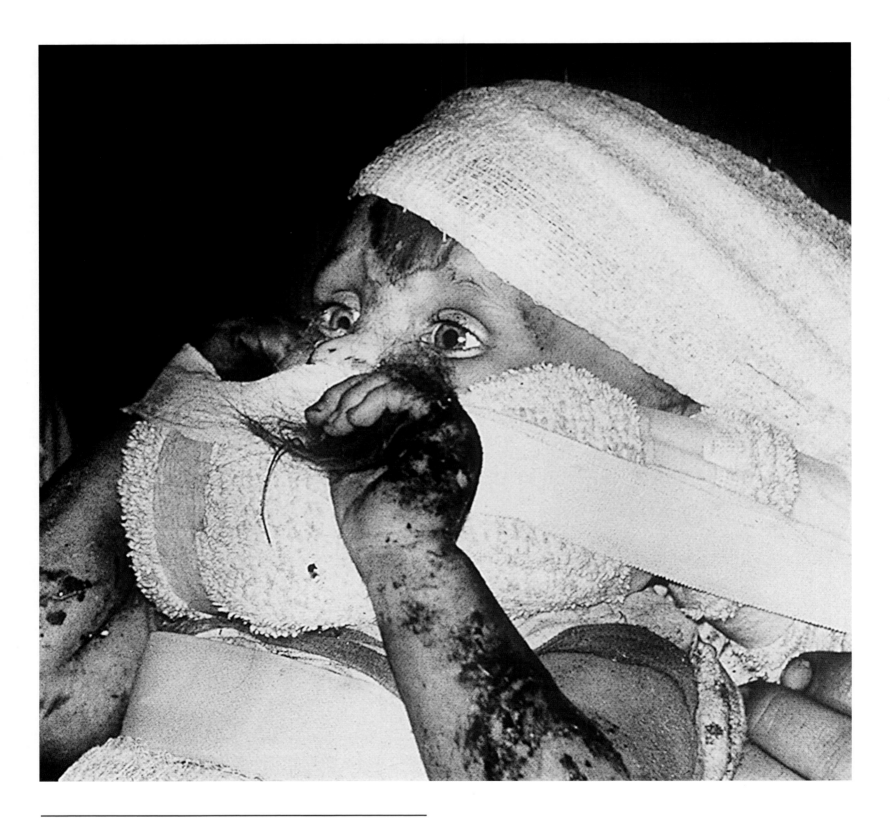

TECHNICAL DETAILS **CAMERA** Nikon
FILM Kodak
LENSES 180 mm and 300 mm
SHUTTER & APERTURE Various

Baby Jessica Saved

BY SCOTT SHAW, THE ODESSA (TEXAS) *AMERICAN*

There is a certain kind of story that takes a fixed place in our imagination and becomes lodged there forever. It is often a small story when seen in the perspective of the world news flow, but from another perspective it is important because, in a microcosm, it is each of our stories. It plays to our shared fears and forces us to ask what we might do should a loved one be the central player. The story's magnetism draws us into the saga, and it becomes our own. The story of Baby Jessica, who fell into a well. was one of those stories—a tiny child in distress, heroic workers fighting against time and nature, and, in the end, a joyous rescue.

It started simply enough. Cissy McClure, visiting her sister's home in Midland, Texas, not far from Odessa, heard the phone ring and went inside to answer it. Jessica, her one-year-old daughter, played contentedly in the yard.

The child wandered toward an eight-inch well hole covered only partly by a flower pot. In an instant, she plunged into the channel and down twenty-two feet, where she lodged in a dogleg turn in the well shaft's narrow channel.

In 1987, Midland was down on its luck because of the oil slump. Cissy and her husband, Chip McClure, were poor teenagers trying to get by; he worked as a housepainter, she occasionally babysat. Midland was also a town of real folks who rallied to bring Jessica to safety.

When word that a child had fallen in a well reached the assignment desk at the *Odessa American*, the editor attempted to reach Scott Shaw, but he was shooting another assignment and missed the call. Another photographer was sent to Midland.

At the scene, the rescue plan was simple—drill a twenty-inch channel down twenty-two feet, parallel to the well shaft that held Jessica, then cut into Jessica's channel and bring her out. There was no shortage of drillers in Midland; that was a trade these oil-field workers knew well.

After ten hours, they were two feet from Jessica, and the best guess was it would take about three more hours. By that time, Shaw had returned to his office and was sent to relieve the previously assigned photographer. At the scene, he waited for the rescue with a few other still photographers and a couple of local TV camera crews.

Suddenly the story changed from a local human interest item to a saga given worldwide attention. Tough granite blocked the path between the driller's shaft and Jessica, granite hard enough to snap expensive diamond-tipped drill points as if they were a schoolchild's lead pencils. The tight quarters of the rescue tunnel hampered workers and their cumbersome cutting tools.

"I don't think I ever drilled anything as hard as that," said driller Charles Boler, recalling the incident years later. "You could hear Jessica crying as we got closer. That's what kept me going, because I had a two-year-old child and I could identify with the family."

MAY 1987 ■ *Democratic presidential nominee candidate Gary Hart is forced to withdraw due to highly publicized adultery charges.*

JULY ■ *A French court finds former gestapo chief Klaus Barbie guilty of war crimes and sentences him to life in prison.*

JULY ■ *Oliver North testifies that he supplied arms to Nicaraguan contras with proceeds from the sale of weapons to Iran.*

OCTOBER ■ *The Dow Jones plunges 508 points, a fall sharper than the drop in October, 1929.*

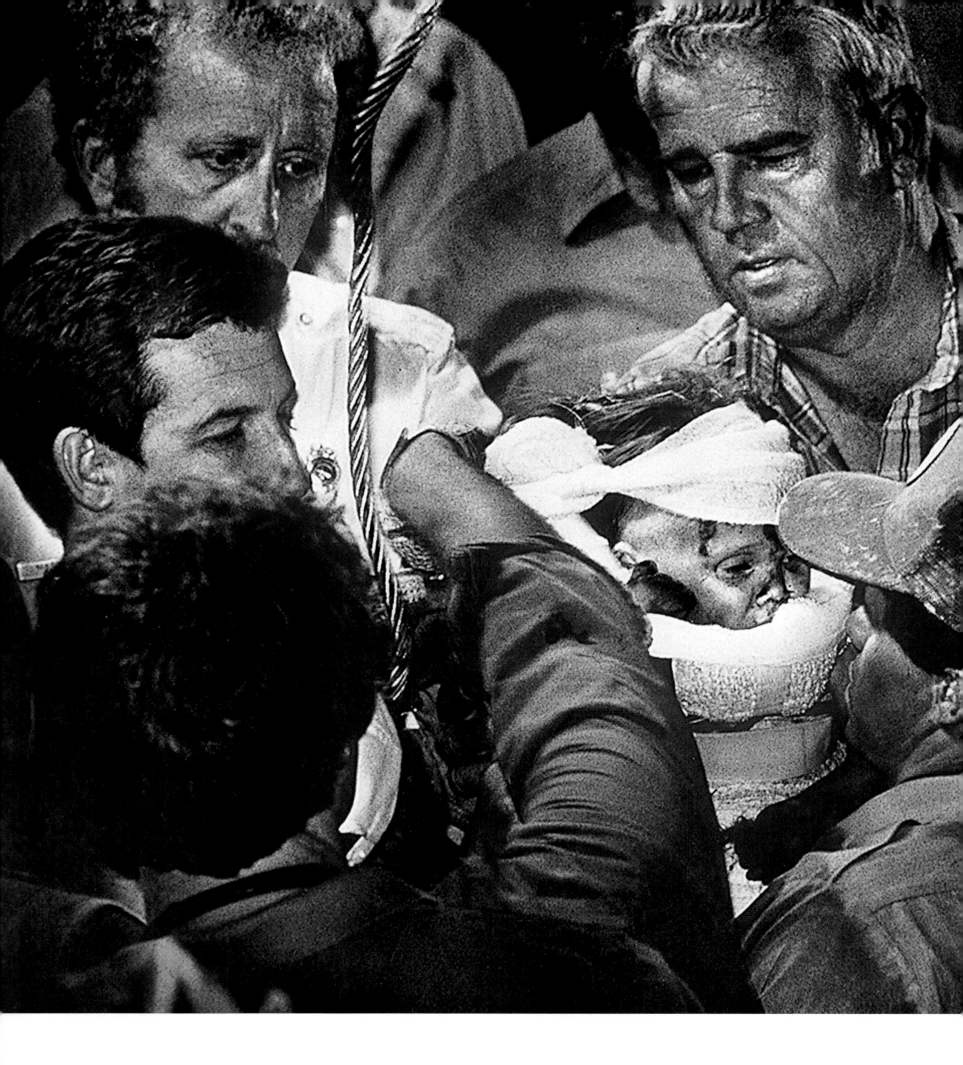

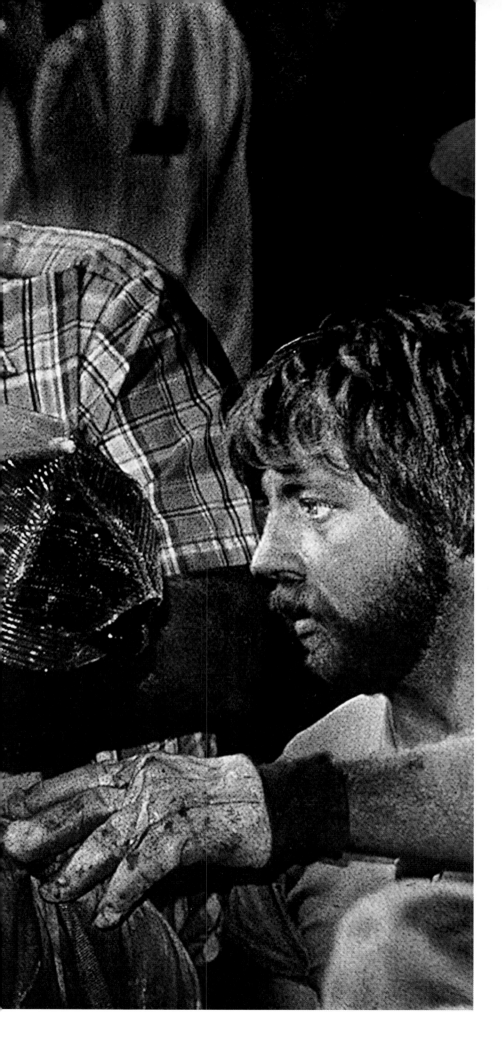

Jessica's extended plight seized the attention of the nation, and then took on global proportions. The small number of local news people was soon augmented by some forty still photographers and a large number of television crews. Shaw kept his attention and his camera focused on the rescue operation. He borrowed a ladder from one local resident, but the man then sold it to a television photographer. A janitor who worked for the *American* lived nearby and provided Shaw with another ladder. He later moved to the bed of a cherry picker brought to the scene as part of the rescue team. Each move took him to an improved vantage point.

Some forty hours after Jessica fell into the well, the workers bit through into the well's channel—a hole about two inches around. Water drills did the rest, patiently and slowly, until the rescuers were through. They covered the child with petroleum jelly, slid her out, and handed her up into the blazing lights of the cameras that sent their images of Jessica around the world. She was safe fifty-eight hours after she dropped into the well; the world breathed a sigh of relief. It was a scene of classic salvation in the Hollywood mode.

Shaw was in a semicircle of photographers poised around the rescue hole, and he shot the first rescue picture with a 180 mm lens. Others used longer lenses, up to 300 mm, but Shaw's wider, looser picture included rescue workers watching intently as Jessica, badly scratched and wrapped in bandages, was lifted out of the hole. He shot seven frames of the scene, but only one captured the intense facial expressions of every worker staring at Jessica at the moment of rescue.

The workers carried the baby across the yard to a waiting ambulance. Shaw changed lenses, attaching a 300 mm to his camera. As Jessica was quickly carried past him he shot automatically, not certain what the image would look like.

Later, in the office, exhausted from the sleepless hours waiting for Jessica's freedom, Shaw saw his long-lens photo; it was dead sharp, with Jessica's bright eyes twinkling in the light. The paper used both photos, one on the front page and one inside.

After the incident, Jessica's parents kept her out of the limelight, hoping that she would enjoy a normal childhood. Later, when ten-year anniversary stories were written, Jessica said she had no direct memory of the incident. She lost a toe and bore a few scars, but there were no other recollections save those gleaned from news reports and portrayed in a television movie entitled *Jessica: Everyone's Baby*.

Shaw left the *American* several years later and took an assignment with the *Cleveland Plain-Dealer*.

1988 [FEATURE]

The Grave Yard

BY MICHEL DUCILLE, THE *MIAMI HERALD*

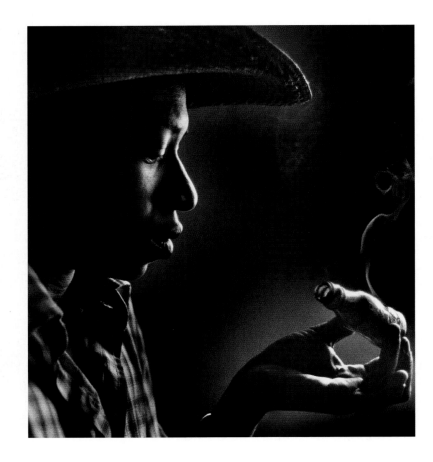

TECHNICAL DETAILS

CAMERA Nikon
FILM Kodak
LENS Various
SHUTTER & APERTURE Various

Both those who lived there and those who came to the Miami housing project to buy dope called it the Grave Yard. The several-block area was a hopeless ghetto whose poor but decent citizens lived in a world populated by dope dealers and their customers. Several apartments were crack dens; and even though an occasional police sting would put a few buyers in jail, life in the Grave Yard changed little over the years.

Michel duCille, of the *Miami Herald,* was determined to demonstrate that the dope problem in Miami was a problem for more than just the black community. It bled over into the Hispanic and white communities, as well. The Grave Yard was proof positive of his opinion.

He sold the idea of a full picture-and-story feature on the project to his editors and then began a seven-month, nearly full-time coverage of the people who frequented the apartments, the hallways, and the streets of the project. It was unprecedented for the *Herald* to devote that amount of time to such a story. Working with duCille was *Herald* writer Lynn Duke.

"The first part of the assignment was winning the confidence of the people who lived in the project," duCille recalled. "We told them from the start that we worked for the *Herald* and that we wanted to do a story on drugs. I knew one person was a dealer, and I walked up to him and asked him to fill me in on how things worked in the project. He just looked at me and walked away.

"After a long time talking to people, I finally arrived with a camera and began, slowly, to take pictures. I never really had any trouble with anyone."

The story appeared in the *Herald's* tabloid Sunday magazine, with some twenty pictures and a full narrative description of life in the world of dope. "The reaction to the story was really satisfying," duCille says.

The police were in the project the Tuesday after the *Herald* carried the story, and a small police station was established. Authorities put a gate on the project, thereby removing the drive-in drug business, and required visitors to say who it was they wanted to see. A cleanup campaign was started, and the crack-den apartments were redone and made livable.

"People who lived there saw the opportunity to make the place a better residence, and they pitched in to hold on to the improvements," duCille said.

A community association was formed, and, at an early meeting, the president called duCille to the podium and the audience congratulated him for the story and pictures that helped make the project so much better.

A decade later, duCille drove past the housing project once called the Grave Yard. "It looked okay," he reported. "It's poor, but the gate is still there, and it looked clean."

DuCille's pictures won the Pulitzer for photography, and the story, entered in a Pulitzer reporting category, was a runner-up, one of the top three entrants of the year.

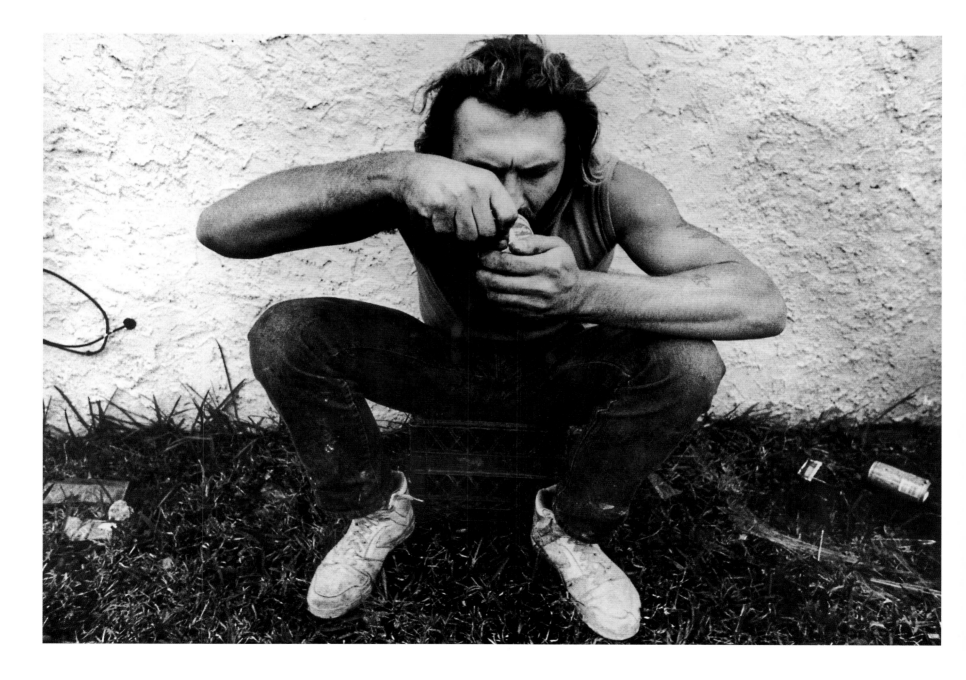

Too Young to Die

BY RON OLSHWANGER, FREELANCE PHOTOGRAPHER

Ron Olshwanger made his living providing architects and designers with interior furnishings used in homes and offices, but his greater love, and his avocation for forty years, was photographing fires.

Olshwanger's interest earned him a directorship of the St. Louis County, Missouri, fire district. His car was equipped with emergency lights, and he listened to both fire and police scanners in his car. Every room of his house contained a radio scanner to monitor fire calls. He began listening to emergency radio frequencies when he was thirteen; and, if the fire was nearby, he would jump on his bicycle and head for the scene with a camera slung over his shoulder.

Early in the morning of a late-December day in 1988, with the thermometer dipping to near zero, Olshwanger made pictures at a major fire in St. Louis. At 5:30 a.m., just as he started his trip home for a shower and breakfast, to be followed by the day's work at his showroom, his radio picked up a call about a fire in an apartment house nearby. Olshwanger saw the column of smoke and decided to take a look.

Firefighters at the scene faced two major problems: to attack the raging blaze and to make their way through the fierce heat inside the building to rescue several trapped residents. The heat steadily increased and the firefighers were about to give up their search when one of Olshwanger's firemen friends, Adam Long, entered the building and crawled along the floor to find a child others said was still inside.

Long could not see in the dense smoke, so he swept his arms across the floor in a blind search for anything human. He bumped into a crib and reached inside, but nothing was there. He swept his arm under the crib and felt a doll. No, not a doll, but a child. He pulled the child into his arms and crawled out.

Olshwanger had arrived moments earlier. He heard screams and saw Long emerge from the building, applying CPR to the child. The frigid outdoor air combined with the heat in Long's clothing to create a sudden burst of steam around man and child. The little body, deadly white against Long's black fire gear, hung limply in his grip. Olshwanger made his picture.

As the fire was brought under control, a photographer from the *St. Louis Post-Dispatch* arrived. He knew he was too late to make his own pictures, but asked Olshwanger if he could take his film to the office. Olshwanger said he would have the film processed and, if anything was good, he'd call. He later sent the film to the newspaper, and his photo was printed large on the front page.

Olshwanger was staggered by the response to the picture. He received some five hundred calls in just a few days, and the newspaper received just as many from readers praising the brave firefighter who saved the child, two-year-old Patricia Pettus, from the inferno. Unfortunately, however, the child died six days later from burns received in the fire.

MAY 1988 ■ *The first Soviet troops begin withdrawing from Afghanistan after nine years of Soviet occupation.*

SEPTEMBER ■ *Canadian runner Ben Johnson is stripped of his Olympic gold medal after testing positive for performance-enhancing steroids.*

NOVEMBER ■ *Vice President George Bush wins the U.S. presidential election, becoming the first sitting vice president to win the election since 1836.*

DECEMBER ■ *Middle-eastern terrorists blow up Pan Am flight 103 over Lockerbie, Scotland, killing all 259 aboard and eleven people on the ground.*

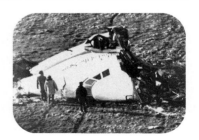

The photo took on a life of its own, as many pictures of this kind do; and a decade later, Olshwanger continued to receive three or four letters or calls a month about it. Firemen said the child and others who died in the fire would have survived had smoke detectors been installed in the apartments, and the picture was widely requested for use to convince builders and residents of the need for them.

The *Post-Dispatch* asked Olshwanger if the paper could enter his picture in the Pulitzer competition, but he did not believe it had a chance. Several months later, however, a surprised Olshwanger was told he won the award, and he was invited to the paper for a celebration.

"I was embarrassed," he says. "I felt a little guilty. Here were all these reporters and photographers who spend all their time covering the news. Somehow it seemed that they should have won the prize, not me."

TECHNICAL DETAILS **CAMERA** Minolta
FILM Studio 35 color negative
LENS Zoom, 28 mm to 78 mm
SHUTTER & APERTURE 1/20th @ f 5.6

Several months passed before Olshwanger realized the major gratification he received from the Pulitzer. "The Pulitzer was a great delight to my wife," he says. "At the time the prize was announced, she was terminally ill with cancer; but the thrill of the prize gave her the strength to put together a book of the letters and articles written about the photo. I believe that God gave her a gift of that prize to brighten her final days," Olshwanger says now. "For that, I will always be grateful."

School Days

BY MANNY CRISOSTOMO, THE *DETROIT FREE PRESS*

Manny Crisostomo's idea was simple enough, but to maintain the required momentum for successful coverage from start to finish would require an unusual level of energy and sustained enthusiasm. The *Detroit Free Press* photographer wanted to document the life of high school students as they passed through a full school year.

"One of the hardest parts," he recalled, "was getting approval from the school district. But I worked with a friend of mine who knew how the bureaucracy worked and how to phrase a request. The answer came back, 'which school do you want?'" He chose a school he described as "balanced—white kids and black kids, Hispanics, middle class. I was looking for something typical."

Crisostomo knew, as did the other Pulitzer winners who undertook photo projects requiring access to the subject, that a period of letting the subject get to know you was essential. Many of the students, Crisostomo recalls, were apprehensive about reporters, photographers, and the media in general. It took time to build trust.

For the forty weeks of the school year, Crisostomo spent three or four days a week hanging out at the school and in the neighborhood. "I met with the kids, I went to class with them, I played their games, I debated with them…and I photographed them. I even went to their dances and to their prom."

After a while, he was accepted as part of the scene and that is when the good pictures happened. It was difficult, Crisostomo recalls now, to keep personal feelings out of the story. He remembers that he developed a certain care, even a sympathy, for the students and their lives, and it would be easy to paint their lifestyle in either a negative or a positive way unconsciously. What he wanted was a truthful balance that showed reality.

By the end of the school year in June 1988, Crisostomo had one hundred pictures that he thought represented the students' life that year. Stories were written to accompany the pictures, and the entire project was published in a single large section as part of the Sunday paper.

The principal, Crisostomo recalls, hated the story, but used it successfully to win a grant for the school from a soft drink manufacturer. One student who went on to an Ivy League university wrote that Crisostomo betrayed the trust that the students showed toward him. A year later, the student wrote again to apologize for the earlier letter and to say that the story had been a true portrait of the year.

Crisostomo contributed his Pulitzer Prize money to the school for use as a scholarship. Once the word was out, his newspaper, the newspaper group, and several large corporations also contributed money. A scholarship fund of $20,000 was accumulated that provided a number of scholarships over the next four years.

Several years after winning the Pulitzer, Crisostomo returned to his native Guam, where he eventually bought and now operates a publishing business. He also began work on a book about the Chamorru, the indigenous people of the Mariana island chain.

TECHNICAL DETAILS CAMERA Canon
FILM Kodak
LENSES 24 mm and 105 mm
SHUTTER & APERTURE Various

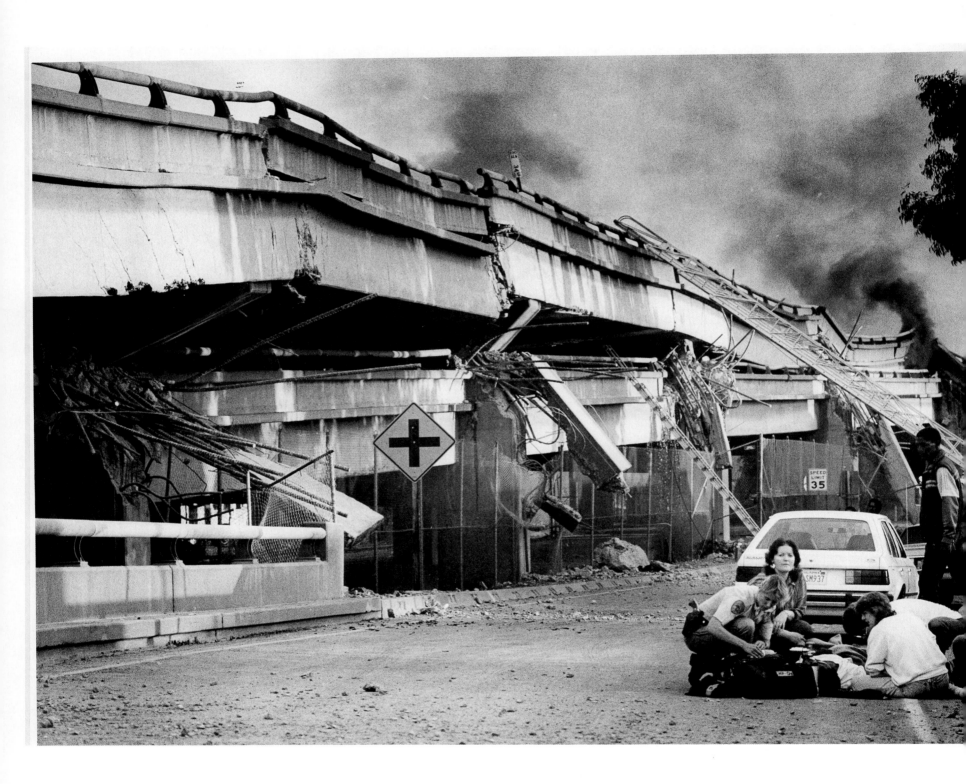

Earthquake

BY THE STAFF OF THE *OAKLAND TRIBUNE*

Batting practice at Candlestick Park was over. The players had completed their warm-ups and were ready to take their places on the field. The fans—some sixty thousand of them in the packed stadium—settled down in anticipation of the first pitch of the third game of the 1989 World Series, October 17, 1989. The series was called the Battle of the Bay because it put the San Francisco Giants against the Oakland A's.

Photographers from the *Oakland Tribune* and from organizations throughout the country had taken their positions and readied their cameras for the game's action.

Then it started, first with a shaking in the ground. Players looked down, startled. A wave of earth rolled across the playing field, much like the roll of a calm sea, except that this was solid ground. The players looked up as the light towers swayed and snapped back as a whip might, but in slow motion. Fans were rigid in their seats. The stadium lights went out, but because it was only 5:04 p.m., there was ample daylight.

The moving stadium walls uttered a moaning wail and a nerve-chilling creak, adding a haunting overlay to the scene. Players took their families from box seats to the center of the field, where they stood, like everyone else, frozen. No one seemed to know what to do until a police car drove onto the field and, using its traffic control speakers, ordered evacuation of the stadium.

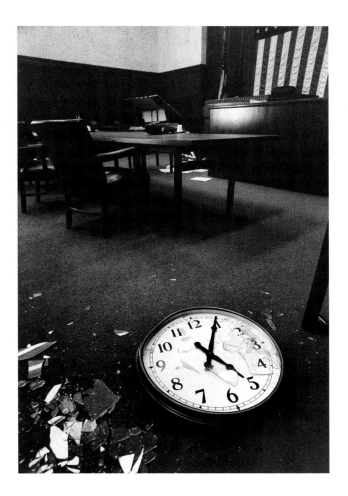

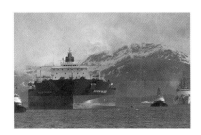

FEBRUARY 1989 ■ *Iran's Ayatollah Khomeini offers $3 million dollars for the death of Salman Rushdie, whose novel* The Satanic Verses *is deemed blasphemous.*

MARCH ■ *The oil tanker Exxon Valdez runs aground on Bligh Reef, leaking 240,000 barrels of oil into Prince William Sound.*

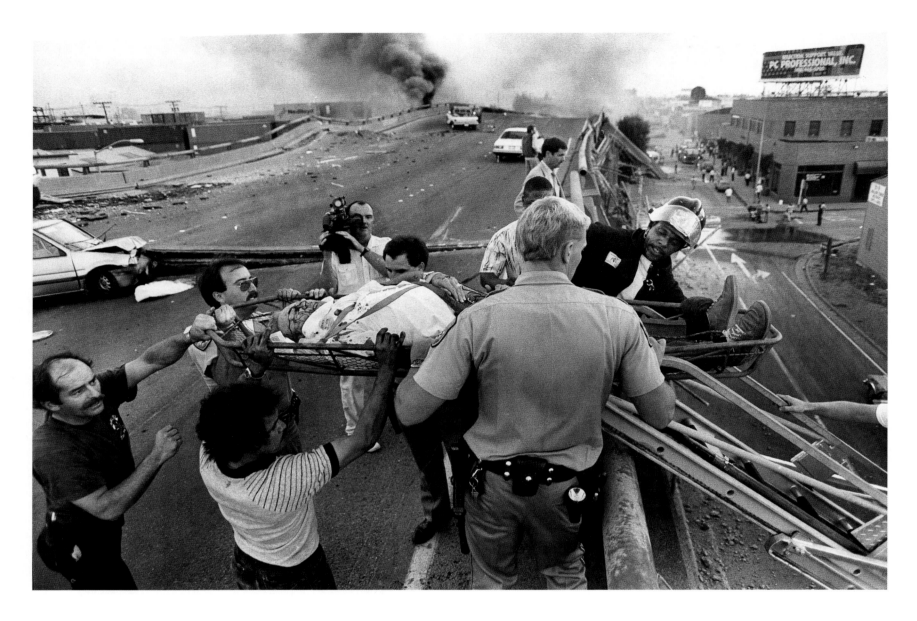

TECHNICAL DETAILS **CAMERA** Canon and Nikon
FILM Kodak
LENS Various
SHUTTER & APERTURE Various

The sense of disaster was carried to the nation by the television broadcast of the game, which first broke up, then turned to snow, and stayed that way.

The stadium structure remained intact, and the crowd was able to leave without any inuries, but that was not the case for those driving on Interstate 880, a two-level roadway near downtown Oakland. The earthquake sent the upper level crashing down onto the lower level; more than forty people died, most crushed in their vehicles by the upper level's cement sheets.

The shaking and rumbling lasted fifteen seconds. Besides the highway, a section of the Bay Bridge, which carries 300,000 commuters daily, collapsed. Highways throughout the area were shattered or closed. Gas mains erupted and burst into flames. Many buildings fell, caught fire, or both.

The *Oakland Tribune's* staff of photographers, some at the game, others at home, took to the streets of their city. They covered the collapsed I-880 and the heroic rescue efforts that recovered both the dead and the injured. In many cases the background for their pictures was the twisted steel and shattered cement that had become a death trap for so many.

The photographers were frustrated, as were most Bay Area residents, by the difficulty in traveling from place to place, so many of their pictures concentrated on the downtown area around I-880.

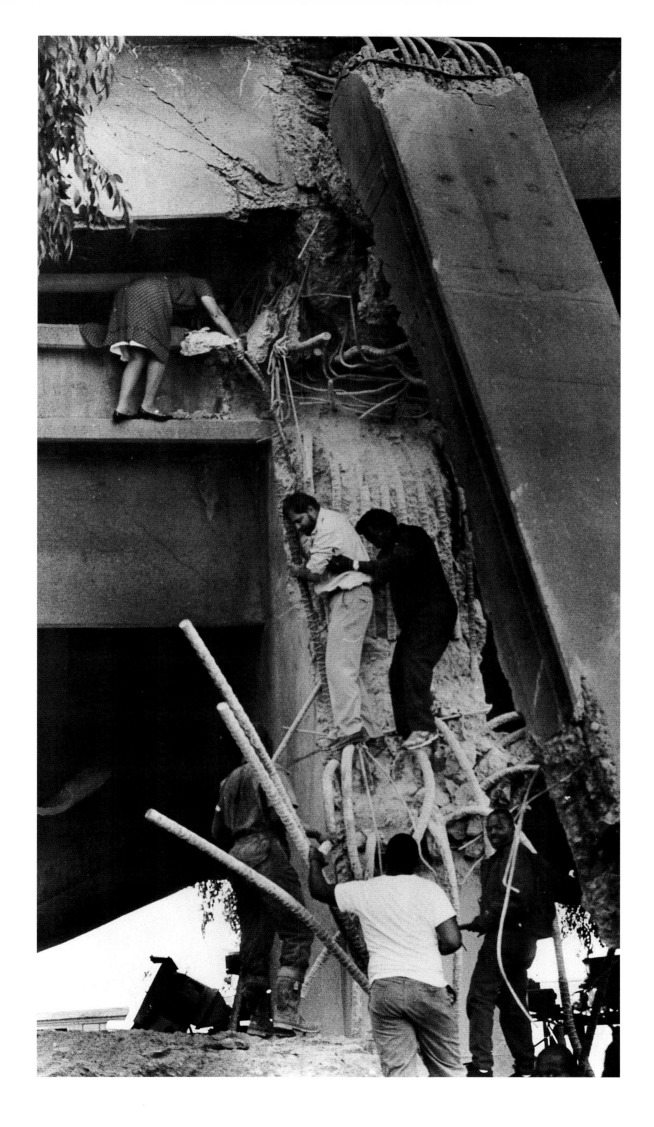

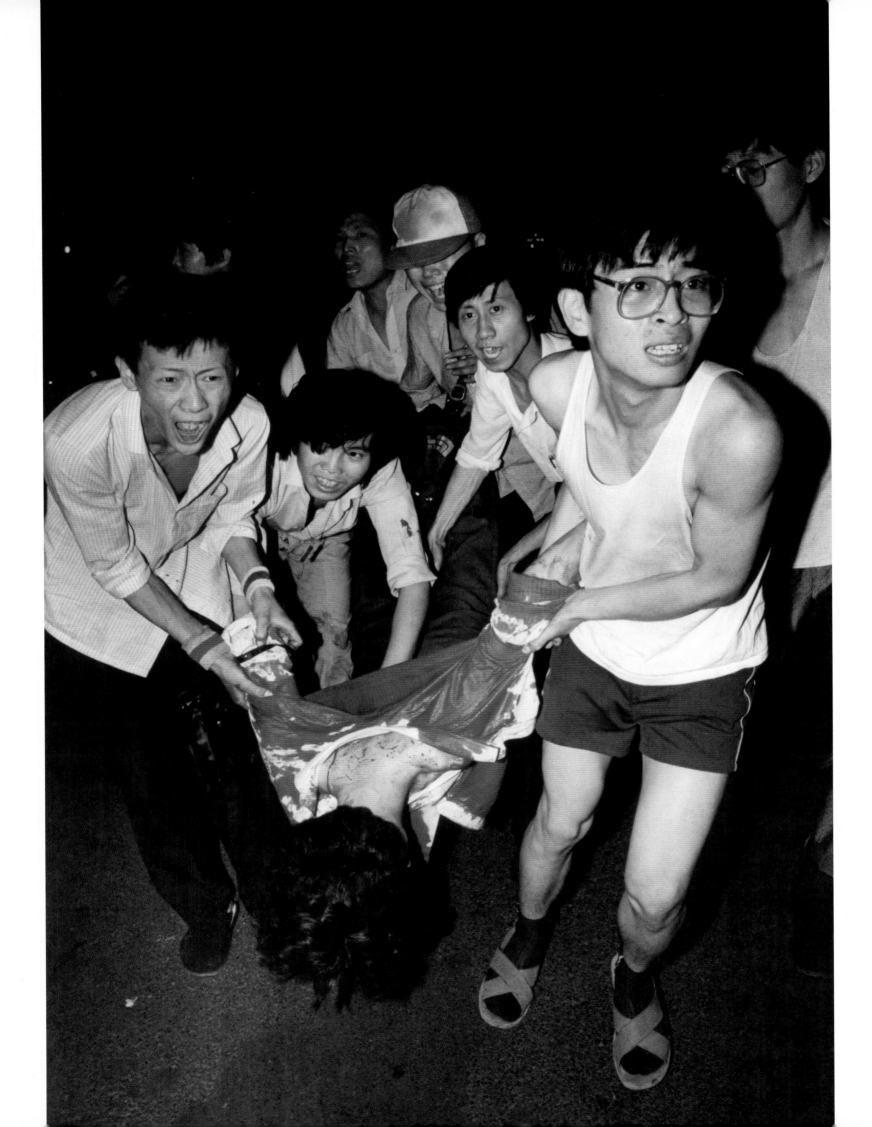

A World of Pictures

BY DAVID TURNLEY, THE DETROIT FREE PRESS

For David Turnley, 1989 was his year of living dangerously. Turnley followed the news from Beijing to Berlin to Bucharest during one of the decade's most dramatic periods. "A year of revolutions," he calls it, "a great historical year."

The *Detroit Free Press* had assigned Turnley to Paris, where he was to watch the news carefully and move quickly when dramatic, historical events began unfolding. In 1989, those stories included the student massacre in China, the fall of the Berlin Wall and the end of the Ceauçescu regime in Romania.

Beijing

The student demonstrations in Tiananmen Square developed slowly at first, with only a few students marching and speaking for a new order in repressive China. At his post in Paris, however, it was clear to Turnley that the streets would soon fill with thousands more, and he flew to Beijing.

"I was too young," he recalls, "to participate in the student demonstrations of the 1960s in the U.S., but my older brother did and I knew something about what happened. In China I felt like I was in a time warp because all around me were scenes that reminded me of the stories my brother brought home. The Chinese students were even playing guitars and singing Beatles songs, but with Chinese lyrics."

Turnley covered the story daily as the crowds grew larger and larger, and the speakers delivered their speeches more and more to the point. The students built a replica of the Statue of Liberty. They slept in the square. They talked. They sang.

Then, on June 3, 1989, came what Turnley calls "...the most dramatic night of my career as a photographer." Turnley was one of the first to get a glimpse of Chinese troops massing near the square. He stood on a shaky bicycle supported only by its kickstand to gain height and photograph the troops. The soldiers spotted him and, after a chase, caught him and broke his cameras. He returned to his hotel and borrowed a camera with a 80-210 mm zoom lens and an extra 20 mm lens and returned to the scene. He worked

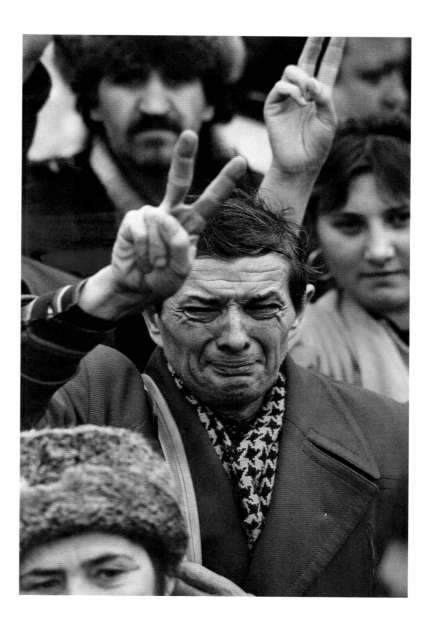

TECHNICAL DETAILS	CAMERA Nikon
	FILM Kodak color negative
	LENS Various, ranging from 24 mm to 180 mm
	SHUTTER & APERTURE Various

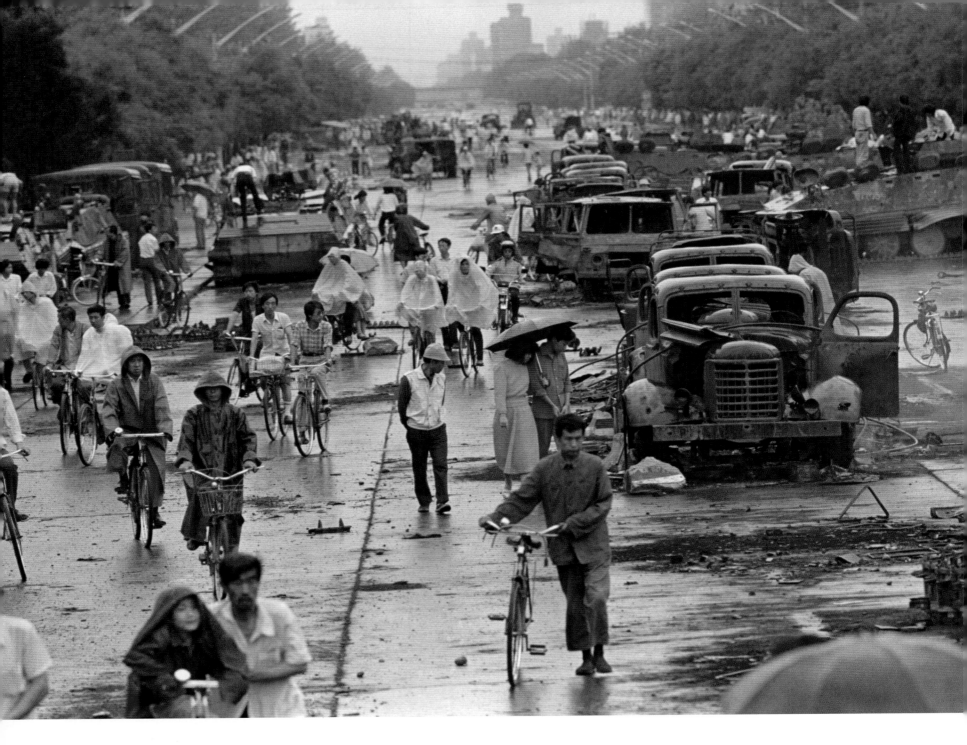

until midnight making pictures of the soldiers pushing the students out of the square. Around midnight, Turnley visited Associated Press's Beijing office, where he processed his film and sent several pictures to Detroit. Then he returned to the scene.

"It is popularly believed," Turnley says, "that the massacre happened in Tiananmen, but it actually took place in a street alongside the square." Students, driven from the square, confronted troops until the troops attacked them and beat back the first two or three ranks of demonstrators. The students reassembled and soon the troops attacked again. Turnley photographed the scene from the student ranks as the troops attacked every fifteen minutes or so. Cars and trucks were set ablaze. Students carried their wounded back through the crowd to hospitals.

By 5:00 a.m. the students were defeated. Many were dead, many were wounded, and many were arrested. Those remaining dispersed, leaving behind burned out vehicles, a street littered with debris, and the never-counted-collection of bodies of those slain during the attacks.

The Chinese authorities pulled the plug on television broadcasts outside of China, but picture connections via international telephone remained alive. The photographs told the world of the bloody night in China.

Berlin

Turnley was in New York attending a photo exhibition when he first heard about the fall of the Berlin Wall, the dramatic symbol of the

Cold War. He rushed home from the exhibition, picked up his camera gear, and a few hours later was on a flight to Germany.

Turnley knew that vehicular traffic would be heavy, so he hired a motorcycle to take him through the maze of streets to the wall. He arrived in time to photograph young Germans hacking away at the wall with hammers and chisels and pulling great sections of the structure crashing to the street.

His most poignant moment came later, when he visited Checkpoint Charlie, the point of east-west passage made famous in a generation of spy novels. He watched an old woman slowly, carefully pick her way across the path and through the checkpoint where she was greeted by another elderly woman. They embraced and wept openly without embarrassment.

Sensing a story, Turnley asked if they were relatives. No, they replied, they did not know each other. They had each lived next to the wall—but on opposite sides—and for forty years they had waved to each other across the barrier that divided the city, the nation, and the world. Now, with the wall down, they were united and shared the hope that their city and their country would follow the same path.

Bucharest

Turnley recalls Romania during the final days of the Ceauçescu regime as the site of a "sinister revolution." It was impossible to get into Bucharest via normal channels, so he hitched a ride with a busload of physicians belonging to Doctors Without Borders bound for the capital to treat the wounded. As he arrived in the city he did not see jubilation or other signs of joy in the faces of the people. The euphoria that nearly always accompanies the fall of a ruthless dictator was not evident.

Turnley made pictures and then, in a crowd, he saw the face of a weeping man with his fingers raised in the "V" for victory sign. He shot a photo of the man, who was watching his life change but with no knowledge of whether it would be for the better or the worse.

His most dramatic moment came when he was making pictures in Ceauçescu's office, which was occupied by the revolutionary forces; the first pictures of the newly slain dictator flickered on the screen.

For his picture coverage of the three hot spots of the year, Turnley was awarded the Pulitzer Prize.

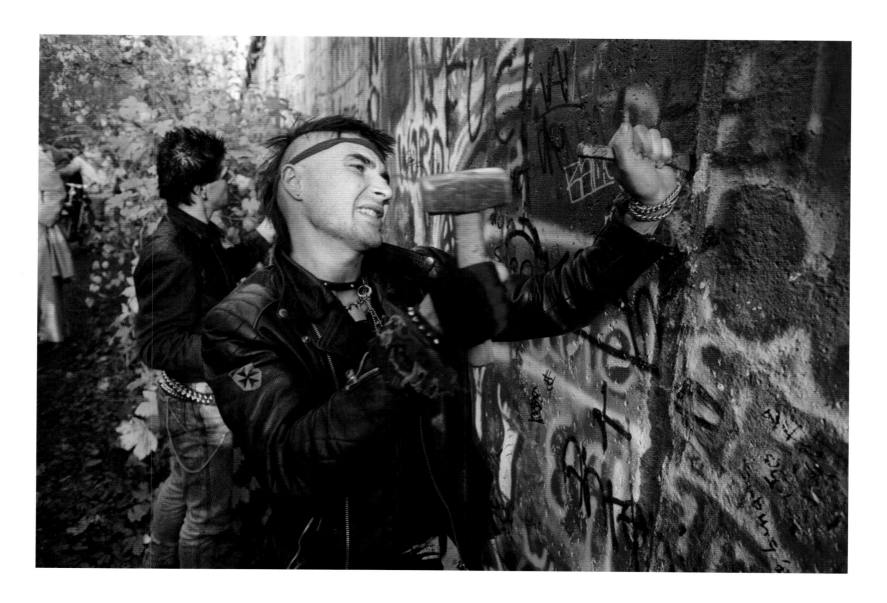

Fiery Death in South Africa

BY GREG MARINOVICH, ASSOCIATED PRESS

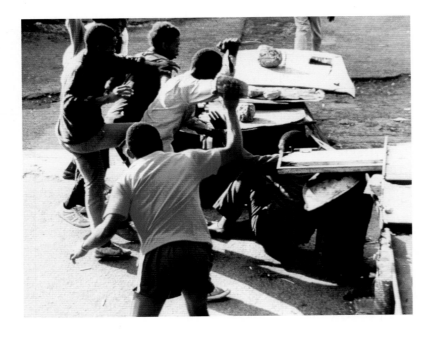

TECHNICAL DETAILS **CAMERA** Nikkormat
FILM Fuji color negative
LENS Zoom, 35 mm to 70 mm and
300 mm
SHUTTER & APERTURE Various

Four white photographers who covered South Africa's violent turn from apartheid to a new form of government came to be called the "Bang-Bang Group." A South African magazine coined the name in recognition of the photographers' consistent picture coverage of the bloody, deadly clashes in the nation's black townships.

Picture-making in townships like Soweto was risky. This was where partisans of Nelson Mandela's ANC party, which was newly legalized, and the Zulu-backed party called Inkatha, fought their bloody struggles for supremacy.

Greg Marinovich, of the Associated Press, was one of the members of the Bang-Bang Group. Greg and his companions, who were both freelancers and staff photographers of Johannesburg newspapers, traveled to the townships early in the morning. They called their forays dawn patrols because trouble frequently exploded when people were on the streets headed for work. The hostels where the workers lived were the flash points of sudden, unpredictable violence.

The group traveled together—sometimes three of them, sometimes four—as a protective measure against the violence that could easily be turned against white photographers when trouble broke out. Also, as the two fighting factions battled hand to hand with rocks, knives, spears, and small arms, police often used excessive firepower to stop the outbreaks, and photographers ended up in the crossfire.

MAY 1990 ▪ *Seinfeld begins a hugely successful nine-year run on television.*

AUGUST ▪ *Iraq invades Kuwait over an oil and land dispute.*

OCTOBER ▪ *After forty-three years of separation, East and West Germany reunite.*

NOVEMBER ▪ *After eleven-and-a-half years in office, Britain's Margaret Thatcher is forced out and replaced by John Major, her handpicked successor.*

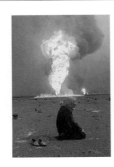

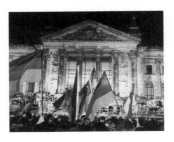

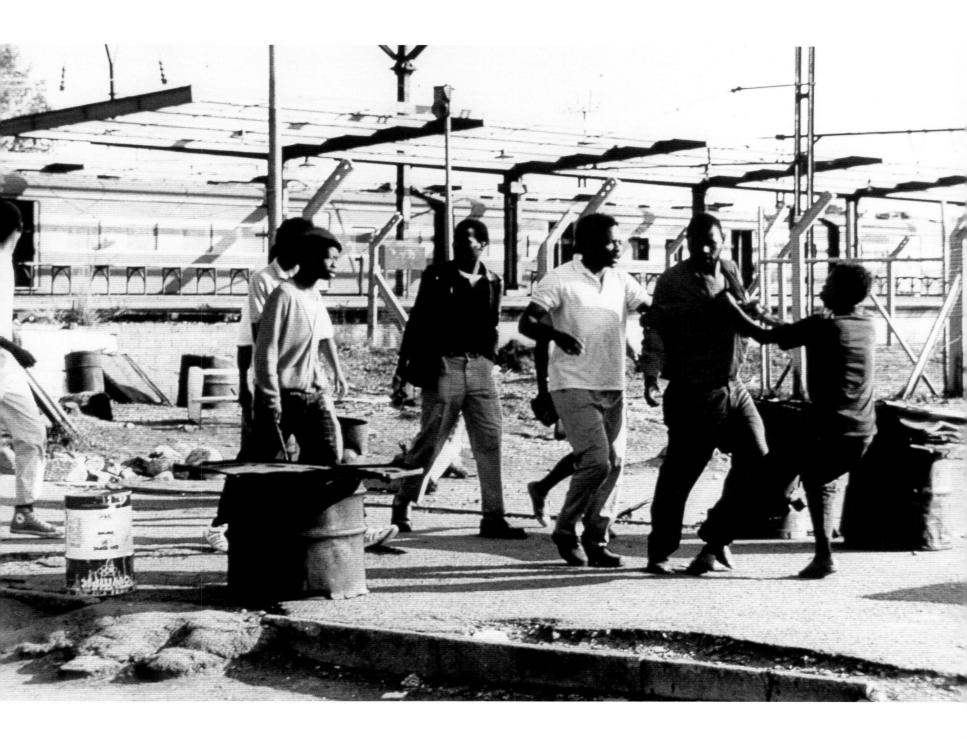

On September 15, 1990, Marinovich was in Soweto watching over the work hostels where hundreds had died in the fighting of recent months. Near a train station, he noted a group of young men crouched along an embankment. They told him that Zulus on the other side had shot at them. At that moment, one of the group fired a pistol in the direction of the Zulu hostel. Other shots were fired, but it was impossible to say where they originated.

A commotion on the train platform caught Marinovich's attention. Four or five men dragged and pushed another man from the station to the street. Marinovich recalls, "The group said the man was Inkatha, a member of the rival Zulu group and a spy. I asked them how they knew. They said, 'We know.'"

They dragged the man into the street and stoned him with fist-sized rocks that knocked him down. Several attackers stabbed him in the chest with large knives. When he got up, the youths threw larger boulders at him and knocked him down again. They told Marinovich, "No pictures! No pictures!" He replied, "I'll stop making pictures when you stop killing him."

The attack continued, however. One man stepped forward and plunged a dagger into the man's head, but still, he got up and staggered in the street. More rocks. More stabs. He fell. Another man stepped forward and poured gasoline over him. A box of matches was handed around, and one person stepped forward, struck the flame, and tossed it on the injured man. The fire swept over him in

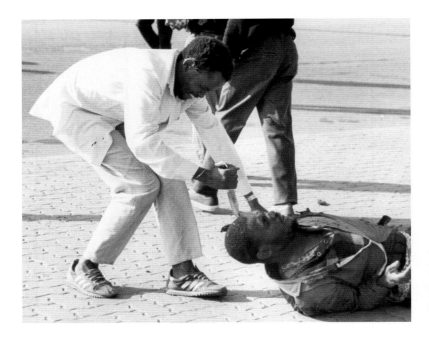

seconds. He jumped up in agony, ran in a few circles, and then fell for a final time.

AP's photo network carried the full picture series around the world in a matter of minutes, and editors at daily papers found themselves dealing with the problem they had encountered with many of the pictures that later won Pulitzer awards. Were they too grisly to publish? One survey revealed that about half the papers polled published the photo of the stabbing or of the burning, and many printed the color photos on the front page. Others said the pictures reflected extreme violence and animalistic hatred and were too tough to print.

The Pulitzer committee showed no such reluctance, however, when it awarded the Pulitzer Prize to Marinovich. The award, in fact, acted as a stamp of approval, and a group of editors and several papers that did not print the pictures when they first appeared published them with their stories on the Pulitzer announcement.

After he won the Pulitzer, Marinovich continued to cover the struggle in South Africa until he was seriously wounded while photographing a tribal clash in 1992. Another member of the Bang-Bang Group was killed in the same encounter. Marinovich later worked in Israel for AP, then left the wire service to try his hand at writing. Kevin Carter, a third member of the group, won the 1994 Pulitzer Prize for a picture from Sudan.

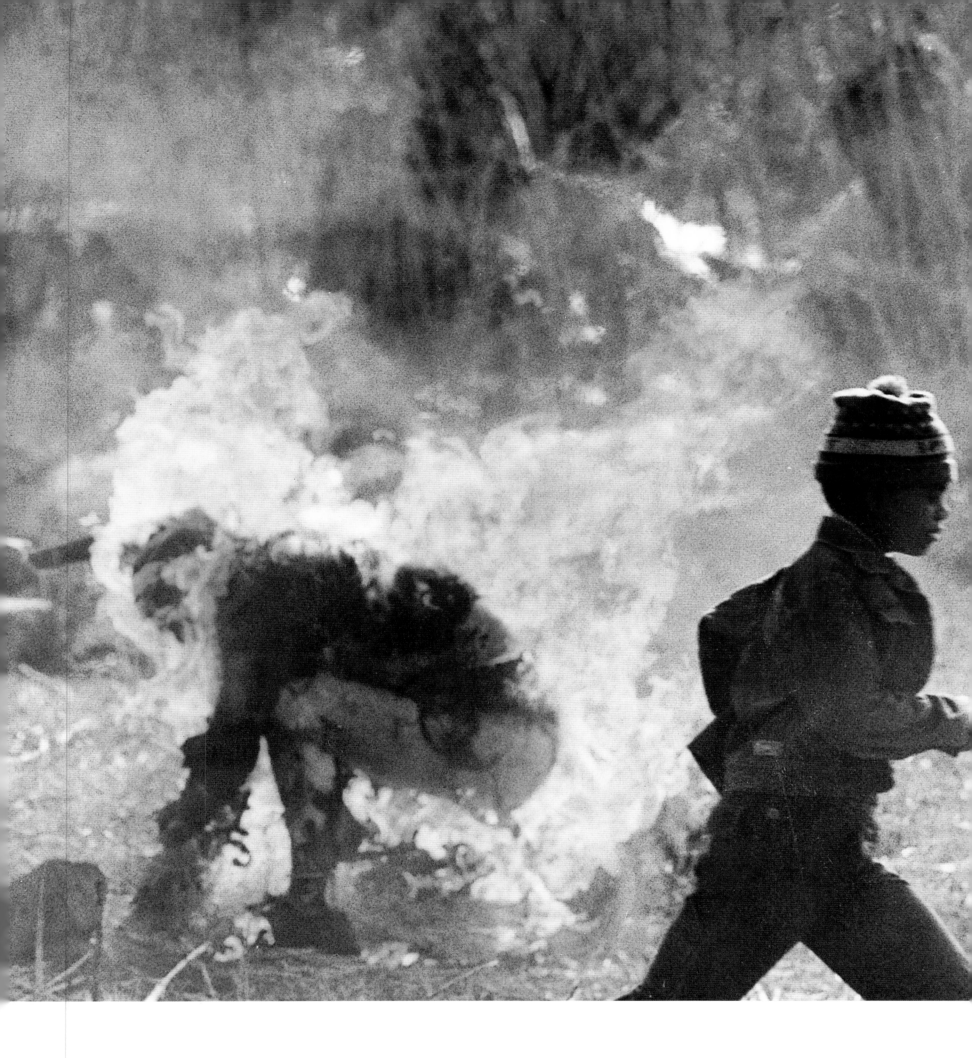

The Irrecoverables of Romania

**BY WILLIAM SNYDER,
THE *DALLAS MORNING NEWS***

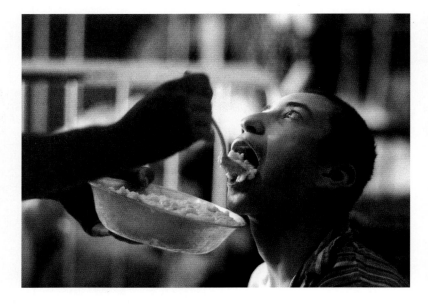

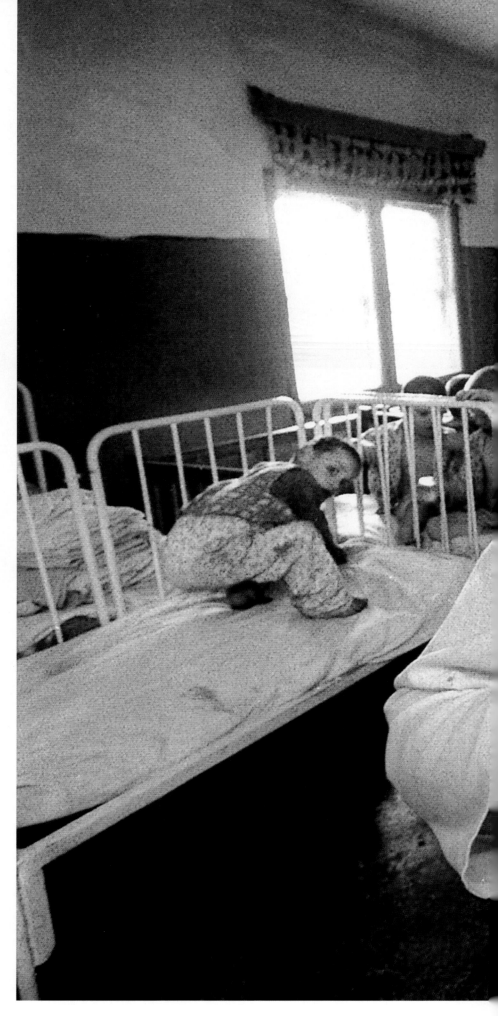

The long, harsh rule of Romanian dictator Nicolae Ceauçescu was over, ended by an executioner on Christmas Day 1989. Free elections, the first in more than half a century, were scheduled for May.

In the social debris that Ceauçescu left behind was a festering problem of orphaned children. Determined to build a worker force, Ceauçescu had outlawed birth control for families with fewer than four children. At the same time, however, economic polices drove up living costs to the point that couples could not support a family of that size, and children were placed in state run orphanages that themselves were understaffed. Dirty needles were used for injections, little attention was paid to babies, and diseases, including AIDS, spread rapidly.

Bill Snyder, of the *Dallas Morning News,* read a short article in the paper that briefly described the devastating problems facing Romanian orphanages, and he knew there was a story there worth doing. When he learned that election experts from Texas would act as advisors to the officials who were organizing the Romanian elections, the way was clear for him to go to Romania.

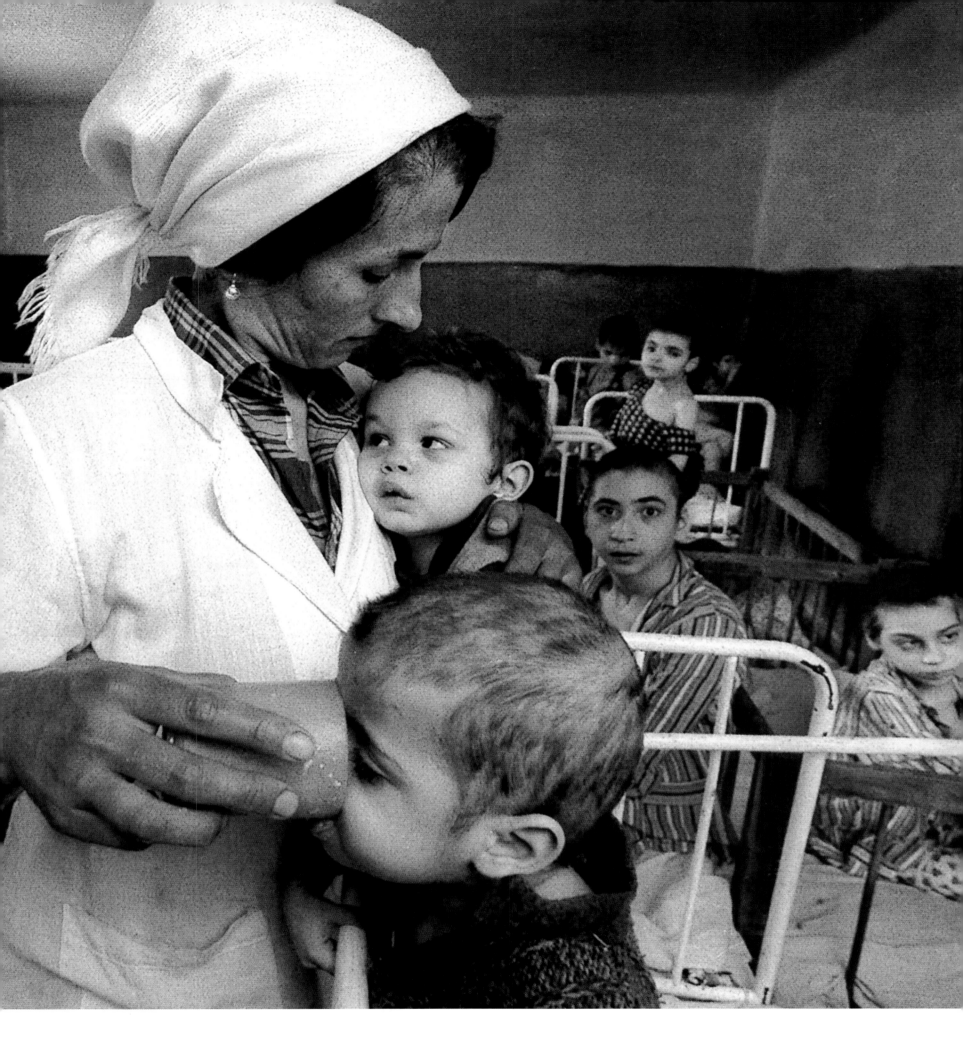

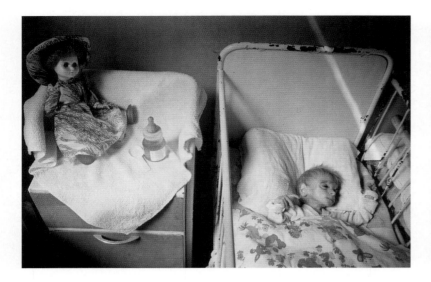

TECHNICAL DETAILS **CAMERA** Nikon
FILM Kodak color negative
LENS Various, ranging from 20 mm
to 180 mm
SHUTTER & APERTURE Various

With the elections near, and with additional story ideas suggested by several *Morning News* departments, Snyder set off on his own for Romania. He would do several stories, including the elections, but the orphan story was at the top of his list.

"I was lucky in so many ways," he said. "A driver-translator I hired was able to get me into practically every place I wanted to visit, including a home for irrecoverables in Vulturesti."

Snyder's pictures captured the fate of children in several orphanages that were jammed far beyond normal capacity. In some cases, he reported, one attendant had to care for thirty infants. Malnutrition was widespread and blood transfusions done with dirty needles had spread AIDS among the children.

"These kids were not being cared for," he said, "they were being warehoused."

Snyder was the winner of three Pulitzer Prizes. In 1993, he shared the award with fellow *Morning News* photographer Ken Geiger for coverage of the Barcelona Olympics. In 1989, he shared in a Pulitzer in the Explanatory Journalism category for a series of articles on air crash investigations illustrated with his pictures.

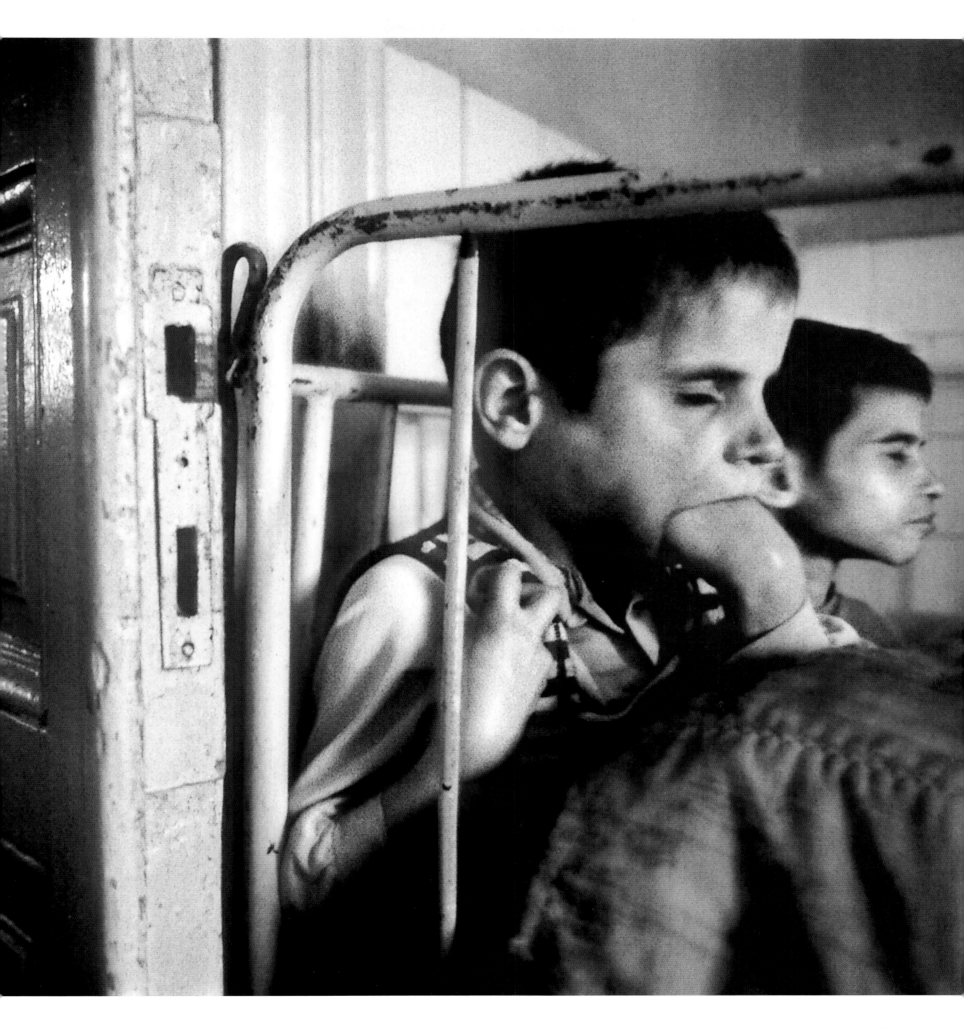

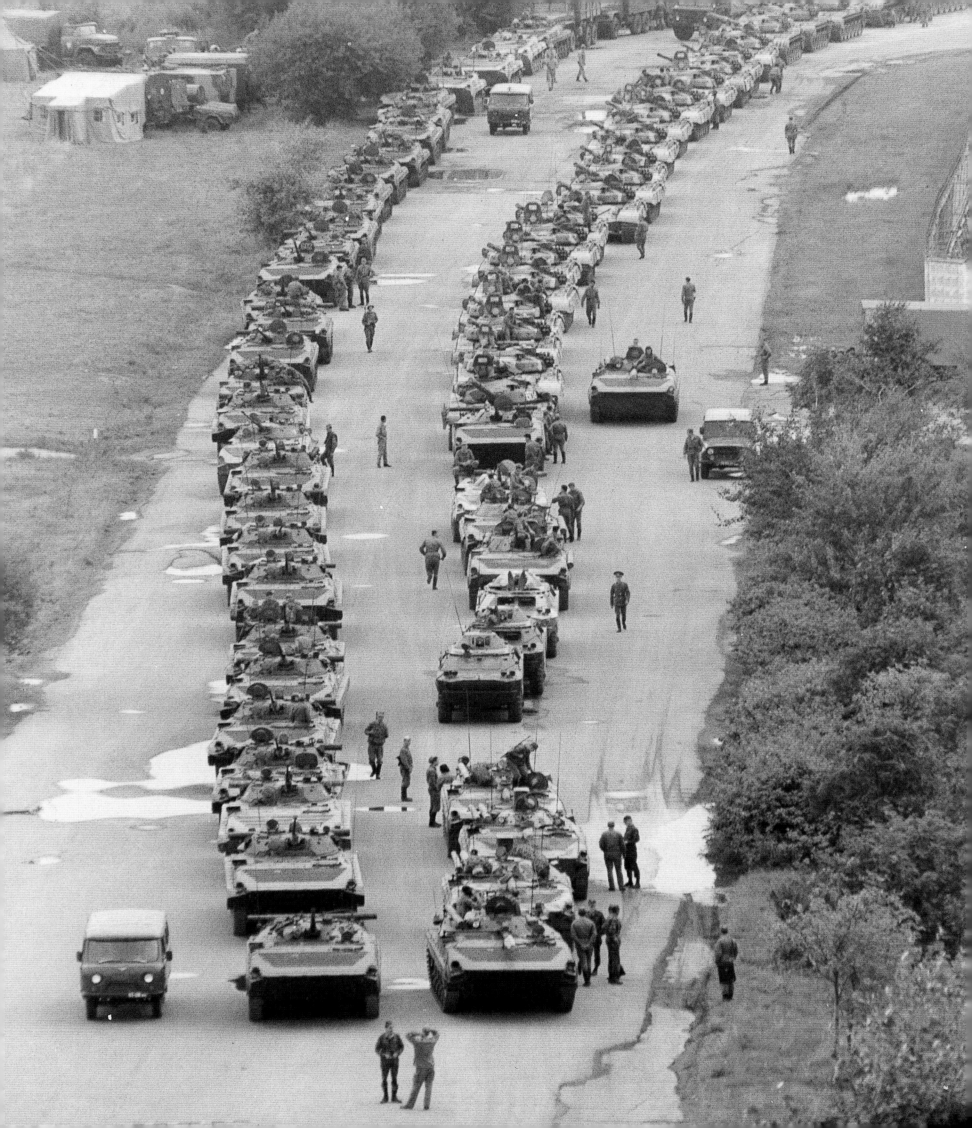

The Death of the Soviet Union

BY THE ASSOCIATED PRESS

Life was changing at an alarming rate in the Soviet Union of 1991. As one Associated Press writer put it: "An AP posting in Moscow always required a sense of adventure, a talent to improvise, a feel for history, and the will to endure hardship. These days, it also requires the ability to adapt to relentless revolution."

The changes began when Mikhail Gorbachev came to power in 1985 and launched *perestroika*. Four years later the Berlin Wall came down, and the Soviet bloc was in chaos. By August the Communist hardliners knew it was do or die; the scene was set for action.

The crisis reached a climax in August, 1991, when the hardliners held Gorbachev for 80 hours at his Crimean dacha. A team of five AP photographers captured the drama in Moscow and around the country.

As one remarkable photo showed, Boris Yeltsin, firebrand activist and President of the Russian Republic, went to the streets and climbed aboard a tank to urge the Russian people to take a stand against the Communist hardliners who wanted to take over the central government. The people followed Yeltsin's lead, as did much of the Russian military and KGB. Some shots were fired elsewhere in the city and three died, but a line of tanks ready at the outskirts did not move.

Russian soldiers balked at firing on tens of thousands of their countrymen who supported change.

The coup collapsed and Gorbachev returned to find street

activists standing on and alongside their trophies, the fallen and shattered statues of Lenin and others of Communism's historic elite.

AP photographers made photos of the emotional scenes in the city but it was a simple, telling picture that captured the moment of greatest historic significance. Gorbachev, under pressure from

FEBRUARY 1991 ■ *The U.S. offensive in Kuwait, named "Operation Desert Storm," begins.*

MAY ■ *Queen Elizabeth addresses U.S. Congress.*

OCTOBER ■ *Anita Hill accuses Supreme Court nominee Clarence Thomas of sexual harassment. After a series of bitter hearings, his appointment is confirmed.*

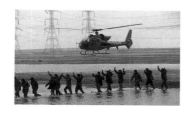

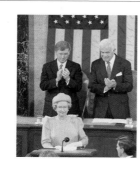

Yeltsin, agreed to dissolve the discredited Communist Party. Later, as Soviet republics seceded from the Union, Gorbachev appeared on television December 25, 1991 and resigned as president of a nation that no longer existed.

His speech completed, Gorbachev closed the file holding his prepared remarks and communism's seventy-four-year rule of Russia came to an end. AP photographer Liu Heung Shing made pictures with a camera hidden under his coat of the last moments of one of history's most dramatic sagas. Moments later the red flag of the Soviet Union was taken down from the Kremlin's highest tower.

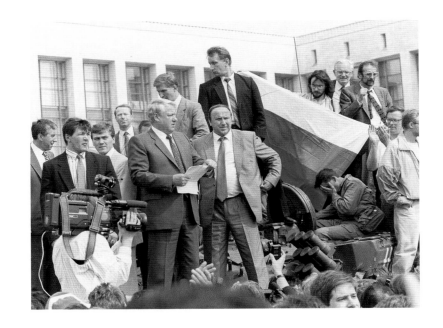

TECHNICAL DETAILS **CAMERA** Leica and Nikon
FILM Kodak color negative
LENS Various
SHUTTER & APERTURE Various

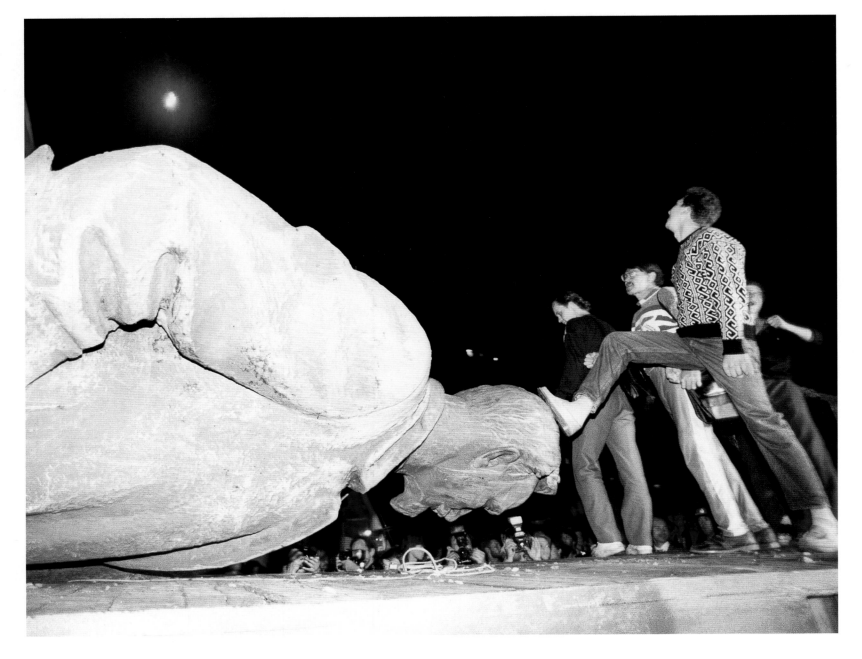

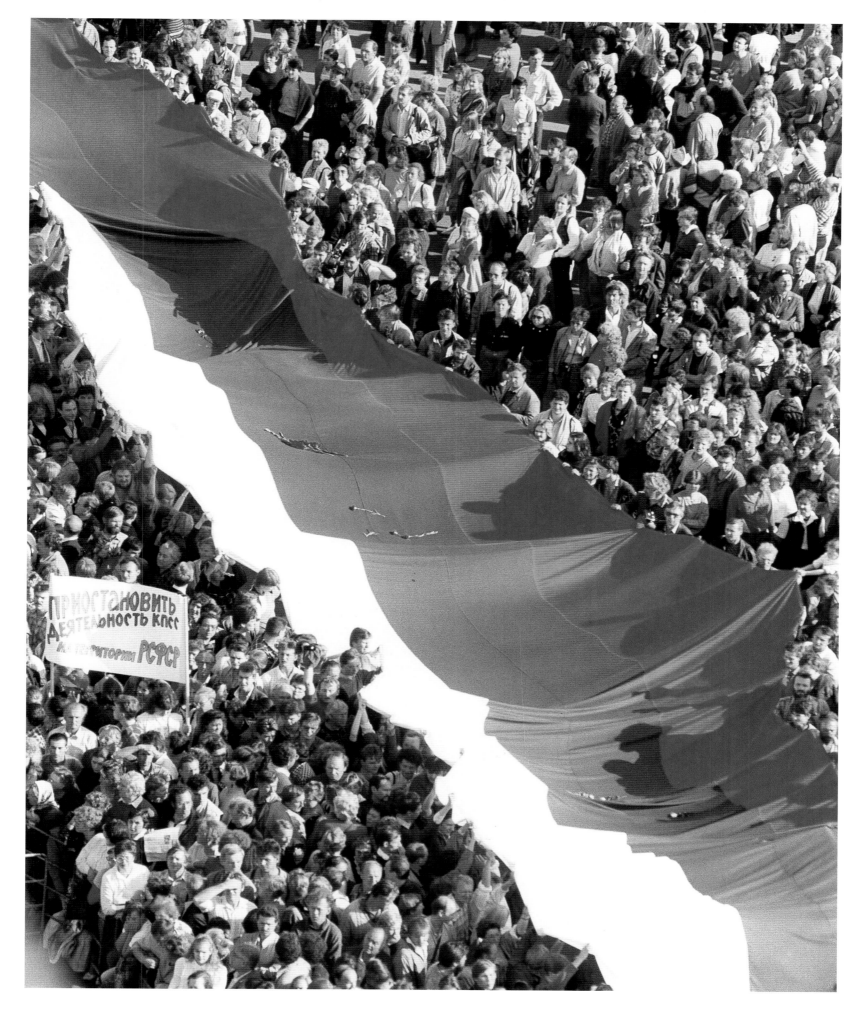

"21"

BY JOHN KAPLAN, THE BLOCK NEWSPAPERS

TECHNICAL DETAILS
CAMERA Nikon
FILM Kodak
LENS Various
SHUTTER & APERTURE Various

Twenty-one years is not a ripe old age. In America, it is the year of passage into adulthood. Twenty-one-year-olds can vote, buy a drink anywhere, and are legally responsible for their actions. A twenty-one-year-old has grown up, chronologically at least.

The idea that resulted in John Kaplan's 1992 Pulitzer for feature photography was the outgrowth of his coverage in Pittsburgh of a twenty-one-year-old youth on trial for murder. As Kaplan followed the story, he soon came to believe that the young man's difficult early years had not prepared him adequately for adulthood at age twenty-one. Were it not for his background, Kaplan believed, the youth might not be facing a murder charge. Kaplan prepared a story—with both words and pictures—about the young man that won the Robert F. Kennedy Award for Journalism.

But what of others at twenty-one; how were other youngsters getting along? To try to answer that question, Kaplan set for himself the task of photographing seven young people in their twenty-first year. Each person was from a different background and lived in a different environment; each had different dreams and ambitions, and was dealing with different challenges.

The seven photo essays featured a heavy-metal rock singer, a young fashion model, a football player, a drug user, a student at Harvard, an illegal immigrant, and a resident of Appalachia. During the course of the year, each young adult, as Kaplan's murder suspect had, faced a personal crisis; Kaplan's documentation of those crises and of how the subjects reacted to them, became a part of his longer project.

This was a unique, compelling experiment in photojournalism, and sufficiently unusual to win the Pulitzer Prize. Kaplan now works as a freelancer and serves as a consultant to newspapers seeking improved picture usage and page design.

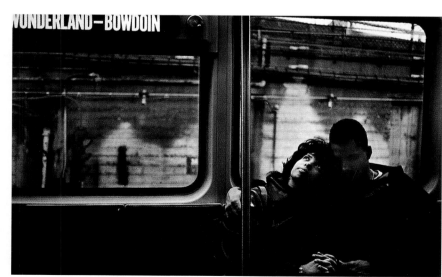

The Barcelona Olympics

BY WILLIAM SNYDER AND KEN GEIGER, THE *DALLAS MORNING NEWS*

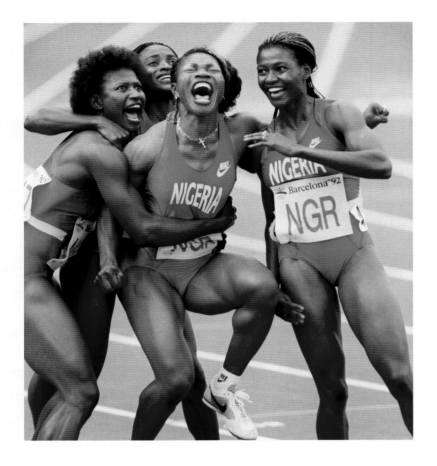

The quadrennial Olympiad is devoted to sports and athletic achievement but, as with so many international events, nationalism and power politics get into the act. The 1992 games at Barcelona were no different. In fact, a case could be made that politics had the edge.

More than fifteen thousand people from 185 countries participated at Barcelona, the largest number ever. There were still, however, these political considerations: The Russians, always a power at the Olympics, entered its athletes as a joint Eastern union of twelve Soviet republics; South Africa was back after a thirty-two-year absence; North Korea and Cuba competed for the first time; and the newly re-united Germany entered a unified team. The program of the Barcelona Olympiad thus resembled a diplomatic document reflecting the political realignments that followed the end of the Cold War.

Bill Snyder, fresh from coverage in Romania that won a 1991 Pulitzer Prize, teamed up with fellow *Dallas Morning News* photographer Ken Geiger to cover the games. A few days in the sun covering sports in Barcelona sounds like one of those dream assignments that turns up a couple of times in a photographer's career, but this is not so at the Olympics, which run from 8:00 a.m. to past midnight for sixteen straight days. And it isn't just shooting

MAY 1992 ■ *After thirty years as host of* The Tonight Show, *Johnny Carson retires.*

AUGUST ■ *Hurricane Andrew, the most powerful hurricane ever to strike the continental U.S., devastates Florida*

NOVEMBER ■ *Bill Clinton defeats George Bush in the U.S. presidential campaign, becoming the first democrat elected president since 1976.*

DECEMBER ■ *Buckingham Palace announces that Prince Charles and Diana, Princess of Wales, have separated.*

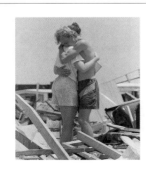

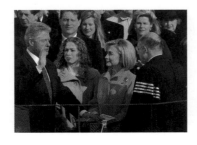

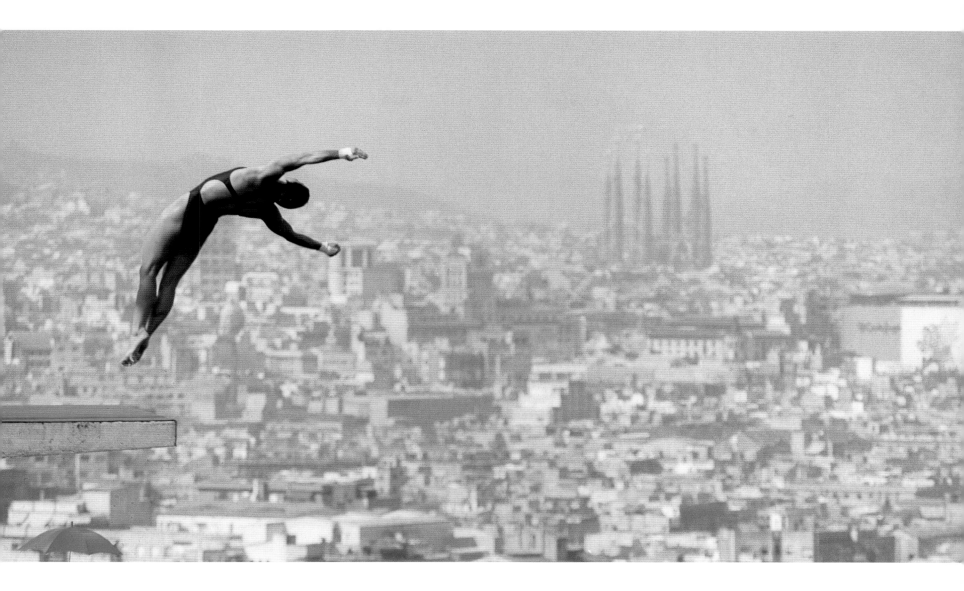

the pictures; film has to be processed, edited, and transmitted to the paper on the other side of the world.

It was a grueling, demanding task in an Olympiad that, beside politics, was said to feature the hottest weather in Olympic history. A normal day started with the swimmers or divers (shoot, process, transmit), then moved to track and field (shoot, process, transmit), and then gymnastics (shoot, process, transmit); and add a basketball game here and there, some equestrian events, and maybe water polo. An Olympiad can offer more than twenty athletic disciplines to competitors.

The two photographers, who had attended university together at the Rochester Institute of Technology, turned in a gold-medal performance on the games and won the Pulitzer Prize. It was Snyder's third award. In addition to the Romanian coverage, he also won for his participation in an Explanatory Journalism story winner in 1989.

TECHNICAL DETAILS

CAMERA Canon
FILM Various color films
LENS Various, ranging from 200 mm to 600 mm
SHUTTER & APERTURE Various

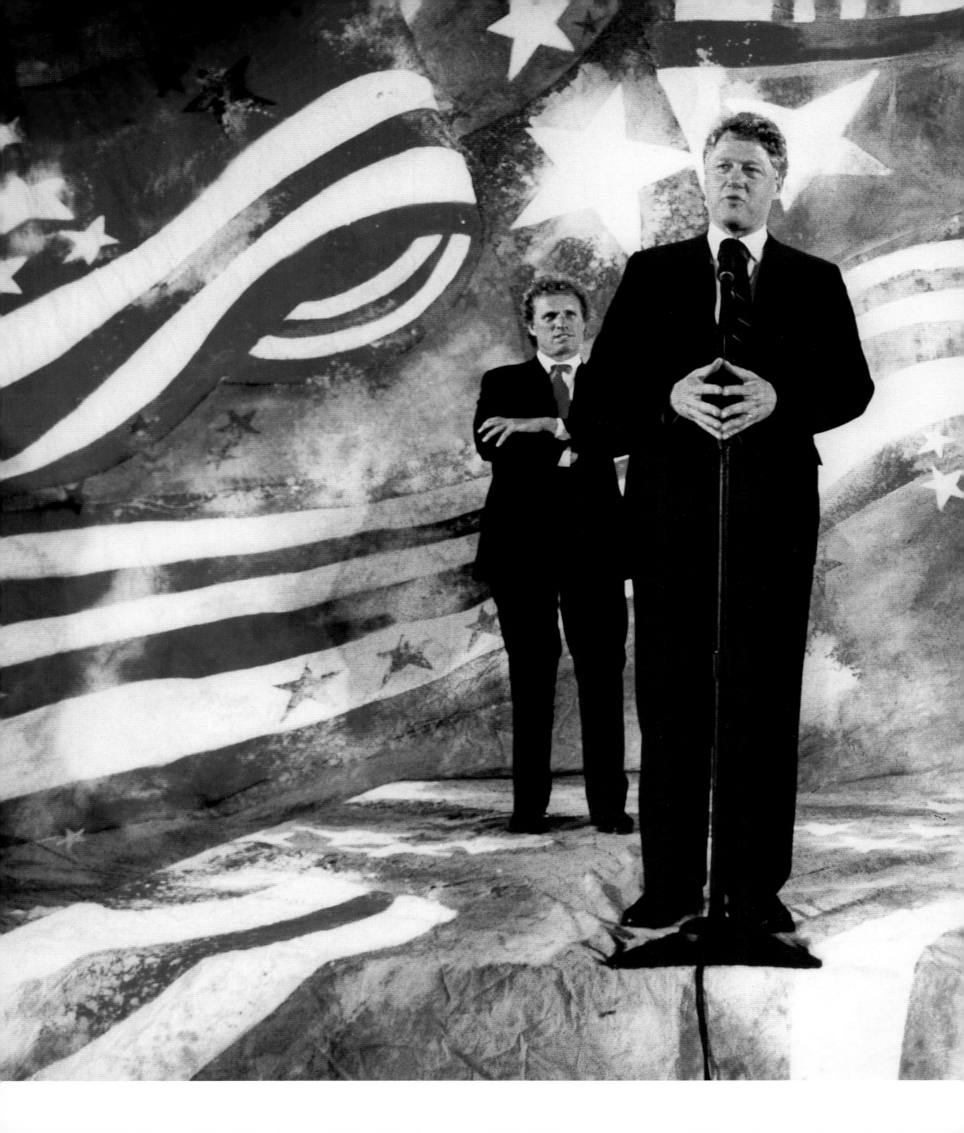

The Clinton Presidential Election Campaign

BY ASSOCIATED PRESS

Wire services face certain inescapable requirements when they cover a presidential political campaign.

- Coverage must be complete, so frequently more than one person photographs each situation.

- The need for speed is ever present. Newspapers and other publications worldwide expect the most recent pictures by deadline.

- Competition is fierce. Scores of photographers cover the campaign, and each one seeks the unusual, the special moment, and the right angle for a photograph.

- Despite the number of cameras present and the demands of speed, photographers still search for the unique, insightful picture that others miss or do not see.

When William Jefferson Clinton pursued the U.S. presidency in 1992, the photographers assigned to the campaign faced all of these traditional challenges. In addition, campaign planners, spin meisters, and others who handled the candidate, moved him here

TECHNICAL DETAILS **CAMERA** Nikon and Kodak digital camera
FILM Kodak color negative and digital
LENS Various
SHUTTER & APERTURE Various

and there—one time for a sound bite, the next time for a picture—always positioning the campaigner to maximum advantage.

Wire-service photographers call the collected daily results of their team coverage "the report." For the Associated Press photographers following Clinton, producing the report of the campaign was a blurred rush from place to place. They shot pictures quickly, and handed the film off to others who processed and edited the expo-

sures while the photographers raced to the next photo op. It was sometimes hours, but more often days or even longer, before a photographer saw the results.

In some situations, photographers waited for hours until the candidate appeared, jealously guarding a spot on a platform that they hoped would put them in the proper position for the best picture of an encounter that might last only a few minutes. At other times, photographers searched for hours to locate a spot no competing photographers occupied in the hope that it might produce a different or telling photo.

Overall, however, the campaign climate was admirably suited to wire-service photographers. Unlike those working individually, they were supported by a network of bureaus across the country, had access to prime positions in pools, and located good positions by using teams to leapfrog the fast-moving candidate. The opportunity for unusual, thoughtful pictures was also enhanced for wire-service photographers because local staff photographers connected to the agency could be assigned the anticipated shot while the AP team sought out the chancy, offbeat pictures.

The pictures shown here from the Associated Press's winning portfolio, are accompanied by statements from the photographers that describe how their pictures came about.

Stephen Savoia

Clinton's media advisers decided to hold this press conference in a hangar at Boston's Logan Airport. They had that backdrop painted quickly. Although it was really big, inside the vast hangar it looked small. I said, "Let me shoot what the image meisters want me to see. But let me put my own spin on it." My intent was to expose the photo op and show how everyone looked like cardboard cutouts of themselves. Some people have said to me that this was an easy picture to make. Technically it was easy to make; but there were fifteen or twenty other photographers there, and nobody else made that picture.

Marcy Nighswander

I was wandering around in the balcony, trying to find a spot where there wasn't already another AP photographer. I noticed Bush and Perot arguing in the background when Clinton was trying to speak. Clinton even turned around at one point to look at them. I think it was the only time in all of the television debates when all three candidates were in action at the same time. I was in the travel pool with Bush, so we packed and left right after the debate. I was so busy, I never even saw the photo until they showed me the package that won the Pulitzer.

Reed Saxon

This was relatively straightforward. Clinton opened the show (the Arsenio Hall Show) by sitting in with the band. The assistant director of the TV studio put me next to the main camera during the staging; but when Clinton played, the music stand blocked my view and cut off his hands and the instrument. At the last minute, I jumped to other side of the TV camera. The photo became one of the signature images for the whole campaign.

Greg Gibson

We had an unusual situation in New Hampshire in that we had one photographer on the candidate and I could be a floater. I picked a booth at the market that I thought would have more news value. I happened to see this little boy sitting on the counter in this shop. His mother let me come back and get behind him. I guess he was hoping to get a chance to talk to Clinton.

American Battle Death in Mogadishu

BY PAUL WATSON, THE TORONTO *STAR*

Somalia's tragic situation in 1993 was a carbon copy of problems that gripped other African nations caught in tribal and clan warfare. A dictator was thrown out of office in 1991, but no central government was formed. Warlords and their clans fought each other for control, but the only result was famine; by 1992, pictures of skeletal, starving children emerged on the world scene.

The photos touched a responsive chord, and the United Nations dispatched relief food. As is so often the case in African nations beset by tribal conflicts, however, the food did not go where it was most needed.

The U.N. sent military forces, including U.S. Marines, to secure the avenues of distribution, but the task was not a simple one. In one encounter, a Pakistani peacekeeping force suffered twenty-four dead in a clash with General Mohammed Farah Aidid, a key player in the overthrow of the dictatorship. Four journalists were killed in July 1993. Aidid was declared an outlaw, and a crack unit of 450 American soldiers was sent to hunt him down.

On October 3, the American unit attacked the Mogadishu hideout of Aidid's lieutenants, and an unexpectedly fierce firefight broke out. Paul Watson, one of the few journalists remaining in Mogadishu, watched the inner-city battle from his hotel rooftop. Two American helicopters, hit by rocket-launched grenades, fell into the city. A rescue convoy encountered fierce resistance in the form of an hours-long battle that continued through the day and overnight. Military experts later described it as the most violent firefight since Vietnam.

The next morning, Watson, accompanied by bodyguards armed with AK-47 weapons, drove into the city to gather facts about the battle. They located the still-smoldering wreck of a helicopter, and jubilant residents told them that the body of an American was being dragged through the streets. Watson and his companions searched for the crowd, finally locating them on a side street.

The bodyguards approached the crowd to see if it was safe for Watson to come forward. The jeering mob stepped aside as he approached, and there before him was the dusty, mutilated body of the American soldier. Ropes were tied around his wrists, and he had been stripped of all his clothes except for his regulation military underwear. Watson made pictures, but the crowd reassembled around the body and moved on. He followed and made more pictures, but his bodyguards heard threats from the crowd about the photography and told Watson to get back in the car.

"As I sped off," Watson later reported, "I was trembling, and I wondered whether the soul—maybe the ghost—of a man I could never know had watched what I had done. I prayed he would forgive me."

The pictures set off a firestorm of criticism in the United States. Readers bombarded newspapers with telephone calls, letters, and canceled subscriptions. Most complained that newspapers showed

JANUARY 1993 ■ *Czechoslovakia ceases to exist; as of midnight on December 31, 1992, the country becomes two, the Czech Republic and Slovakia.*

FEBRUARY ■ *Tennis star Arthur Ashe dies of AIDS, which he contracted through a blood transfusion.*

FEBRUARY ■ *A bomb explodes in one of New York City's World Trade Center towers, killing five people.*

APRIL ■ *After a fifty-one day siege, the F.B.I. storms the Branch Davidian compound in Waco, Texas.*

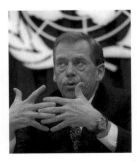
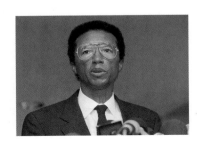
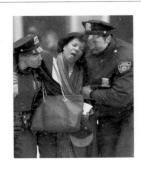
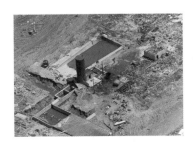

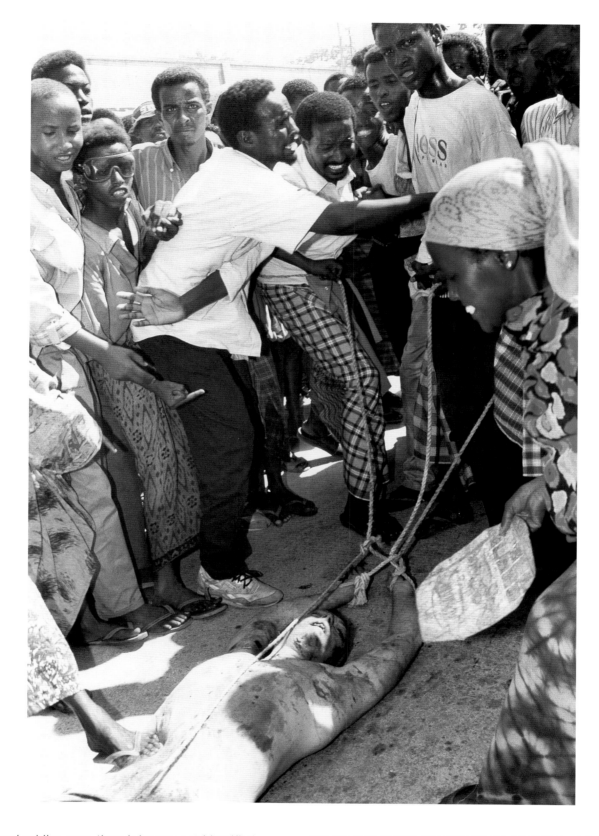

insensitivity to the dead soldier, even though he was not identified. Editors responded that only by seeing Watson's picture—which was more vivid than any written report—could anyone understand the brutality of the fighting in Somalia. The picture was compared to the compelling photo icons that won Pulitzers from the Vietnam War.

The picture also had a sobering impact in government circles. Within months, U.S. forces and the United Nations withdrew from Somalia. Western news agencies withdrew most of their staff because

TECHNICAL DETAILS **CAMERA** Nikon
FILM Fuji color negative
LENS Zoom, 35 mm to 70 mm
SHUTTER & APERTURE Unknown

of the danger. In 1996, Aidid was killed, but Somalia continued to suffer without food and without a central government. Watson took up a new post in South Africa, and was later transferred to Asia.

1994 [FEATURE]

The Vulture and the Baby

BY KEVIN CARTER, SYGMA

Kevin Carter, a freelance photographer and an internationally known chronicler of South Africa's unhappy struggle with apartheid, found Sudan on the brink of famine when he arrived there to photograph the rebel movement in early 1993.

Africa's largest nation, Sudan was embroiled in a civil war that had begun at the time of the country's independence from Great Britain in 1956. The animist peoples of the south feared domination by the Muslim-controlled government in the north, and sought regional independence during three decades of intermittent fighting. By 1992, the government had attempted to impose Islamic law on the south and diverted international aid from the south to the north. Local food production, constantly threatened by drought, had been sharply reduced by the constant civil strife. Millions were displaced by the fighting and the bloody ethnic encounters. Finally, agencies of the United Nations, under attack from both government and guerrilla forces, discontinued food distribution to villages in the interior.

The political and social strife that ripped apart so much of Africa was well known to Carter. For most of his journalistic life, he had photographed the violent struggle in his homeland of South Africa. He started as a weekend sports photographer, but soon worked as a staffer on a series of newspapers; he became linked with a group of white South African photographers who covered the brutal aspects of the apartheid story. By 1990, that coverage included the exceedingly

dangerous tribal warfare between Nelson Mandela's supporters and those who supported the Zulu-based opposition.

Carter teamed up with three other photographers—the Associated Press's Greg Marinovich, Pulitzer winner in 1991; Ken Oosterbroek, of the *Johannesburg Star;* and freelancer Joao Silva. The group's pictures of the vicious tribal clashes were so well known that a local magazine writer nicknamed the four, who traveled together for protection in South Africa's black townships, the Bang-Bang Group.

In February 1993, Carter took a leave from *The Weekly Mail* and, with Silva, went to Sudan. Their plane landed at the village of Ayod, where a feeding station had been setup. Carter spent much of the day photographing the horrific scene of starving people stumbling into the station in search of food.

In the course of his coverage, he walked into the bush near the station and heard the barely audible sound of a child whimpering. A little girl was crouched in the dust, making her way toward the station. At that moment, a vulture landed nearby, sensing carrion. Carter positioned himself to make a picture of the child with the vulture waiting patiently for its time. Carter made a few photos, then chased the bird away.

Carter's friends later reported that he was depressed after making the picture, but the poignant image touched a global nerve. In March, the *New York Times,* seeking a photo from Sudan, used Carter's gut-wrench-

AUGUST 1993 ▪ *The Mississippi River and its tributaries burst their banks, flooding twenty million acres of farmland, the worst flooding in U.S. history.*

SEPTEMBER ▪ *Israel and PLO sign a peace treaty, providing for limited Palestinian autonomy in the Gaza Strip and the West Bank.*

DECEMBER ▪ *Steven Spielberg's moving film* Schindler's List *opens.*

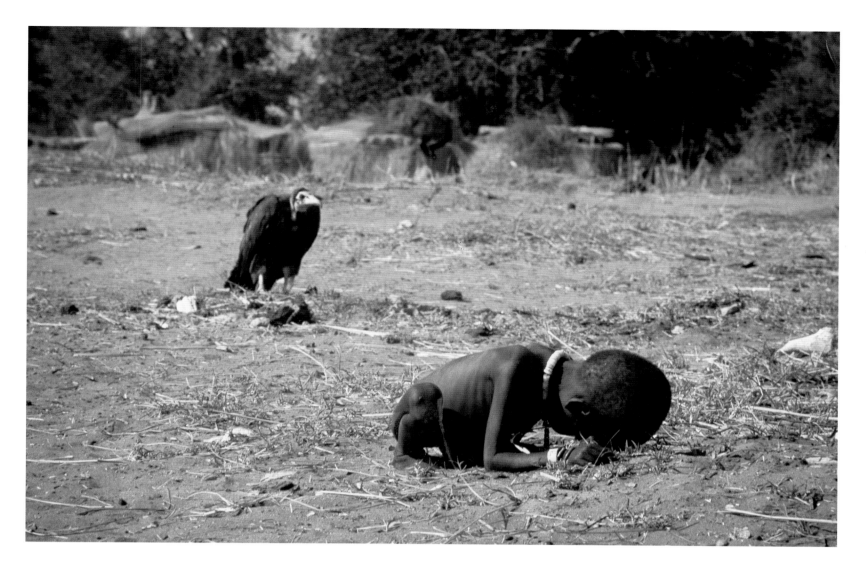

ing picture. It was quickly picked up by others and widely published internationally; it soon became a worldwide icon of African suffering.

The extensive use of the photo and the fame that it brought encouraged Carter, by then back in South Africa, to leave the *Mail* and freelance. Freelancing presented a glamorous image but it had a downside—long waits between assignments, periods of income high and low, no health insurance or benefits. Carter signed up with the Reuters news agency but the road was not smooth for him.

In April 1994, just days after Carter heard that he had won the Pulitzer Prize, the Bang-Bang Group covered bloody fighting just outside Johannesburg. Carter left the scene early and returned to his office. When he arrived he learned that in the short period of time that he had traveled from the scene of the fighting to his office, his best friend Ken Oosterbroek had been killed and Greg Marinovich seriously wounded. Carter was devastated.

Although a prize like the Pulitzer brings fame and, along with it, increased attention to a photographer's work, the focus is not always kind. Some colleagues in Johannesburg said the picture was a fluke, or that Carter somehow had set it up. More stinging, however, were others who questioned his ethics, saying that a photographer who concerned himself with the picture instead of helping the child was just another

TECHNICAL DETAILS　　　**CAMERA** Nikon
FILM Fujichrome
LENS 180 mm
SHUTTER & APERTURE Unknown

vulture on the scene. Others asked why he had not helped the girl. These criticisms only added to the photographer's devastation.

The June Pulitzer award ceremony brought Carter to New York for the first time, where he was honored and feted by the photo media world. He was delighted, but upon returning home he fell into what his friends described as a funk.

On the night of July 28, 1994, shortly after he savored his prestigious Pulitzer in New York, Carter parked his red pickup truck alongside a river that passed through the Johannesburg suburb in which he grew up. He attached a hose to the exhaust pipe with gaffer tape and threaded it into the cab of the truck, climbed into the vehicle, closed the windows, and turned on the engine.

The explanatory note he left behind told of a man frustrated by lack of money and haunted by unrelenting memories of killings, madmen with guns, starving children, of corpses and pain. His note said he hoped to join his friend Ken. Carter was thirty-three years old.

New Regime in Haiti

BY CAROL GUZY, THE *WASHINGTON POST*

Haiti slumbered in the Caribbean sun between 1991 and 1994, isolated from much of the world by a United States-led trade embargo that had been enacted after the ruling generals threw out the legally elected president, Jean-Bertrand Aristide. The junta rule was cruel, some three thousand Haitians were said to have been killed, and the generals repeatedly broke promises to return Haiti to a democratically run state.

The result of the trade embargo was that the island grew poorer and poorer, and the generals' rule grew harsher and harsher. Thousands of Haitians fled the island and were interned at U.S. military facilities at Guantanamo Bay, Cuba.

By 1994, there was talk of a multi-nation military incursion of the island. That was averted through negotiation, however, and Aristide was returned to his presidential post in the company of a multi-national peacekeeping force of twenty thousand. The generals, meanwhile, agreed to leave.

During the same period, Carol Guzy made frequent visits to Haiti, some as a *Miami Herald* photographer and others as a *Washington Post* photographer. It was natural that the *Post* would

send her to cover the explosive situation in Port-au-Prince in 1994.

The transition from military rule to that of Aristide, who had been an active opponent of American activities both political and business, was uneasy. Many saw him as an unreliable ally in the area, but his return went forward as planned.

At a parade held in celebration of the new government, a junta supporter threw a hand grenade into the crowd, killing several and wounding others. Soldiers, civilians, and newspeople alike threw themselves to the ground, but some members of the crowd grabbed a man they believed threw the bomb and began beating him. A GI rushed forward, pistol in hand, and forced the crowd away from the suspect, saving his life. Working from a low angle, Guzy made a dramatic shot of the GI confronting the crowd and restoring order that was awarded the Pulitzer Prize.

Guzy stayed in Haiti and kept her camera on events there as the small country gradually returned to its democratically elected order. She was the first woman to win two Pulitzer Prizes. She shared her first, in 1986, with Michel duCille, also a double winner, for their combined coverage of a volcano disaster in Colombia.

JANUARY 1994 ■ *An earthquake measuring 6.6 on the Richter scale strikes Los Angeles, killing fifty-one.*

APRIL ■ *Former U.S. president Richard M. Nixon dies at age eighty-one.*

MAY ■ *Nelson Mandela is sworn in as the first black president of South Africa.*

MAY ■ *Former first lady Jacqueline Kennedy Onassis dies at age sixty-four.*

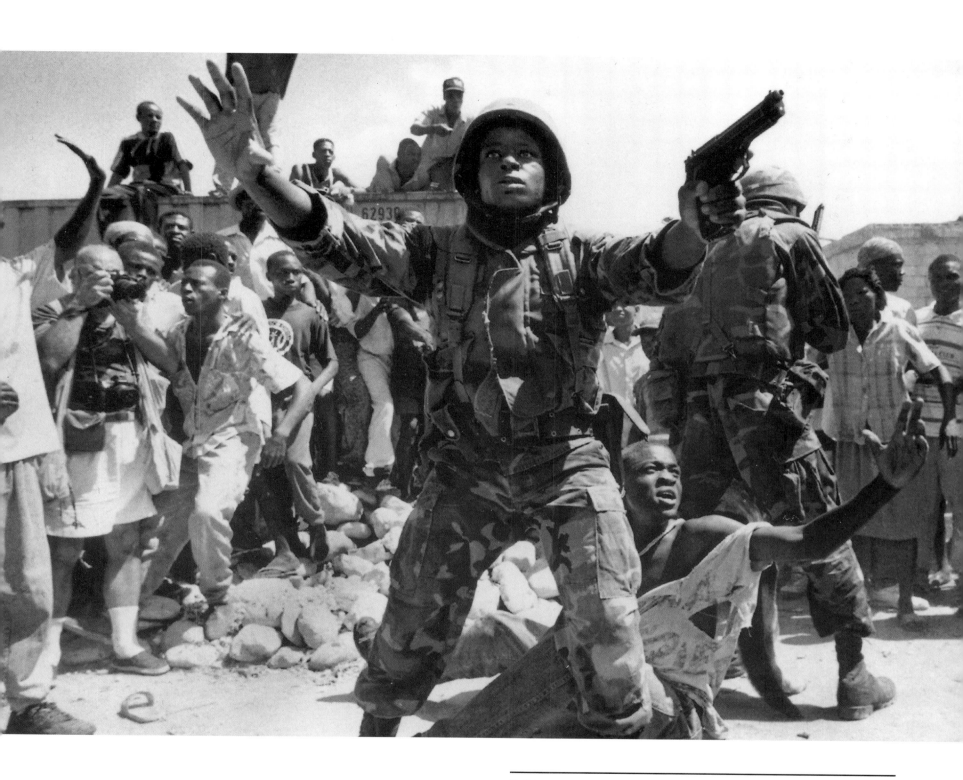

TECHNICAL DETAILS CAMERA Nikon
FILM Kodak
LENS 20mm
SHUTTER & APERTURE Unknown

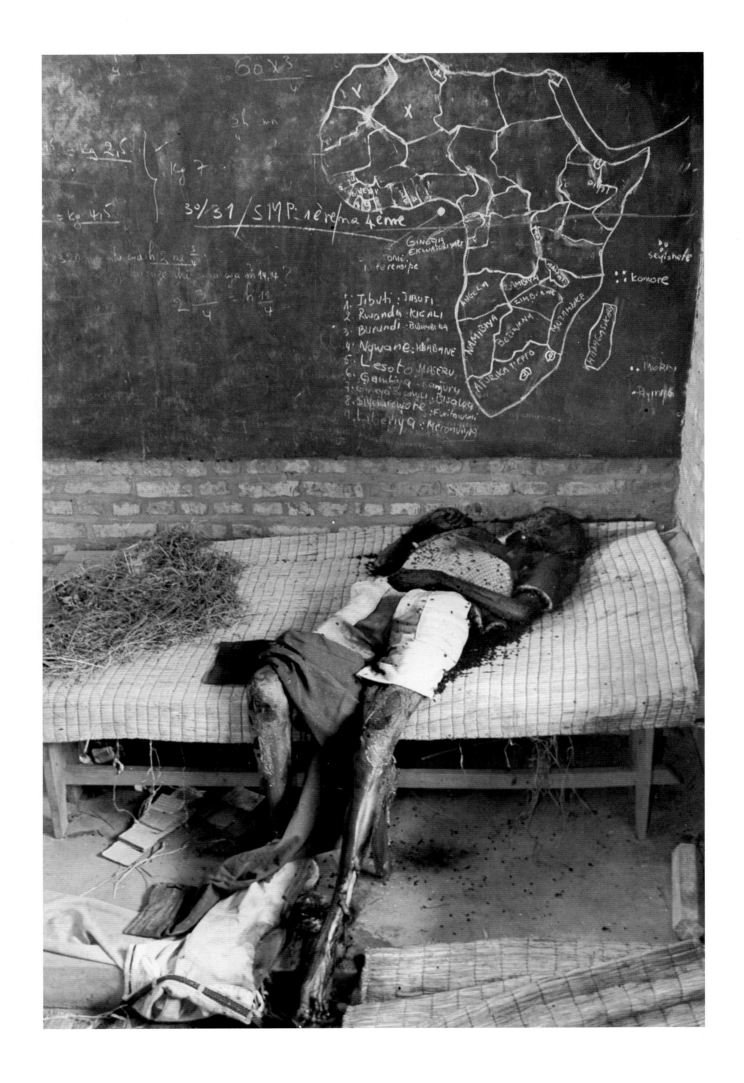

Rwanda: Village of Death

BY ASSOCIATED PRESS

It is rare in the annals of the Pulitzer Prize that awards for reporting and photography are made for the same story. In 1995, however, the Pulitzer committee awarded Associated Press the prizes for feature photography and for international reporting for its coverage of the tragic killing fields created by tribal warfare in the African nation of Rwanda.

The feature photo award was made to an AP photographer team composed of Jacqueline Arzt, Javier Bauluz, Jean-Marc Bouju, and Karsten Thielker. The writing award was presented to Mark Fritz.

The combination Pulitzer award for writing and photography offers an unusual opportunity to use Mark Fritz's words to describe the situation in Rwanda from which the four photographers' images came.

"Everybody here is dead. Karumbamba is a vision from hell, a flesh-and-bone junkyard of human wreckage, an obscene slaughterhouse that has fallen silent save for the roaring buzz of flies the size of honeybees.

"Karubamba is just one breathtakingly awful example of the mayhem that has made beautiful little Rwanda the world's most ghastly killing ground. Karubamba, thirty miles northeast of Kigali, the capital, died April 11, six days after Rwandan President Juvenal Habyarimana, a member of the Hutu tribe, was killed in a plane crash whose cause is still undetermined. The paranoia and suspicion surrounding the crash blew the lid off decades of complex ethnic, social, and political hatreds. It ignited a murderous

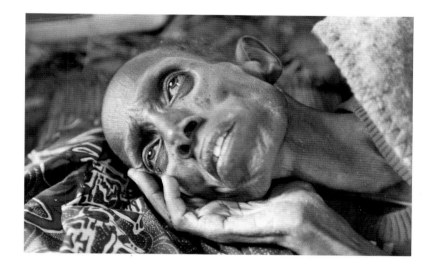

spree by extremists from the majority Hutus against rival Tutsis and those Hutus who had opposed the government.

"Almost every peek through a broken window or splintered door reveals incomprehensible horror. A schoolboy killed amid tumbling desks and benches. A couple splattered against a wall beneath a portrait of a serene, haloed Jesus Christ.

"On the night of April 11, the killers swarmed among the neat rows of buildings and began systematically executing the predominantly Tutsi population with machetes, spears, clubs, and guns.

DECEMBER ▪ *Russian soldiers enter Chechnya to bring the breakaway republic to heel.*

DECEMBER ▪ *Yassir Arafat, Shimon Peres, and Yitzhak Rabin win Nobel Peace Prize.*

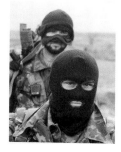

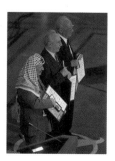

"At the primary school midway between the maternity clinic and the church, a man lies prone beneath a meticulously drawn blackboard sketch of Africa, the capital of each nation listed alongside.

"A rebel commander said an estimated 1,500 to 2,000 people died in the carnage at Karubamba. The only sign of human life in the area is a lone sentry posted roughly where the fresh air begins. When asked about the massacre the officer said, "It's happening everywhere.'"

The images by the four prize-winning photographers are each accompanied by the photographer's comments about his or her experiences photographing in the refugee camps of Rwanda and of nearby Zaire.

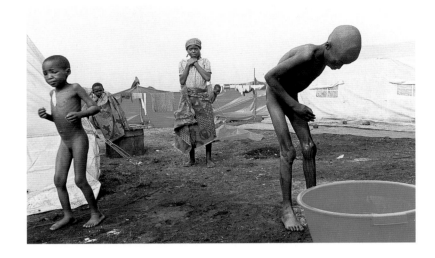

Jacqueline Arzt

Africa is the continent where humanity was born, but in July and August of 1994, other AP staffers and I saw it become saturated by misery and take its offspring back to the earth. As I was photographing, my eye would routinely linger in the frame to see if the person I was photographing was breathing. For me, winning the Pulitzer means that those who see these pictures will consider once again the evil that flourishes when good men do nothing. Nearly a year later, those who have managed to survive in the refugee camps and the orphanages are still living on a prayer in a God-less land.

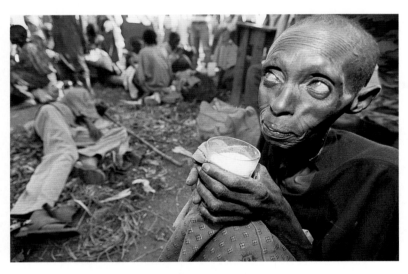

Javier Bauluz

I met with a photojournalist friend. We were saying that we had never seen such a terrifying thing in our lives. I heard weeping and I saw a blanket by the edge of the road. One more dead, I said to myself. Then I heard a cry from the blanket. I got closer. I unfolded the blanket and found a child, maybe seven years old. Fighting the repugnance of the smell and grime, I took him in my arms and walked some hundred yards to the hospital. I left him there.

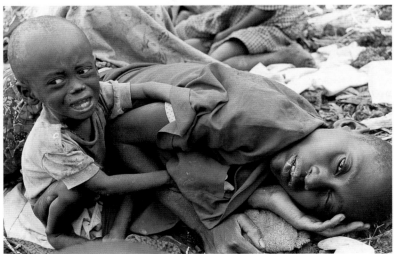

Jean-Marc Bouju

Rwanda 1994, the quickest genocide and biggest exodus in modern history. The thick smell of rotting bodies hung over the country for weeks. I think of Rwanda as a once-in-a-lifetime story. If my pictures, with the pictures and text of my colleagues, helped others to understand even a little bit the scale of the Rwanda nightmare, I am happy.

Karsten Thielker

This sickening sweet smell came from out of nowhere, we were one and a quarter miles from the scene of a three-week-old massacre. Three hundred bodies in the middle of nowhere. I was confronted with scenes that no one could ever imagine. I didn't want to send pictures of bones in dirty, bloody clothes from the church massacre, of the rotting bodies in the middle of the street. I dreaded sending pictures of these hundreds of dead, lying together as if they were still afraid to die. No one could participate in this if it were not part of covering a major story.

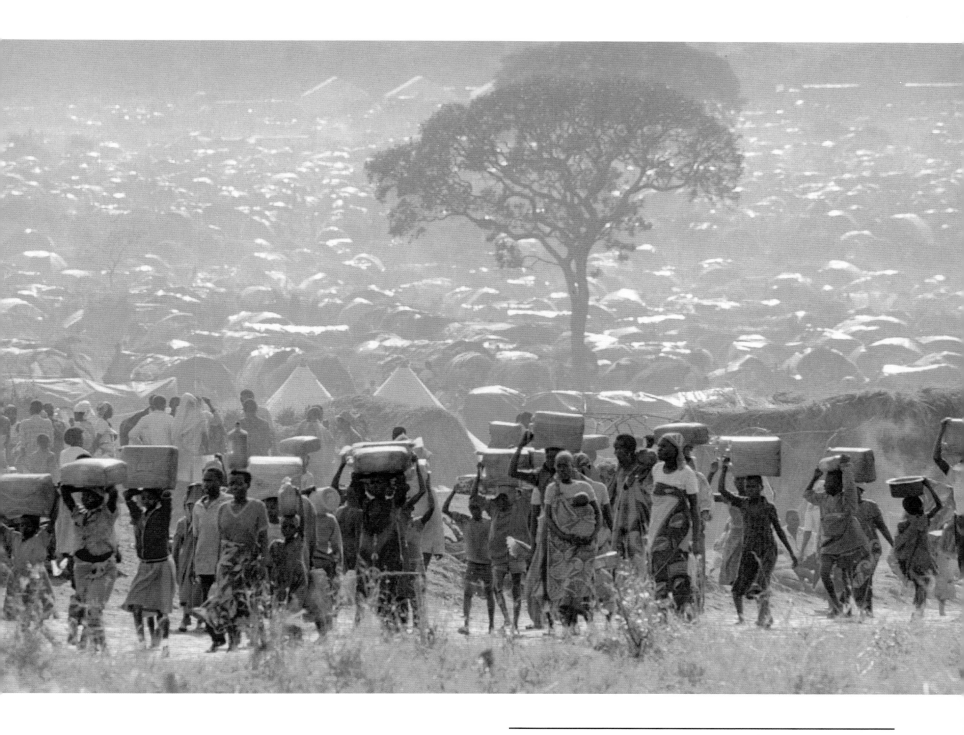

TECHNICAL DETAILS **CAMERA** Leica and Nikon
FILM Fuji Color negative
LENS Various
SHUTTER & APERTURE Various

1996 [NEWS]

Oklahoma City Bomb Victim

BY CHARLES PORTER IV, ASSOCIATED PRESS

Charles Porter IV was settled into his morning's work as a credit specialist in a downtown Oklahoma City bank when he was jolted from his concentration by a loud explosion. It was 9:02 a.m., April 19, 1995. He thought the blast, obviously nearby, sounded like a demolition charge.

An avid amateur photographer, Porter left his office, grabbed his camera from the trunk of his car, and headed toward the scene on the chance that he might make a few interesting pictures.

In moments, just three blocks from the bank, he was caught up in chaos at the Alfred P. Murrah Federal Building. The entire front of the building had been shattered, blown away by the explosion Porter had heard. Smoke and dust swirled through the air. The bleeding wounded ran through the streets, some assisted, some not. He saw rescue workers pulling the dead and injured from concrete debris thrown about by the bomb. There were many children among the victims and some, to his untrained eye, appeared to be dead. This was a new world for Porter. His photography experience had consisted primarily of shooting pictures at the Bullnanza Rodeo at the Lazy E Arena. That was fun; this was horror. Undaunted, he made pictures.

Inside the building, the cries of children attracted Police Sgt. John Alvera as he searched the crumbled hallways and rooms of the federal building. He and other officers moved pieces of concrete and uncovered two babies, one of which he picked up to carry outside.

Alvera got to the street just a few feet from where Porter was standing with his camera. Porter watched as Alvera, clutching the injured child to his chest, moved toward firefighter Chris Fields. Alvera shouted, "I have a critical infant." And then again, "I have a critical infant." Porter raised his camera and started shooting as Alvera placed the bloody, dirt-covered infant in the firefighter's outstretched arms. Fields held the child briefly and gently checked for signs of life, but there was no pulse under the arm. There was no slight whisper of breath on the fireman's face when he held it just millimeters from the child's mouth. Fields hurried to the medical teams at the scene. He said later that, as he held the child, all he could think of was his own two-year-old son.

Porter continued to take pictures of the overwhelming scenes around the federal building, then went immediately to a nearby Wal-Mart to have his film processed and printed. When he first saw the pictures twenty minutes later, he didn't think he had much, but the firefighter print was well-exposed and sharp. His opinion was changed by the attendants at the Wal-Mart developing counter, who burst into tears when they saw the picture of the bloodied child, arms and legs limp, cradled in Fields's arms.

Since Porter was uncertain about what to do with the pictures, he consulted a former professor who was also a friend. "Take them to Associated Press," he was told. Porter did, and the pictures flashed around the world in minutes.

JANUARY 1995 ■ *A devastating 7.2 earthquake strikes Kobe, Japan, killing thousands.*

MARCH ■ *A religious sect releases deadly nerve gas into the Tokyo subway system, killing eight people.*

APRIL ■ *A bomb hidden in a truck parked outside the Alfred P. Murrah building in Oklahoma, killing 168 persons.*

SEPTEMBER ■ *A manifesto written by Theodore Kaczynski, the Unabomber, is published by the* New York Times *and the* Washington Post.

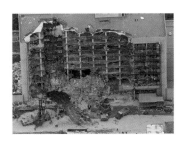

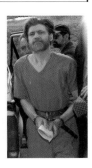

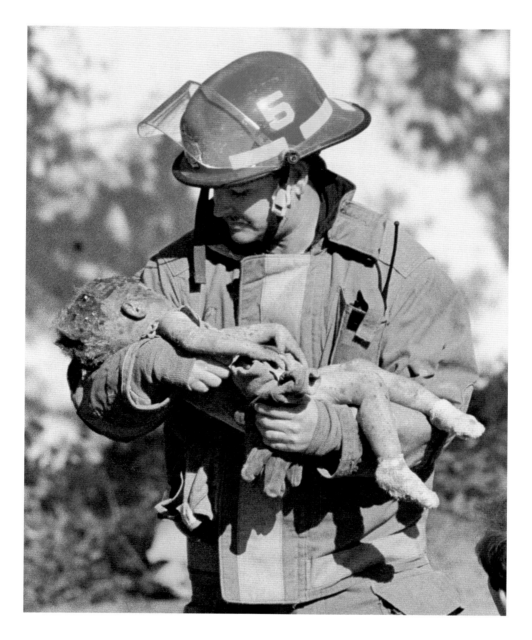

Some hours after the bombing, Porter began to feel the impact of the picture, and he decided to find out who the child was. With his picture in hand, he visited hospital after hospital and asked over and over again if anyone had seen the baby. But no one remembered the child. The baby, declared dead upon arrival at the hospital, was later identified as Baylee Almon, the daughter of Aren Almon, a single parent.

When Aren Almon saw the picture on the front page of the local paper the morning after the blast, she knew it was Baylee. Grief-stricken by her child's death, she was nonetheless relieved and touched by the gentle demeanor of the fireman who had handled her child so carefully.

Editors around the United States who had to decide whether to use the picture knew that they would hear from angry readers about the invasion-of-privacy and lack-of-taste issues that the photo would raise, but most printed the picture in color on the front page on the grounds that, more than any other image, it captured the heart-piercing terror of the bombing.

TECHNICAL DETAILS **CAMERA** Canon
FILM Kodak color negative
LENS Zoom, 70 mm to 200 mm
SHUTTER & APERTURE Unknown

It is not surprising that Porter won the Pulitzer Prize for spot news photography, one of the few amateurs to do so. It is also not unexpected that his picture took on a life of its own. Photographs of this kind—the 1945 Iwo Jima flag photo, the 1969 and 1973 winners from Vietnam, the 1976 winners from Boston, the Kent State winner of 1971, and other images not awarded Pulitzers—become photo icons that represent a story in all its aspects, that somehow define a special moment in history. The people involved with these pictures—the subject, the photographer, and even those peripheral to the scene—find themselves connected permanently.

The picture remains one of century's icons.

African Rite of Passage

BY STEPHANIE WELSH, FREELANCER

It is an ancient rite, steeped in the customs of certain traditional societies and pursued to protect a woman's chastity, prepare young girls for womanhood, and support family solidity. It goes by many names—female circumcision, female genital mutilation, vaginal cutting.

Supporters say it is a rite of passage; and many of the millions of teenage girls who voluntarily submit to the cutting, as well as those who forcibly submit, defend it as an accepted part of their life. The elder women likewise insist that the practice is both an important part of a young girl's transition to womanhood and a

preparation for marriage. Unfortunately, however, the young women who suffer the treatment frequently contract infections or diseases that stay with them forever.

The purpose of the rite is to remove surgically the clitoris and sometimes part of the labia, thereby reducing sexual pleasure and the potential for adultery. In many cases, however, the cutting is done in mud huts, using glass, razor blades, or other improvised instruments. It is a traumatic event in a young woman's teenage life.

Stephanie Welsh, newly graduated from university, accepted a year-long internship at *The Nation*, a newspaper in Nairobi, Kenya. She learned Swahili while in Kenya, read about the circumcisions, and made up her mind that she would witness and photograph the rite.

Contacts were made through social workers and medical teams working in the Masai countryside, but early attempts to make photographs failed. Welsh witnessed a number of cuttings, but the villagers involved would not permit cameras. In one case, an agreement was reached for photography, but, at the last minute, Welsh was told that there could be no pictures.

The constant setbacks only hardened Welsh's determination, however. On her fourth try, she was introduced to a contact who knew that a cutting would take place in the remote village of

OCTOBER 1995 ■ *After a ten month trial, football star O. J. Simpson is found not guilty for the murder of his ex-wife, Nicole Brown Simpson, and her friend Ronald Goldman.*

OCTOBER ■ *Louis Farrakhan leads a march of over 500,000 black men on the mall in Washington, D.C.*

NOVEMBER ■ *Israeli Prime Minister Yitzhak Rabin is assassinated after attending a rally to counter resentment at the concessions given to the Palestinians.*

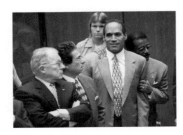

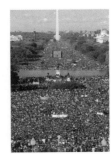

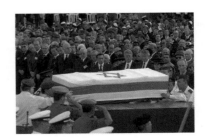

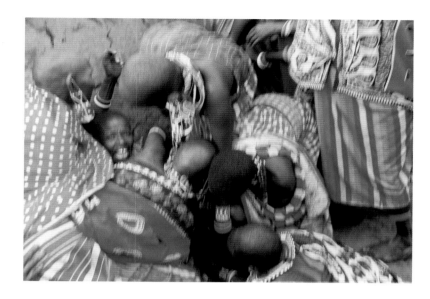

Wamba, a ten-hour bus and car ride from Nairobi. A sixteen-year-old girl named Seita Lengila would be circumcised.

Some of the elder women did not want Welsh to make pictures, but as quietly and unobtrusively as possible, she worked her way into the group performing the rite. They held the girl down and, without anesthetic, used a razor blade to perform the surgery. Seita screamed, "Why are you trying to kill me?" at the woman who performed the operation. "I'm dying, I'm dying," she mumbled. Others of the group held her legs and stifled her cries. They scolded her, "Stop that, it doesn't hurt." After the operation, Seita was examined by one of the elder women to make certain the procedure had been done properly.

Welsh's pictures captured the frenetic activity of those who did the cutting. She also photographed young Seita who, screaming and in pain, left the hut amid the swirling red costumes of the older women and with her own blood splashed on her legs. The young girl went off alone into the bush to examine herself and make certain the cutting had been done correctly. If wrong, the operation would have to be done again.

Welsh later would say about her photographs, "This was something I couldn't not do. After you see it once, you can't get it out of your mind."

The pictures were distributed by the Newhouse News Service, and they drew a reaction that Welsh described as a "very, very positive, compassionate response." She donated part of her Pulitzer Prize award money to causes dedicated to stopping the mutilations.

TECHNICAL DETAILS **CAMERA** Nikon
FILM Various, color negative and transparency
LENS Various, ranging from 28 mm to 180 mm
SHUTTER & APERTURE Various

Rescue

BY ANNIE WELLS, *SANTA ROSA (CALIFORNIA) PRESS DEMOCRAT*

Mantanzas Creek flows through Bennett Valley just southeast of Santa Rosa, California. After some heavy rain, the water was moving fast, and to sixteen-year-old Marglyn Paseka and her friend, the swift current offered the chance for a small adventure. They decided to ride downstream aboard garbage-can lids.

The girls entered the water aboard their makeshift surfboards, but as they rode down the creek, the current became a raging, near-flood-stage torrent that caught the inexperienced adventurers unaware.

Annie Wells, a photographer for eight years on the *Santa Rosa Press Democrat,* was on assignment when the radio that linked her to the paper's city room crackled to life. Night city editor Janielle Jobe told her that the fire department scanner had just reported two girls were in danger of drowning in Mantanzas Creek. She told Wells to drop what she was doing and go to the scene. A short car ride and a dash through waterside brambles and low-hanging limbs brought Wells to the scene.

Marglyn's friend had grabbed a tree limb close to shore, and a fire department rescuer brought her to solid ground, but the tree Marglyn had caught was further out, where the current was stronger and churning with great force. Fireman Dave Lopez worked with fellow fire department rescuers to fix his lines solidly before he moved toward Marglyn. Wells began to make a series of pictures, but the events were unfolding so quickly that she was afraid she would run out of film

when Lopez reached the girl and that she would not have time to reload. She stopped shooting to await the right moment.

Lopez entered the water, and Marglyn yelled that she was afraid she could no longer hold onto the limb. Her stamina, weakened by the constant rush of cold water, the cutting bark of the tree limb, and fear, was fading quickly. Water swirled around her shoulders.

Wells realized that this was more than a rescue; it was a dangerous struggle between life and death. She waited as Lopez edged toward the girl. He was close. The water's power turned him slightly on his side as he reached to grasp Marglyn so he could bring her to shore. Wells shot the picture and remembered—frame twenty-four on a thirty-six exposure roll. She recalled later that she knew it was the best picture she had ever taken.

The next morning, February 5, 1996, the color photo was printed six columns wide on the front page of the *Press Democrat.* It was picked up by the wire service and distributed worldwide.

Incidents like this one often end in tragedy, and newspapers are criticized for carrying a photo that shows loss of life; but this story had a happy ending, and readers responded positively. Lopez received several commendations for his heroic rescue work, and Marglyn was featured in several teen and water-safety publications. Her parents, however, drew the line when a German magazine wanted to do a photo spread on her.

FEBRUARY 1996 ■ *Gene Kelly, star of many beloved movies including* Singin' in the Rain, *dies at eighty-three.*

JULY ■ *Steffi Graf wins her seventh Wimbledon women's singles title.*

JULY ■ *Dolly, a sheep, is born in Scotland. She is the world's first complex animal to have been cloned from an adult somatic cell.*

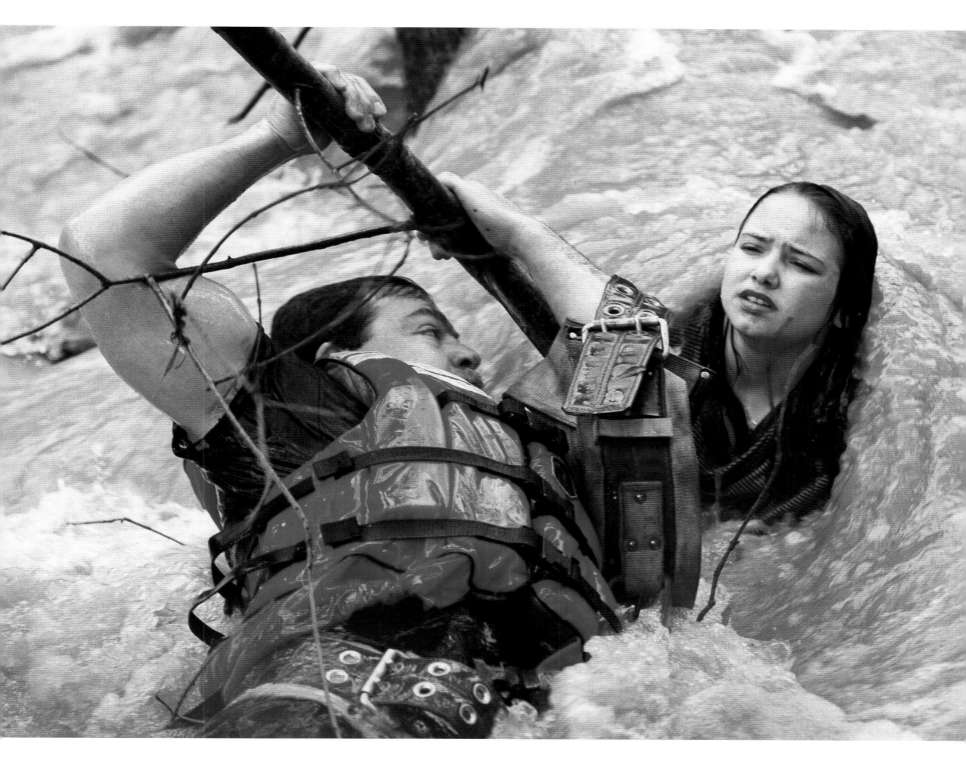

Wells was awarded the Pulitzer Prize for the photo, but she regretted she could not share it with her editor, Janielle Jobe, who had died of cancer just two months after it was made.

Wells had joined the *Press Democrat* after working at papers in Colorado and Utah and with Associated Press in California. She later moved to Los Angeles, were she took an assignment at the *Los Angeles Times*.

TECHNICAL DETAILS **CAMERA** Nikon
FILM Fuji color negative
LENS 180 mm
SHUTTER & APERTURE Unknown

The Dancing Bear

BY ALEXANDER ZEMLIANICHENKO, ASSOCIATED PRESS

Politicians seeking office possess a common instinct that transcends barriers of culture and distance—each and every office seeker will do anything to get the vote. Boris Yeltsin's 1996 effort to win the hearts, if not the minds, of the Russian voter featured dancing.

He danced in Ufa as he pressed for votes and sought peace in Chechnya. He danced in Novosibirsk, Siberia, as he charged that the Communists were stirring up trouble during the election campaigns. His wife tried to pull him off the dance floor there.

Vice President Al Gore, on a visit to Russia, even complimented Yeltsin's campaign dancing during a stop in Barvikha, a Moscow suburb.

Yeltsin's political opponent, Gennady Zyuganov, tried to get on the bandwagon, as well, when he took to the dance floor in a Moscow nightclub.

But the mother of all dances was Yeltsin's vigorous performance of a tricky but unclassified number with two leggy, short-skirted performers at a rock concert in Rostov.

Associated Press photographer Alexander Zemlianichenko covered Yeltsin on many of his campaign swings across Russia and had photographed him dancing before, both with his wife, at the session at Novosibirsk, and at Ufa, where the dance was in the classic Russian mode.

Zemlianichenko's Rostov picture captured the political antics of Yeltsin, but it said even more about Russia. It told of a Russia now different than the menacing bear of the Cold War. The women dancers could be anywhere—London, Frankfurt, Rome, or New York. The white-shirted Yeltsin, tie flapping and arms askew, could be any American politician looking for a laugh that translated to votes, or any London businessman out for a night on the town. The electronic apparatus of the western rock concert added a small, but meaningful detail associated with modern music. And, best of all, the picture possessed humor, that most difficult of all emotions to capture in still photography.

Zemlianichenko made the photo in a city that would have been difficult to visit only a few years earlier. And the image showed a Russian leader quite different than Joseph Stalin, or even Mikhail Gorbachev. All these things were known, of course, but there they were, frozen in a single photo.

The picture was flashed around the world and was published on front pages from London to Tokyo, from New York to Seattle. It brought Zemlianichenko a second Pulitzer; his first was as part of the team that won the 1992 Pulitzer for its coverage of an attempted Moscow coup.

JULY 1996 ■ *TWA flight 800 explodes over the Atlantic, just minutes after taking off from JFK airport. The cause is attributed to a fuel tank ignited by a spark.*

NOVEMBER ■ *In an attempt at post-Cold War reconciliation, Fidel Castro meets Pope John Paul II in the Vatican.*

TECHNICAL DETAILS
CAMERA Nikon
FILM Fuji color negative
LENS 300 mm
SHUTTER & APERTURE Unknown

Trek of Tears

BY MARTHA RIAL, THE *PITTSBURGH POST-GAZETTE*

By and large, images awarded Pulitzer Prizes portray special moments. Sometimes they are memorable reminders of history's markers; other times they catch moments of high drama as life hangs in the balance. Occasionally they depict purely human vignettes that offer insights far beyond their specific, frozen sliver of time.

The ethnic genocide that characterized Hutu and Tutsi enmity in Central Africa of the mid-1990s held a promise of dramatic pictures that drew photographers the way a flame draws moths. The bloody and vicious events had been well documented; the pictures amply illustrated the treatment of one group by the other and showed the world what remained—orphans, widows, rape victims, and refugees. A Pulitzer had been won in 1995 for pictures of this story. Martha Rial, a staff photographer for the *Pittsburgh Post-Gazette,* sought to approach a photo essay of the social devastation from a different perspective. Rial was impressed by a conversation with her sister, a nurse assigned to the International Rescue Committee who worked in Tanzania in an area close to the Burundi border. Their exchange led Rial to seek an assignment from her paper to photograph the Hutu-Tutsi conflict through the life of the refugees that would focus on their desire to overcome adversity and find a new life. She envisioned the coverage to be presented in the form of a photographic journal that she called *Trek of Tears.*

TECHNICAL DETAILS **CAMERA** Nikon
FILM Color negative
LENSES 35 mm to 300 mm
SHUTTER & APERTURE Various

MARCH 1997 ▪ *Comet Hale Bopp streaks across the sky, delighting the world with its astounding visibility.*

APRIL ▪ *Twenty-one year old Tiger Woods becomes the youngest Masters Tournament winner, and sets a new tournament record with a score of 270.*

MAY ▪ *In the first change of government in eighteen years, Labour leader Tony Blair becomes prime minister of the U.K.*

JUNE ▪ *Fashion designer Gianni Versace is murdered outside of his Miami, Florida, home.*

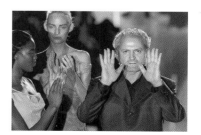

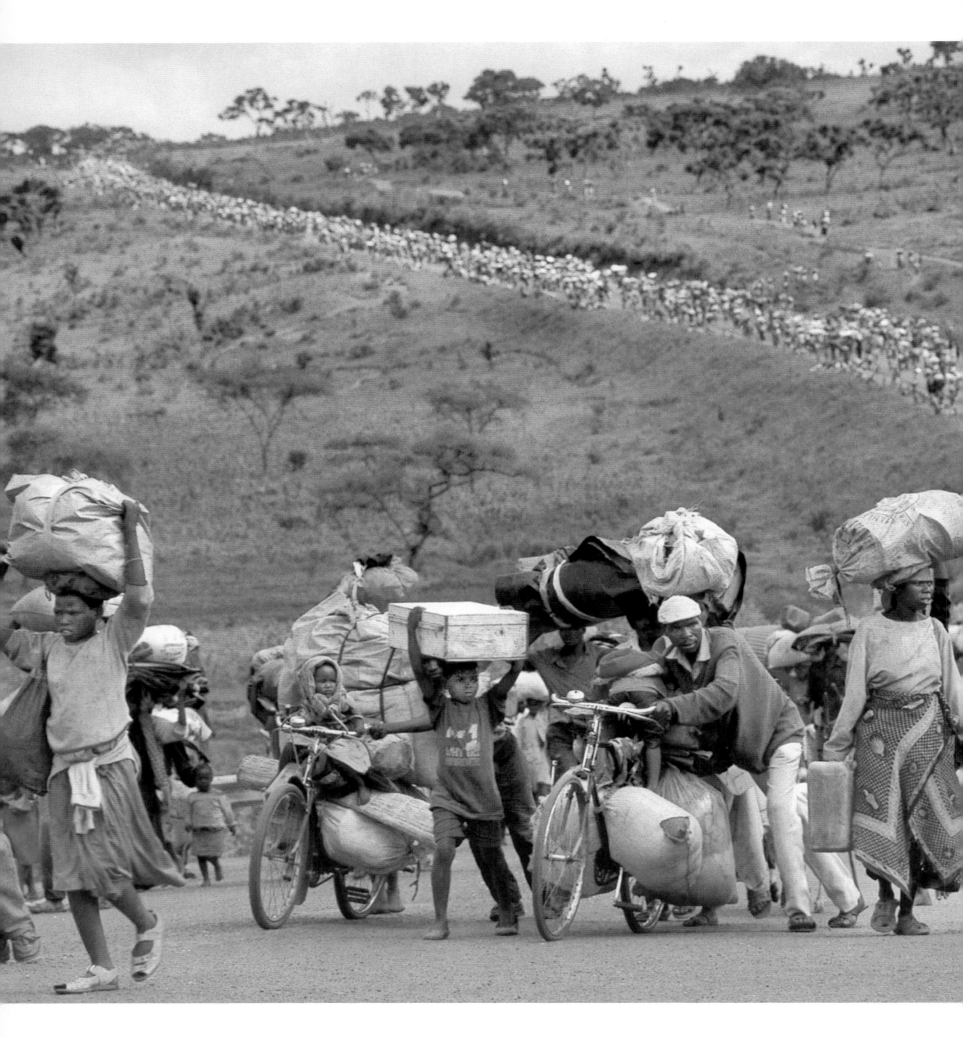

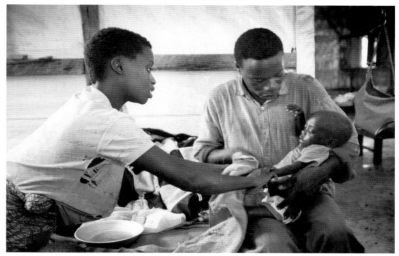

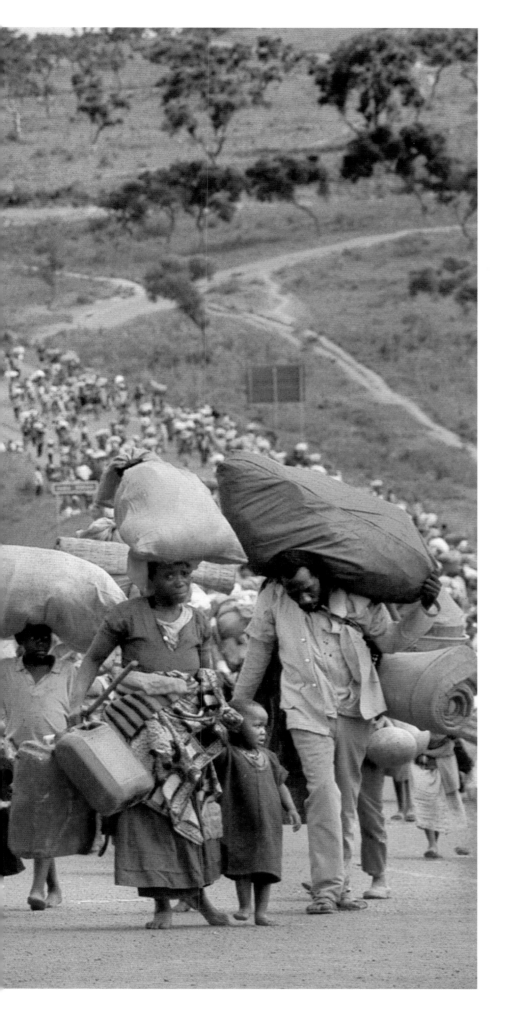

Impressed with her clear vision of the assignment, the *Post-Gazette* took the unusual step of sending one of their photographers halfway around the world.

Her pictures showed Hutu/Tutsi couples in mixed marriages who had adopted orphans to raise as their own children. She shot pictures of single women who adopted children from the other tribe. She caught the vitality of a people who had very little to live with, but who nevertheless had the spirit to live for the future. She photographed women, stabbed by bayonets and raped, who were ashamed of their scars but were willing to pose for Rial's camera in order to tell the story to the world.

Dealing with cultural differences was difficult. Rial saw men push women aside in food lines at the refugee camps. She saw a few armed military types controlling miles-long lines of refugees and wondered how the travelers could submit so easily to such harsh leadership. She was touched by the countless orphans she met who were starving for affection— some whose parents were slain in the tribal warfare, others who had lost their parents on the long flight from the war, still others who had just been abandoned.

This was not an easy assignment. Evening walks in the villages and refugee camps left Rial's eyes burning from the smoke of campfires. Her cameras and film were under constant attack from the red clay dust that permeated the atmosphere. Journeys to distant campsites were arduous and dangerous.

Rial spent three weeks in Africa shooting pictures.

The *Post-Gazette* printed forty-seven photos and her written journals. The passion Rial had for the story, which clearly comes through in her carefully crafted pictures, many of them artistically beautiful despite their harsh subject matter, led to her win the 1998 Pulitzer Prize.

1998 [FEATURE]

Orphans of Addiction

BY CLARENCE WILLIAMS, THE *LOS ANGELES TIMES*

TECHNICAL DETAILS

CAMERA Nikon
FILM Color negative
LENSES 35 mm to 105 mm
SHUTTER & APERTURE Various

Clarence Williams, a young photographer on the staff of the *Los Angeles Times,* drew the assignment to make pictures that would tell the story of the children in Long Beach, California, who live with parents addicted to drugs.

These children flounder desperately in the wake of their parent's constant pursuit of drugs. They are orphans in every meaningful sense of the word—they have little love; they have homes but little protection in a dangerous world; they live in dirt and filth, unaware that there is another way.

Williams was pleased with the assignment because, as he put it, "I see the use of drugs around me, in the street, in some of my friends, even in my family." He believed his experience helped him approach the story with an open heart, and to tell it with meaning and sensitivity.

"I never felt danger in the neighborhoods where I had to go to make pictures," he said. "The only danger I felt was a fear that I would not provide the kinds of pictures that would tell the story properly and be acceptable for publication. This was an important story, and it had to be told correctly. I will do anything I have to do to make the proper pictures. It is important to bring a spiritual feeling to the photography. Even then, when you show the pictures to

JULY 1997 ▪ *The British colony of Hong Kong is transferred back to communist China.*

AUGUST ▪ *Diana, Princess of Wales, is killed in an automobile accident in Paris at age thirty-six.*

SEPTEMBER ▪ *Mother Teresa, the "saint of the slums" dies. She was eighty-seven years old and had devoted her life to caring for the sick and destitute in Calcutta.*

people, you know that there are others who suffer from problems that also need telling."

Many of Williams pictures took readers into the life of three-year-old Tamika, who toddled behind her mother as she searched for drugs. On one occasion, Tamika's mother met a friend who offered to share drugs with her. Williams went along. They entered a small shack, and Tamika's mother told her to rest. Williams saw the child lay down on a bed still wet from semen and urine while her mother shot up and smoked crack.

Williams pictures nevertheless showed that Tamika was indomitable, running and playing and charged with energy even though, as with many children who live in a society of drugs, she had to be her own best playmate.

When the story appeared over two days in the *Times,* it forced authorities to look into the case. Tamika was placed in a foster home, and her mother entered rehab. A year later, while working on a follow-up story to the first feature, Williams made pictures at Tamika's fourth birthday party, the first birthday party the child had ever experienced, with real candles and a cake. Her mother attended, and the road ahead looked much better than the road behind. But the drug habit is hard to beat, and Tamika's mother slipped back into a life seeking speed and crack. It appeared that Tamika would be put up for adoption.

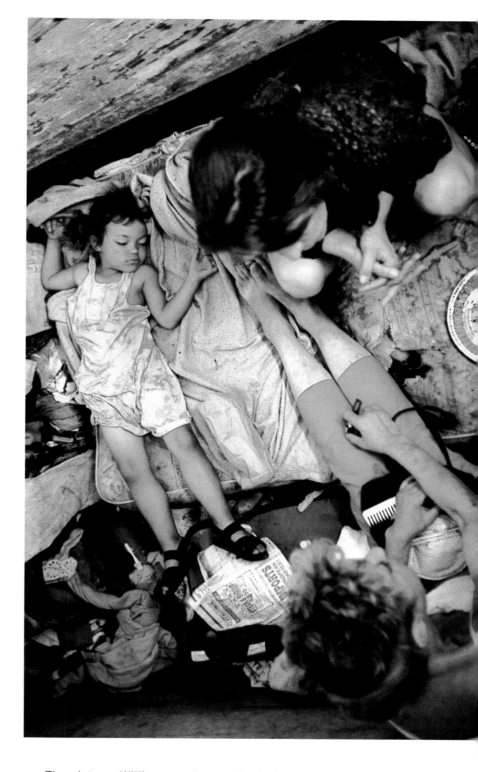

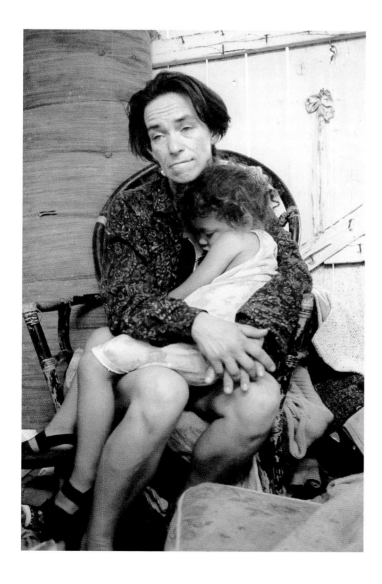

The pictures Williams made won the Pulitzer Prize, and he is pleased by the honor. It poses problems, too, because he approaches photography and photojournalism with a spiritual devotion to doing the stories correctly. "The Pulitzer pushed the standard higher," he says. "And sometimes I am disappointed because I cannot reach that height every time."

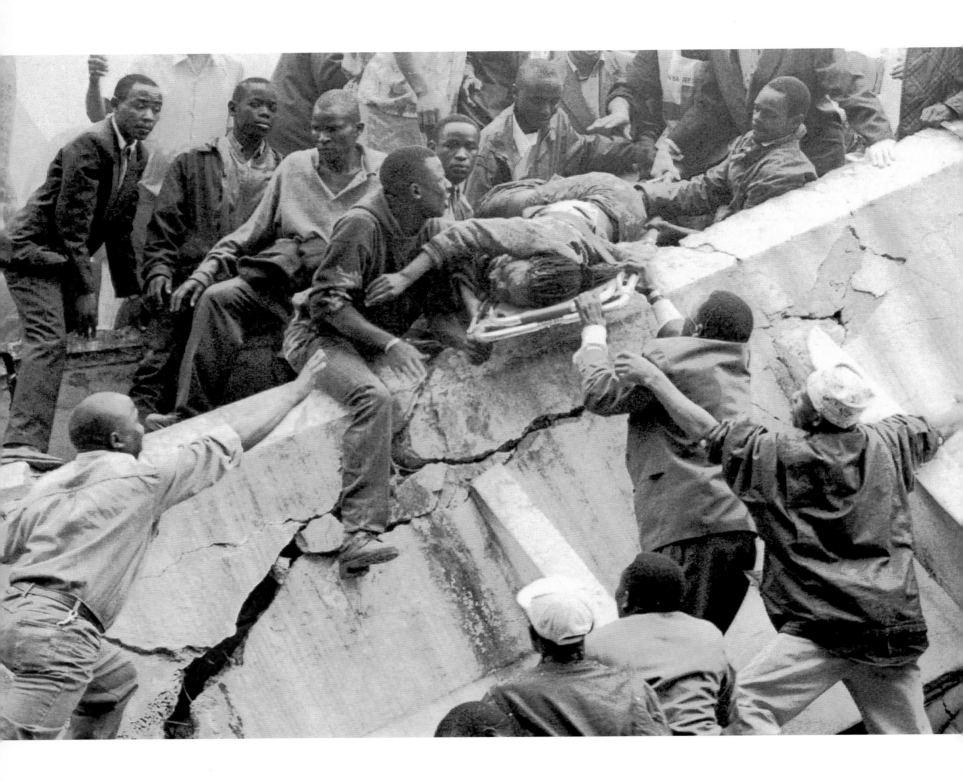

Terror Attacks at United States Embassies in Africa

BY ASSOCIATED PRESS

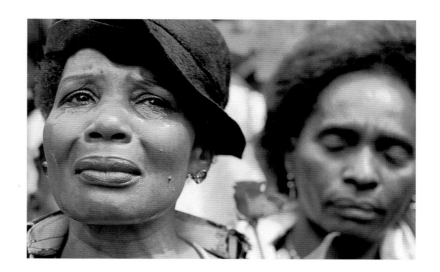

Terrorist attacks are most effective when they rip through the routine life of the unsuspecting and, in an instant, transform normalcy to chaos. The morning of August 7, 1998, was normal in Nairobi. Along Haile Selassie Avenue, the street that fronted the U.S. embassy in Kenya, the mid-morning crowd was building. Offices and banks were busy.

A truck drove up to the embassy gate and the driver, waving his arms, demanded entrance. Embassy guards moved forward. Shots were exchanged. Then a hand grenade was thrown.

People in modern office buildings nearby went to the window to see what happened. A bank robbery, perhaps; there were several banks in the area. Suddenly a shattering explosion drove slivers of glass into their faces with the speed of bullets. The building shook violently, then collapsed.

A sheet of fire swept across parking lots and enveloped the vehicles in nearby streets. Bombproof doors of the embassy were blown off. In some cases, people and furniture were thrown out of buildings. Every window within a quarter-mile radius was blown out.

Just minutes later, some five hundred miles away in Tanzania, a truck pulled up in front of the U.S. embassy and exploded, tearing off the whole side of the multi-story building. Seven died and seventy-two were injured in the area, a residential section of Dar es Salaam.

At the Associated Press office in Nairobi, about a half mile from the embassy, photographers Azim Sayyid and Khalil Senosi were pouring their morning coffee when the explosion shook the office. They grabbed their cameras and ran into the street.

Sayyid recalls the scene, "People were running away from the embassy. There was dirt, smoke, glass everywhere. As we came close to the embassy, we began to see bloodied people, their faces cut open. We were the first on the scene, even before the police; but already passersby who were not injured were helping those who

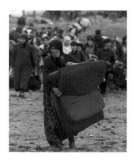

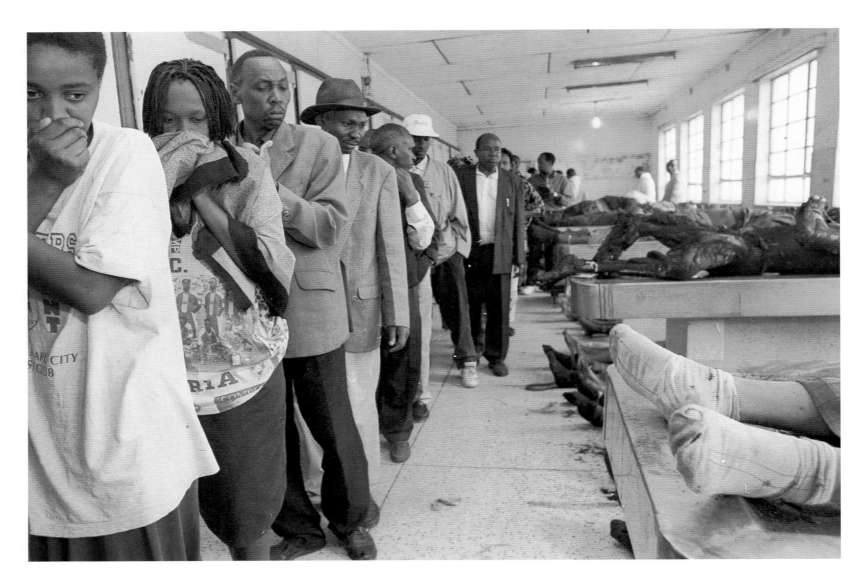

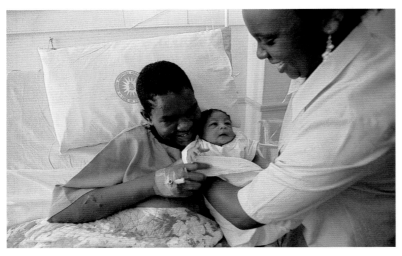

TECHNICAL DETAILS **CAMERA** Nikon
FILM Color negative
LENS Various, ranging from 35 mm
to 200 mm
SHUTTER & APERTURE Various

were hurt. Marine guards came out quickly and helped and tried to keep the crowd away."

Sayyid and Khalil split, one photographer went to the back of the building and one to the front. The street was littered with burned bodies and smashed vehicles. A school bus (Sayyid later learned it had stopped for a red light) was burned out, with most inside killed.

At the back of the building, Khalil watched as the wounded poured out of the embassy, and he photographed the dramatic scene of an injured person being passed over a broken wall on a stretcher. Nearby, the seven-story Ufundi House collapsed, killing scores of Kenyans. At Cooperative House, a tall modern structure, people were killed on each of its twenty-one floors. In the embassy itself, twelve Americans died.

The images left in the minds of those who were there were of charred bodies draped over buses, other bodies stacked in pickup trucks, the dazed and injured wet and stained by blood. Passing motorists took the injured to hospitals. Even the taxi-like vehicles that act as small buses and are known for their money grubbing ways pitched in to transport the wounded.

As is always the case with wire services like Associated Press, pictures must be transmitted to the world. After about thirty minutes of photography, Sayyid picked up film from Khalil and returned to the bureau, where he processed film and scanned pictures into a computer.

"My fingers were still shaking as the photos appeared on the screen and I prepared them for transmission to London and Frankfurt," he says. "They no sooner left our office than they were back on our screens, which means they had been distributed worldwide almost instantly."

Sayyid's background included both agency and newspaper work in Nairobi, but he said he had never seen anything as bloody as the scene he photographed, not even when a 747 airliner crashed before his eyes years before. This was up close and personal. Months later, Sayyid said he still jumped every time a car backfired.

The final toll at the two blast scenes—224 dead and 5,000 injured, mostly Kenyans.

Associated Press followed up on the story, covering the blast site for three weeks as rescue workers prowled through the rubble seeking at first survivors and then evidence that would identify the terrorists.

Associated Press photographer Jean-Marc Bouju, who was on the border of Rwanda and the Congo when the explosion occurred, rushed back to Nairobi. The Pulitzer-winning portfolio included his picture of Katherine Bwire, a pregnant Kenyan woman blinded by flying glass who he photographed over several months, and who, tragically, would never see her baby.

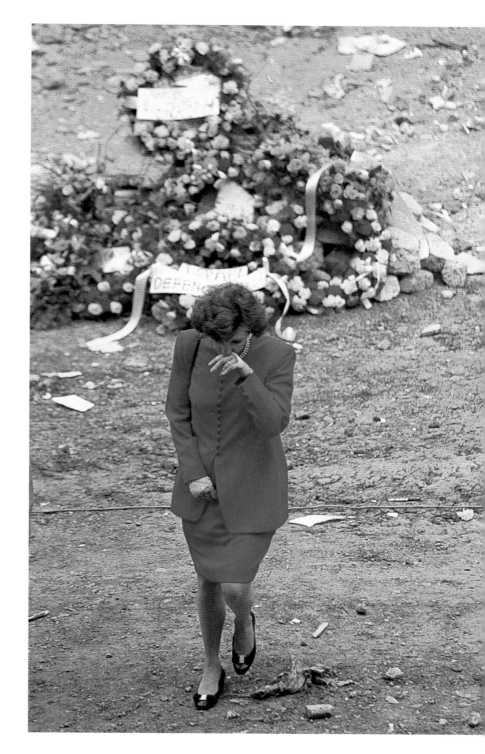

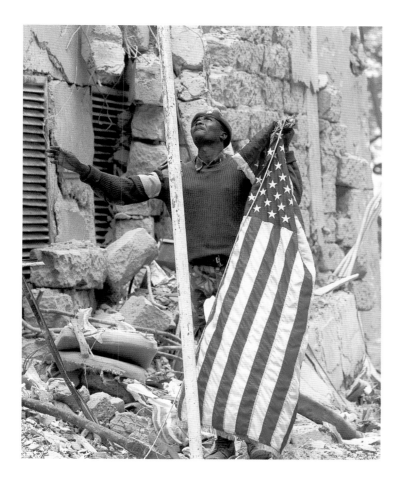

The Clinton-Lewinsky Saga

BY ASSOCIATED PRESS

The story of President Bill Clinton and White House intern Monica Lewinsky was a classic Washington drama played out in the classic Washington manner.

Questions and answers poured forth; often the same questions received different answers. Someone lied; someone else didn't lie. That person leaked; no, that one leaked. Top administrative officials were involved, as were secretaries. The hallowed Secret Service was involved, as was the White House steward who served the coffee. The media was celebrated. The media was damned.

The entire sequence of events boggled the mind. Observers couldn't tell the players without a scorecard, and the scorecard became the pictures that appeared daily on front pages and television screens as the players rushed here and there, passing through doors enroute to meetings, hearings, or depositions in the White House, the Senate, the House of Representatives, or lawyers' offices. The players were repeatedly greeted by bursts of flashes and shouted questions as they were crushed by hordes of photographers and crowds of reporters.

All of the debate was over an ageless question—did they or didn't they? Europeans laughed at the pictures, the moralists wrung their hands; the Republicans gloated and the Democrats winced. The movie *Wag the Dog* got a boost.

JUNE 1998 ■ *Basketball great Michael Jordan, playing in his last season, leads the Bulls to their fifth NBA championship.*

JULY ■ *France wins soccer's World Cup, defeating Brazil.*

OCTOBER ■ *Slugger and first baseman Mark McGwire hits his seventy-first home run, setting a new record.*

Bill bit his lip and Hillary watched. Monica ran the gauntlet. The images took shape and created perceptions as they always do: Black haired, saucer-eyed Monica; harassed Bill; stoic Hillary; distressed Paula; legalistic Kenneth; ominous Linda. The pictures sorted the players out, put them in a row, and helped John Q. Public identify.

The Associated Press's problem was keeping track of it all, and making certain photographers were assigned to the proper portals and the correct hearing rooms. The photographers would wait hours for a single burst of six or eight frames of film as someone walked from a doorway to waiting limousine. Pictures were transmitted by cell phone from digital cameras in the halls of Congress in order to meet late deadlines and match panting headlines.

At the end, and looking back, the program was complete and the players all there and properly identified.

What a show!

TECHNICAL DETAILS
CAMERA Kodak/Nikon digital camera
FILM Digital
LENS Various, ranging from 20 mm to 300 mm
SHUTTER & APERTURE Various

Rampage at Columbine High

BY THE STAFF OF THE DENVER *ROCKY MOUNTAIN NEWS*

Columbine High School, named after the fragile, delicately colored Colorado state flower, served the middle-class suburb of Littleton on the edge of Denver. The campus, large and sprawling, was the scene of a bloody massacre in 1999, the carnage executed by two Columbine students with methodical precision in less than 90 minutes. When the shooting stopped and the smell of gunpowder dispersed, 15 were dead and 23 were wounded. The shooters died by their own hands. Except for one teacher, all of the dead and wounded were students.

Killers Eric Harris and Dylan Klebold planned their assault carefully over several weeks. At 11:15 a.m. on the morning of April 20, they drove into the school parking lot and, dressed in long, black coats—their typical attire—walked into the school and dropped backpacks loaded with explosives in the cafeteria. They returned to their car and waited for the explosion, but the bombs failed to detonate. (A bomb planted in a nearby field as a diversion exploded moments later and alerted authorities.)

The pair walked toward the school armed with shotguns, automatic weapons, and homemade bombs. They paused at a small flight of steps leading to the entrance and pulled out weapons from under their coats. "Go, go!" one of them shouted, and they opened

JANUARY 1999 ■ *President Bill Clinton impeached.*

JULY ■ *John Kennedy, Jr., and wife, Carolyn Bessette Kennedy, die in plane crash.*

SEPTEMBER ■ *Turkish earthquake kills thousands.*

DECEMBER ■ *The United States spends $100 billion immunizing computer against the Y2K bug.*

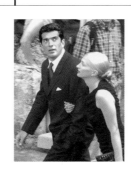

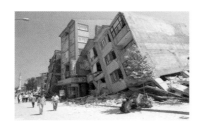

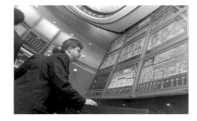

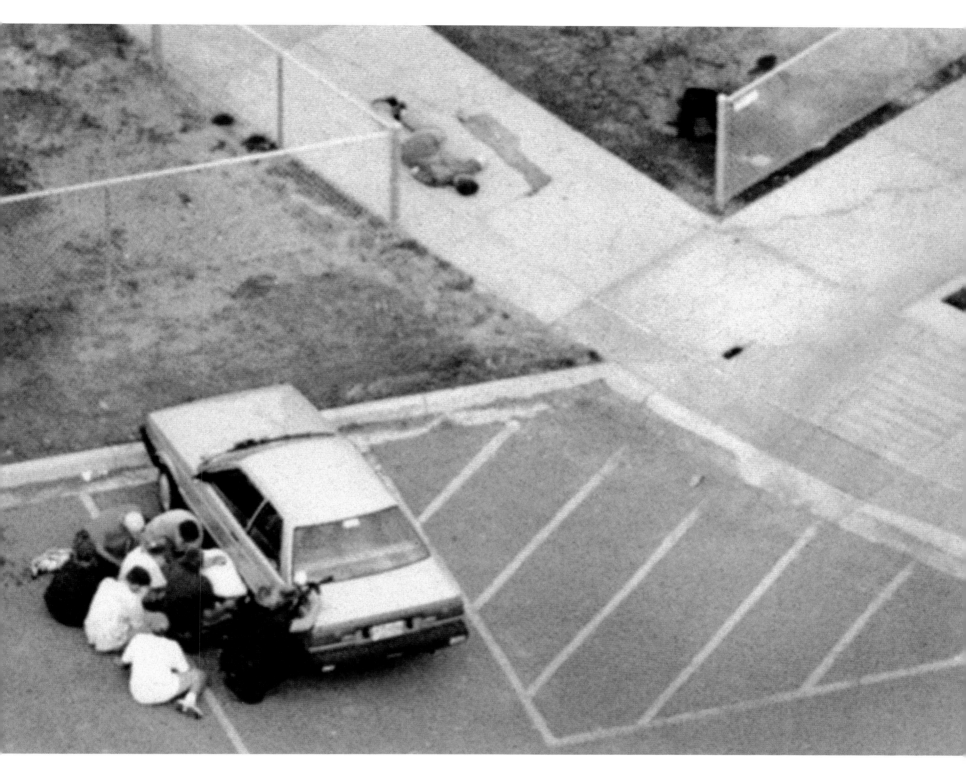

fire. The first hit were two students sitting on the grass nearby. Eight others soon fell victim to the massive firepower.

"This is what we always wanted to do," one of the gunman shouted. "This is awesome."

The first police officer arrived in less than five minutes and exchanged shots with the two teenagers, who continued firing as they retreated further into the school. A teacher directing students to safety fell, mortally wounded. Harris and Klebold entered the library and fired randomly, killing and wounding more students.

They roamed the school halls shooting and throwing bombs. The killers went into the science area, then moved on to the cafeteria. They fired into the backpacks they had placed there, but the bombs did not explode.

Chaos ensued. Students fled, some escaping through windows and doors. Others hid in closets and under desks as the shooters continued their rampage through the school before finally returning to the library. About 12:45 p.m. a police officer on the street saw two simultaneous muzzle flashes through a window.

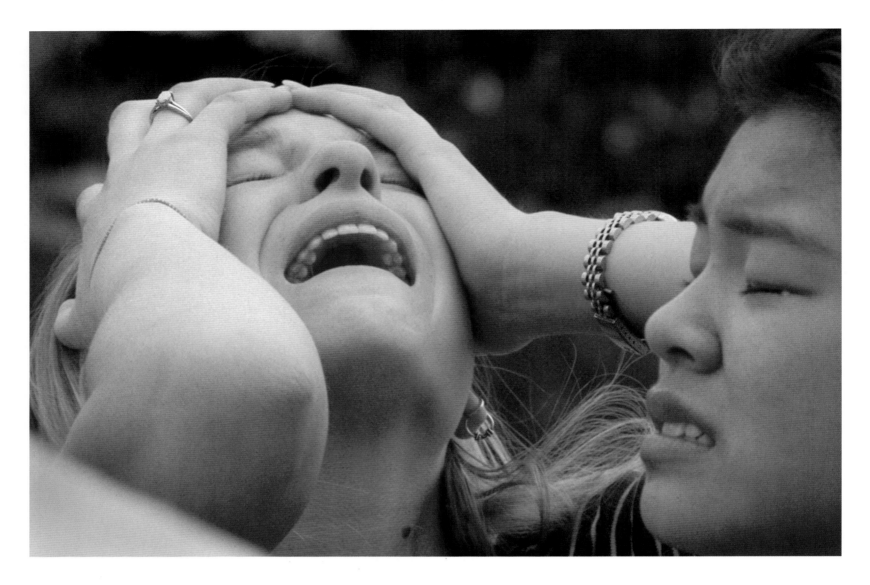

Then all was silent. It wasn't known at the time, but it was later suspected that the two flashes were the suicide gunfire that ended the lives of Harris and Klebold. They would be found sprawled on the library floor.

The horrific extent of the massacre was quickly established. Students broke down in tears; parents, alerted by media bulletins, arrived to search for their children.

When the first police call was heard in the offices of the *Rocky Mountain News*, Director of Photography Janet Reeves dispatched photographers to the scene. The first to arrive saw students fleeing the building and running for protection behind cars before being led to safety by police. But it was impossible to determine where the shooters were, and whether they were dead or waiting in ambush for police to enter the school building.

One photographer, on assignment at a local airport, boarded a helicopter and flew toward the school. Reeves, meanwhile, watched the story unfold live on television and phoned information to photographers on the scene. Other photographers went to local hospitals to capture the bandaged and bloodied students on film.

The *News* photo team used telephoto lenses to cover the scene at the school. Later they photographed distraught students and parents as they searched for one another. Many searches ended in an emotional family embrace; others ended with the heartbreaking realization of an injury or a death.

"I can still remember," Reeves recalls, "seeing those first pictures in the film that was brought to the office. You literally could not believe what you were looking at."

Rudy Gonzalez, in the helicopter, took pictures of a slain student on the sidewalk outside of the school.

George Kochaniec, Jr. was covering the Colorado legislature that morning before returning to the *News* office and being immediately assigned to the school.

"I had my 500mm lens with me," he says, "and I took a position far back from the school at the area where a triage was established. There were twelve or fifteen kids spread out on the lawn and on the sidewalk, some injured, some possibly dead. You couldn't tell. I tried to be invisible, to stay out of the way. As I scanned the survivors through my lens I made a picture of a young student gazing skyward

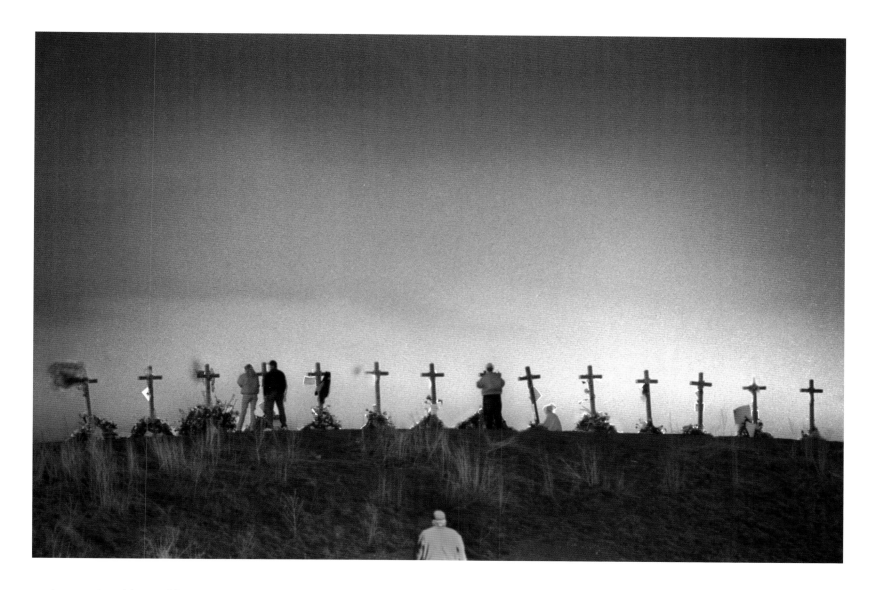

and screaming. I learned later that she was in the library when the shooters entered and shot and killed her best friend. As I made pictures I couldn't help but think of my own kids who were coming up on the age of these kids. Still, even today, when I'm in the area I drive by that scene and stop for a minute to remember it."

The story did not end with the shooting. Funerals followed. Some were photographed; others were not. The families decided. "Throughout," Reeves says, "we tried hard to use pictures that were as tasteful as possible but still told the story. Our editor wrote to each of the parents and asked them to tell him how they felt about the coverage. Most appreciated the effort we made to tell the story without being sensational."

The paper hired counselors to spend time with staff—writers, reporters, and photographers—and help them come to grips with the events they had covered. Many staff members took advantage of the help; others preferred to keep their feelings to themselves.

"Everybody involved felt the tragedy," Kochaniec recalls, "the police, firefighters, medical people and, of course, the families who lost their children or saw them hurt in an attack no one really understood." One veteran photographer in particular struggled with his emotions, recalling the scenes each time he raised his camera on later assignments. It was a feeling that he says haunted him for more than a year.

TECHNICAL DETAILS **CAMERA** Canon
EXPOSURE Various
FILM Color negative
LENS Various

Kosovo Refugees

BY CAROL GUZY, MICHAEL WILLIAMSON, AND LUCIAN PERKINS, *WASHINGTON POST*

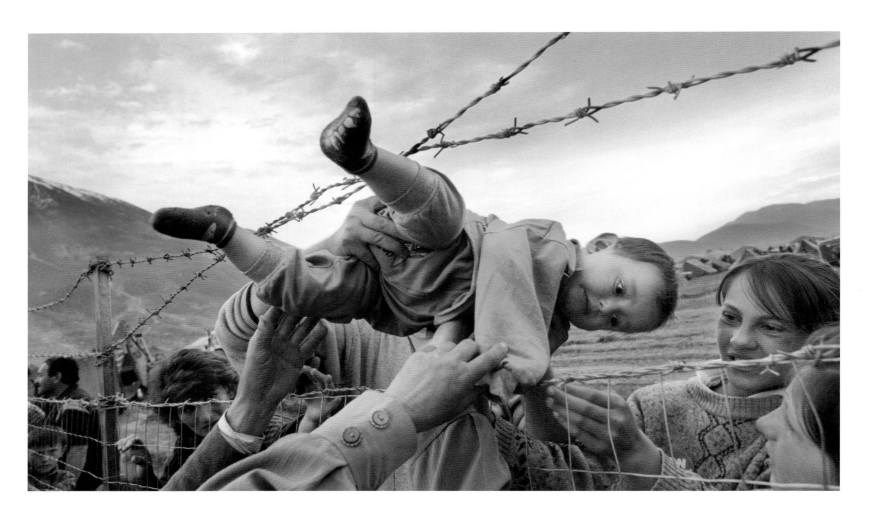

Tens of thousands of refugees, fleeing war and genocide, moved like a human river across Kosovo's borders into Macedonia and Albania. They frequently were stripped of their valuables, and had their documents burned and their identity papers destroyed before they were allowed to leave their homeland. Across the borders, refugee camps awaited them. Families were separated, food was in short supply and shelter was scant. The human misery was made worse by the spring thaw and the muddy terrain that accompanied it. But still they came,

day after day, to escape the genocidal violence that ravaged Kosovo.

The *Washington Post* sent two photographers to the refugee camps, Carol Guzy and Lucian Perkins, and a short time later added Michael Williamson. All were seasoned photojournalists who had worked difficult assignments before. All were previous Pulitzer Prize winners.

"We wanted to tell the refugee story in a way that went beyond the mechanics of regular coverage," Perkins says. "Our goal was to

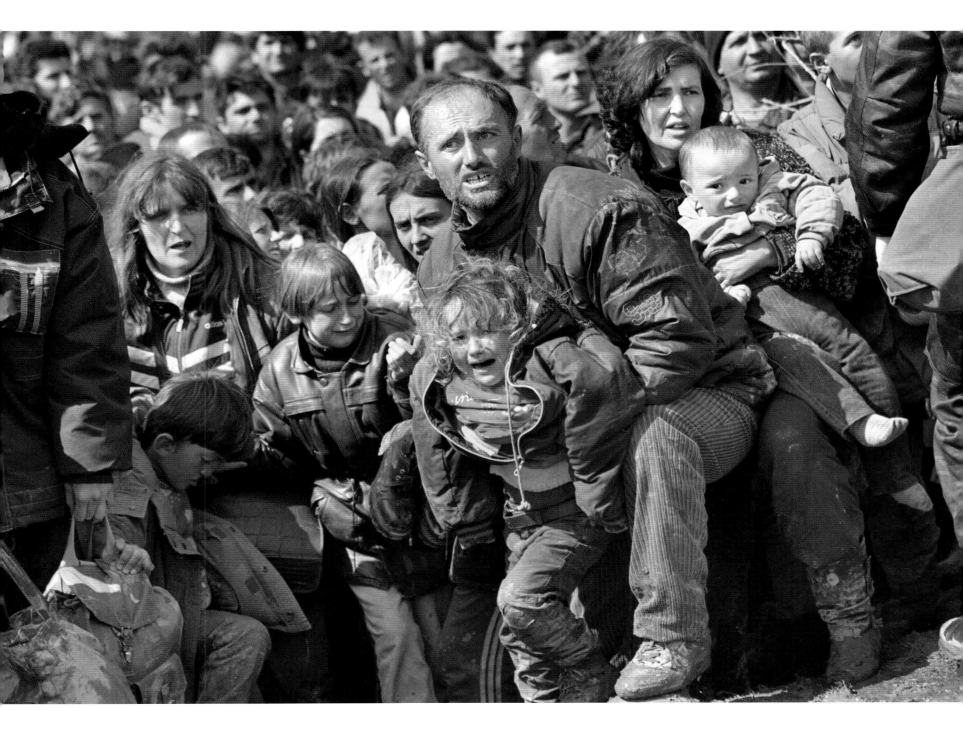

follow individuals closely, to explore avenues of the story that were offbeat and at the same time photogenic."

Perkins arrived in Skopje not far from the camps, and Guzy headed for refugee settlements near Kukes. Though only 25 miles apart, the condition of the roads and the immense crowds made contact between them a two- or three-day trip. Each photographer worked alone in covering the story.

At one point Guzy watched a family reunion. Some refugees were inside the camp as members of their family arrived from Kosovo. They met on either side of a fence and, in their joyful reunion, passed babies back and forth through the barbed wire.

Guzy photographed a scene that showed, amid misery, the unbridled joy of family and relief in the knowledge that loved ones were safe from the slaughter in their homeland.

Perkins, meanwhile, photographed the camps near Skopje, a three-hour drive to and from his editing setup. He was joined by Williamson, and together they transmitted a steady flow of pictures to the *Post*. Guzy transmitted from her cell phone at Kukes.

"It was bizarre," Perkins recalls. "We would spend the day in the mud of the camps, then return to Skopje, run our film through a one-hour lab and transmit pictures to the desk back in Washington."

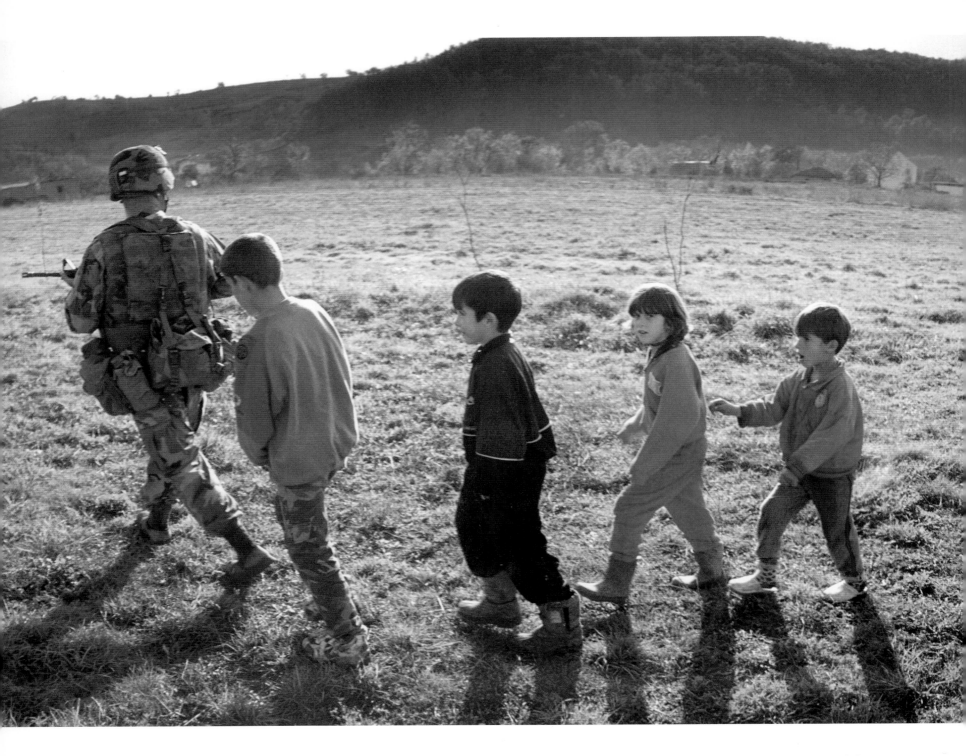

One of Perkins' pictures showed a man trying to bring attention to his sick daughter in an effort to obtain medical help. "Another man," Perkins says, "offered me $1,000 in cash if I would help him with his dying relative. Helpless, I could only direct him to the medical authorities in the camp."

The human tragedy recorded in the refugee pictures earned the three photographers the Pulitzer Prize. Says Guzy, a three-time Pulitzer winner who has covered difficult stories at many of the world's trouble spots, "It's hard to witness this type of inhumanity. It's getting harder and harder to look."

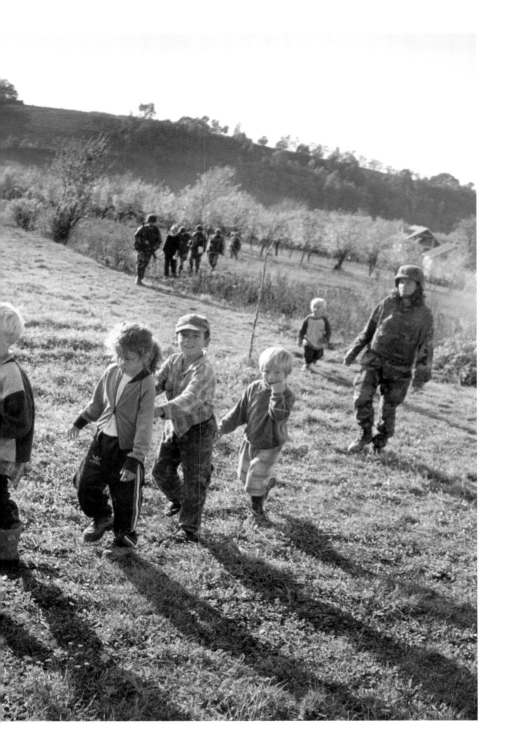

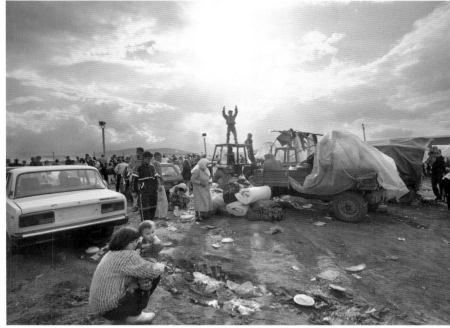

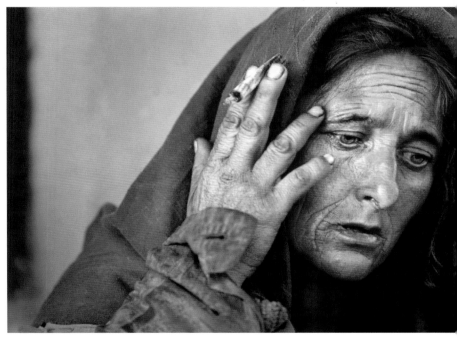

TECHNICAL DETAILS **CAMERA** Nikon
EXPOSURE Various
FILM Mixed digital and film
LENS Various

The Taking of Elian

BY ALAN DIAZ, ASSOCIATED PRESS

Elian Gonzalez, age 6, sunburned and dehydrated, drifted aimlessly across the ocean's surface on an inner tube. The vessel that was to carry him, his mother, and others from Cuba to new lives in the U.S. encountered unfriendly waters and sank. His mother drowned and it appeared that Elian would suffer a similar fate.

Miraculously, a vessel appeared and Elian survived. He was taken in by relatives in Miami, seemingly to start a new life in the Latino community of South Florida.

However, politics got in the way. Elian's father, who had remained in Cuba, insisted that the child be returned to his homeland. His Miami relatives said no. The boy would be better off with the advantages the U.S. offered, and Elian was safely tucked away in his uncle's house in Miami's Little Havana. The story quickly

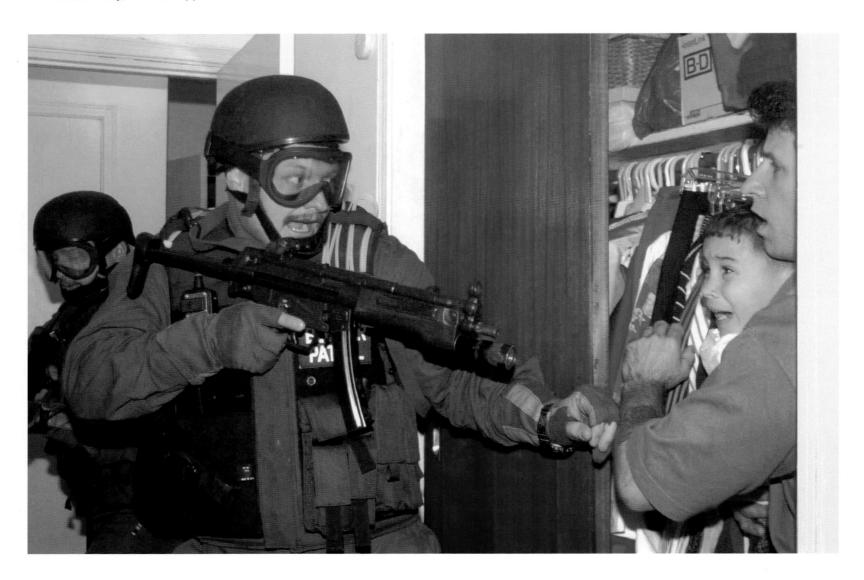

escalated to worldwide proportions as Miami's anti-Castro Cuban community, continuing its long-running battle with the Castro government, resisted the efforts of U.S. immigration authorities to return Elian to his father.

Enter photographer Alan Diaz, a Cuban-American born in New York, a one-time resident of Cuba and a longtime Miamian. He freelanced for the Associated Press, using his Little Havana contacts to cover stories of interest to the wire service. AP assigned him to the Elian story from the start, and five months later he had spent more time in the Gonzalez family's neighborhood than he had in his own home. Elian's uncle, who had taken in the boy, trusted the Spanish-speaking, culturally attuned Diaz. By April, 2000, his many months at the scene and his insightful grasp of the Cuban community made him a central figure in the AP's picture coverage.

Diaz, and others who followed the story, knew that one day the Justice Department would take Elian by force and return him to his father. The question was when, and the answer came on April 22, five months after Elian was lifted from the ocean.

Diaz recalls, "I knew that night that it would come down soon. It's something you feel. The presence of lawyers constantly negotiating, and the tension coming from the family told me that it would happen."

In the early morning hours of April 22, Diaz was seated in a chair alongside an NBC television van. "Just after midnight," said Diaz, "Elian's uncle called me over and told me that when the time was right I had his permission to enter the house." Diaz asked, "Can I come in now?" Elian's uncle replied, "No, too many lawyers, too many phone calls. Not now."

Just before dawn, Diaz heard the tramping of booted feet behind the house. He dashed toward the house, leapt over a three-foot fence alongside the driveway, and ran through a now-open door.

"I knew which bedroom Elian was in," Diaz says, "but when I went in and turned on the light there was no one there. He could only be in the other bedroom so I went in there and found him in the arms of Donato Darlymple," the man who rescued Elian from the ocean and who was now a trusted family friend. They were standing in a closet with the door open.

"Elian looked at me. He was obviously frightened. 'What's happening, what's happening?' he asked in Spanish. I replied, in Spanish, 'Nothing's happening, baby. You'll be all right.'"

Diaz continues the story, "I made one picture of the boy and the uncle in the closet to make sure I had something, then I went into a corner of the room. I didn't know what would happen. I knew the agents would be armed and I knew there would be danger because of the tension. I just waited."

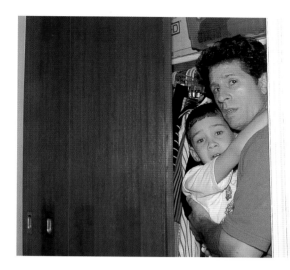

TECHNICAL DETAILS **CAMERA** Nikon
EXPOSURE f16 @400, electronic flash
FILM Digital
LENS 50mm

In seconds, helmeted agents in riot gear and carrying automatic weapons burst through the door. Diaz's strobe flashed as he made a picture. Then another and another. He started to move and an agent told him, "Back off." Diaz stopped his advance but continued taking pictures. The agent reached out and pulled Darlymple and Elian toward the doorway and into the hall. The agent backed out of the room. Diaz moved forward to follow but the agent said again, forcefully, "Back off!"

In another room a female agent took the child and, with the others, went out the front door into a waiting van and drove off.

Chaos ensued. Diaz made pictures of the now hysterical family and others in the neighborhood who were nearby shouting. A few moments later Diaz sat down on the stairs of the house, nearly paralyzed with exhaustion. He realized the long period of waiting was over. He said to himself, and later to others, 'I am going home; I cannot shoot any more pictures tonight.' Another AP staffer who had arrived on the scene asked for the digital cartridge that held the pictures and headed to a transmitting station down the street.

Diaz's exclusive pictures of Elian being taken by a federal agent dressed in military garb and toting an automatic rifle were printed on front pages around the world. Within hours copies of the picture taken from Web sites were circulating on leaflets throughout Miami's Cuban community.

That afternoon Elian was turned over to his father in Washington, and several days later he returned to Cuba, where he was greeted by Fidel Castro, himself. Elian later returned to school in his native town.

2001 [FEATURE]

After the Fire

BY MATT RAINEY, NEWARK *STAR-LEDGER*

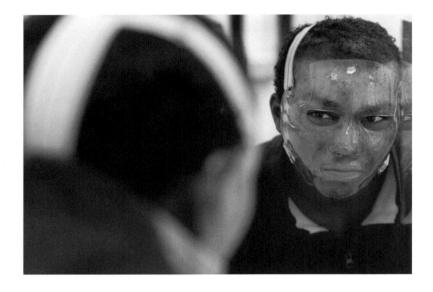

When the dark hours between midnight and first light settled over the silent campus of Seton Hall University in South Orange, N.J., a couch in a dormitory caught fire. Flames spread. Soon the room and nearby areas were an inferno. Students ran from their rooms, some forced to crawl through smoke and flame to escape the horror. Three died; another 58 were injured, many seriously.

The fire struck January 19, 2000, just days after the school reopened following the millennium holiday.

Several nights after the fire, photographer Matt Rainey and reporter Robin Fisher from the *Star-Ledger* of Newark, N.J., met parents of two of the fire's survivors: Alvaro Llanos, who suffered burns over 58 percent of his body, and Shawn Simons, with burns on 16 percent of his body. *Star-Ledger* Photo Editor Pim van Hemmen, who had long wanted to do a story on the burn unit at Saint Barnabas Medical Center, sent the two photojournalists to the hospital.

The two New Jersey freshmen were each in a coma when Rainey and Fisher, working closely with Saint Barnabas' staff, suggested to their parents that they be allowed to follow the young men over the weeks and months of their recoveries. The parents agreed with one condition—if either boy, once out of the coma, did not want to participate, the arrangement would be discontinued and nothing would be published.

Simons came out of his coma in early February, Llanos in late March. Both agreed to the story, and Rainey embarked on coverage that would take him and Fisher into the lives of the two families. From late winter until September they photographed the story almost daily.

"We became very much a part of the family," Rainey says, "both at the hospital and later when the boys returned home. We spent nearly every day seeing them and capturing the details of their painful journey toward recovery."

MAY 2000 ■ *Vladimir Putkin elected President of Russia in free elections.*

JUNE ■ *Microsoft battles over legal problems.*

JULY ■ *Concorde crashes in France.*

AUGUST ■ *Terror in Israel.*

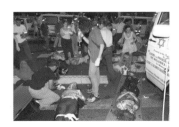

Rainey recalls one particularly poignant moment when he was preparing to photograph Simons in a small hospital room.

"His mother left the room and a technician came in to shave his head with a dry razor. I put down my cameras and I knelt down beside him and held his hand for 30 minutes. We said nothing. We just were together during the ordeal."

The story was published in the *Star-Ledger* in several parts and with more than 100 photos. Readers reacted strongly to the pictures. Some wrote, after the first article appeared, that the photos were intrusive. Then for several days there was little response. Some 1,000 emails and letters followed the period of quiet. Most of them commended the paper for telling the story of the students' courage with sensitivity and understanding.

"We responded to every letter and every email we received," Rainey said. He believed that some readers were put off by the first pictures. But he also believed that, as the stories continued, readers came to know the two boys, came to identify with their lives, and came to appreciate the courage they showed.

One reader wrote, "I changed my life to make time for that story. I got up early, I took it to work, I read it at lunch, I called my sister, I gave it to my kids." At one point the paper skipped a day and published no story, which prompted calls from readers wondering when the next piece would appear.

"The most significant thing that happened to me during the coverage," Rainey says, "was the emotional impact. During the first eight weeks there were many evenings when I spent my trips home from Saint Barnabas in tears. We became heavily invested in the boys, as they did in us. We were literally part of their family."

When Rainey won the Pulitzer Prize for his picture journalism he commented, "Doing what you love is why you do it; then to have this happen, it validates everything."

TECHNICAL DETAILS

CAMERA Nikon
EXPOSURE Various
FILM Tri-X
LENS Various

SEPTEMBER ■ *Firestone recalls 14.4 million tires.*

SEPTEMBER ■ *Mad cow disease strikes Europe.*

OCTOBER ■ *Serbia's Slobodan Milosevic is overthrown.*

DECEMBER ■ *Election fracas in Florida.*

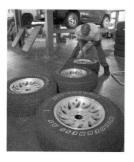

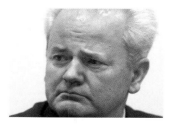

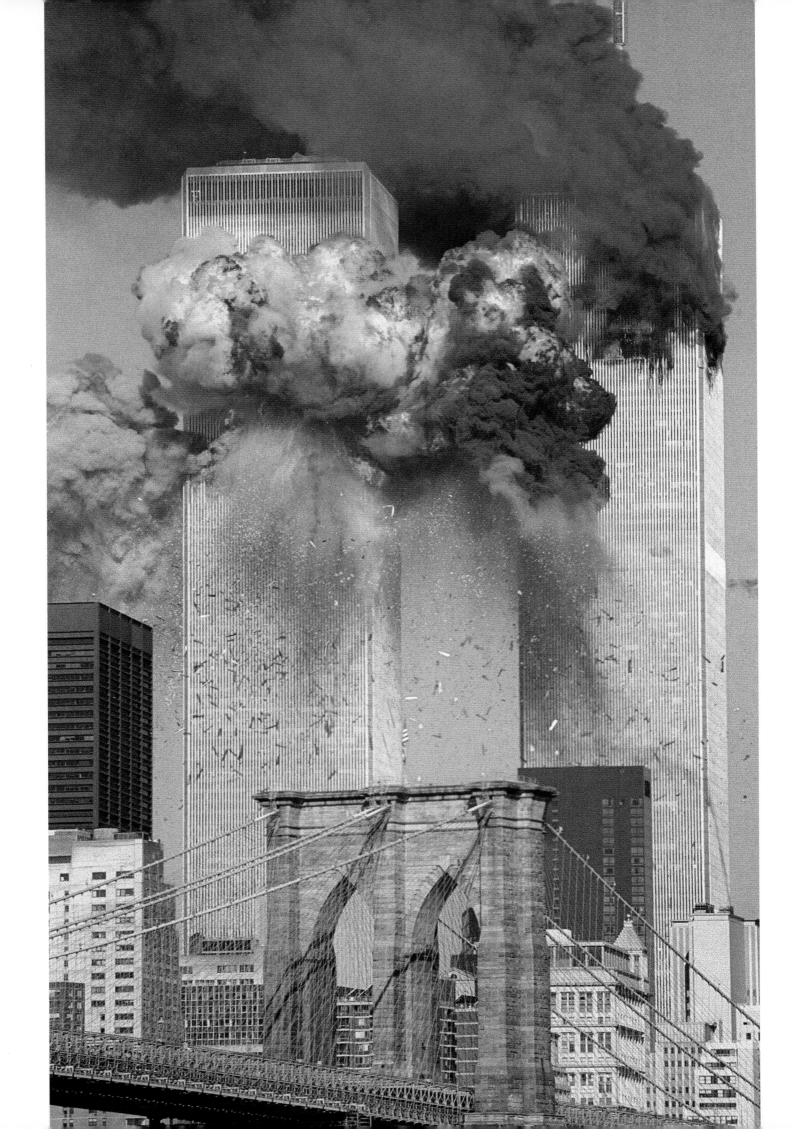

Terror Attack on the World Trade Center

BY THE STAFF OF THE *NEW YORK TIMES*

News photographers were out early in New York City on the morning of Tuesday, September 11, 2001. It was primary day and voters were to decide party nominees for the forthcoming mayoral contest. Immaculate weather made it a perfect election day—warm and sunny with a brilliant blue sky that stretched clear to the horizon. Voter turnout would be heavy.

By 8:30 a.m., the first New Yorkers had cast ballots, and photographers had made their early pictures. But the ballots that day would not be counted, and those voters' pictures would not be published.

By 8:30 a.m., hijackers had captured a jetliner—American Airlines Flight 11, headed from Boston to Los Angeles. One hijacker took over the controls, swerved the plane from its flight path, and set a course toward the skyline of lower Manhattan. Another plane, United Airlines Flight 175, also from Boston to Los Angeles, was similarly taken and steered toward the same target. Two other airliners were captured in flight. The aircraft, loaded with fuel for the transcontinental crossings, became missiles in the hands of terrorists on a suicide mission that would shock the world.

The first word of their attack in New York was vague. At 8:47 it was reported that a plane of undetermined size (American Airlines Flight 11) had crashed into one of the two towers of the World Trade Center.

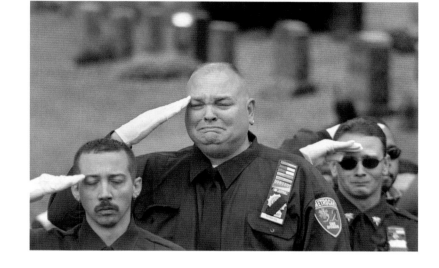

About that time Margaret O'Connor, Picture Editor of the *New York Times*, turned on the television set in her apartment. She saw the tower ablaze. Jim Wilson at the *Times*' picture desk took her call and told her that photographers were on the way, several of whom had been called off the election story. Deputy Photo Editor Mike Smith was moving forward with the coverage.

"There is a journalistic instinct that kicks in on a story of any size, and even at this early stage good journalists started to move

JANUARY 2001 ■ *George W. Bush sworn in as 43rd U.S. President.*

FEBRUARY ■ *U.S. submarine Greenville sinks Japanese fishing boat.*

OCTOBER ■ *IRA agrees to dismantle weapons.*

OCTOBER ■ *Anthrax scare.*

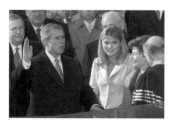
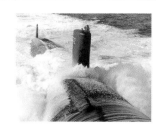

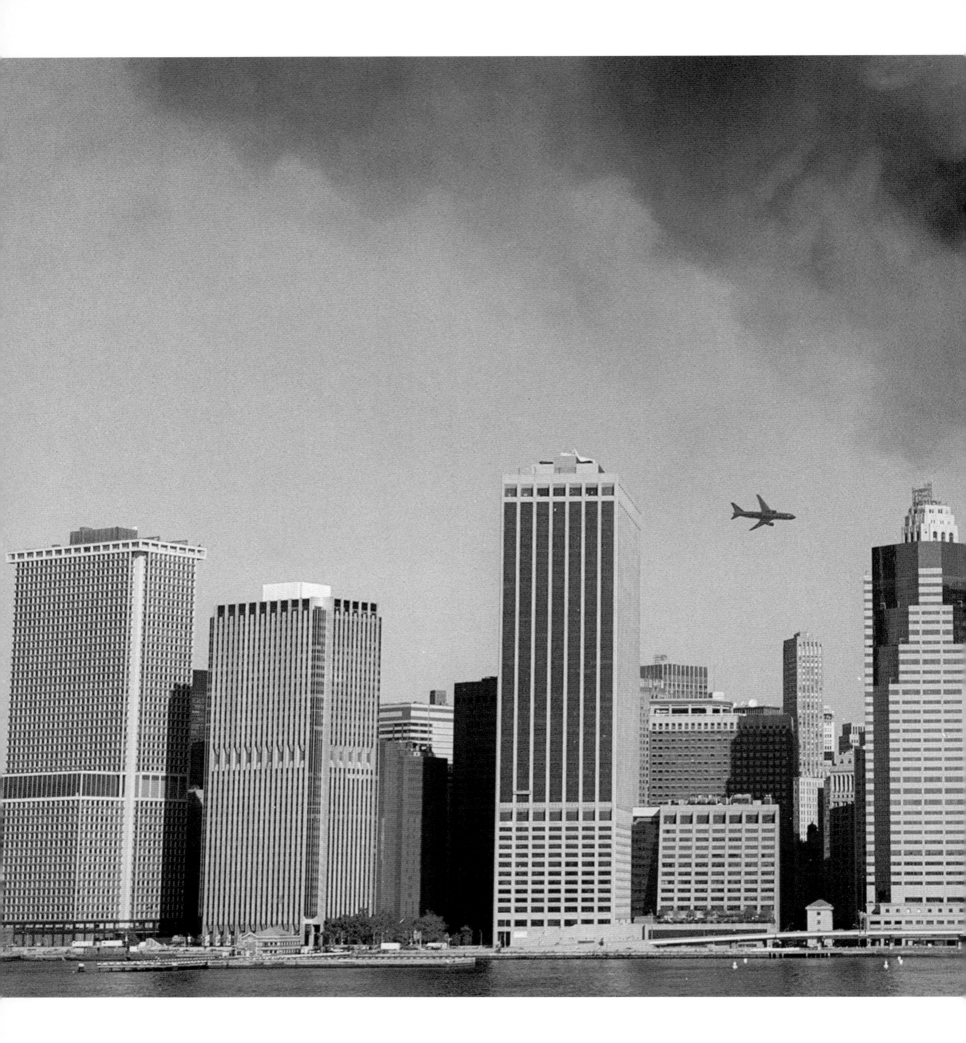

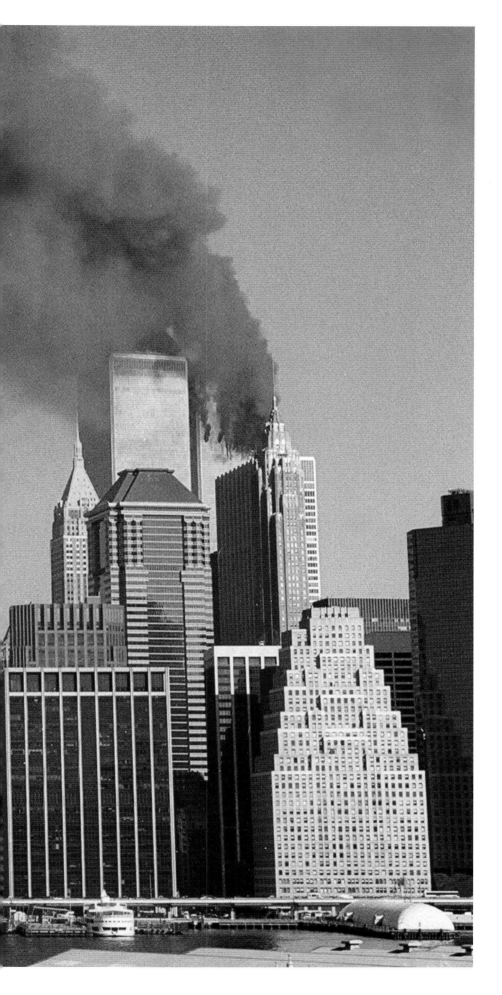

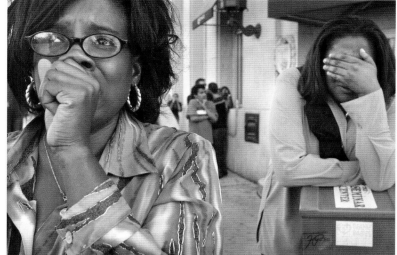

toward the telling of what appeared to be a spectacular accident, but then became known as an assault on the city and nation," O'Connor said.

Eighteen minutes after the first tower was hit, United Flight 175 slammed into the second of the World Trade Center towers. Balloons of fire and a shower of debris erupted from high above the street. Bodies flew out of shattered windows and walls. Some of those trapped in the towers clung to twisted metal girders, but the inferno created by the burning jet fuel forced them over the edge, and they fell dozens of stories to their deaths.

"By that time," Smith says, "the dimension of the story had expanded. We knew that this was no accident but a carefully planned terror attack of major importance."

Photographers, alerted to the story by the initial blast, dropped everything and headed for the scene. When Kelly Guenther was called she had her jeans on but was still wearing her pajama top and flip-flop shoes as she prepared to head out the door. Steve Ludlum, a freelance photographer who worked for the *Times*, was on a rooftop photographing flowers when the first plane hit. Angel Franco, in the Bronx covering the election, drove toward the Twin Towers, which he could see burning clearly even from upper Manhattan. Ruth Fremson, assigned to Queens for the election, first headed for LaGuardia airport and a helicopter, but the airports were quickly closed. She saw a line of speeding vehicles with flashing lights, joined the caravan, and was convoyed to the scene.

Guenther made her way to a spot along the East River, which put the New York skyline between her and the towers. But the view was wide and, as she photographed the burning North tower, a second airliner came into view. She photographed it as it soared over

TECHNICAL DETAILS CAMERA Mixed, Nikon and Canon
EXPOSURE Various
FILM Mixed, digital and color negative
LENS Various

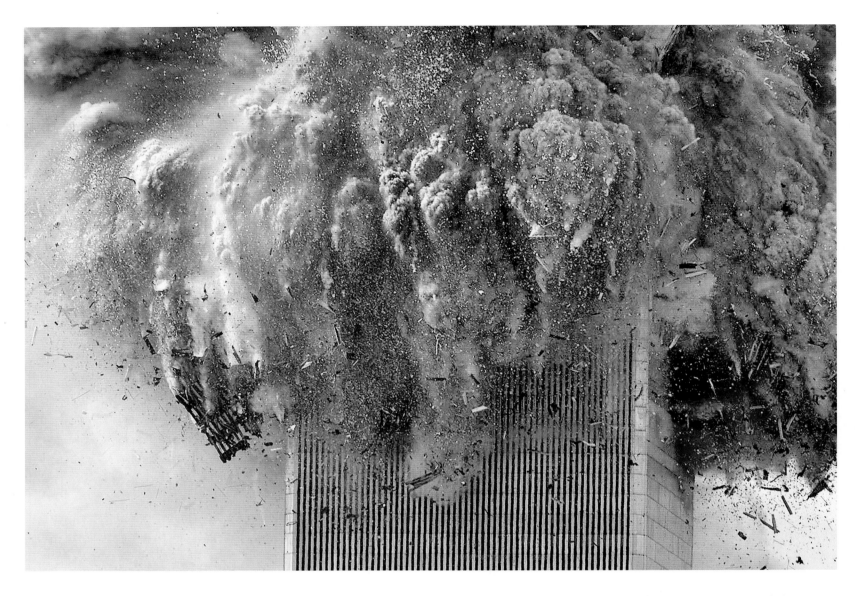

New York's trademark skyline toward the second tower. "I remember seeing Kelly's film for the first time. It showed a series of several shots showing the second plane moving toward the tower. I remember feeling chills," recalled O'Connor.

Ludlum could see the towers from his rooftop position. In front of him was the Brooklyn Bridge, with the World Trade Center part of the backdrop behind it. As he photographed the first tower ablaze, the plane that Guenther had photographed moments before hit its target, and a rolling ball of smoke and fire erupted from the upper floors of the structure. Ludlum's picture froze the moment in time—the inferno, a rainfall of shattered debris, the first smoking tower in the background.

Franco and Fremson arrived at the towers at about the same time. Franco looked for crowd shots of people reacting to the horror in front of them.

"I turned my back on the buildings at one point," he says, "and photographed two women. Their mouths opened and their eyes widened, and I turned around in time to see one of the buildings fall...and then the second building fell. I am not a religious man

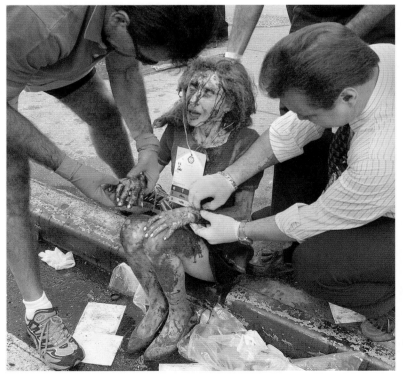

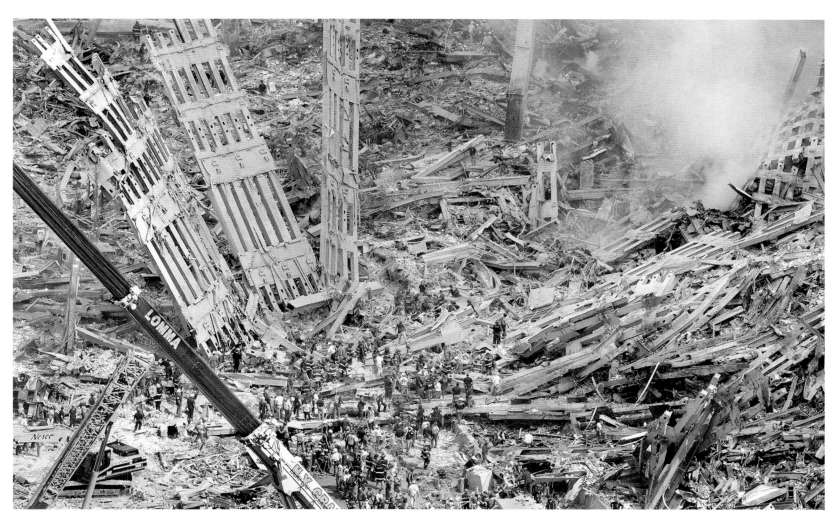

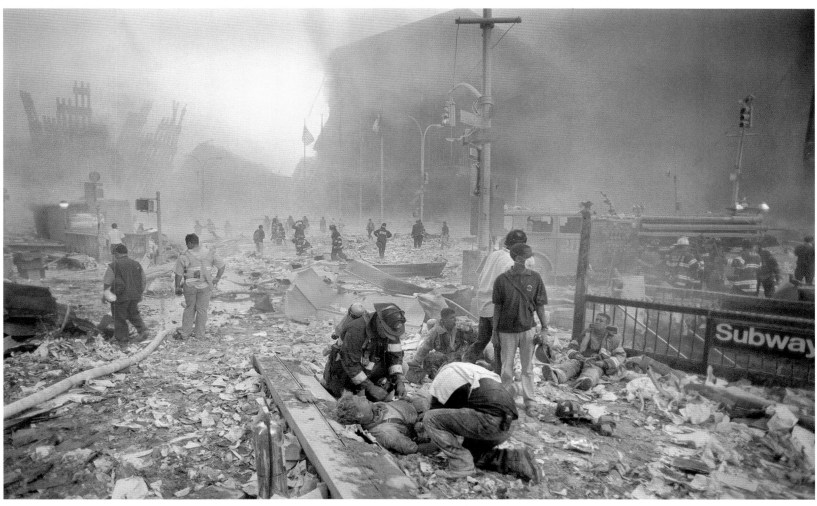

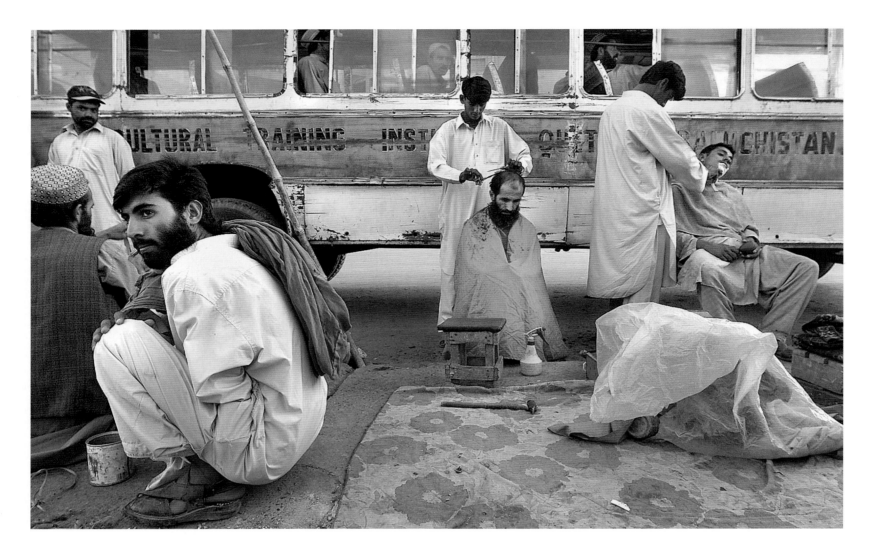

but I instinctively crossed myself at the thought of the people in the buildings. Two-and-a-half blocks away, as the second building collapsed, I saw a ball of gunk coming down the street at me. I knew what would happen and rushed into a deli and told everyone to duck behind the counter. It turned dark at first, then the light turned incredible, unreal, a soft yellow, almost like a religious experience."

Fremson reached the scene: "I looked up at the building, and suddenly it started to expand, and then came apart. Everyone started to panic. Keep your heads, I said to myself, keep your heads. Some people ran into the subway, but I have a fear of caves and caverns so I stayed outside. I looked for something to hide behind; a mailbox, but it wasn't big enough; then something else but it wasn't sturdy enough. The cloud was coming from behind me now. I saw an emergency or police official crawl under a car and I joined him. I hung onto his leg, just to have a human connection. The cloud rolled over us and it was totally black."

After the cloud lifted and the ash settled Fremson photographed the results—the wounded, the wreckage of two of the tallest buildings in the world, people covered with dust and soot and ash.

Back at the *Times*' picture desk O'Connor and Smith worked

with editors to prepare pictures for editions that would go to press in the late afternoon. They said the same thing about the staff teamwork: that it was not unusual for a staff to pull together on a story of this dimension, and to respond quickly to guidance. And that is what happened. Photographers called in to ask what they could do, where they should go.

The editorial process moved forward. "We had to cover the whole story," Smith says. "The explosions, the horror of it, the reaction of those at the scene and those that escaped the towers. And the later developments at the Pentagon, and soon thereafter the plane crash in Pennsylvania. And we were concerned about the staff," O'Connor adds. "Were they all right? Communication went down, cell phones failed; all we could do was to wait to hear from the photographers."

"Our executive editor [Howell Raines] says he realized the traumatic circumstances for the staff when he saw Ruth Fremson, covered in ash, her fellow editors picking debris from her hair and clothes," said O'Connor. Hundreds of photos poured in from staff, from known freelancers, and from people the *Times* had never heard of. "We had to immediately set up a system to keep track of all the film and the digital pictures," O'Connor said. The *Times* uses digital

photography to a great extent but also has a large film processing capacity. "We used both systems on this story," she said.

"We knew early on that this would be a major photo story," O'Connor says. "The dimension of the photo aspects became clear as the pictures moved across the photo desk. We prepared a solid photo presentation for our editorial meetings in the early afternoon."

Smith said, "Our edit had to reflect the full range of the story, including the impact on people; we had to be complete and that meant the Washington and Pennsylvania aspects of the story." Photo selections at the desk mounted, were pared down to a smaller collection, then increased again as more pictures moved into the system.

Ludlum's spectacular photo of the second tower surrounded by the fiery explosion of the plane emerged as the key picture in the *Times*' presentation. Other compelling photos showed the reaction on the street, the injured being treated, the deadly cloud of snow-like debris that hid the sun's light, and much more.

Pictures filled nearly half the front page in a display of picture journalism unusual for the *Times*, or any daily newspaper.

The story did not end there but moved half a world away to Afghanistan, where the terrorist forces that made the World Trade Center attack possible were harbored by the Taliban regime. *Times*

photographers Vincent Laforet, James Hill, and Tyler Hicks made their way to Pakistan and then into Kabul, Afghanistan, where they photographed an ancient world locked in a medieval lifestyle by a repressive regime of religious fanatics. One photo in particular captured the sense of the time and place—James Hill's picture of wizened peasants on the rocky landscape beneath a sky etched with the contrails of jet bombers.

Ruth Fremson, fresh from the disaster site in New York, was one of the team whose graphic, telling photos showed readers what Afghanistan was like and how its people lived.

The two picture portfolios submitted by the *Times* to the Pulitzer committee won both Spot Breaking News and Feature News Photography awards, the first time in Pulitzer history that a publication captured both photo Pulitzers in the same year.

"One way we coped with our own shock was to pour great energy into the story. We started in New York on September 11 and continued through the end of the year. We kept up that energy level in New York, in Pakistan, in Afghanistan."

She also pointed out that, "This was so much a picture story. Everyone wanted to look at all the pictures. There was not a moment's hesitation about devoting plenty of space to the visuals. This was new for us."

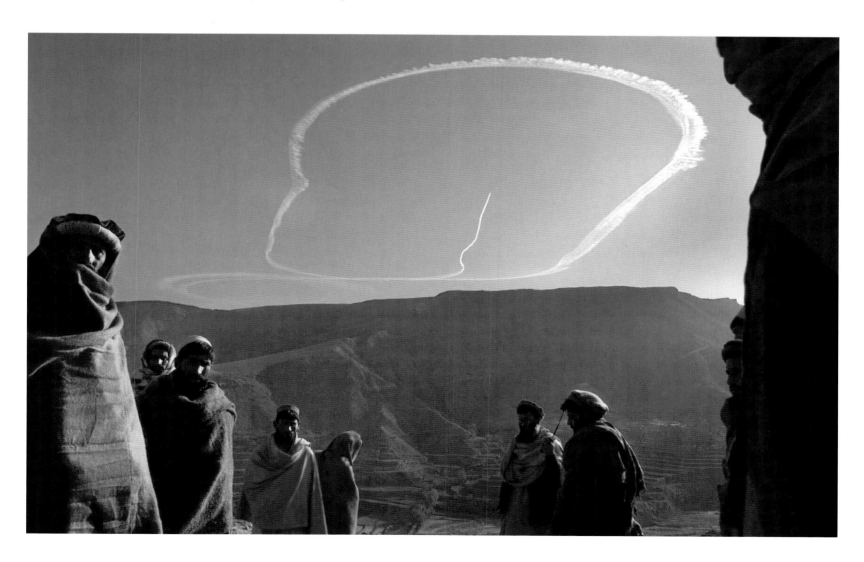

The Digital Revolution

By the turn of the century digital photography was the technology of choice for staff and free-lance photographers who made pictures for publication and especially for photographers in daily picture journalism. Film and prints were outdated technologies.

Most assignment editors commissioned coverage only to photographers who were equipped with digital cameras and transmission tools. In the offices of picture agencies and in the newsrooms of publications, digital systems captured the images and relayed them into the publication and distribution systems quickly and with excellent technical quality. Newspaper reproduction of photos rivaled magazine reproduction.

But did digital photography change the look of picture journalism? The answer is yes and no.

Visual reporting had been changing slowly but inevitably during the decades that preceded the emergence of digital. New lenses, the growing talent of individual photographers, and the gradual use of color on newspaper pages exposed readers to pictures with perspectives and insights not seen in the day-to-day journalism of earlier years. Memorable photographs of news events have always been part of picture journalism's history. Joe Rosenthal's Iwo Jima flag-raising and other pictures from World War II, the pictures of the Hindenburg explosion, and the photographs of the horror of the Nazi concentration camps are etched in memory. Many other examples exist, but more recently, photographers brought a graphic quality to pictures on a day-to-day basis not previously seen.

In this same period—the latter part of the twentieth century—editors gradually began to understand the power of photography and accept it as realistic and meaningful reporting. They made room for picture coverage that in previous generations would have been unheard of. More complete picture coverage and better display of pictures was the result.

A separate influence came from the growing presence of all-news television that often showed the news as it happened. To be relevant, photographers for the printed page rose to the challenge to make more telling pictures.

Nevertheless, there were problems. Color pictures by wire were generally of poor quality. Local color was often difficult to reproduce. Chemical-optical and film photography required extra staff on assignments far from home. Deadlines were difficult to meet. Circuits, especially international circuits, were unreliable. Even as late as the 1970s pictures from Vietnam were transmitted on poor-quality radio connections.

Enter digital photography. Enter satellite phones, an expensive but vital tool for the picture journalist. Enter wireless picture transmission that made possible faster delivery of local pictures from the stadium across town to the picture desk miles away. Enter high-speed circuits that flashed pictures around the world in seconds.

Wire services were the first to utilize the new technology,

because photographs were their bread and butter. But soon all photographers and their photos were just a phone call away, regardless of distance.

Distant stories, once the bailiwick of the wire services, whose staffs could handle weighty equipment and provide manpower to handle film coverage, were easily available to the lone newspaper photographer armed with digital cameras, a laptop computer, and a satellite phone. Cost was the only obstacle and many newspapers paid the costs so that they could have their own coverage.

The technology thus created new opportunities for the camera storyteller. Digital photography freed photographers from the burdensome, time-consuming logistics of the chemical optical process. Enlargers, darkrooms, and running water were no longer required. A photographer could send his pictures from anywhere—from a boat, a car, a bus, a desert battlefield, an upcountry African village devastated by genocidal mobs.

Digital photography reduced the distance from the scene of a story to the printed page, overcoming the inherent perishable nature of daily news. Connected to home base by reasonably reliable communications, photographers could roam the world and still get their pictures home to meet today's deadlines.

The digital process also affected the printing process. Once cumbersome and chancy, color became as easy to publish as black and white once was, and it enlivened the newspaper page. All news pictures were shot in color, even those that were printed in black and white because of press limitations.

To sum up: It was not that digital processes changed the look of pictures. Digital technology made possible the expansion of meaningful picture journalism by overcoming the burdens of an outdated technical process. With more photographers than ever before making more pictures than ever before and delivering them faster than ever before, readers gained greater insight into major news events regardless of their location.

The changing scenario was reflected in the Pulitzer Prizes. Pulitzers awarded to pictures from abroad, once the domain of wire services, were now being given to newspaper photographers as well, photographers who went to the scene of the story and delivered their pictures in nearly real time to newspapers and online services.

Ethical issues remained a major concern. Digital pictures could be easily manipulated. It had always been possible to alter pictures, but in the digital world manipulation was easier, faster, and more difficult to detect. Most editorial policies forbade alteration of a photograph, a policy adhered to for the most part. Several photographers, however, were fired for their efforts at manipulation. Several publications came under severe criticism because of picture manipulation that changed the tone and the message of a photo.

The ethical battle will almost certainly continue.

Colorado Wildfires

BY THE STAFF OF *THE ROCKY MOUNTAIN NEWS*

Gov. Bill Owens of Colorado said it on June 9, 2002: "All of Colorado is burning today."

Colorado surely had more than its share of the fierce fires that swept across broad stretches of the western United States in the summer of 2002. Like a perfect storm at sea, a variety of factors combined to create the largest and most destructive wildfires recorded in the state.

A historic drought dried out the countryside, single-digit humidity further sapped the moisture, 80-degree temperatures were common, and unpredictable winds blew the fires and powered their jumps across natural and manmade barriers. Steep, rock-strewn terrain frustrated firefighters already hampered by narrow, winding roads. Heavily wooded hills and a buildup of undergrowth provided the fuel. Even coal seams in the earth helped to carry the raging, sometimes 500-foot towers of flame across the landscape.

The *Rocky Mountain News* faced two major fires. In Hayman, just a few miles south of Denver, a fire started on June 8 and burned for 21 days. On Missionary Ridge, further southwest of Denver, another major fire burned for weeks.

Photographers with the *News* followed firefighters into the wooded areas and took pictures of fire-threatened homes and evacuees abandoning their belongings to stay ahead of the fast-moving wall of flame. *News* staffers also used aircraft to photograph planes of World War II vintage dropping fire retardant on the burning

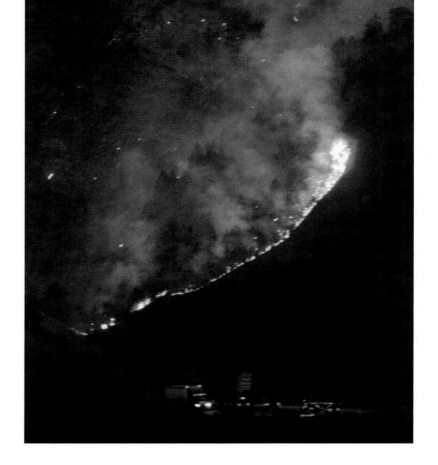

JANUARY 2002 ▪ *Europeans switch to the Euro.*

JANUARY ▪ *Queen Elizabeth II celebrates her Jubilee year.*

MARCH ▪ *Halle Berry, is the first black actress to win an Oscar.*

MAY ▪ *Boston's Cardinal Bernard Law resigns.*

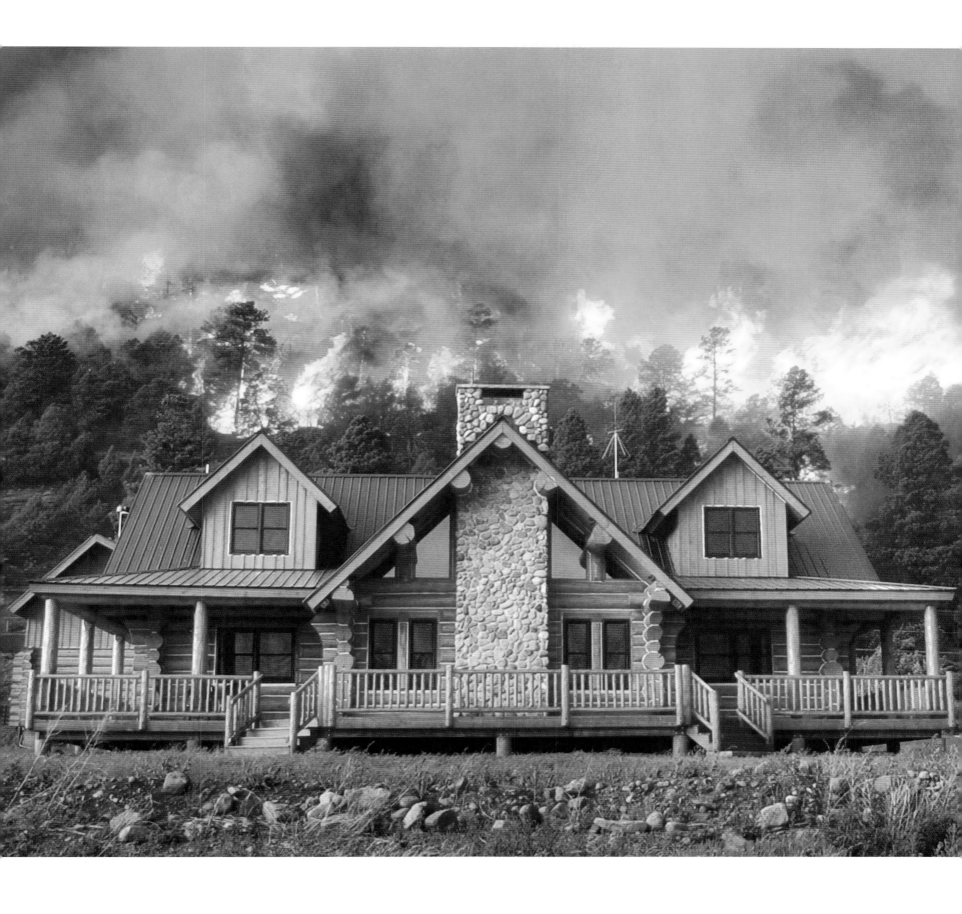

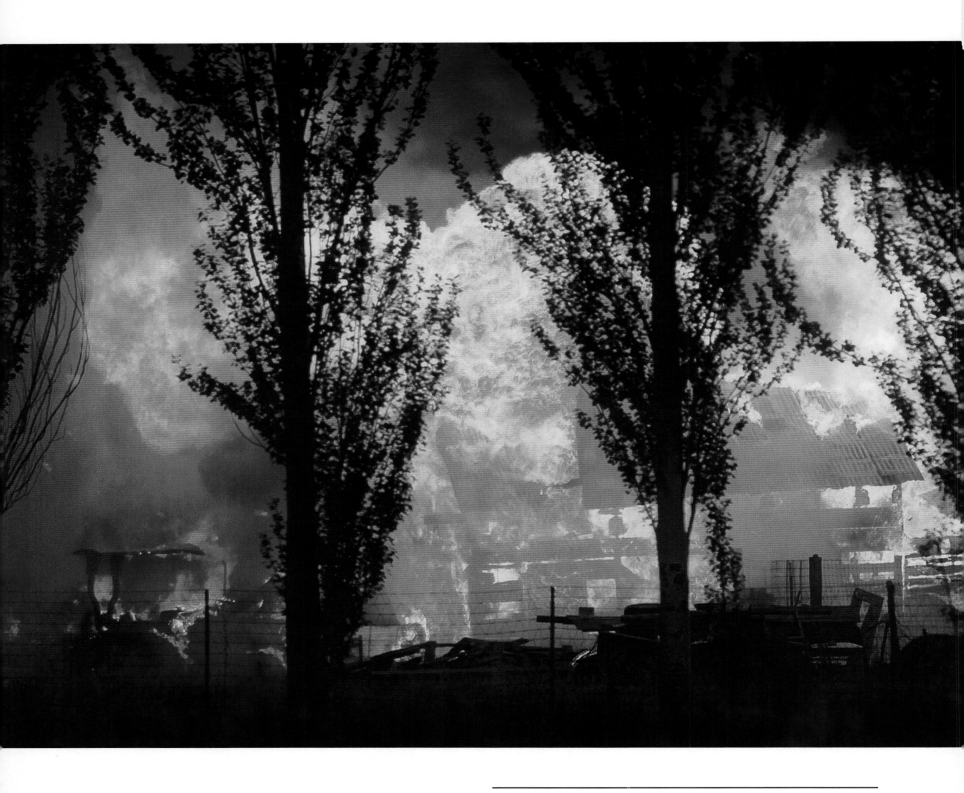

TECHNICAL DETAILS **CAMERA** Nikon Digital
EXPOSURE Various
LENS Various

countryside. They even photographed one plane that burst into flame itself and plunged into the woods, killing two pilots.

Fires eventually blackened more than 200,000 acres during the summer-long onslaught. Thousands were evacuated and hundreds of homes were destroyed.

The *News'* picture portfolio submitted to the Pulitzer judges showed the flames threatening houses and small towns, and the exhausted firefighters who battled the flames but could not stay ahead of them.

Director of Photography Janet Reeves described the Pulitzer Prize as historic. The picture coverage, she said, was not just about houses destroyed and lives lost. The experience of losing our treasures is sad, she said, because trees for Coloradoans are like buildings in big cities. She credited the entire staff (15 photographers and four picture editors) as contributors to the prize.

Only two years earlier the *News* had won a Pulitzer for its photographic coverage of the Columbine school massacre.

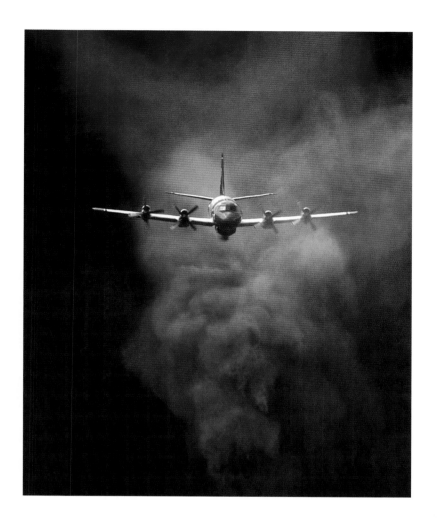

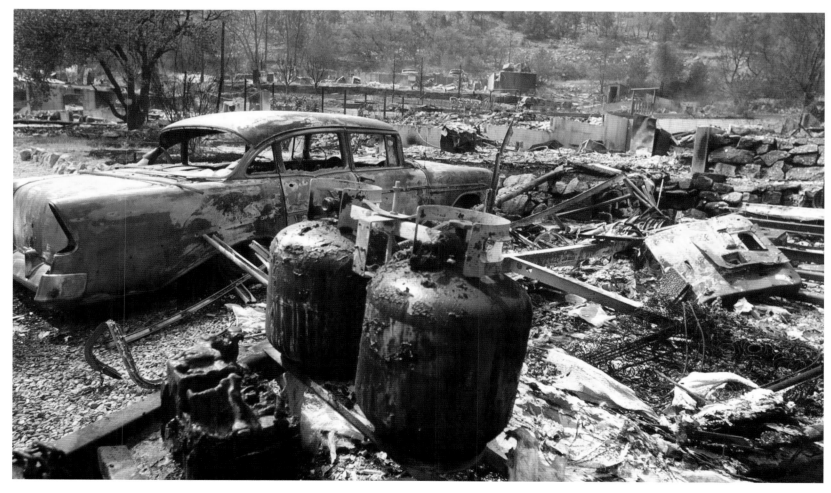

Enrique's Journey

BY **DON BARTLETTI,** *THE LOS ANGELES TIMES*

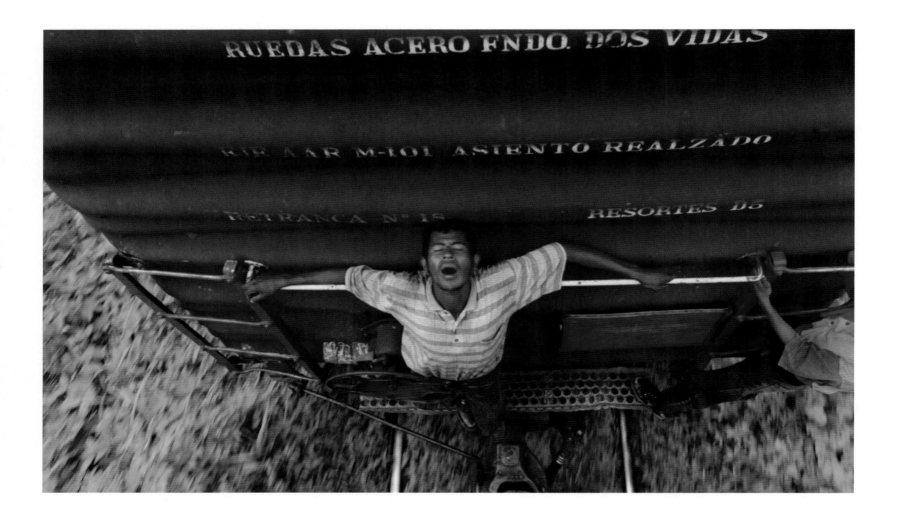

The trail for the undocumented alien from Central America to the U.S. bank of the Rio Grande River is perilous. Each year, however, thousands of youngsters make the journey without funds, using their wits to outsmart gangsters and border guards, police and railroad officials who frustrate their passage.

Los Angeles Times photographer Don Bartletti and writer Sonia Nazario combined their talents to re-create the journey made by Enrique, a Honduran boy who traveled more than 10,000 miles to join his mother in North Carolina. Enrique's story, which Ms. Nazario first heard from the woman who cleans her home, is like that of thousands of children who enter the United States illegally to find

their parents, who came here before them along the same route.

To make the journey from Central America, Enrique hopped trains, where he was nearly brushed off the roof by low-hanging tree limbs; hitchhiked with 18-wheelers; and rode buses when he could raise money. He built makeshift rafts to cross rivers. He left home in the subtropics but soon found himself in the higher elevations of Mexico, where cold nights chilled him to the bone. Eight times he was caught and returned to the border of Mexico and Honduras, only to begin again. His will and the desire to reconnect with his mother drove him forward. Enrique eventually made it safely to North Carolina.

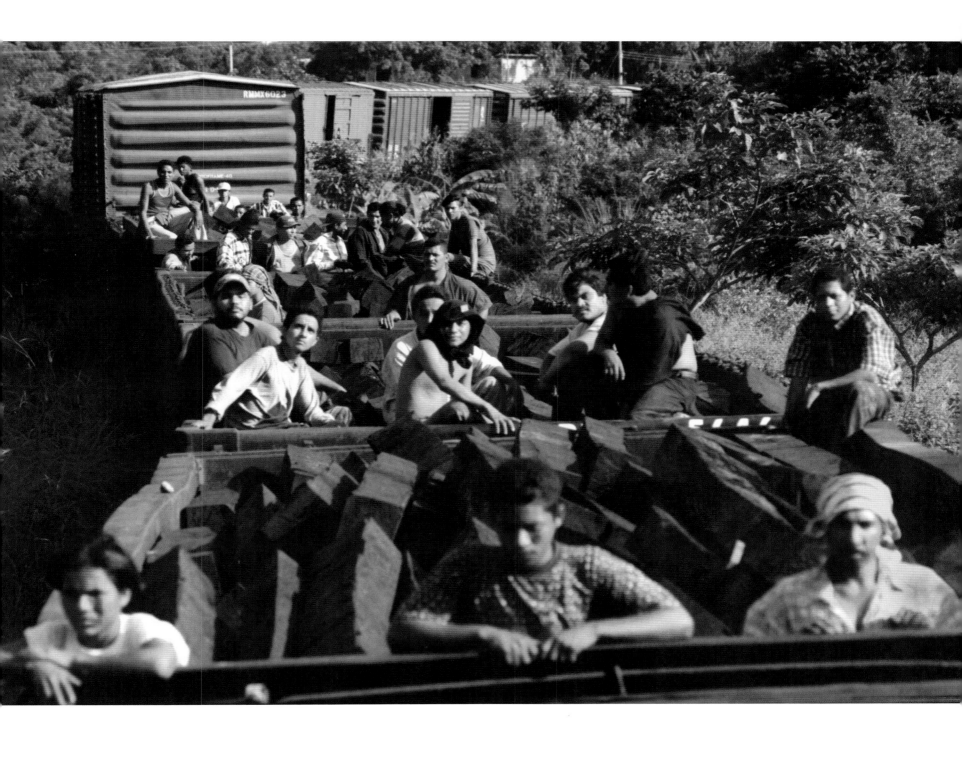

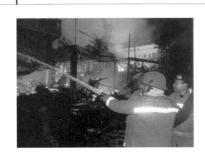
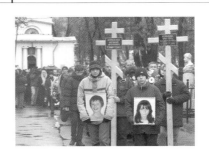
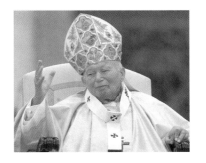

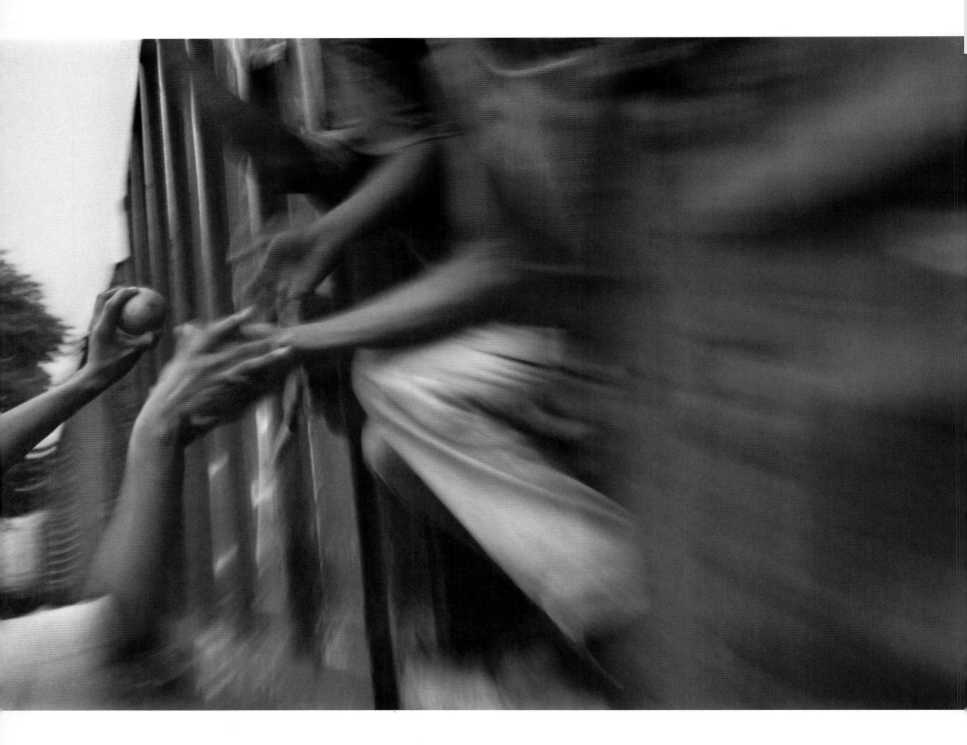

Bartletti re-created the trip by following the same tortuous path and photographing others on the road, following the well-known trail that Enrique and so many others had taken. Bartletti rode trains where Enrique rode trains, and hitchhiked where Enrique had hitchhiked. He saw illegals caught and put in prison, then returned to the border. He had his camera equipment stolen. His pictures and Nazario's stories re-created the journey in textured detail—or, as they put it, took their readers on the same ride that Enrique had taken.

The *Times* printed the story in its step-by-step format as a series of six articles from September 29 to October 7, 2003.

In separate Pulitzer awards, Bartletti won the feature photography award and Nazario won the feature writing award.

TECHNICAL DETAILS

CAMERA Nikon
EXPOSURE Various
FILM Mixed, Koda and Fuji
LENS Various

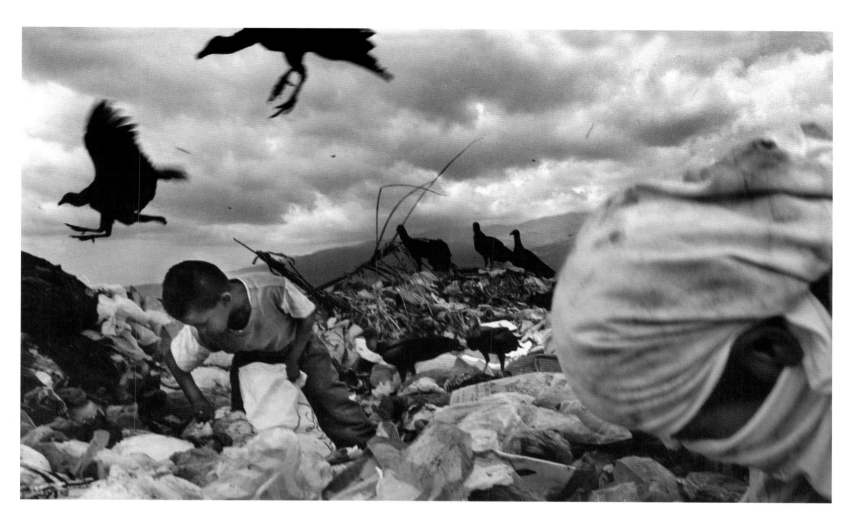

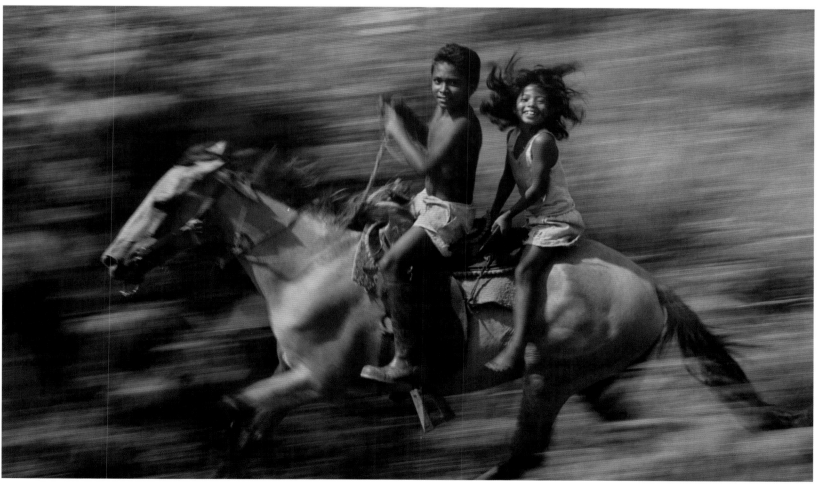

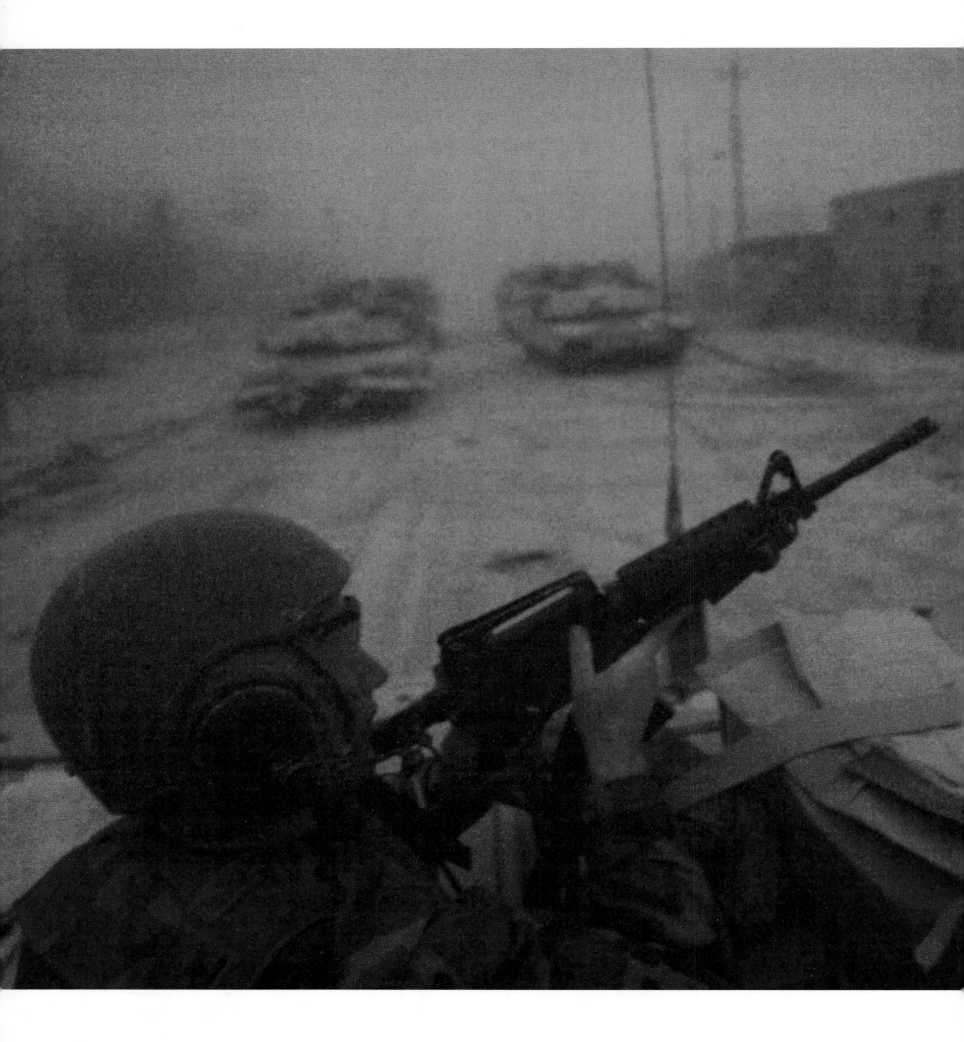

284

War in Iraq

BY CHERYL DIAZ MEYER AND DAVID LEESON, *DALLAS MORNING NEWS*

Cheryl Diaz Meyer and David Leeson, senior staff photographers of the *Dallas Morning News*, crossed the Kuwait border with the American advance into Iraq in 2003. Diaz Meyer was embedded with the Marines' 2nd Tank Battalion and Leeson was with the Army's 3rd Infantry Division. They lived with U.S. troops that passed through the Iraq desert and entered Baghdad in the early stages of the Iraq war.

Both were experienced war photographers. Leeson covered the 1991 Gulf War and civil strife in Angola. Diaz Meyer covered the war in Afghanistan. Leeson was a three-time Pulitzer finalist for earlier coverage in his 20-year career; Diaz Meyer was a first-time finalist.

As journalists embedded with U.S. forces the photographers were required to stay with the troops throughout the unit's assignment in Iraq. They lived with the soldiers, ate with them, and traveled when they traveled, night or day. If they left the unit for any reason they could not return. They were in the field for the duration.

Their Pulitzer Prize–winning picture portfolio was taken from their weeks of daily coverage through desert sandstorms, roadside encounters with the Iraqi forces outside cities, and in the capital itself. More than the broad spectacle of war, their pictures focused on the smaller, daily encounters that soldiers and civilians face in combat.

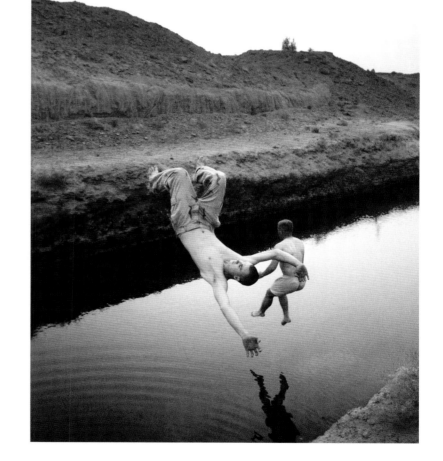

FEBRUARY 2003 ■ *Space shuttle Columbia disintegrates while landing.*

FEBRUARY ■ *More than 100 die in Rhode Island club fire.*

MARCH ■ *Coalition invades Iraq.*

APRIL ■ *Actor Robert Blake arrested for murder.*

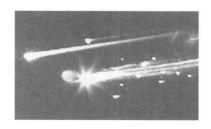
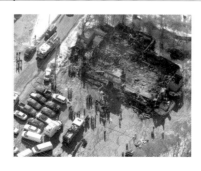

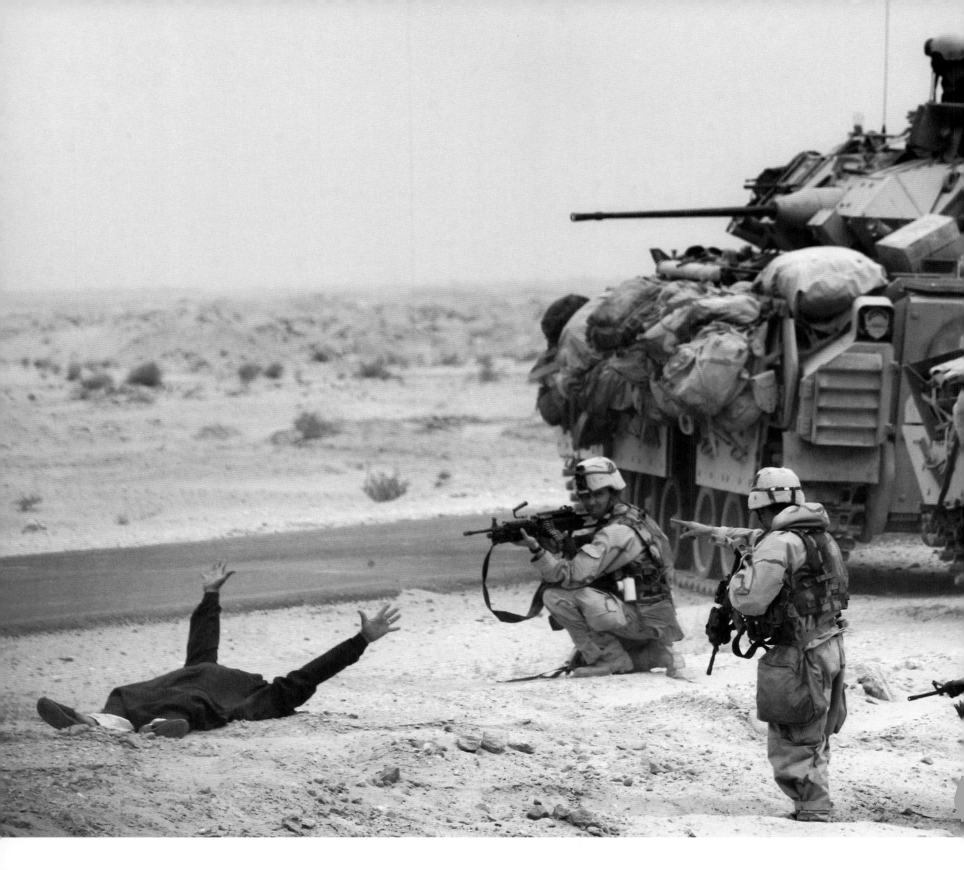

Throughout, the pictures captured the vicious nature of the fighting (at one stretch Leeson was exposed to 23 straight days of hard combat with his troops), but they also focused on the civilians caught in the crossfire of war, and the impact of the war on the soldiers themselves.

At one point Diaz Meyer watched and photographed Iraqi civilians uncovering the relics of relatives buried years earlier in mass graves. Leeson photographed a burning man shot by soldiers, and the tearful face of a soldier at the service for a fallen comrade.

Commenting on the Pulitzer, Leeson said: "The Pulitzer Prize has a great service in that it gives these images an additional life, so that future generations will see them and these photographs will continue to speak truth about the cost of war, and about the price of freedom."

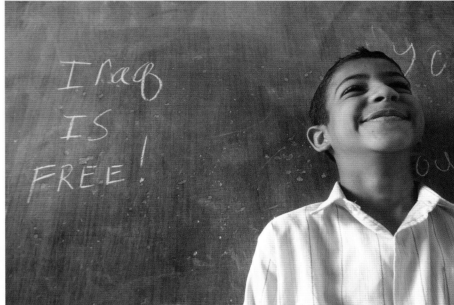

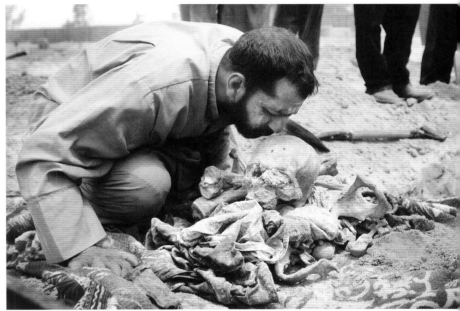

TECHNICAL DETAILS **CAMERA** Nikon Digital
EXPOSURE Various
LENS Various

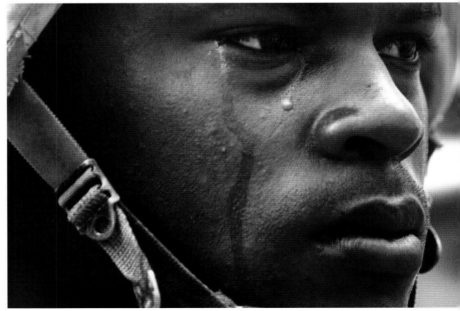

Monrovia Under Siege

BY **CAROLYN COLE**, *THE LOS ANGELES TIMES*

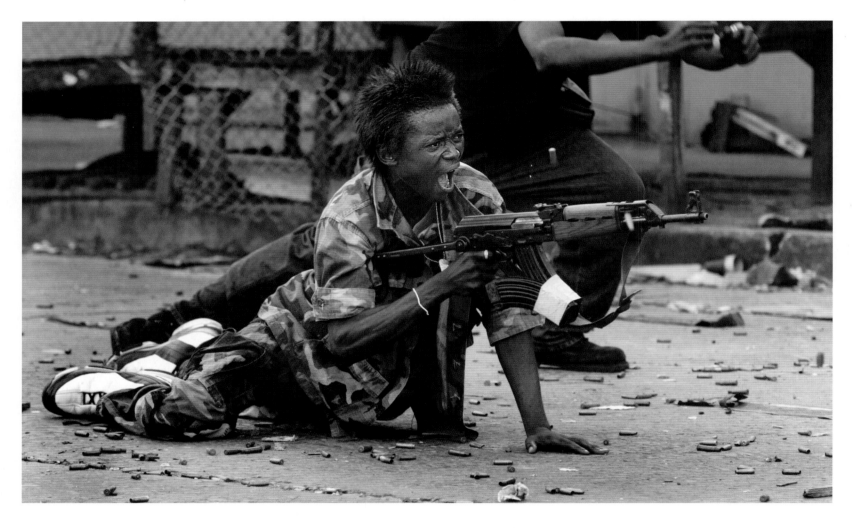

The long-time civil war in Liberia had, by 2003, repeated itself for decades—an insurgent assassinated the president in 1980; and a warlord executed the insurgent in 1989. By 2003 the warlord was besieged by rebel forces, themselves led by factional warlords.

President Charles Taylor of Liberia, one-time rebel leader and warlord who assumed his office in an election held after the assassination of his predecessor, held power for more than a decade. Since Taylor's ascendancy in 1989, rebels, most of them rural factions led by other warlords, had opposed his regime. For years the countryside was torn by strife, but Taylor clung tenaciously to his power in the cities. He accumulated a personal fortune said to

amount to $100 million. Now, in the summer of 2003, rebels tightened the noose and Taylor's corrupt regime was under fire.

Rebel forces made a bloody advance toward the capital of Monrovia. Families from the countryside fled to the city in the belief that it would offer the safest refuge.

That is when photographer Carolyn Cole and her editors at the *Los Angeles Times* decided to do a picture story about the impact of the constant fighting on the common people of Liberia. War was not a new assignment for Cole. She was in Iraq as the Liberian story came to a head. Before Iraq she had been in Afghanistan; and she was a Pulitzer Prize runner-up for her picture coverage of war

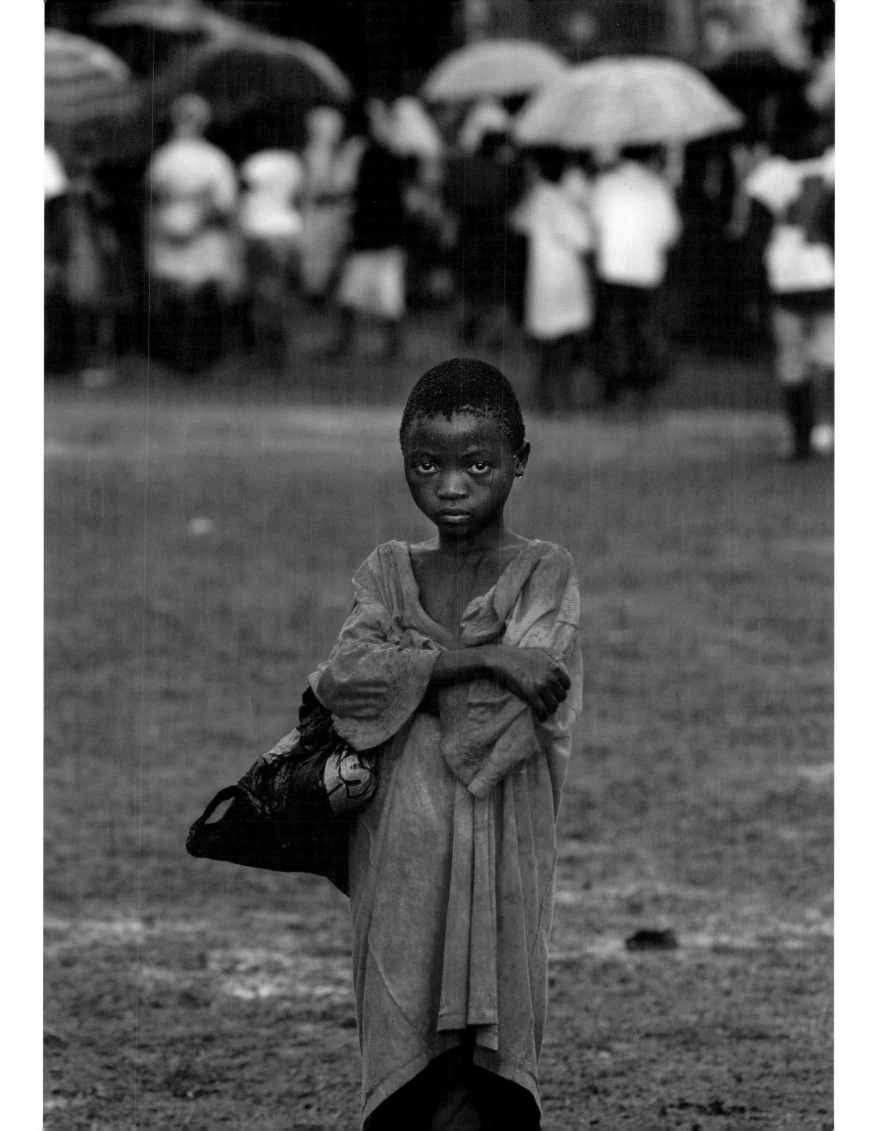

in Israel. But she found the level of violence in the street fighting that erupted in Monrovia as the rebels moved into the city to be extraordinary, even in the eyes of an experienced war photographer.

So fierce was the firepower that some downtown streets were covered over with spent cartridges. Caught in the crossfire were the Monrovians and their new neighbors, the rural people who had fled to the capital. Refugees took up residence in a stadium, in an old Masonic building scarred with bullet holes, in a former U.S. radio station—anywhere away from the fighting.

Cole was in the middle of it. Her pictures captured the bloody combat as rebels and government soldiers, both armed with automatic weapons, met head to head in fierce, unrelenting urban warfare that made Monrovia a shambles. She photographed, with great sensitivity, those caught between rebel and government fighters. Her pictures showed the shattering impact of the fighting on the people, on their life in camps and in makeshift housing. Her photographs were published in July and August of 2003. Finally, Taylor and his cronies, under international pressure to stop the bloodshed, went into exile in Nigeria.

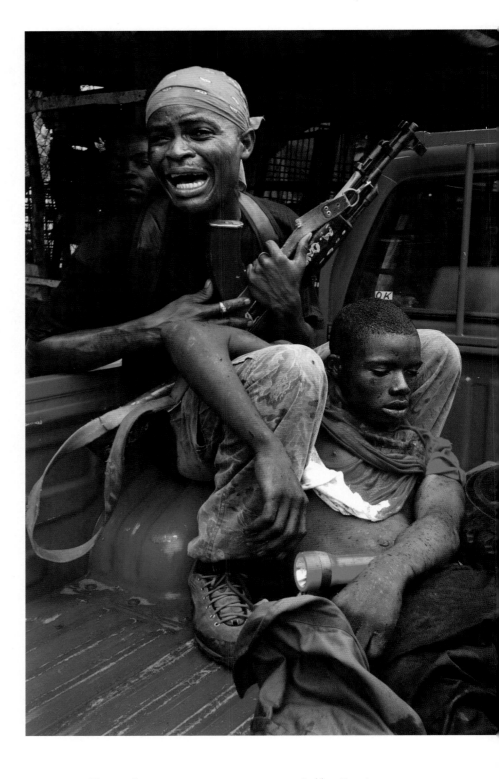

TECHNICAL DETAILS **CAMERA** Canon Digital
EXPOSURE Various
LENS Various, 35 mm to 200 mm

AUGUST ■ *Blackout darkens eastern United States.*

OCTOBER ■ *Arnold Schwarzenegger elected California governor.*

NOVEMBER ■ *First openly gay Episcopalian Bishop Gene Robinson named.*

DECEMBER ■ *Saddam Hussein captured.*

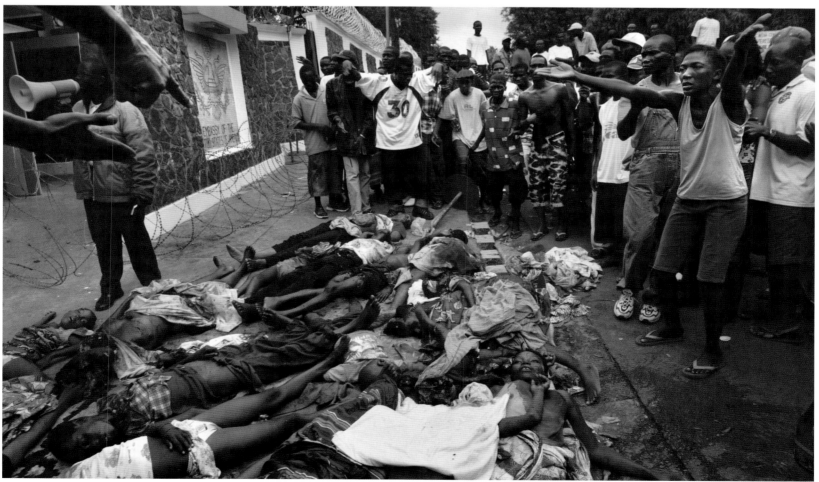

Iraq War Revisited

BY THE STAFF OF THE ASSOCIATED PRESS

Picture journalism in Iraq in 2004 was always dangerous, sometimes fatal. The nature of the war changed from what was once broad battlefield encounters to insurgency and urban warfare marked by car bombs, sudden highway attacks, kidnappings, and house-to-house searches in the cities. Journalists were kidnapped and sometimes murdered. Places like Fallujah appeared in headlines and captions.

To meet the new challenge the Associated Press assembled a tested, experienced group of international photographers and teamed them with locally hired Iraqi cameramen. Some of the Iraqi photographers were experienced; others had to be trained. Some lived in the neighborhoods where insurgents operated, making the work all the more dangerous. Threats to their lives and those of their families from fellow Iraqis were not unheard of. Sometimes they were shot at by American troops uncertain of their purpose in a war where cunning trickery by attackers was common.

The new Iraqi photographers were trained by the old hands, which included John Moore, a veteran of the Iraqi story since the first day of the invasion, and Jim MacMillan, on leave from the *Philadelphia Daily News* to be with the AP for a year in Iraq.

Moore, and others on the team traveling with American troops, photographed the story from the other side. The portfolio submitted to the Pulitzer judges from his mixed group included photos of bloody street fighting, heart-warming examples of soldier loyalty, and at least one case of outright murder.

Masked insurgents in Fallujah, for example, knew Bilal Hussein as a neighbor when he photographed them firing mortars from city streets at U.S. troops patrolling their city. Khalid Mohammed photographed U.S. contractors whose bodies were burned, dismembered, and then hung, as charred remains, from a bridge. He recalls telling his driver to "keep the car running" as he moved forward to photograph the grisly scene. He took pictures but was immediately threatened by the celebrating crowd. He left the scene, and his pictures became a terrible reminder of the event.

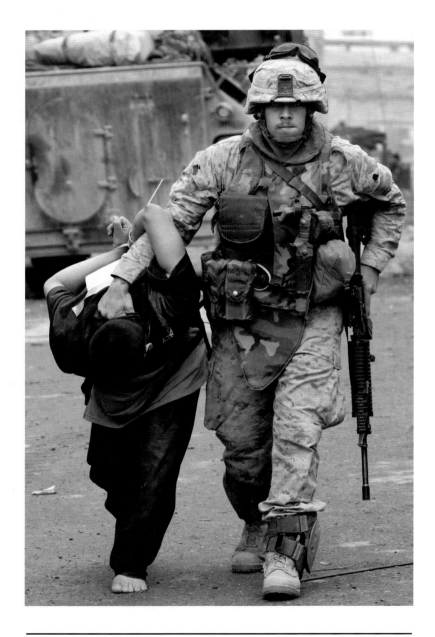

TECHNICAL DETAILS **CAMERA** Nikon Digital
EXPOSURE Various
LENS Various

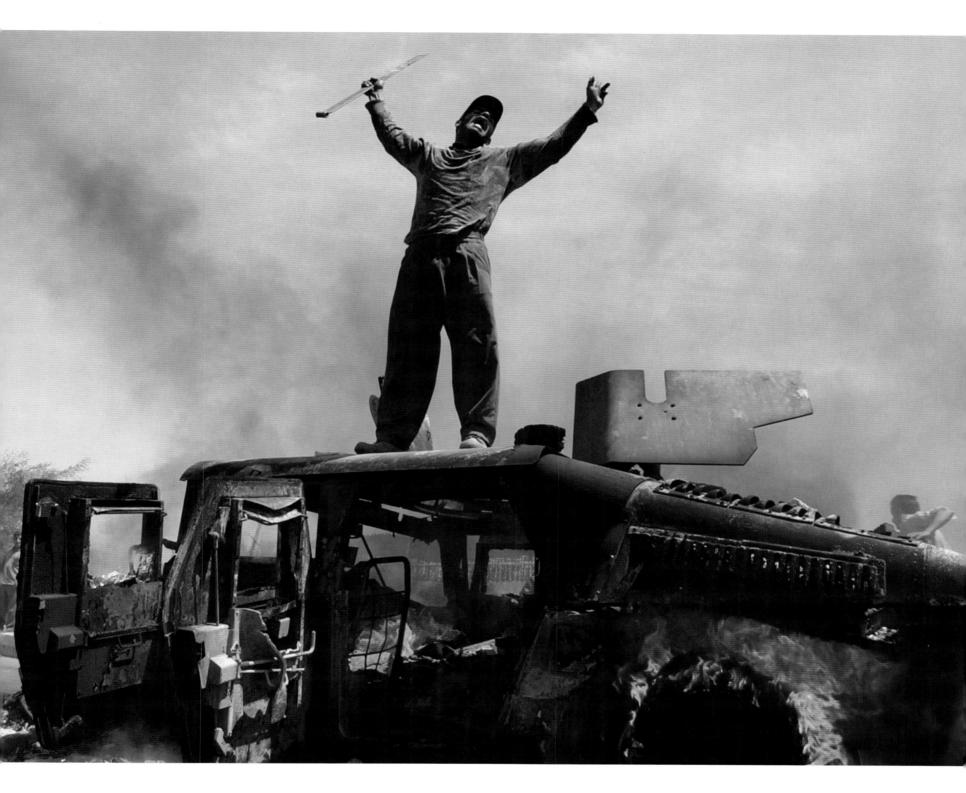

One of the Pulitzer photographs carried the credit line "stringer." Fearing deadly reprisals, the photographer remained unidentified after he photographed insurgents, pistols in hand, murdering election workers. Tipped by a colleague about burning vehicles in a city street, the photographer went to the scene and found two cars that were bombed. One continued to burn. Others in the street directed traffic away from the scene. The photographer left his cameras in his car some distance away and sought information from the crowd. "None of your business," he was told. He

returned to his car, at which time an explosion nearly knocked him down. He turned and saw armed men in the intersection attacking election workers. Using his camera with a 400-mm lens, he shot the scene as two of the election workers were shot to death in the intersection.

Combined, the work of this international and local staff produced a continuing series of remarkable photographs that required courage and determination and told unflinchingly the brutal story of Iraq in 2004.

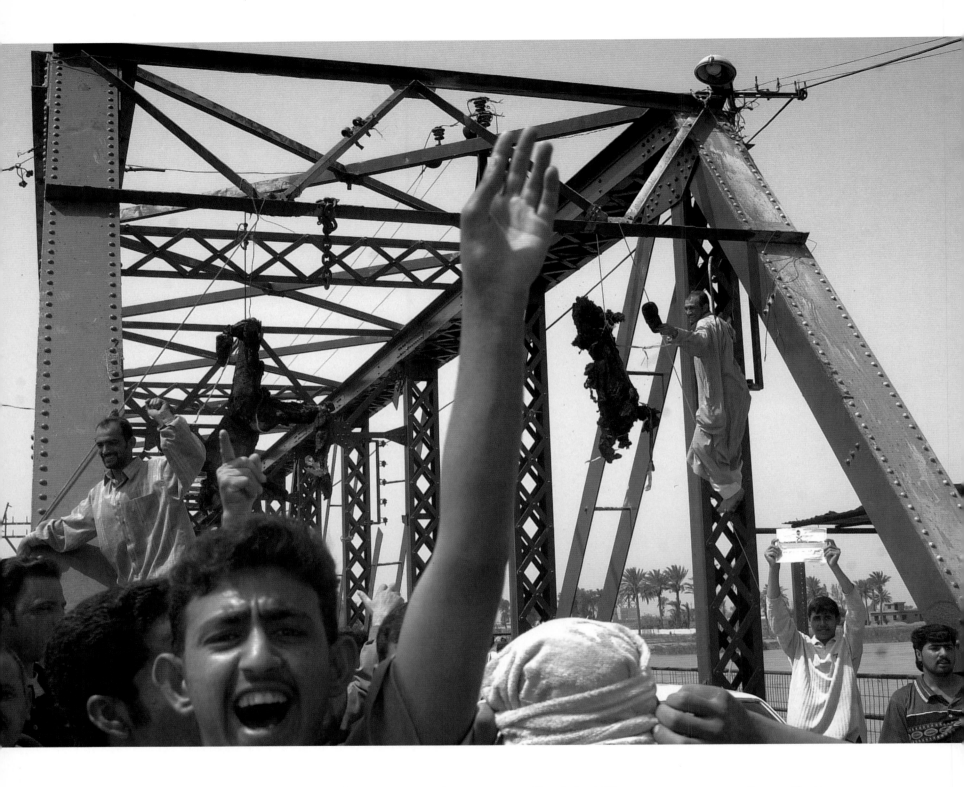

TECHNICAL DETAILS CAMERA Nikon Digital
EXPOSURE Various
LENS Various

Operation Lion Heart

BY DEANNE FITZMAURICE, THE *SAN FRANCISCO CHRONICLE*

In Iraq a roadside bomb suddenly exploded and a boy nearby was killed. His brother, age nine, took horrendous wounds in the abdomen. His right hand was blown off and some of the fingers of his left hand were gone. One eye was torn from its socket; the boy was near death. U.S. Air Force doctors patched him up, and launched an international mercy mission. They were so impressed by the boy's bravery, by his resilience and steadfastness, that they nicknamed him Lion Heart.

Saleh Khalaf ended up in Children's Hospital in Oakland, California, in the company of his father. More than thirty surgeries would take place over the next ten months to repair at least some of the damage, physical and psychological, that had scarred the boy's young life.

Deanne Fitzmaurice, a 16-year veteran photographer for the *San Francisco Chronicle* believed this story was worth telling in intimate detail. Fitzmaurice and *Chronicle* writer Meredith May began their coverage of Lion Heart's rough road to recovery.

The long-form picture story is among the most difficult assignments for a photographer. Like a word story, it must have a beginning, a middle, and an end. In the case of a young boy so seriously injured, the photographer cannot just worry about the pictures. A human being is involved—vulnerable, in a strange land, undergoing constant medical procedures. Saleh's father was with him, but the remainder of his family, two sisters and his mother, stayed in Iraq to await the outcome of the treatment. Fitzmaurice was sensitive to the family's condition and started the picture coverage slowly, building a relationship with Saleh and his father.

Carefully, over the months, Fitzmaurice came to be part of the family. In the early stages she communicated with Saleh by showing him pictures she made on the back of her digital camera.

But the boy was understandably insecure about his appearance and easily upset by the stares of passersby in the street. At one point he ran from a supermarket. His father caught up and the boy knelt, sobbing at his father's feet. Fitzmaurice captured the telling moment.

Gradually the story unfolded. With the astonishing resilience of youth, Saleh improved. Doctors repaired much of the damage. Nurses showed him how to draw pictures with his shattered hand. He drew pictures of planes with bombs falling. He played soccer in the hallway with an attendant. His father got a job. He finally entered a local school and made some friends. A family living nearby hosted father and son when the hospital stay came to an end. His father then found a job in the hospital. Fitzmaurice's camera, driven by her steady, compassionate photographer's sensibilities, captured the step-by-step progress. She and May produced five well-illustrated stories over the course of ten months.

SEPTEMBER ▪ *Terrorists attack school in Beslan.*

SEPTEMBER ▪ *Oil prices rise to $50 a barrel.*

NOVEMBER ▪ *George Bush reelected President.*

DECEMBER ▪ *Tsunami kills thousands in Asia.*

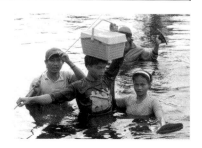

Finally, Saleh's mother and family came to the United States and took up residence.

One picture in Fitzmaurice's coverage captured the essence of a life renewed. It was the graphic shot of Saleh's father dancing a vigorous jig with his son in a spontaneous reaction to the family's union and the promise of a life together once again.

The photo story has come full circle—the terrible beginning, the slow but measurable progress of the middle, and a rare happy ending. The Pulitzer judges and committee recognized the careful camera work and the telling pictures it produced, and awarded the feature photo Pulitzer to Deanne Fitzmaurice.

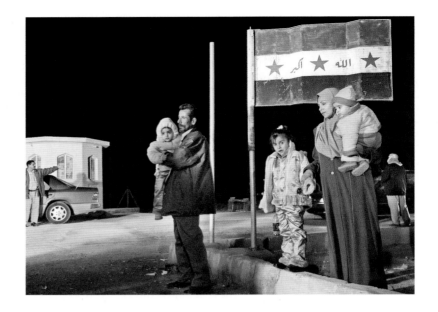

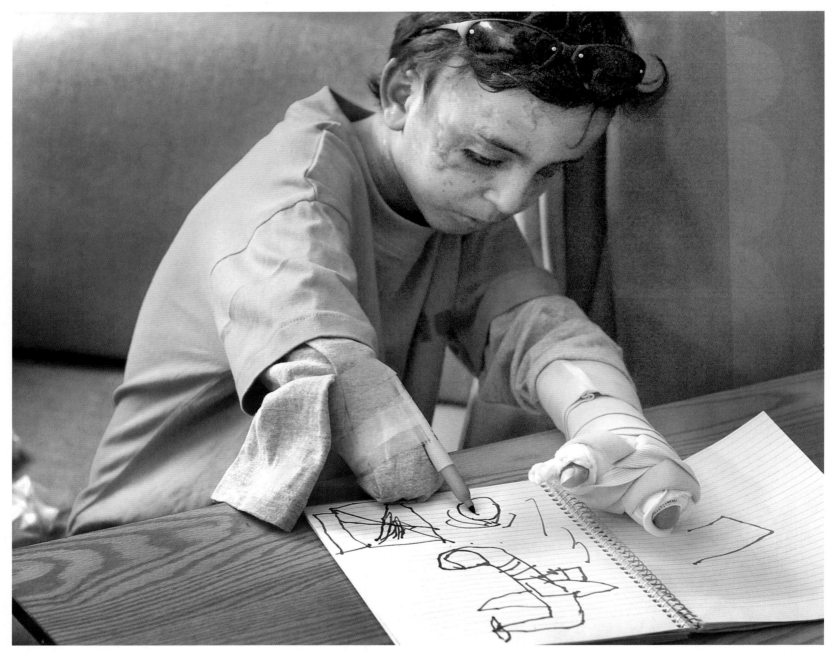

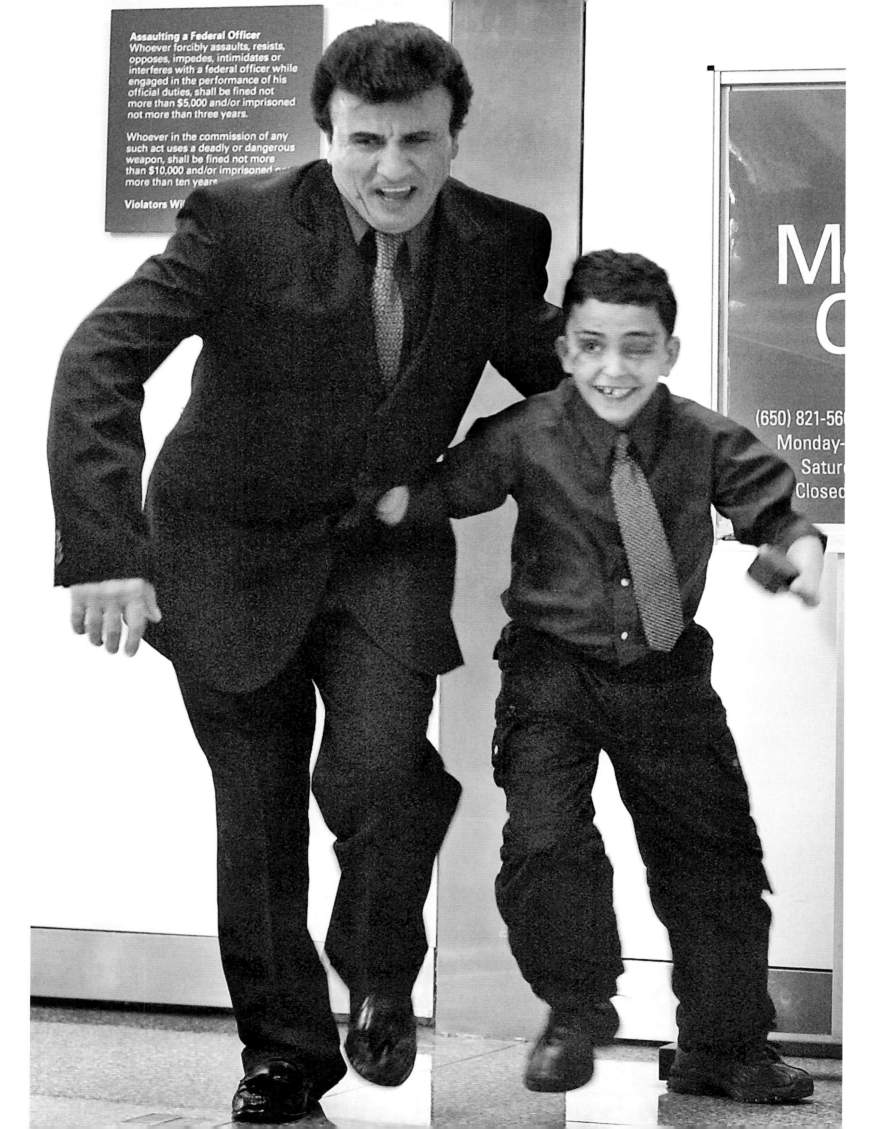

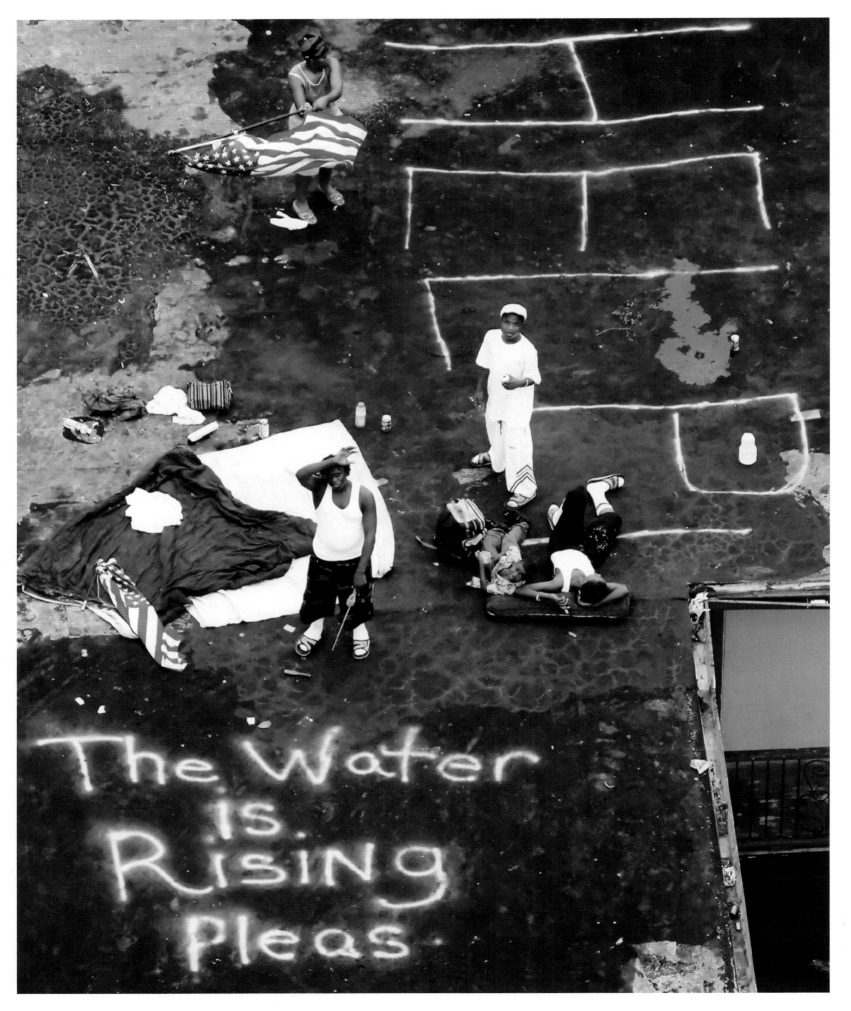

300

Hurricane Katrina

BY THE STAFF OF THE *DALLAS MORNING NEWS*

Katrina was born in the southeastern Bahamas on August 23, 2005. It was the twelfth tropical depression of the season. The next day, Katrina developed into a tropical storm, moving slowly north and west through the Bahamas. By the early evening of its third day, Katrina had reached landfall in the vicinity of Miami. Winds increased to seventy-five miles per hour, with gusts as strong as ninety miles per hour. Katrina was elevated to a Category 1 storm.

The hurricane continued to move in a southwesterly direction, covering the tip of southern Florida with five inches of rain. Winds decreased a bit over land but regained strength once the storm arrived in the Gulf of Mexico. Katrina's course shifted west toward Texas, then shifted again to the north for two days. Winds reached 170 miles per hour. Five days after its inception, Katrina was labeled a Category 5 storm.

Landfall came on August 29. Rain fell at the rate of 1 inch per hour and accumulated up to 10 inches in some areas. Winds were clocked at 140 miles per hour in southeastern Louisiana, 100 miles per hour in New Orleans.

Bill Snyder, director of photography at the *Dallas Morning News*, watched Katrina's progress. Planning coverage of a hurricane is tricky for a number of reasons. Landfall is seldom known until the final hours of the storm's progress. When the storm hits, mobility is always hampered to some degree. Highways are closed; air traffic is restricted; stores and gas stations are shut down or damaged; motels are boarded up, their owners seeking sanctuary inland; communications are lost; and photographers are often unable to transmit photos. The magnitude and strength of Katrina led Snyder to believe that his photography team would have to deal with all of these factors and that destruction would be widespread.

Then the levees in New Orleans collapsed under the weight of rushing waters; lowlands flooded, towns along the coast were wiped out, and a whole new dimension of the story opened up. The storm was the worst the United States had seen since 1928. More than 1,600 people perished. Some $75 billion in damage littered the landscape.

A car from Dallas was dispatched carrying some sixty gallons of gasoline to power generators for satellite phones. It carried water and food as well. Most photographers thought the cell phones would be out of business, and they were. The team relied on satellite phones to transmit most of their pictures. Photographers were put in place in New Orleans and Mississippi ahead of landfall.

Morning News staffer Michael Ainsworth was in Louisiana ahead of the storm. It was his third hurricane assignment of the season. He made his way to New Orleans, where he photographed crowds of people whose tempers flared as they jockeyed for space on transportation away from the city to safer, livable areas.

APRIL ▪ *Cardinal Joseph Ratzinger blesses Pope John Paul II coffin. Ratzinger is elected Pope Benedict XVI.*

JULY ▪ *Terrorist bombs kill 52 in London.*

JULY ▪ *U.S. Cyclist Lance Armstrong wins his seventh straight Tour de France.*

OCTOBER ▪ *Earthquake kills thousands in Pakistan.*

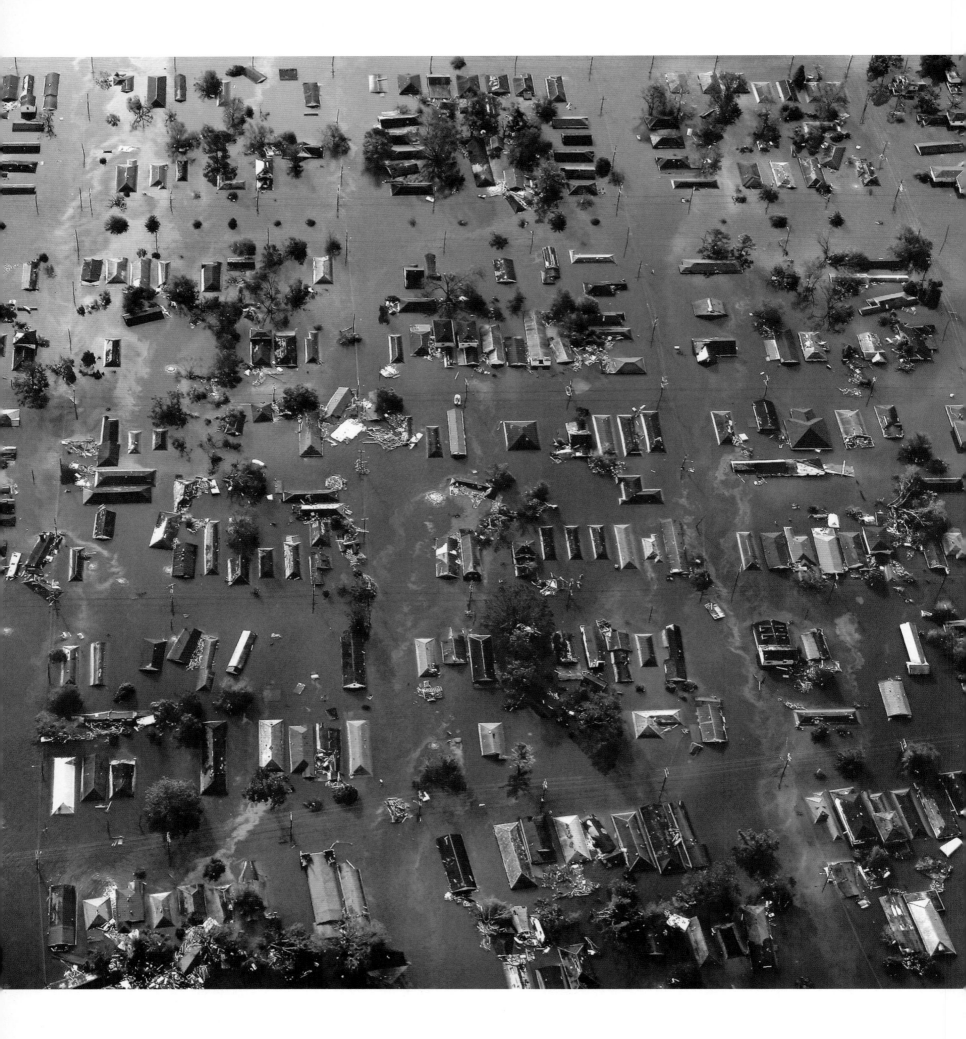

One picture caught the chaos—unruly crowds jammed together; smoke in the background; confusion, fear, and fury showing on their faces.

"They were waiting there for eight hours," Ainsworth later recalled for a *Morning News* story. "They were trying to keep their families together. They were unable to go the restroom. They went where they were standing or they would lose their place in line."

"It was crazy, but it was just people trying to save themselves."

Staffer Smiley N. Pool was assigned to Lafayette, where helicopters normally available to service offshore oil towers were used to take telling air views of the storm's damage. Rental cost was prohibitive, however, so the *Dallas Morning News* flew a chopper from Dallas to the hurricane area, and working with AP, set up a coverage plan for pictures from the sky. Pool's photographs captured the wide devastation along the coast and in New Orleans. The helicopter was up every day for more than three weeks.

Irwin Thompson, a photographer who had worked in New Orleans and knew its highways and byways, skirted barricades and got into the city to photograph refugees fleeing the floodwaters.

Katrina became a local story when refugees were taken several hundred miles from New Orleans to shelters in Dallas. Photographer Melanie Burford was assigned to cover the local angle and produced compelling images of those who had lost their homes, belongings, and loved ones.

"The story did not end with the end of the storm and its aftermath," Snyder said. "We continued to cover the aftermath, and will do so as long as there is a story to tell."

Eight photographers contributed pictures to the paper's Pulitzer Prize-winning portfolio: Irwin Thompson, Smiley N. Pool, Michael Ainsworth, and Melanie Burford, plus Barbara Davidson, Tom Fox, Brad Loper, and Michael Mulvey.

Photographers who cover stories like Katrina find themselves eyewitnesses to human disasters. Each picture becomes a story with its own set of unique tragedies. Although empathy is a necessary ingredient of the coverage, frequently photographers are criticized for being insensitive to the suffering they capture with their cameras.

Thompson summed up his reaction to the scenes his camera portrayed "As a photojournalist you hide your emotions behind a camera. But at the end of the day [photographing Hurricane Katrina], you would put down the camera and sit in the truck by yourself, and that's when it would hit you."

TECHNICAL DETAILS CAMERA Various
 EXPOSURE Various
 LENS Various

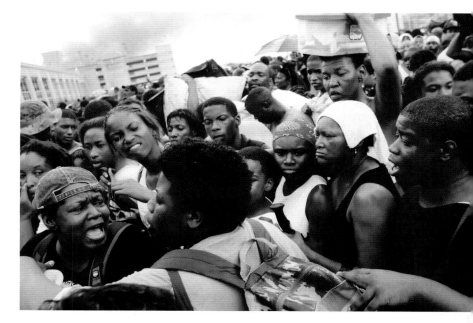

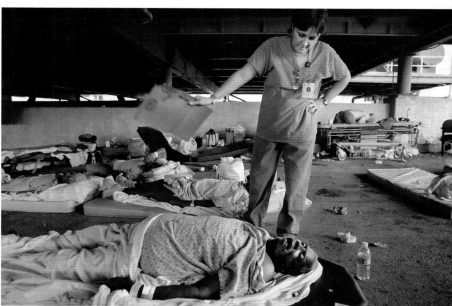

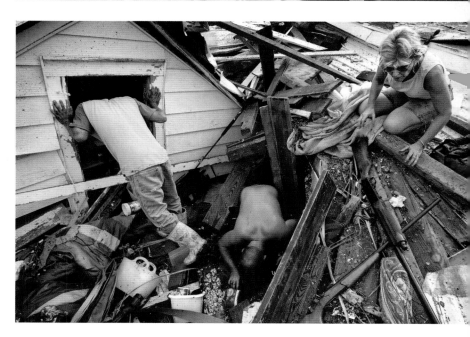

Final Salute

TODD HEISLER OF THE *ROCKY MOUNTAIN NEWS*

Questions scroll through the photographer's mind as grief unfolds before the camera. When does the camera become intrusive? When should the photographer back off? When should he move forward? Does the photographer make the grief worse? Or does the picture offer an opportunity to share the pain? Each situation is different; each requires sensitivities developed largely through experience.

Photographer Todd Heisler struggled with these questions over and over again during the year he and reporter Jim Sheeler spent with Major Jack Beck, whose assignment was to look after the families and funerals of Marines killed in Iraq.

Sheeler and Heisler accompanied Beck as he went from family to family, first arriving with word of a young Marine's death, then meeting with the family when the Marine's body arrived home for burial. Families inevitably became the story; Beck was the thread that held the pictures together across the year.

"Major Beck intervened on our behalf," Heisler says. "He told families that Jim and I wanted to talk to them and most of the families agreed to see us, and then agreed that we could photograph the funeral of their returned war hero."

"In order to get this story right," Heisler said, "you have to absolutely commit yourself. You are so close to the pain that you also feel it....The hardest thing was to get close, but not too close."

Early in the coverage the three men—Marine, photographer, and reporter—noted passengers watching from aircraft windows as a flag-covered casket was taken from the belly of the plane.

"You see the people in the windows," Beck said. "They're gonna remember bringing that Marine home the rest of their lives, and they should." Heisler sensed that there was a picture there, but he was unable to take it during their passages through various airports. One night at the Reno airport the picture came together. A casket came out of the plane and the photograph captured the moment that war touched people at home.

The deceased Marine was 2nd Lieutenant James Cathey of Colorado. Only days before, Beck had notified the officer's wife, Katherine, of her husband's death in Iraq. Heisler and Sheeler

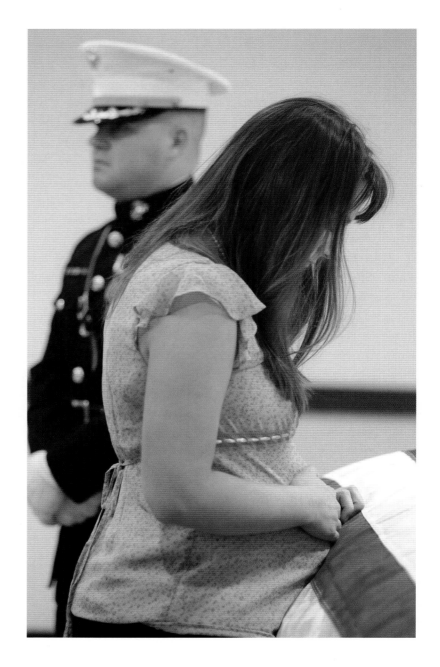

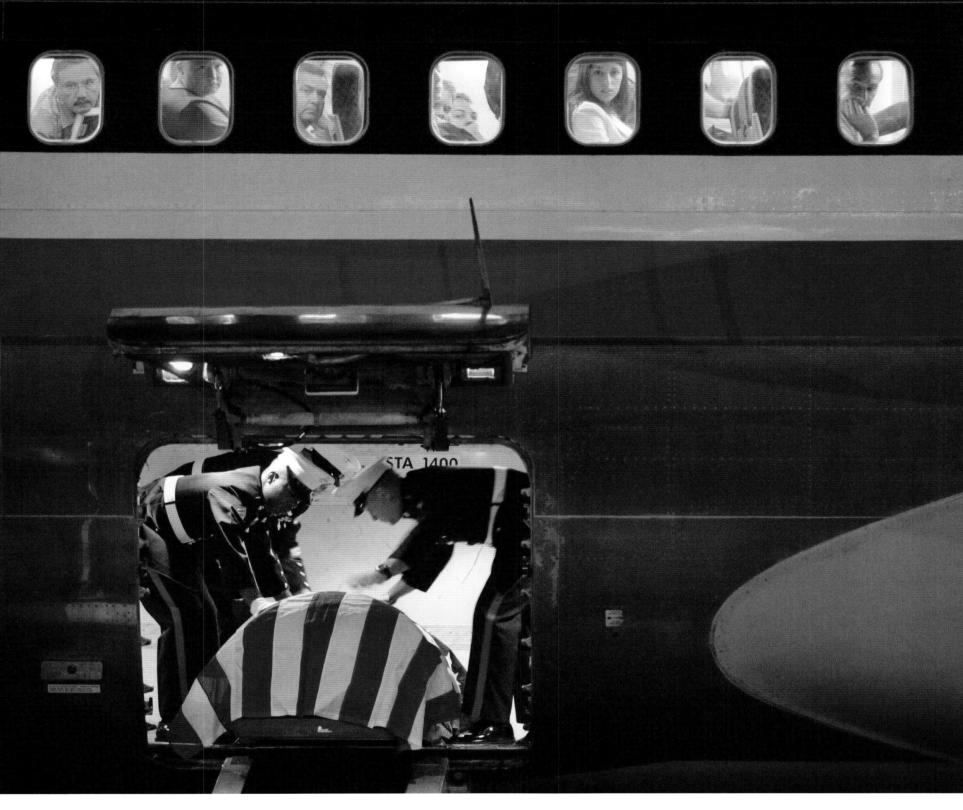

OCTOBER ▪ *Saddam Hussein trial begins in Baghdad.*

OCTOBER ▪ *American military dead in Iraq reaches 2000.*

OCTOBER ▪ *Chicago White Sox win World Series, first since 1917.*

NOVEMBER ▪ *Angela Merkel named Germany's first female Chancellor.*

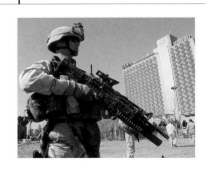

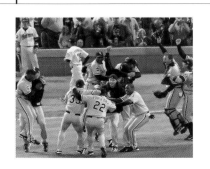

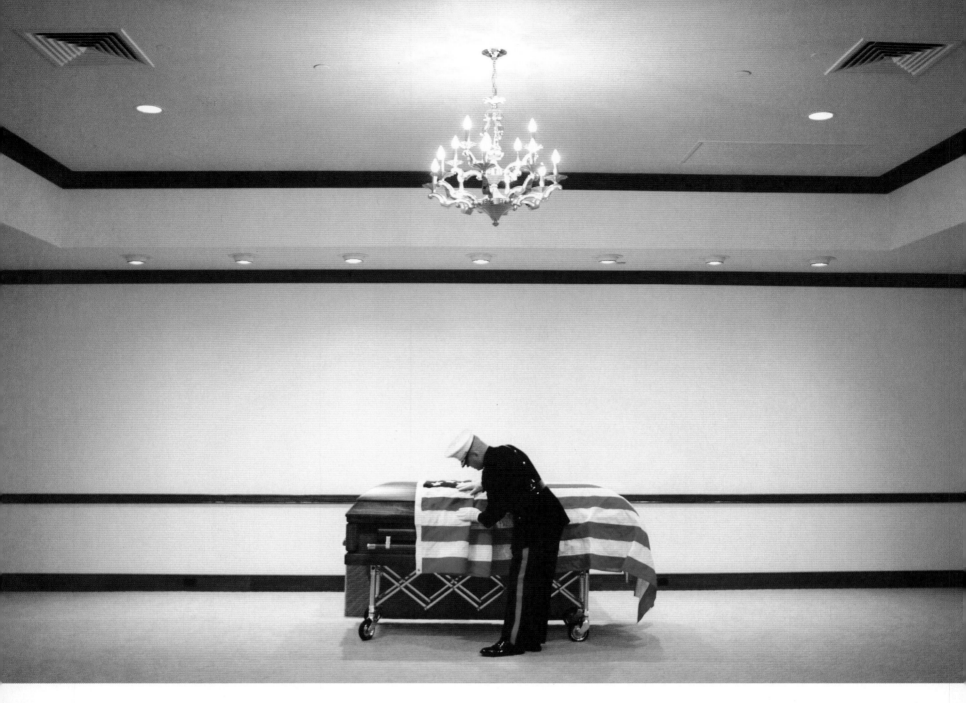

spent an evening with Katherine, talking to her until midnight, listening to stories of her life with her Marine husband. Heisler and Sheeler were welcomed by the Cathey family; as Katherine later told them, "You guys made my night,"she said, referring to their patience and ability to listen.

Coverage of the home front was a natural follow up for the two *Rocky Mountain News* staffers. Sheeler, in fact, had previously taken on the beat of the home front for the paper. A series of conversations between writer and photographer developed the story they wanted to tell.

Heisler said his favorite photograph was the scene in which Katherine slept in the room with her husband's casket on the night before the funeral. Heisler covered the war in Iraq on three different visits and, with Sheeler, narrowly escaped death when their vehicle was blown over by a roadside bomb.

Another photograph Heisler thought compelling was made as

Katherine pressed her stomach, alive with the couple's unborn child, against the casket. It was as close as the child would ever be to his father. Heisler made two frames and then drifted into the background.

Photos of the Cathey family were published in *The Rocky Mountain News*, as were photos of other families coping with the loss that the Iraq war brought home. Altogether, over the life of the coverage, six or eight families were covered in depth, and many others on a day-to-day basis.

The paper decided to bring together a special 24-page section that contained some 12,000 words and more than 30 photographs. It was published on November 11, 2005—Veteran's Day.

"Reader reaction was overwhelming," Heisler said. He received a stack of letters and more than 1,000 e-mails. "The theme throughout was that we had to remember those who gave their lives for our country.

"One Vietnam veteran wrote that he had seen lines of coffins on the tarmac in Vietnam and he often wondered what happened when they arrived home. He said that now he knew and he was grateful for our stories."

Heisler continued: "Katherine told us that she was especially pleased that all the information in our stories was accurate. And other families said the same thing...the right names...the correct relationships...all kinds of small accuracies."

"It seems so simple," Heisler said, "but it is so important to get the details right on stories like these that are so close to the families."

Sheeler's stories were also awarded a Pulitzer Prize. The rare distinction of a double prize for the same story attested to the remarkable power of the combined effort of photographer and writer.

TECHNICAL DETAILS **CAMERA** Canon Digital
EXPOSURE Various
LENS Various

One Against Many

BY ODED BALILTY, *ASSOCIATED PRESS*

Conflict was not new to Oded Balilty, who, in his two years as an Associated Press staff photographer in Jerusalem, covered confrontations between Palestinians and Israelis. On February 1, 2006, in the West Bank town of Amona, just a short distance from Ramallah, the situation was a bit different: Israelis were confronting Israelis.

Israeli settlers in Amona had built structures on Palestinian land, houses that Israel's courts ruled illegal and ordered evacuated. Israeli security forces were assigned to oversee the evacuation. Confrontation was a certainty, the settlers would resist, and Balilty and other photographers were on the scene to cover whatever happened.

The situation quickly became chaotic. The security forces moved toward the settlement. The settlers threw stones. The government forces continued toward the buildings.

"I saw the woman hesitate a little bit, and I saw the line of police moving forward and I just grabbed my camera," Balilty recalled later. The lone woman held up a barrier, but the police slammed head-on into the flimsy barricade. Balilty made his picture—a single girl in a long dress attempting to stop black-suited, club-swinging forces. The girl went down. The troops hit her with clubs, pulled her hair, and continued toward their objective.

The picture was in the classic David and Goliath tradition (though this time, someone later commented, David lost), and it was published widely around the world.

The girl in the picture, who identified herself only as Nili, was a 15-year-old resident of Amona. She called the picture a disgrace to Israel because, she said, it showed the security forces attacking the people instead of defending them.

"I knew I had a good shot," Balilty said, "but Pulitzer Prize never entered my mind." When he won the prize, he said he felt "like I kissed the moon."

The picture was seen differently by many viewers. Some said that the Israeli government finally did something about the settlers; others believed the government acted unwisely and that the picture captured an unnecessarily heavy-handed attack on the community. About these contradicting responses, Balilty said, "Some said it (the picture) reflects left-wing views, some say it's biased toward the right. That's the beauty of the shot, both sides say they have come up on top. One side says, 'Look, they are fighting,' the other says, 'Good, they're evacuating settlers.'"

In addition to the Pulitzer, the photo won many other international awards for Balilty, who was born in Jerusalem and learned his photography in the Israeli army. He worked for a newspaper and an agency before joining AP. In an unusual twist, Balilty was also a member of an AP team that produced one of the 2007 Pulitzer runner-up picture stories—the Israel battle with Hezbollah in Lebanon.

JANUARY 2006 ▪ *Hamas election victory in Palestine.*

MAY ▪ *Kentucky Derby winner Barbaro injured at the Preakness.*

MAY ▪ *ENRON executives found guilty of fraud and conspiracy.*

JULY ▪ *Iraq insurgent leader Abu Musab al-Zarqawi killed.*

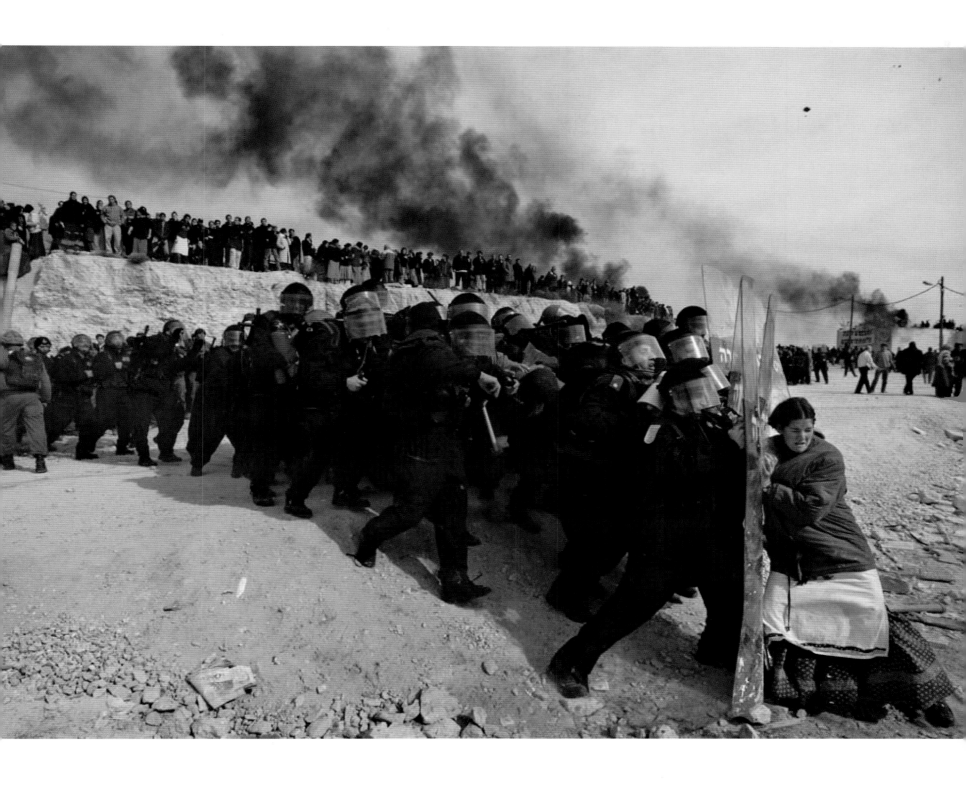

TECHNICAL DETAILS **CAMERA** Canon Mark II
EXPOSURE f7.1 @ 1/1000
LENS 16-35 mm f2.8

A Mother's Journey

BY RENEE C. BYER, *THE SACRAMENTO BEE*

The death of a loved one is sad; the death of a young child when spun out over many months is tragic. The heartbreaking story of one child is captured in a gripping series of pictures from Renee C. Byer's Pulitzer Prize-winning photostory published in the Sacramento, CA., *Bee*.

The mother of the child, Cyndie French, a single mom of five children, met Byer, a staff photographer at the *Bee*, at a conference in May of 2005. The conference explored the problems of young people who suffered from serious illness. French told Byer the story of her son, 10-year-old Derek, who suffered from a rare childhood disease called neuroblastoma, a cancer that starts in the nerve cells and eventually takes over the body organs. As they talked, a rare rapport developed, and French allowed Byer and writer Cynthia Hubert to follow the story of Derek's struggle.

The two journalists spent a year with the family. They accompanied Cyndie and Derek to the hospital and saw Cyndie race him through the halls in a wheelchair to take his mind off the coming medical examination. They visited doctor's offices and medical clinics for scanning, and attended countless examinations of the most exotic kind. And they spent much time in the French home. They saw the gradual change in Derek's personality as the constant pain ravaged his body and prompted angry outbursts—sometimes at his mother, sometimes at his siblings, sometimes at no one or nothing in particular.

The story developed on two levels. First, it was the hearttugging account of a mother's unconditional love for her child and second, it showed the fight to keep a family together in the face of a lost business, limited resources, and consuming medical problems that

JULY ▪ *Israeli tanks launch attack on Hezbollah in Lebanon.*

SEPTEMBER ▪ *Katie Couric becomes TV news anchor at CBS.*

SEPTEMBER ▪ *John G. Roberts Jr. becomes new Chief Justice of the United States.*

SEPTEMBER ▪ *Famed golfer Byron Nelson dies.*

altered family relationships. It was a story French wanted told so that others in a similar situation might benefit from her knowledge and experience.

Derek called the two journalists the "Bee ladies" and came to accept them as part of his life. It was a comfortable relationship, carefully nurtured, and it resulted in some of the finest pictures of the essay.

Byer's pictures are compelling and unforgiving. But they capture the ceaseless realities of day-in-day-out struggle. And, going beyond Derek's illness, they depict the other daily encounters the family faced and survived, despite limited resources.

Byer drew on her 20 years as a newspaper photographer to insure the story was told properly. The photos are intimate but not intrusive, caring but not sensational.

"In a situation like this," she said, "your instincts as a person are to try to help. But as a journalist, you have to step back and let things unfold as they naturally would. It can very, very painful.

"I was documenting a story that needed to be told, and it was a gift to be allowed to be there. Throughout I had a bigger vision that, because of what I was witnessing, it would bring hope to other families."

Derek's situation worsened over the months. His weight

dropped. His pain became unbearable. Toward the end he slept most of the time. But Cyndie never left his side. Derek died, finally, in his mother's arms in the spring of 2006.

Four lengthy stories with many pictures ran in the *Bee* in July.

When Byer was awarded the Pulitzer, French joined her in the Bee's newsroom, and they embraced. Readers responded with enthusiasm to the stories, an outpouring of support and understanding that enabled French to launch a project to collect funds for other families struggling with the same problems.

TECHNICAL DETAILS **CAMERA** Various
EXPOSURE Various
LENS Various

OCTOBER ▪ *Civil Rights activist Rosa Parks dies.*

NOVEMBER ▪ *Democrats are big winners in U.S. mid-term election.*

DECEMBER ▪ *Saddam Hussein is executed by hanging.*

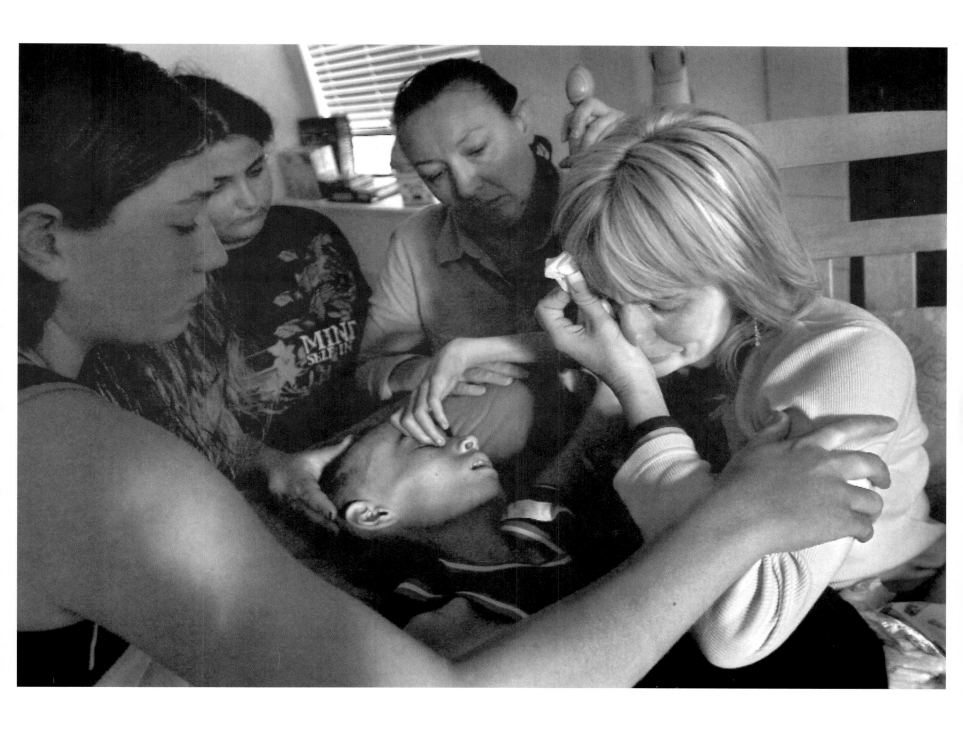

2008 [NEWS]

Death at the Sule Pagoda

ADREES LATIF, *REUTERS*

Myanmar, formerly known as Burma and for many years closed by its military rulers to visits of most foreigners, was increasingly the scene in 2007 of a restive populace protesting the escalating cost of fuel. There were reports of violence, including the shooting of students by the military in the nation's capital, Yangon (its name had also been changed from Rangoon).

Reuters photographer Adrees Latif, assigned to Bangkok, heard about the uprisings and made his way to Yangon, arriving there on September 23, 2007. How he got there, despite tough regulations against journalist visitors, Latif would never say. Within a few days, however, he knew his way around the city and located the trouble spots.

Latif spent considerable time at the Shwedagon Pagoda, well known to residents and visitors alike for its golden spires and spectacular images of Buddha. Located near the center of the city, it was the gathering point for monks prior to their demonstrations. Each day monks and their civilian followers marched from Shwedagon to the nearby Sule Pagoda.

The number of demonstrators increased daily and soon hundreds became thousands. The military presence also escalated. On September 27, the crowd peaked in size and soldiers responded by rolling barbed wire into the streets. Latif's experience told him that a serious confrontation was likely.

"Knowing that hundreds of people were gunned down in similar circumstances in a 1988 uprising, I climbed an old crosswalk directly overhead and settled into a spot offering a clear view of the street."

He watched the crowd wave flags and sing songs. Some demonstrators taunted the soldiers. In the early afternoon, truck loads of troops rolled into the area and were met by a barrage of fruit and water bottles. The demonstrators were warned to leave the area, but few did.

Then the shooting started. Among those on the street facing the oncoming troops was Kenji Nagai, a Japanese videographer for Agence France Presse.

"Out of the corner of my eye," Latif reported, "I saw a person flying backwards through the air. Instinctively I started photographing and captured several frames of the man on his back." Shots continued. Latif saw a soldier, rifle in hand, standing over the Nagai as he attempted to photograph over his head at the troops charging into the students.

"More shots rang out...the crowd scattered before the advancing soldiers. Smoke bombs were released. The whole incident was over in seconds,"

Latif made a few more frames then knew it was time to get off the bridge before the soldiers spotted him and his camera. He

FEBRUARY 2007 ■ *Troop surge deployed to Iraq.*

APRIL ■ *Massacre of students at Virginia Tech.*

JULY ■ *Final* Harry Potter *book released.*

AUGUST ■ *Minnesota bridge collapses into Mississippi River.*

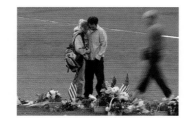

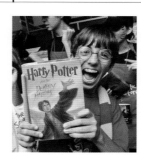

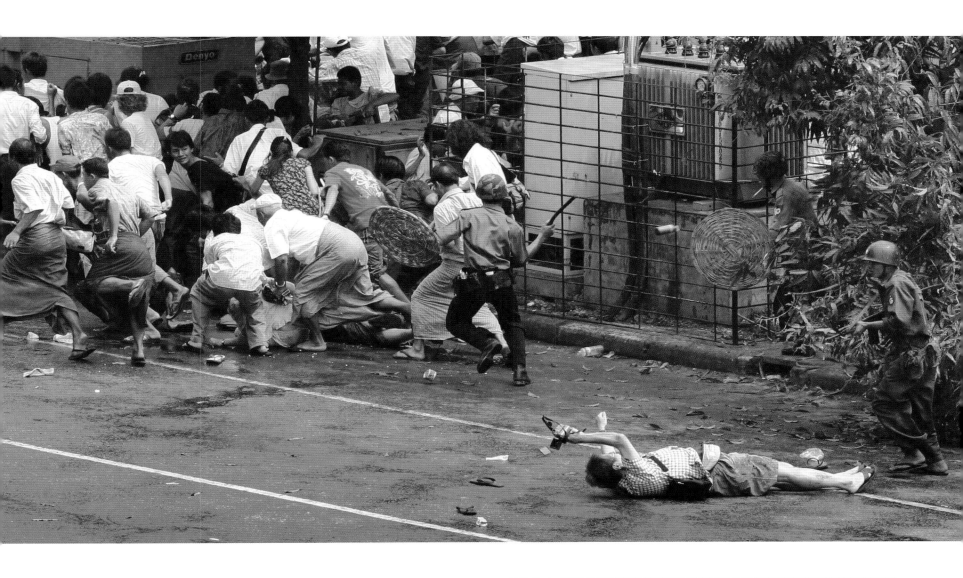

followed the protestors for another hour or so but the demonstration dissipated. Latif returned to his hotel through back streets to avoid confrontation with police or army.

His picture transmissions—he refuses to reveal his method of transmitting out of the country—were received in Reuters' London office in the early hours of the morning where editors, working with their Tokyo bureau, identified Nagai. Latif reported in his caption that the photographer was wounded but the London office determined he had been killed. Latif later met with Nagai's family and told them the details of the incident at the Sule Pagoda.

Thanks to Reuters' international picture network, the exclusive photos were published worldwide. Latif's credit line was omitted to protect his security in Myanmar. The picture was Reuters' first Photo Pulitzer.

TECHNICAL DETAILS **CAMERA** Canon 5D, digital
EXPOSURE 1/1000th @ f7.1, ISO 800
LENS 135mm

Remember Me

PRESTON GANNAWAY, THE *CONCORD MONITOR*

Carolyn St. Pierre, stricken with a rare form of liver cancer and knowing that her time was limited, had a final wish. She wanted her family to have a record of their life together so that her husband and three children would "Remember me, and our life."

A mutual friend convinced Carolyn and her husband, Rich, both 44, that a reporter at the Concord, New Hampshire *Monitor* would write a sensitive story about the family. The friend contacted writer Chelsea Conaboy and asked her to create a written memorial that would forever recall the details of a mother's love for her family. Conaboy brought in Preston Gannaway, a photographer with more than five years experience at the *Monitor*.

"At first," Gannaway said, "we planned a single story about a family living with a dreaded disease destined to take away their wife and mother." But they were struck by the courage that Carolyn showed as the cancer slowly took her life. "So we did another story as a followup, and then another. We published five stories and some 30 photographs. The story-by-story chronicle just evolved, one story at a time over a year and a half."

Gannaway and Conaboy visited the family nearly every week, fitting visits into the hurly-burly routine of a small daily newspaper. They published pictures and stories of a family that endured surgery, long hospital stays, chemotherapy, and 14 visits to hospitals and medical centers.

Sometimes Gannaway stopped by the house just for a chat, not taking a single picture but just spending time with the family. Other times she would photograph family life: the activities of the children; Rich resting in bed alongside Carolyn as they talked; visits by Carolyn's mother.

The story of Carolyn's final, intimate days and the journey her family traveled posed an awesome challenge for the photographer. Just how intimate should the photos be? When does the desire for a record become an intrusion of a private crisis? How much light should be cast upon the moment that a family's heart copes with the deep darkness of love lost. Gannaway found herself in those situations several times and these judgments were not simply made.

"We became involved emotionally with the family and their

AUGUST ▪ *Barry Bonds breaks baseball's home run record.*

SEPTEMBER ▪ *New refugee crises in Sudan.*

OCTOBER ▪ *Wild fires in California cause $1 billion in property damage.*

DECEMBER ▪ *Pakistan's former Prime Minister Benazir Bhutto assassinated.*

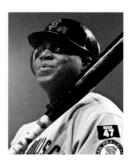 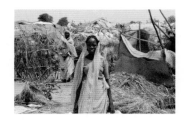 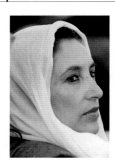

struggle, and it was difficult to retain our journalistic separation as we watched Carolyn's life ebb away and saw the impact on the family. I personally was challenged by the problem of shooting pictures of the family as they struggled with their awesome challenge, then the next day be assigned to cover a high school ski jumping contest."

"It was the most profound experience of my life," Gannaway said.

When, finally, the illness reached the point where there was no hope, Carolyn stayed at home with her family. The end came in February, 2007, and Gannaway was at her bedside with the family. She photographed the funeral as the devastated family placed pink roses (pink was Carolyn's favorite color) on the coffin.

The coverage did not end with Carolyn's death. One subsequent picture showed Rich and the youngest child, Elijah, planting trees on the family property as a living memorial to their wife and mother. The two *Monitor* staffers visited the family later and did a story on the life of the older boy, Bob, a troubled lad who struggled with school and finally attended a special school that led to a new relationship with Rich. Their daughter, Melissa, who was 14 when her mother died, was also photographed.

A portfolio of 19 pictures captured the 2008 Pulitzer Prize for Feature Photography. It was the first Pulitzer for the *Monitor*, and the first Pulitzer won by any New Hampshire newspaper.

Ironically Gannaway learned of the prize as she drove west in Nebraska headed for a new job at Denver's *Rocky Mountain News*. She headed back to Concord where a party was planned, attended by Rich St. Pierre as well as the newspaper staff. Rich brought a picture of Carolyn and propped it up on the party table.

"She would be pleased," he said.

TECHNICAL DETAILS **CAMERA** Nikon digital
EXPOSURE Various
LENS Various, but 90% 16-35mm zoom

A People In Despair:Haiti's Year Without Mercy

PATRICK FERRELL, *MIAMI HERALD*

Hurricanes and tropical storms are born off the coast of Africa and gather strength as they move west across the Atlantic Ocean toward North America. The storms find landfall between the mid-Atlantic coast or the coastal areas of the Gulf of Mexico. Along the way they often leave a trail of disaster in the islands south of Florida.

In 2008 tiny Haiti, impoverished in the best of times, got more than its share of fierce storms sweeping in from the Atlantic. Between mid-August and early September three tropical storms—Fay, Gustav and Hanna—washed over the island. Each storm left behind floods, destruction and death. If that were not enough a fourth storm, Hurricane Ike, struck the island on its way to becoming the third strongest hurricane to hit the U.S.

Patrick Farrell, veteran staff photographer at the *Miami Herald*, visited Haiti four times in 2008. He was in Haiti the night Ike hit, and was out early to photograph an island already pummeled from previous three storms and now struck prostrate by Ike. Farrell and *Herald* reporter Jacqueline Collins made their way to Cabaret, a coastal community that bore the brunt of Ike's fury.

"It was one of the most awful days of my life as a photojournalist," Farrell would say later. The city was partially covered by chest-high water, he recalled. Many people lived on their rooftops. "Bodies of drowning victims were scattered on street corners all over town," Farrell said. "The dead children looked like porcelain dolls."

Farrell photographed grieving parents clutching their dead children who had been pulled from their hands by Ike's rushing flood waters; the scramble for food distributed by churches and other rescuers; a woman frustrated by futile attempts to wash clothes in muddy flood waters; and the chaos of a community leveled by repeated, unrelenting forces of nature.

As difficult as it was to make the pictures, Farrell found satisfaction in the response from readers who called and emailed asking how they could help the rescue work. "The response was speedy and, no matter how tough the assignment, the reaction of our readers made it worthwhile," he said.

Luis Rio, Director of Photography, believed the pictures "were the most complete story I have ever seen. Still photos rule in the multimedia world we now face."

"This could have been an assignment we didn't have to go on in the midst of a newspaper facing today's challenges, " said *Herald* Executive Editor Anders Gylllenhanl, "but we did not decide that way—we decided to cover this story in our back yard. Not just cover it but do exemplary work."

Farrell is a hometown photographer, born, raised, and educated in Miami. As a youth he was hit in the eye with a shot from a BB gun and spent time in a hospital with both eyes bandaged. He discovered, when the bandaged were removed, that he had a new

JANUARY 2008 ■ *World financial crisis.*

MAY ■ *Earthquake hits China.*

JULY ■ *Gas prices hit record high.*

AUGUST ■ *Russian Troops invade Georgia.*

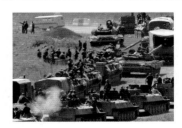

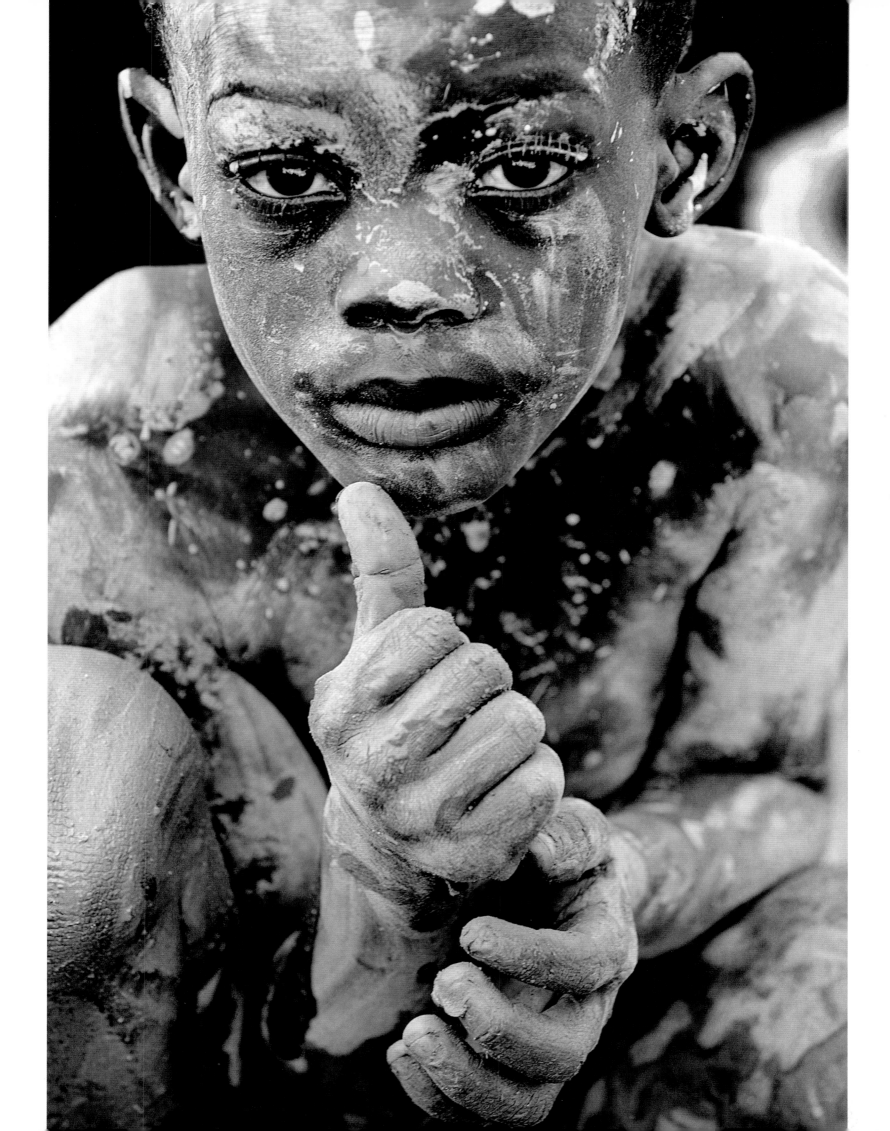

appreciation of detail and lighting, and turned to photography. He holds his camera to his left eye when he shoots instead of the natural use of the right eye.

His Pulitzer portfolio consisted of 19 photographs from his 4 trips to Haiti to cover storm damage.

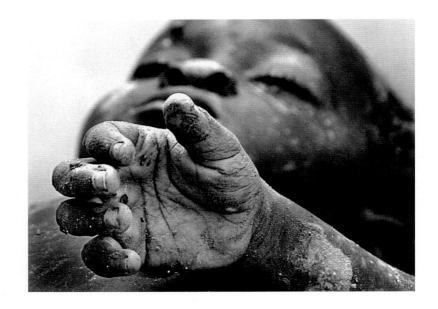

TECHNICAL DETAILS	**CAMERA** Canon EOS 1-D Mark III
	EXPOSURE Various
	LENS 16-35mm and 70-200mm

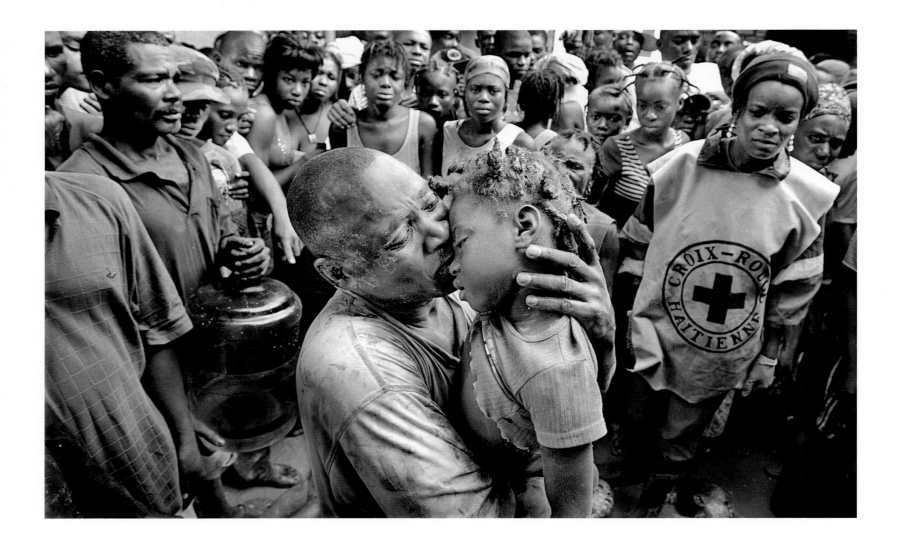

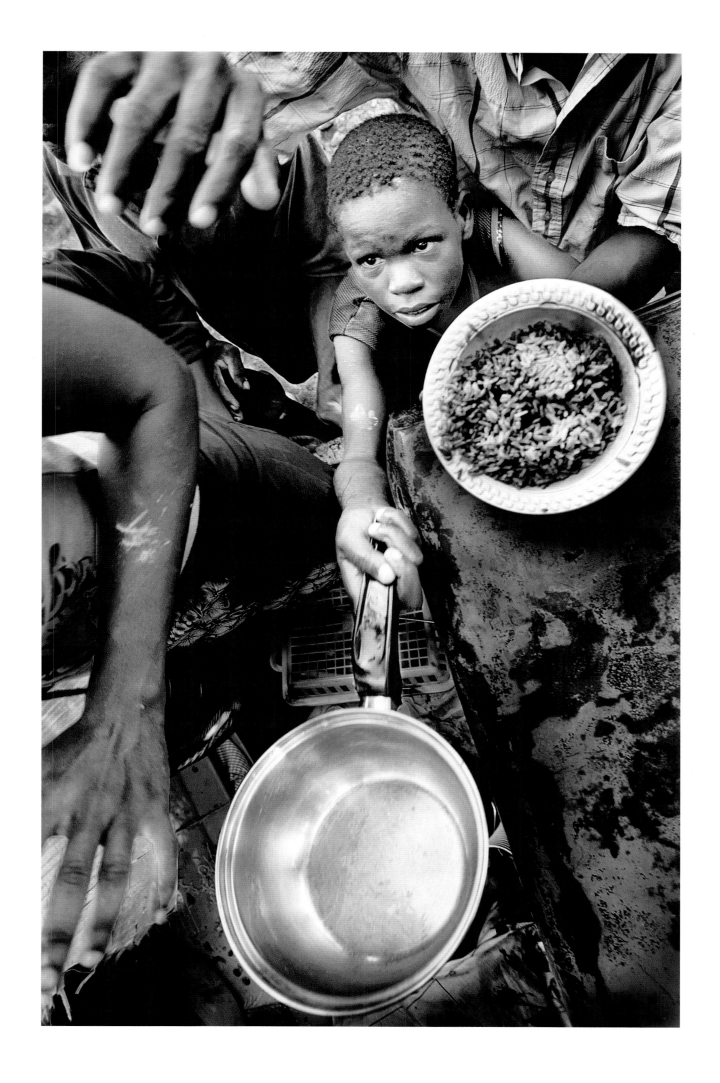

2009 [FEATURE]

Barack Obama's Presidential Campaign

DAMON WINTER, *THE NEW YORK TIMES*

For the photographer, a presidential political campaign is a grueling, daily pursuit of different or unusual pictures of similar scenes often repeated. Campaign managers keep the candidate "on message." That translates to politicians repeating speeches before local crowds primed to enthusiastically adore their candidate amid posters and vote-getting paraphernalia that is consistent from whistle stop to whistle stop.

The campaign of Barack Obama was no different. In fact, those who have covered numerous campaigns report that the Obama camp set a new standard for efficiency. And the candidate himself presented a cool, controlled image even in the most stressful situations.

From 7A.M. until nearly midnight, a photographer must keep a vigilant watch for the fleeting gesture, nod or look that makes an eye-catching picture. Those moments flickered by in an instant.

Damon Winter of *The New York Times* faced the challenge for nine months as he followed Obama from his declaration of candidacy, through the Democratic Political Convention up until he was elected.

"Obama was both easy and difficult to photograph," Winter recalls. "His profile is instantly recognizable from any angle, front or back. That makes it easy. But he was also cool, unruffled." He retained his composure, Winter said, and that made it difficult to get the odd or expressive picture.

"I covered Hillary Clinton a bit before the campaign," he said,"and she was emotional, expressive, and that showed in the pictures. Obama was the opposite.

"The crowds that greeted Obama were enthusiastic and that offered good pictures. One I especially liked was kids rushing to a fence in dwindling light, hopeful to catch a glimpse of the candidate.

"Security was very, very tight, restrictive to a degree that frustrated photography. But the security also made a good photo."

Still in all, Winter found the photo possibilities limitless. "The big problem was to not miss something significant as you searched for something different.

"The *Times* had big team on the story and their editors were helpful providing information that might make for picture possibilities. We worked together closely."

Winter is an experienced hard news photographer with a delicate eye for the offbeat but this was his first full-time political campaign. "The constant need for attention to the story over such a long period of time was emotionally and physically exhausting," he said, "but witnessing history in the making was fascinating."

Winter estimates that he made some 90,000 images during the coverage and transmitted nearly 100 pictures a day to home base at the New York picture desk. His pictures were used in the daily editions of the *Times*. Several slide shows were put together for online distribution.

SEPTEMBER ▪ *New York Stock Exchange in free fall.*

NOVEMBER ▪ *Barack Obama elected first black president.*

NOVEMBER ▪ *Terrorists attack Mumbai hotel.*

DECEMBER ▪ *Israel at war in Gaza.*

Putting together a Pulitzer portfolio of 20 pictures was difficult from such an extensive collection of photos. "We got it down to 30 but I had to leave the final 20 selection to the editors. They did a great job and it was a rewarding experience to receive the Pulitzer."

TECHNICAL DETAILS **CAMERA** Canon 5 D
EXPOSURE Various
LENS Various

ACKNOWLEDGMENTS

Special thanks and appreciation for making this book possible go to the following individuals: Lou Reda, of Reda Productions, for his persistence and moving the book from idea to reality; J. P. Leventhal, of Black Dog & Leventhal Publishers, for saying yes; David Halberstam, author and journalist, for his up-front comments; Lesley Bruynesteyn and William Kiester, of Black Dog & Leventhal Publishers, for their sharp-eyed editing and clear thinking; Dutton & Sherman Design for a beautiful book; Patricia Lantis and Jorge Jaramillo, AP/Wide World, for making the pictures happen; John Kuss, of Corbis, for the UPI pictures; Elliane Laffont of Sygma, friend and picture provider; Vincent Alabiso, Associated Press, for guidance on AP's recent Pulitzer winners; Claudia DiMartino, for finding a mother lode; Fred Sweet, Associated Press, for making the book one hundred percent complete; Jerry Cammarata; and Angela, for patience and a lost summer.

PHOTOGRAPHY CREDITS

The timeline photographs are courtesy of AP/Wide World Photos.

The Associated Press Pulitzer Prize winners are courtesy of AP/Wide World Photos.

The United Press International and David Turnley's Pulitzer Prize photographs are courtesy of Corbis.

Kevin Carter and Charles Porter IV's Pulitzer Prize photographs are courtesy of Sygma.

Damon Winter Pulitzer Prize photographs are courtesy of Damon Winter/*The New York Times*

All the other Pulitzer Prize photographs are from the individual photographers and publications as indicated.

Index